REMBRANDT

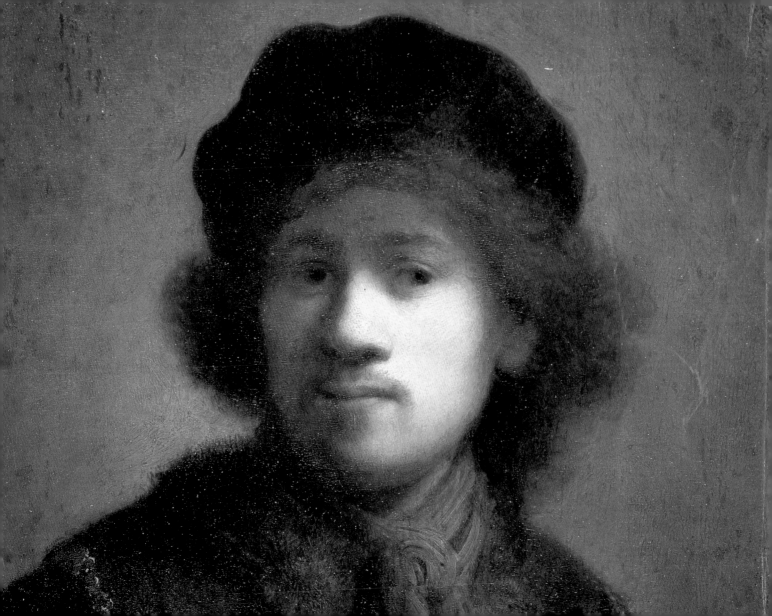

REMBRANDT

D. M. Field

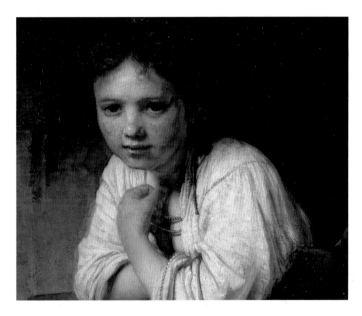

This edition published in 2007 by
GRANGE BOOKS
An imprint of GRANGE BOOKS PLC
The Grange
Kingsnorth Industrial Estate
Hoo, Near Rochester, Kent.
ME3 9ND
www.grangebooks.com

Copyright © 2007
Regency House Publishing Ltd.

For all editorial enquiries please contact
Regency House Publishing Ltd at

www.regencyhousepublishing.com

ISBN 13: 978-1-8401-3961-7

Printed in China
by Sino Publishing House Ltd.

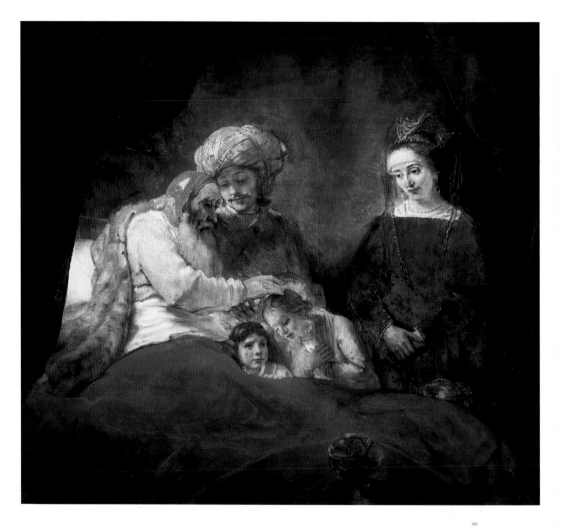

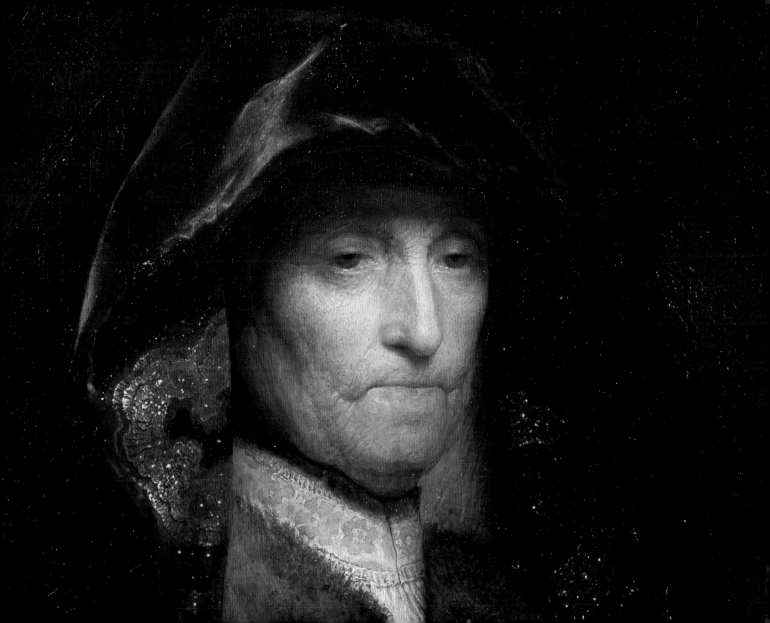

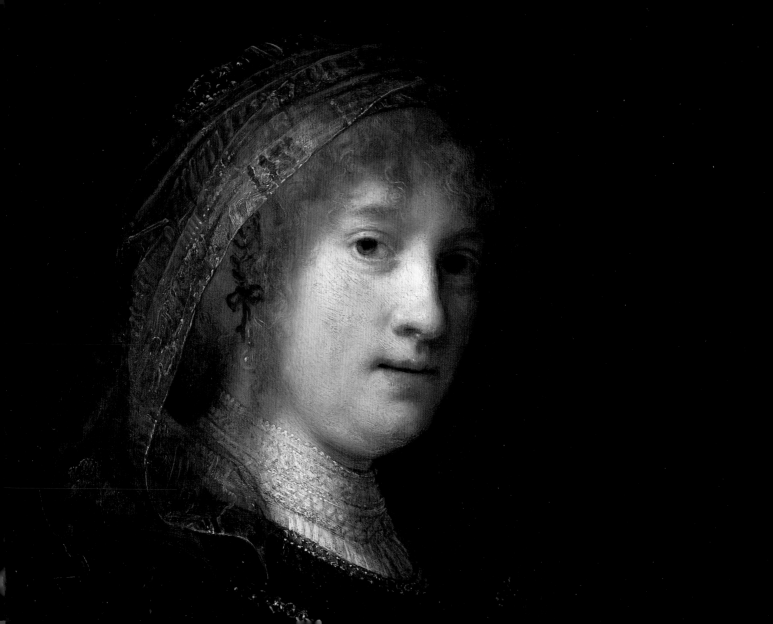

CONTENTS

Introduction

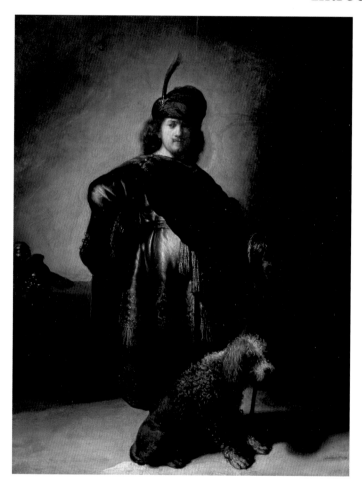

Although it would be absurd to say that Rembrandt is the greatest painter who ever lived, it would be less unreasonable to conclude that in the Western world, even among people who know nothing in particular about art, he is the best-known. Asked at random to name a single great artist, more people would think of Rembrandt first, even before Picasso or Van Gogh.

Rembrandt was prolific, and many of his paintings survive. Exactly how many it is impossible to say, because the ownership of a few is unknown, or at least well concealed, and, more particularly, because the list of works accepted as authentic varies with every authoritative book on the artist – and there are an even larger number of those. Research on Rembrandt remains lively, and as the years, almost as the months go by, we learn more, although it often seems that for every question that is settled, a new one arises. The new catalogue produced by the Rembrandt Research Project is probably as near to the final word as we shall get for the time being, though that is not to say that every scholar agrees with all the RRP's conclusions. But the situation has improved, and the number of authentic Rembrandts, while it will never be set in stone, is at least less subject to the large variations of the past. An early attempt to establish Rembrandt's oeuvre awarded him 614 existing paintings, many of which the compiler of the list had not seen, and in 1913, a Dutch scholar raised the number to a dizzy 998.

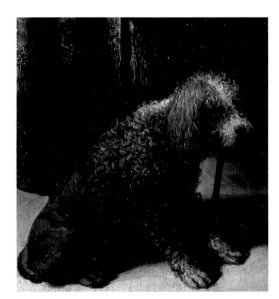

Reaction set in, and a rather freakish catalogue published ten years later reduced the total to a mere 48! In 1935, the great Rembrandt scholar Abraham Bredius raised the total again to 630. His catalogue is still widely cited in the revised form published by Horst Gerson, which reduced the number, sometimes rather arbitrarily, to 420. Many more, almost a

quarter, have been queried or excluded outright by the RRP, which even raised a question over *The Polish Rider* (pages 302–03) in New York's Frick Collection, generally regarded as a great masterpiece.

This breathtakingly severe reduction of Rembrandt paintings, based on formidable research into the most esoteric details, still leaves a relative abundance, not to mention the innumerable etchings or drawings, and will no doubt encourage the excitement that breaks out when (increasingly rarely) a major work appears on the open market. Such an event provokes an outburst of raising of funds, wooing of philanthropists and consumption of grants. Anyone who lived in New York (or most other places) in the 1960s will remember the highly publicized acquisition of *Aristotle Contemplating a Bust of Homer* (pages 288–89) by the Metropolitan Museum, New York, for what was then a record price.

Fashions in art, as in everything else, change, but Rembrandt's reputation was high in his own time, has remained high ever since, and is not perhaps near its peak. Views have naturally varied, and he was certainly not immune to criticism, both in his own time and in later ages, particularly in the 18th century. Generally accepted standards and values in the appreciation of art have undergone profound changes since the Romantic movement transformed the critical approach to art, and much of the criticism of

OPPOSITE
Self-Portrait in Oriental Costume, 1631
Oil on panel, 26 x 20¹/₂in
(66 x 52cm)
Musée de la Ville de Paris, Musée du Petit-Palais

This rather grand, though not large, self-portrait, seems to confirm that Rembrandt was a short man. The dog, a spaniel (detail left), stands here as a symbol of nobility and duty.

INTRODUCTION

Portrait of Rembrandt's Father
Mauritshuis, The Hague

OPPOSITE
Portrait of Rembrandt's Mother
Collection of the Earl of Pembroke

The paucity of our knowledge about Rembrandt has led to many paintings being identified as Rembrandt portraits of his family or other acquaintances. This alleged portrait of his father is especially doubtful.

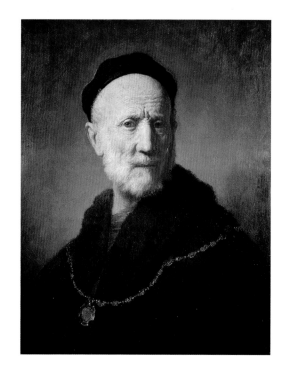

Rembrandt by his contemporaries and by 18th-century critics strikes us as not so much wrong as irrelevant; sometimes he was criticized more on moral than aesthetic grounds. Alternatively, his work was condemned for precisely the qualities that make him admirable to us, such as his alleged indifference to the Classical ideals on which the art of the Renaissance was founded.

While it is difficult to generalize about a large and varied body of work, and while Rembrandt's style naturally changed with passing time, we can see certain fundamental constants that distinguish his work from that of other artists. First, light and colour: typically, in a Rembrandt painting, there is a more or less central area of light, surrounded by larger areas of comparative darkness. The light almost never extends as far as the edge of the painting: the artist also seems to have liked heavy, dark frames for his pictures. The colours are rich, but they are not bright, 'pure' colours, with marked borders – as, for instance, in Florentine frescoes of the 15th century. They are a constantly changing mixture, and glow like the embers of a fire. In the lightest and the darkest parts they almost disappear, but in between they grow more intense, often, and especially in Rembrandt's later period, towards a stronger red. Sharply contrasting colours are rare, and the strongest colour, like the strongest light, is restricted to a relatively small area of the picture. The colour appears to come from within, defining the form, rather than being

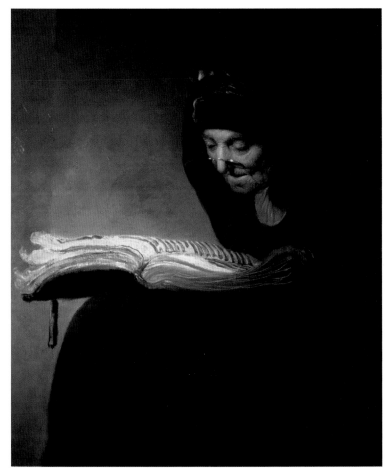

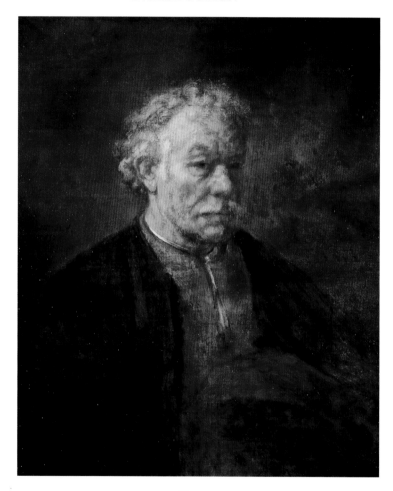

RIGHT
Portrait of an Elderly Man
Mauritshuis, The Hague

OPPOSITE
Portrait of an Old Man
Galleria degli Uffizi, Florence

This painting was probably purchased by Cosimo de' Medici on a visit to Rembrandt's studio.

OVERLEAF
Jean Pellicorne and His Son Casper, c. 1632–34
Wallace Collection, London

The father is handing on a fat bag of money to his well-fed only son and heir. (See also page 137). Although this is attributed to Rembrandt, it may well have been by one of his followers.

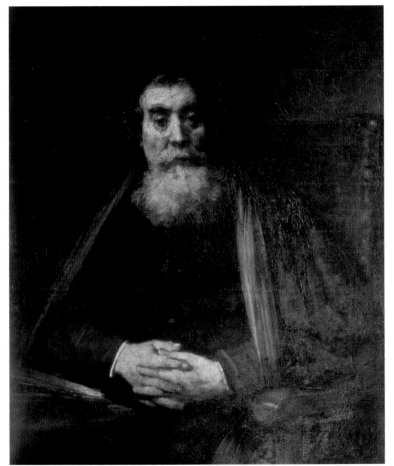 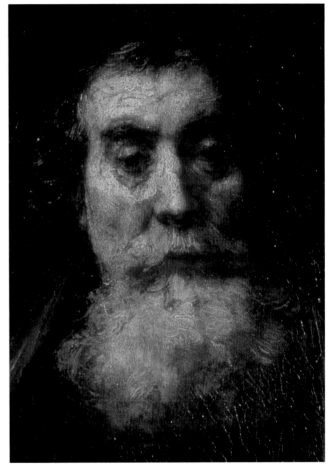

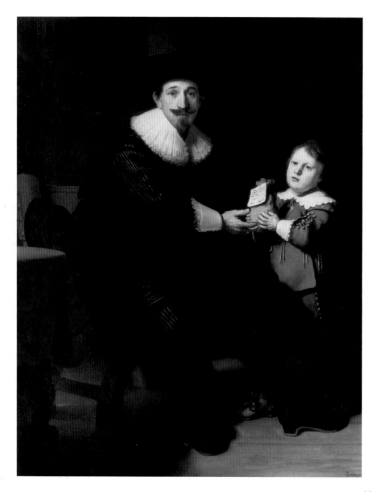

imposed from without. Colour, however beautiful, is not deployed for its own sake; it is never merely decorative. (Rembrandt's colour is also, unfortunately, notoriously difficult to reproduce, even with the latest printing techniques, as anyone who has stood in a gallery admiring a painting known previously only from reproductions will agree.)

Seen in a gallery, much of the background of a Rembrandt painting may appear as a solid, dark brown. This is usually the result of ageing, and suggests that the painting might benefit from cleaning. In fact, the background is, like the colours elsewhere, made up of a mixture of closely associated browns, greens and greys, which acquire life and atmosphere from reflected light. In Rembrandt, the background, however insignificant it may at first appear, is never just packaging, it is an integral, functioning part of the design.

But the basis of Rembrandt's art is not so much colour as tone – the effects of light and shadow known by the term *chiaroscuro*. It is this that decides the scheme or composition of the picture. Colour may be used to raise the emotional response, or direct the eye, but it is essentially an aid, integrated with the *chiaroscuro* and possessing little or no significance in itself. Some paintings – and not exclusively those portraits of Dutch burghers and their wives who wore nothing but black and white! – are almost without colour. Rembrandt's mastery of *chiaroscuro* was admired in his own time no less than it is today.

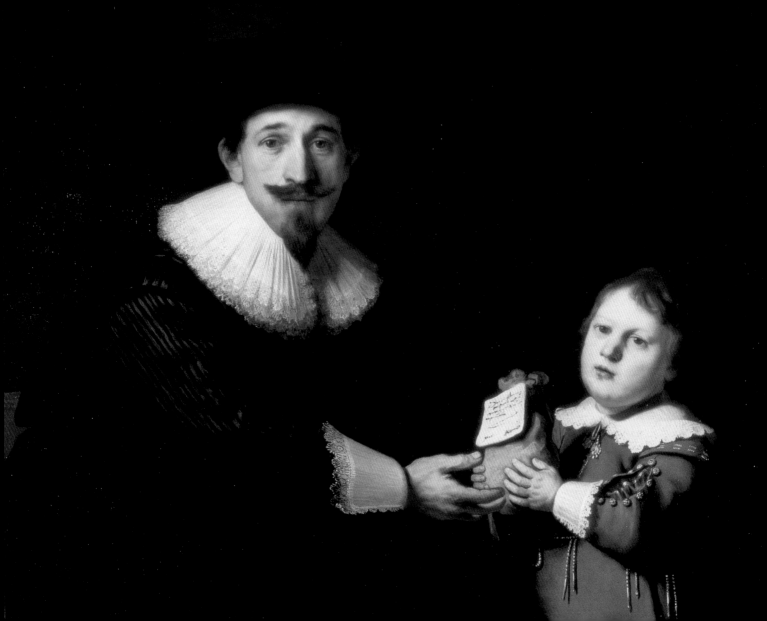

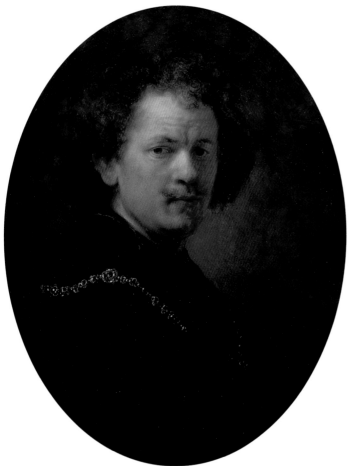

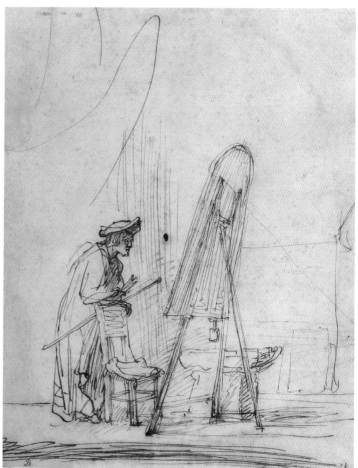

REMBRANDT

It cannot be separated from his equally striking sense of design. As we have seen, his paintings have a 'centre', and they hardly ever contain different, self-contained areas of interest. His compositions are quite simple, but strong and unerring. In his later period, at least, there is little movement, one of several reasons why Rembrandt's style cannot be simply described as 'Baroque', except perhaps during his middle period. Rembrandt's figures, seen against backgrounds that, while interesting, do not compete with them, have an impact that does not spring exclusively from his intellect or his unique psychological insight. Design and technique are also responsible.

Nevertheless, it is as a painter of faces of extraordinary conviction that Rembrandt is most renowned. Well over half his paintings are portraits – including an unparalleled number of himself. (One brief *Introduction to Rembrandt*, illustrates 33, including etchings and drawings, and mentions a dozen or so more; the total surviving in all media must be about 100.) If group portraits and figures from the Bible are included, the proportion of portraits is even greater. This is partly to be explained by the artist's need to make a living, and portraits of themselves is what his patrons generally, though not exclusively, demanded. Portrait painting was not then, any more than now, considered the highest form of art, and it did not have the prestige attached to what was called 'history' painting. Faces, many of them of old people, are

OPPOSITE LEFT
Self-Portrait, 1633
Oil on panel
Louvre, Paris

OPPOSITE RIGHT
An Artist in a Studio, c.1632
Pen and brown ink on paper,
8¹/₁₆ x 6 ¹¹/₁₆in (20.5 x 17cm)
J. Paul Getty Museum, Malibu

LEFT
An Actor Standing
Sanguine on paper, 9⁵/₈ x 6⁷/₈in
(24.5 x 17.5cm)
Hermitage, St. Petersburg

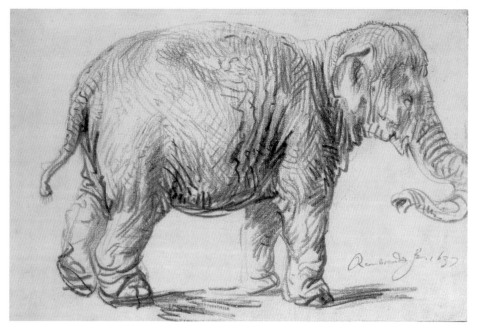

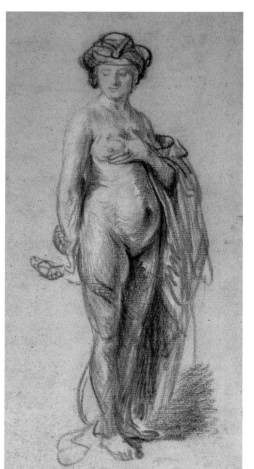

usually serious, always expressive. We can almost sense the desire of the subject to project his or her self to the artist and, by extension, the viewer, and also the equally intense, concentrated gaze of the painter.

In Rembrandt's oeuvre, the largest category after portraits is scenes from the Bible and, less often, Classical mythology – history paintings in other words. There are also landscapes, though they are much more common among his etchings and drawings than his paintings. Examples of genre scenes, in spite of the huge popularity of this form in 17th-century Holland, are comparatively rare, if we discount a strong element of genre in some of his religious pictures and occasionally in portraits.

Rembrandt was a committed artist. A humorous and a sensual man, in his art he is always serious, even solemn and indeed mysterious; for he does not put everything down on the canvas, but always requires the viewer to exercise his or her imagination. We may sometimes feel uneasily that something significant is eluding us.

For all the brilliance of his technique, Rembrandt never shows off. His brushwork may be admirable, but that is not the reason for it. Although he seldom paints a real room or a real landscape background, his art does not aspire to rise above nature, but shows us the essence, the true reality, of it. As a modern biographer says, 'He was driven by a passion to set down every shape, area, tone and colour exactly as he

OPPOSITE LEFT
An Elephant, 1637
Charcoal on paper
Graphische Sammlung Albertina,
Vienna

OPPOSITE RIGHT
Study of a Nude Woman as Cleopatra
Christie's Images, London

LEFT
A Young Man
Oil on canvas, 31 x 25^1/4in
(78.6 x 64.2cm)
Dulwich Picture Gallery, London

This was once thought to be Rembrandt's son, Titus, though few scholars now believe this to be the case.

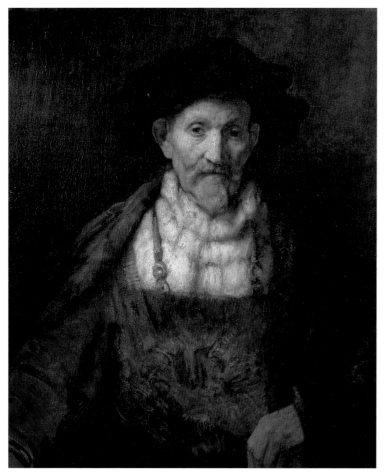

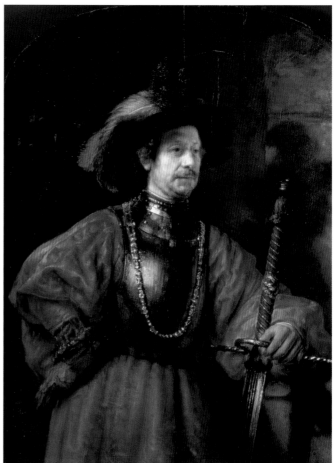

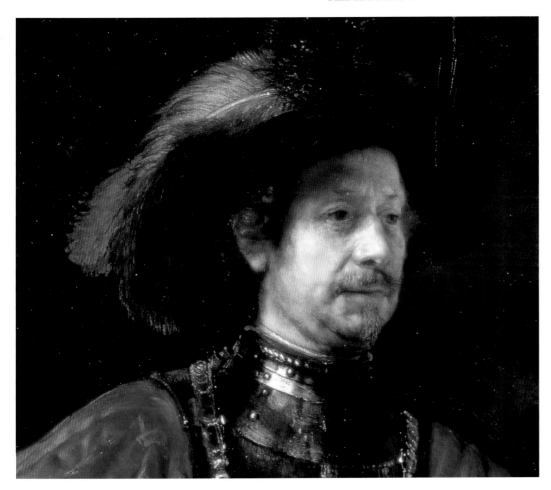

OPPOSITE LEFT
Portrait of an Old Man in Period Costume, 1651
Oil on canvas, 31 x 26¹/₂in (78.5 x 67.5cm)
Chatsworth House, Derbyshire

OPPOSITE RIGHT
Portrait of a Man in Military Costume, c.1650
Oil on panel, 50³/₈ x 40⁷/₈in (128 x 103.8cm)
Fitzwilliam Museum, Cambridge

This had long been attributed to Rembrandt, but most modern scholars are now doubtful.

OVERLEAF
The Archangel Raphael Taking Leave of the Tobit Family, 1637
Oil on panel, 26 x 20¹/₂in (66 x 52cm)
Louvre, Paris

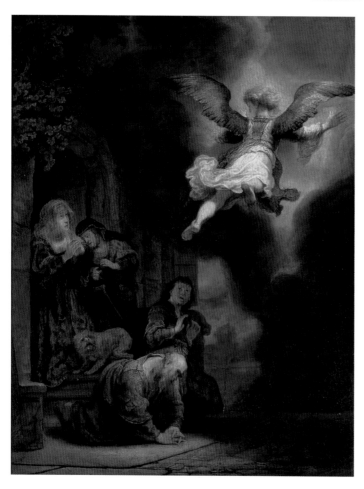

saw it'. The contemporary criticism that he failed to follow the Classical conventions misses the point, because Rembrandt does not paint the ideal, he paints the reality. When, in an etching of 1641 based on one of his favourite sources, the apocryphal *Book of Tobit*, the angel takes leave of Tobit's family and ascends heavenwards, we observe that his receding bare feet are those of a peasant, and are none too clean at that. Italians, and Classicizing Dutch artists too, would have been shocked.

Until little more than a generation ago Rembrandt's sterling qualities – his independence, honesty, dedication, tolerance, humanity – produced a popular image of him which was more that of a kind of Protestant saint than a working artist, an embodiment of virtue rather than an ordinary man. While it may be right and reasonable to grant those estimable characteristics to Rembrandt who, among great artists, is one of the most sympathetic of human beings, a certain Rembrandtesque realism is called for. Sentimental attitudes are out of place, especially in relation to this humane but most unsentimental of men. We should remember too that some of the qualities for which Rembrandt has been so highly praised may exist largely in the reconstructions and theories of a later and different culture. (It would indeed be interesting to bring back almost any great man or woman from an earlier age and observe their reaction to their present reputation. Besides scorn and/or

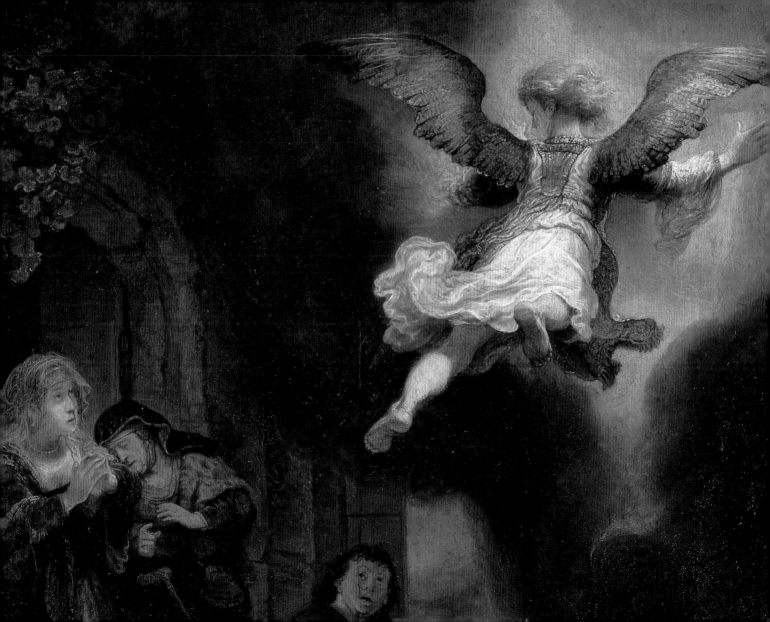

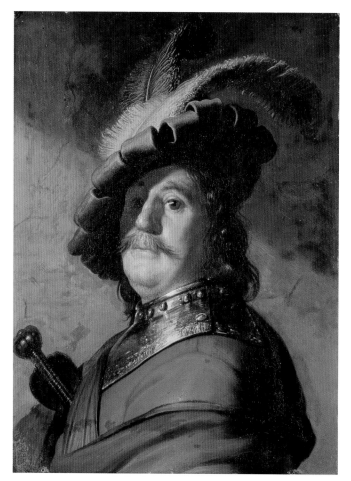 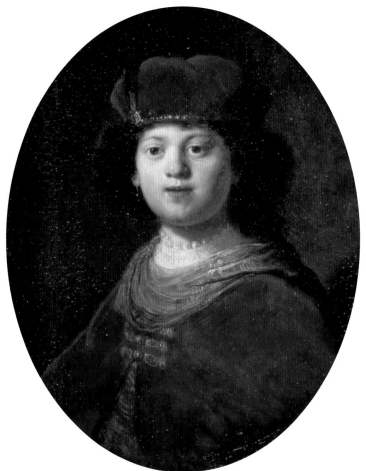

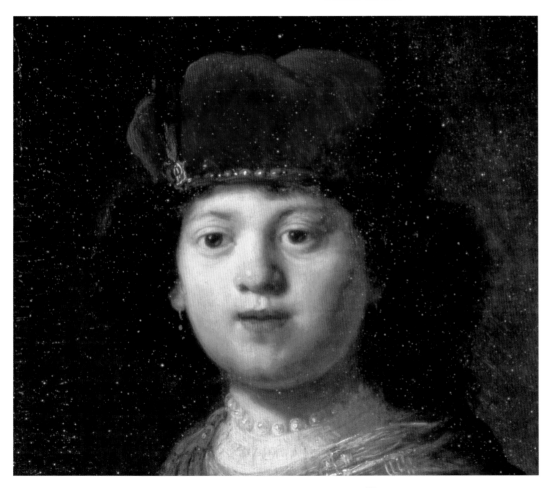

OPPOSITE LEFT
A Warrior, c.1628
Oil on panel, $15^{3/4}$ x $11^{5/8}$in
(40 x 29cm)
Christie's Images, London

*This was painted over an earlier
portrait of an old man, with which
Rembrandt was presumably dissatisfied.*

OPPOSITE RIGHT
Portrait of a Boy, c.1633
Oil on canvas
Hermitage, St. Petersburg

*There are several portraits of children
from the 1630s that cannot be traced
in contemporary documents, which
always casts doubts on their
authenticity; but this richly-dressed lad
is almost certainly by Rembrandt.*

Landscape with a Coach, c.1637
Oil on canvas
Wallace Collection, London

satisfaction, one might expect a good deal of bewilderment.)

It is doubly unfortunate that, whereas we know a good deal about Rembrandt the man, we know surprisingly little of his art, very little from his own mouth – and that at second-hand – and not a great deal more from his contemporaries. Our ideas are inevitably rooted largely in later opinion based on criteria very different from those of the 17th century.

Rembrandt himself, and 17th-century Europe generally, may have been unaware of some of the qualities with which he is commonly credited today, just as some of their ideas may be imperfectly understood by us. For example, sincerity seems to us post-Romantics an admirable quality in an artist, one reason why Rembrandt stands so high in the pantheon, but it was not within the reckoning of earlier generations. More objectively if more narrowly, they looked exclusively at the work, which was judged by quite hard-and-fast rules, whereas we tend to look also at the artist and his personal vision. Once, Rembrandt's naturalistic style and sympathy for the poor, the old and the ugly, were deplored. His style was considered quite unsuitable for Biblical subjects. But our feelings on this score are precisely the contrary. The people in the Bible were, for the most part, poor people, for whom a night in a stable was no great hardship, and Rembrandt's 17th-century Dutch peasants strike us as more 'honest' representations of the people of the Bible than the idealized figures of the Renaissance. Of course they are no more

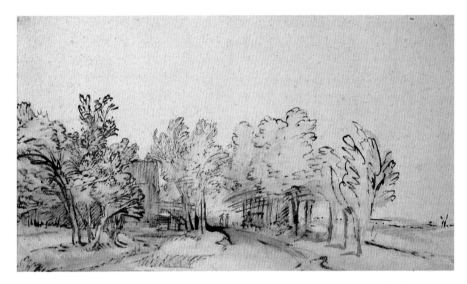

accurate historically than those of Raphael, for example, but they are truer in spirit. They confirm Rembrandt's artistic integrity – his respect for truth. (That is not, of course, to say that we ought to prefer Rembrandt to Raphael, or vice versa.)

According to early biographies, Rembrandt is supposed to have said that an artist ought to be guided by nature and not by any other rules. That implies a flat contradiction of the

Avenue with a Footpath and a Farmhouse on the Left
Pen and brush with brown ink on paper, 4$^{1}/_{3}$ x 7$^{1}/_{2}$in (11 x 19.3cm)
Kunsthalle, Hamburg

27

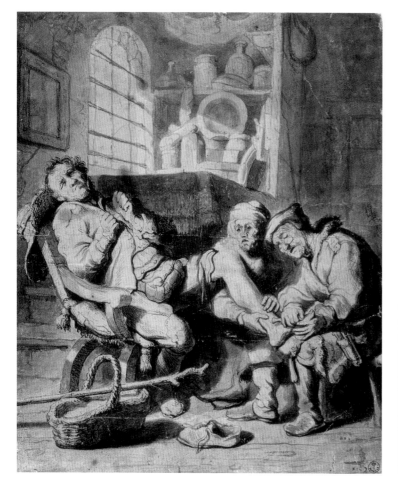

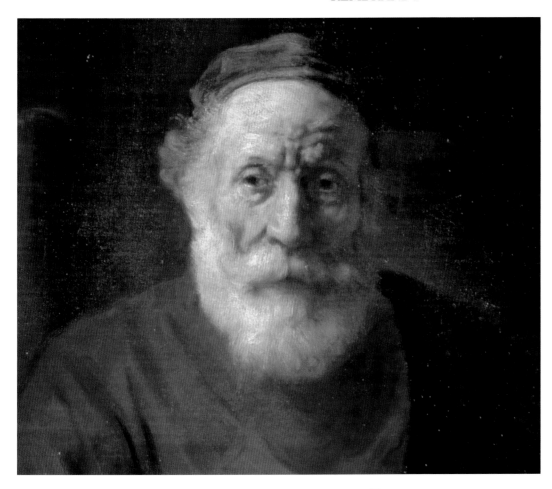

OPPOSITE LEFT
The Sprained Foot
Pen and ink and watercolour on paper
Private collection

OPPOSITE RIGHT
An Old Man in Red, c.1654
Oil on canvas, 42$^{1}/_{2}$ x 33$^{7}/_{8}$in
(108 x 86cm)
Hermitage, St. Petersburg

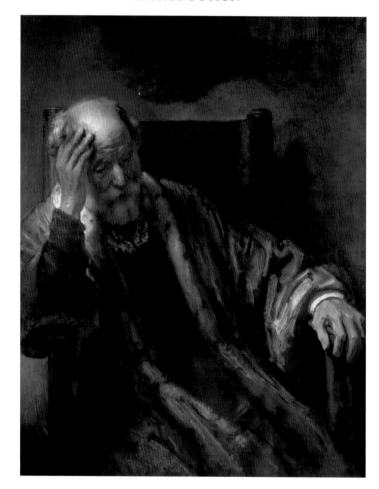

An Old Man in an Armchair, 1652
Oil on canvas, 43³/4 x 34⁵/8in
(111 x 88cm)
National Gallery, London

This painting is signed and dated 1652,
the year Rembrandt began working on
Aristotle Contemplating the Bust of
Homer *(pages 288–89), with which it*
seems to have an affinity.

RIGHT
Cottages before a Stormy Sky
Pen and ink
Graphische Sammlung Albertina,
Vienna

OPPOSITE
View of Houtewaal
Pen and brown ink
Christie's, London

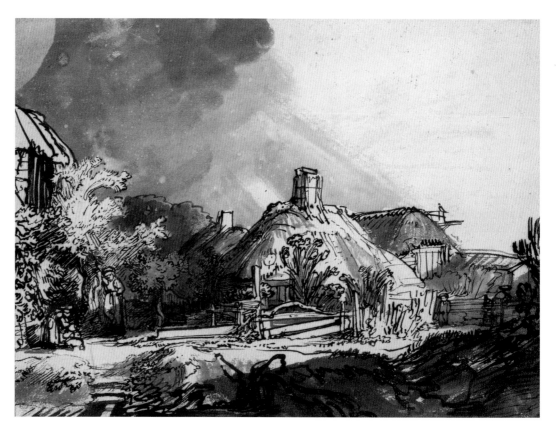

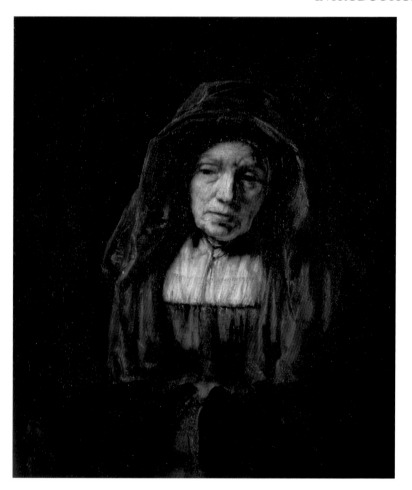

Classical conventions, and it does not truly reflect his universal practice. Leonardo da Vinci said much the same, also without the qualifications that the evidence of his work demands. Rembrandt was once seen as a humble painter of the people, with little education and very little knowledge of, never mind respect for, Classical principles. Several critics remarked accusingly that, unlike so many northern-European artists, he had never visited Italy. The image of him was of a man who was scarcely literate. We now know that this conception is badly awry. Rembrandt was a natural intellectual, very knowledgeable, well-read, and capable of holding his own in abstruse religious and philosophical discussions. While he may not have evolved his own fully-fledged theory of art, he understood the Classical rules as well as any of his contemporaries – he could hardly have painted his *Danaë* (pages 200 and 201) otherwise – and the work of recent generations of art historians has revealed numerous fascinating affinities, influences and imitations that connect him with his great predecessors, from Leonardo onwards. 'The more closely one looks at Rembrandt's work,' wrote Kenneth Clark, 'the more one realizes how intelligently he studied the great Italians of the Renaissance, especially Raphael.'

In common with some at least of his Dutch contemporaries, Rembrandt played fast and loose with another Classical convention, which divided painting into distinct categories – portraits, history painting, etc. Those

OPPOSITE
Portrait of an Old Woman, 1644
*Oil on canvas, 29^1/8 x 24^3/4in
(74 x 63cm)
Pushkin Museum, Moscow*

There is a companion piece, An Old
Man with a Beret, *in the same museum.*

LEFT
Reclining Female Nude
*Black chalk and body colour on paper,
6^1/2 x 10^3/8in (16.4 x 26.3cm)
Kunstalle, Hamburg*

*While not Classical in spirit, this
drawing shows a thorough
understanding of the conventions of
Classicism.*

Portrait of an Elderly Woman, c.1650
Oil on canvas, 32^{1}/$_{4}$ x 28^{1}/$_{3}$in
(82 x 72cm)
Pushkin Museum, Moscow

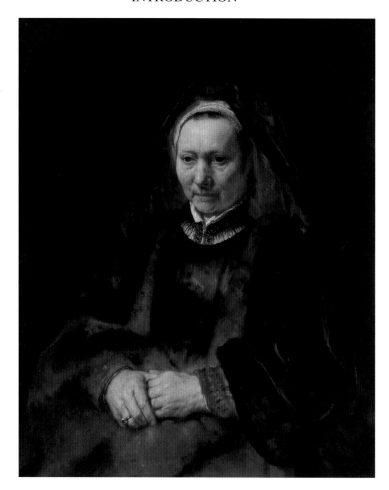

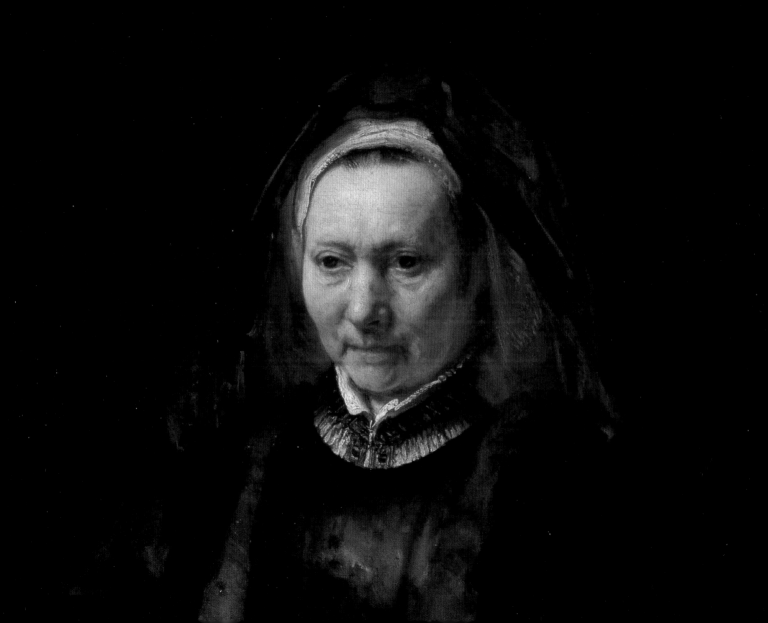

categories were not supposed to mingle. But, as already remarked, his religious paintings often merge into genre, portraits into pictures of saints. But it is clear that he regarded only certain subjects as suitable for paintings, others as more appropriate to etchings or drawings. Landscapes from nature are comparatively rare among his paintings, where backgrounds are generally based on imagined scenery, but they are common among his etchings and drawings. Genre scenes are common among drawings, but hardly exist in paintings other than in domestic scenes from the Bible, which incidentally added a new, poetic quality to genre by the association with religion, something that perhaps could only have happened in a Protestant society.

One final note about looking at Rembrandt's paintings. Reproductions in books or prints, in spite of all the marvels of modern technology, can never be perfectly faithful. Sometimes they give a disappointing impression of the original (and occasionally the opposite). Rembrandt notoriously reproduces poorly, especially, but not only, his colour. And that problem is exacerbated by the generally muted colours he employed (except in the early paintings) while, like anything else well over 300 years old, however well cared-for, time has inevitably had a darkening effect. Fortunately, the great public collections of the world contain many Rembrandts. There are, for instance, nearly 30 in London, 20 of them in the National Gallery, and other big museums like the Louvre in Paris; the New York

Metropolitan, not to mention the finest collection of all in the Rijksmuseum, Amsterdam, contain comparable numbers. To appreciate Rembrandt's true worth it is necessary to go and see them.

• • •

A Note on Names

Rembrandt's full name was Rembrandt Harmensz. van Rijn. In the early 17th century, surnames had not fully developed and most men called themselves by their first name and patronymic, which in Rembrandt's case was 'Harmensz'. That is short for Harmenszoon, i.e. 'son of Harmen', and the abbreviation was apparently used in speech as well as writing. Had Rembrandt been born a girl it would have been 'Harmensdr.', 'dr.' being short for *dochter*, 'daughter'. Until shortly after what turned out to be his permanent move to Amsterdam, Rembrandt often signed his pictures, 'RHL', standing for Rembrandus Harmenni Leidensis (Rembrandt Harmensz. of Leiden). Thereafter his signature varied, but most often he wrote his first name alone.

Dutch names can be confusing and their spelling varies considerably. For the sake of consistency, the names in this book follow the forms adopted by Gary Schwartz in the English edition of his *Rembrandt, His Life, His Paintings* (1985), even when different versions are more common. There are a few exceptions, mostly in the case of individuals, such as William the Silent, who are so well known that the Dutch version would look strange to a non-Dutch reader.

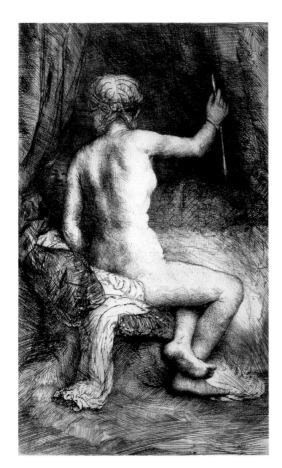

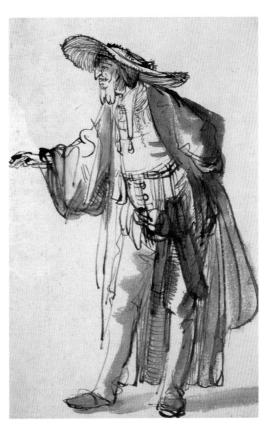

FAR LEFT
The Woman with the Arrow, 1661
Etching
Fitzwilliam Museum, Cambridge

The meaning of the gesture has been the subject of much ingenious discussion.

LEFT
Actor with a Broad-Rimmed Hat
Pen and wash on paper, 7¹/8 x 4⁵/8in
(18.2 x 11.8cm)
Kunsthalle, Hamburg

Self-Portrait, after c.1661
Prado, Madrid

*This bears such a close resemblance to
the Self-Portrait of c.1661–62 on page
273 that it raises questions as to
whether it is another version by
Rembrandt, without the mysterious
circles, or a copy by another person.*

OVERLEAF
Self-Portrait with Plumed Beret, 1629
*Oil on panel, 35$^{1}/_{3}$ x 29in
(89.7 x 73.5cm)
Isabella Stewart Gardner Museum,
Boston*

Chapter One
The Dutch Republic

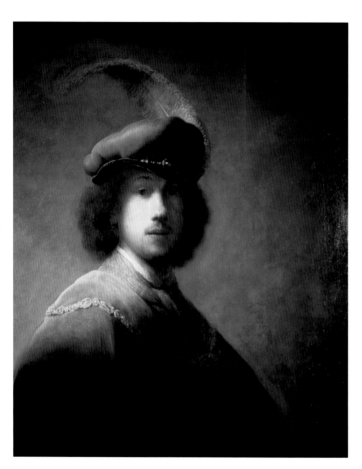

Rembrandt lived in the Golden Age of the Netherlands, when that small and recently created country was in many ways the leader of Europe. With the exception of Switzerland, it was the only popular republic in a continent of monarchies, having won independence and forged nationhood in a long and bloody struggle against the greatest military and imperial power in the world. Self-confident and thrusting, its commercial and maritime dominance fuelled rapid economic and structural development. Its citizens amassed considerable wealth, especially if they held shares in the hugely profitable Dutch East India Company, which was founded from an amalgamation of smaller, competing companies in 1602, four years before Rembrandt was born. The United Provinces, as the country was officially named from 1579 to 1795, also supported an extraordinary number of highly gifted artists.

Half a century before Rembrandt's birth, when Dutch prospects looked very uncertain, no one would have prophesied such an outcome. Holland, much the largest and therefore the dominant province of the future republic, was then one of the 17 provinces of the Spanish Netherlands, a conglomerate once ruled by the Duke of Burgundy, which had passed to the Habsburg emperors and eventually to Philip II of Spain, whose titles included Count of Holland and Duke of Brabant.

In 1559 Philip had left Brussels, the capital of Brabant,

for what proved to be the last time. Thanks to the still-prevailing mystique of monarchy, he was personally a fairly popular figure in the Spanish Netherlands, but the government of the province, under his regent, was less popular, and in 1560 was already facing a series of problems that were becoming increasingly serious as time went on. It was jostled by a native nobility eager for a greater share of power, and harassed by the deputies of the quarrelsome and fractious Estates. Its operations were severely circumscribed by a depleted treasury with no feasible means to restock it without worsening the existing troubles. Such problems were by no means rare among European royal governments in the 16th century, but that in the Netherlands suffered additionally from a fundamental and increasingly resented characteristic: it was foreign. The regent, Margaret of Parma, although as it happened she had been born in the Netherlands, was a Spaniard – Philip's half-sister in fact.

There was one further disparity, which was to become decisive in causing the rift between the Dutch and their Spanish masters. Philip II's Spain was the guardian of the old religion, the sword of Rome and the champion of the pope. It was fiercely hostile to heretics, who were harshly dealt with by the Spanish Inquisition. A notoriously ferocious body, the Spanish Inquisition also operated in the Spanish Netherlands, where heretics in the form of Protestants made up a significant proportion of the population. In the 1560s their number was still small, but it was growing. The natural leaders of the country – the nobility – were almost all Catholics, including William of Nassau, Prince of Orange (later known as William the Silent and the father of the Dutch republic), but the Protestant minority, especially the Calvinists, carried greater influence than their numbers warranted. The Calvinist church, with its government by laymen, benefited from the widespread dislike of priests that extended to people of all faiths. In time, political pressures would turn William the Silent into, first, a Lutheran, and later, a Calvinist. Meanwhile, economic failures brought depression and unemployment, and attracted even larger crowds to the meetings of Calvinist agitators who demanded relaxation of the anti-heresy laws.

Religious tolerance was not to be contemplated by Philip II, and the efforts at mediation of the Dutch nobility, in the person of William himself, as well as others such as the Count of Egmont, met stony resistance. The government in the Netherlands was in a cleft stick. Whether its policy was resistant or conciliatory, it was bound to antagonize either the local people or Spain. When the Regent nervously agreed to meet representatives of a league formed by the lesser nobility to demand a more liberal policy, one of her advisers dismissed them as *ces gueux*, 'these beggars', a nickname that would come to haunt the Spanish in a few year's time. During the 1660s there were a succession of violent

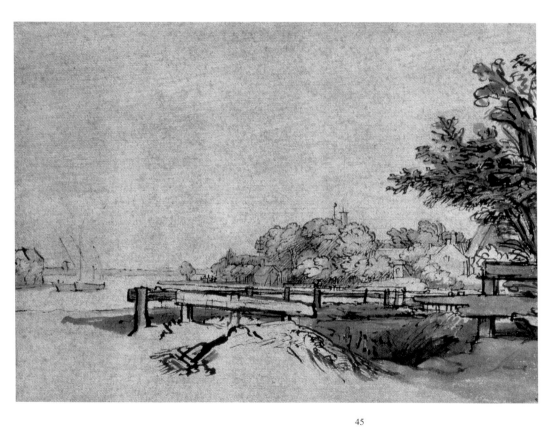

The Jetty
Pen and brown ink
Christie's, London

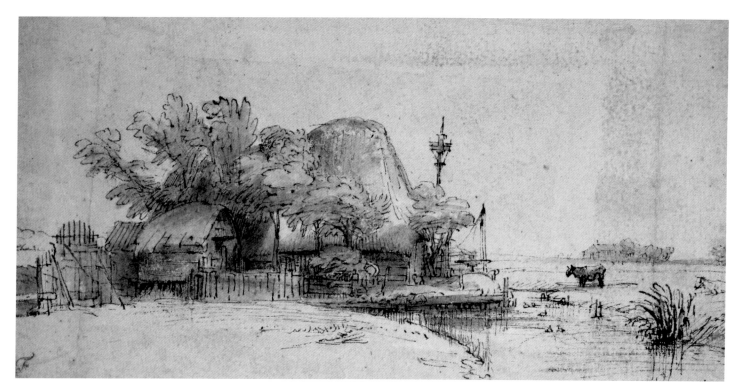

OPPOSITE
Farmstead by a Stream
Reed pen and brown ink
Christie's, London

LEFT
Two Thatched Cottages with Figures
at the Window
Pen and brown ink
Christie's, London

Self-Portrait with a Plumed Hat and
White Collar, 1630
Pen and ink on paper
Louvre, Paris

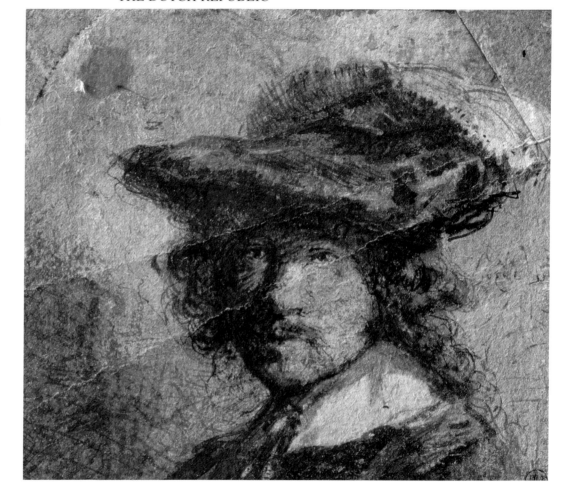

outbreaks. They eventually fizzled out, but all hopes that moderation might prevail disappeared when Philip II dispatched an army to the Netherlands under the Duke of Alba. He was commissioned to enforce a policy of pitiless repression, including massacres of civilians. The counts of Egmont and Horn were executed and William of Orange was declared an outlaw, whereupon the Estates of Holland defiantly elected him their stadholder ('governor' is the nearest equivalent).

From a Spanish viewpoint the end results of Alba's terror were disastrous. Spain was mired in a war it could not win. The population was superficially quiescent but sullen and resentful, and Alba, while invincible on land, could do nothing about the *Gueux de Mer* (Sea Beggars), the Dutch privateers who eventually succeeded in blockading the entire coast. Moreover, Alba's rule had strengthened the hitherto fragile alliance of nobles and people, in a struggle which, initially for freedom of worship, had become a war of independence. Alba's successors attempted some compromise, but it was too late. A crucial episode in 1574 was the defeat of the Spanish forces laying siege to Leiden, one of Holland's chief cities, when the Estates opened the dykes, enabling the *Gueux* to relieve the city.

Three days after the sack of Antwerp, the chief commercial city of the Spanish Netherlands, by mutinous Spanish troops in 1576, the Pacification of Ghent was agreed. It was accepted by the provinces in the Union of Brussels and, if with obvious reluctance, by the Spanish governor. But by this time a serious division had developed between the predominantly Catholic provinces in the south, where William the Silent was never quite trusted, and the more Protestant provinces in the north. By the time William was assassinated (1584), the division between the Northern and Southern Netherlands was already too deep to heal, although that was not yet generally accepted and some people, including the princes of Holland, never gave up hope of reuniting the two. Under the leadership of William's son Maurice (Mauritz), elected stadholder of Holland and Zeeland in succession to his father, it became evident that Europe had gained a new sovereign state, though it did not achieve international recognition until 1596 and Dutch independence was not formally acknowledged by Spain until 1648.

The United Provinces (Friesland, Groningen, Overijssel, Guelderland, Holland, Utrecht, Zeeland), often seen today as the first 'modern' state, were something of a constitutional oddity. Under the Union, sovereignty lay not with the Estates General, in which each province had one vote and decisions were supposed to be unanimous, but with the seven provincial estates. In theory, the Estates each elected a stadholder, but in practice Holland and Zeeland always chose a prince of Orange and others tended to follow suit. The

stadholder held command of the armed forces and he, rather than the Estates General, formulated foreign policy, though in this field the pensionary of Holland, the office held by Jan van Oldenbarneveldt from 1586 to 1619, became the more influential figure.

Meanwhile, the war to drive the Spaniards out of the whole of the Netherlands continued. In the 1590s, while Rubens was learning his trade in Antwerp, Prince Maurice, stadholder of Holland, with his cousin William Louis, stadholder of Friesland, reorganized the army as a small, tightly disciplined force. It became the exemplar for all European armies, and the tool with which Maurice fashioned a succession of victories against the Spanish. By 1598 he had captured virtually all the territory north of the Maas (Meuse) river. There he was stopped. Philip II, shortly before his death, made a final effort to prevent the separation of the north and south by granting sovereignty of the Spanish Netherlands as a wedding gift to the Archduke Albert of Austria on his marriage to Philip's daughter Isabella, but Albert's attempts at reconciliation were eventually rejected and all parties were forced to confront, if not to acknowledge, the permanent division between the Protestant north and the Catholic south.

The division was made easier to accept by certain unplanned economic developments. When the Spanish had occupied Antwerp, the Estates had blockaded the estuaries of the Scheldt, thus virtually shutting down the port. Since the silting-up of the harbour had crippled Bruges, Antwerp had become the hub of commerce and the centre of banking and business in northern Europe. Now, cut off from the sea and partly destroyed by the mutinous Spanish troops of 1575, Antwerp was ruined. But as Antwerp declined, Amsterdam prospered, and it is not surprising that the Dutch, especially the merchants of Amsterdam, were unwilling to reopen the Scheldt (it was not reopened until 1792 – by the French).

By 1598, the United Provinces were caught up in a heady economic boom, and Amsterdam itself was growing at an unprecedented rate. The new Dutch state was emerging as a major maritime power, in both peace and war, and the city in which Rembrandt spent most of his adult life was a boom town.

The security of the United Provinces was not yet assured, and Spanish fortunes enjoyed an unexpected revival after France (in 1598), then England (1604) made peace with Spain, freeing Spanish resources for war in the Netherlands. Oldenbarneveldt concluded that it would be wise for the United Provinces to make peace, even if it meant surrendering further territorial ambitions. Negotiations were not easy, and Oldenbarneveldt's policy was far from universally popular, but eventually, with French mediation, a 12-year truce was arranged in 1609. Although the truce was just that, a truce not a treaty, and certainly not a Spanish

admission of the statehood of the United Provinces, from our perspective it effectively confirms the independence of the Dutch republic.

The truce ended fighting, temporarily, but it gave rise to many of the disagreements among the Dutch that made the period of Rembrandt's childhood a turbulent one in the United Provinces. Oldenbarneveldt's truce, though a triumph of diplomacy, ran contrary to Maurice's aggressive policy and it was disliked by the merchants of Amsterdam, who wished to continue the war with Spain in the hope of rich pickings from the Spanish possessions in the West Indies. The most divisive and persistent problems surrounded the perennial problem of religion.

These problems would affect Rembrandt personally, and it is time to narrow the focus from the rising fortunes of the Dutch nation to events near a certain mill in the city of Leiden, three years before the signing of the Twelve-Year Truce.

Sailing Boat on Nieuwe Meer
Pen and brown ink
Christie's Images, London

Rembrandt Harmensz. van Rijn was born in Leiden, soon to be Holland's largest city after Amsterdam, on 15 July 1606. The surname refers indirectly to the River Rhine (Rijn), perhaps more specifically to the mill part-owned by Rembrandt's father, which stood on a stream feeding the Rhine on the outskirts of Leiden. The mill itself appears in a map of Leiden published a few years before Rembrandt's birth.

Harmen Gerritsz., Rembrandt's father, came from a long

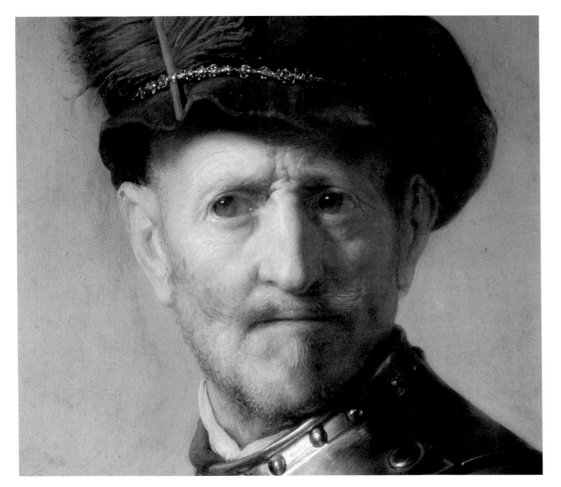

**Man in a Plumed Hat and Gorget,
c.1631**
Oil on panel, 65 x 51 cm
J. Paul Getty Museum, Malibu

*Dozens of portraits of a small group of
elderly men emanated from Leiden at
about this time, and most have been
hopefully ascribed to Rembrandt at
some point. This is genuine, for
although the signature 'Rembrandt
f[ecit]', is false, it has been written
over the initials RHL, which are in
Rembrandt's hand (see page 75).*

Self-Portrait with Gorget, 1629
Oil on panel, 15 x 11⁵/₈in (38 x 29cm)
Mauritshuis, The Hague

Rembrandt is wearing a gorget, which
also appears in another self-portrait of
this time and was perhaps the one also
worn by the older man on the previous
pages.

line of millers; they have been traced back to his great-grandfather in 1484. In 1589 he married Neeltgen Willemsdr. van Zuytbroeck, from another solid family of tradesmen – bakers (an appropriate match for a miller) – though they had connections a shade above Harmen Gerritsz. in the social scale. She was 21, the same age as her husband. In due course they had ten children, of which Rembrandt was the ninth. Both of them sprang from Catholic families, and Rembrandt's mother, while formally adopting Calvinism, may have remained at heart loyal to the old faith. His father had also converted to Calvinism, along with other members of his family, but Rembrandt's strong Catholic connections were perhaps something of a social and professional handicap in Leiden after Maurice's coup of 1618 established Calvinist control of the city.

On 3 October, the defenders of Leiden and their descendants commemorated their victory over the Spanish in 1574, as they do to this day, with a celebratory breakfast of white bread and herring. Something like one-third of the inhabitants had died during the siege which, had the Spaniards been successful, might well have resulted in the defeat of Holland and made the Union of Utrecht impossible. Leiden became a symbol of heroic Dutch resistance, and the first Protestant university in the Netherlands was set up by William the Silent as a memorial to the heroes of 1574. It became a magnet for refugee Protestant scholars from the south and rapidly acquired a reputation across Europe.

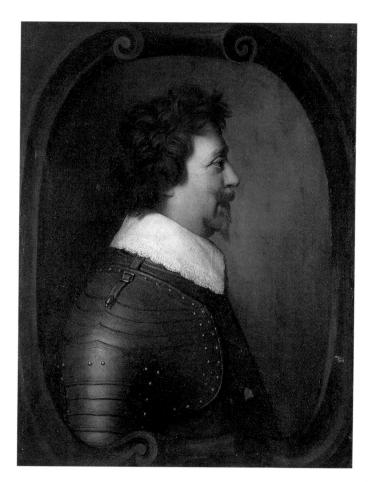

Leiden was then still a small, static medieval city of less than 20,000 people, built around a large canal and bordered on one side by the Rhine. It had seen more prosperous days in the past when it was a centre of the then-prosperous clothmaking industry. By the time of Rembrandt's birth, things were again changing fast, and Leiden, invigorated by the proud nationalist impulse that sprang from the defeat of the besieging Spanish, was among the leaders of the commercial boom, second only to Amsterdam. As it turned out, the boom did not last. Leiden soon outgrew itself and entered a long recession, but during Rembrandt's childhood its growth was so fast that it caused a serious housing crisis in the city.

For some people, including the families of Rembrandt's parents, Leiden had become a less sympathetic place. The period of the war with Spain coincided with the victory of the Reformation in the northern Netherlands, and by 1600 all government posts in Holland were held by Protestants, when 30 or 40 years earlier practically all would have been held by Catholics. Probably more than half the total population, even in Leiden, were still Catholics, or at least not convinced Protestants, but they had become the silent majority.

However, the Protestants were not all members of one Church, far from it. The largest groups were the Lutherans and the Calvinists, but there were also many smaller denominations or sects, including the Mennonites, to whom Rembrandt himself seems to have been attracted later.

OPPOSITE
Gerard van Honthorst
Frederik Hendrik, 1631
Oil on canvas, 28^7/8 x 23^5/8in
(73.4 x 60cm)
Huis ten Borsch, The Hague

LEFT
Self-Portrait, 1630 *(detail)*
Oil on copper, 6 x 4^3/4in
(15 x 12.2cm)
Stockholm Nationalmuseum

Rembrandt rarely painted on copper,
though there are two other examples
from this period, one the portrait of a
very old woman (possibly his mother) in
Salzburg.

Moreover, these groups usually contained their own factions, typically dividing into what might be called, using the terms relatively, a 'radical' and a 'conservative' wing. There were no doubt many who, like William the Silent, would have preferred more tolerance in religion, but the religious leaders were not among them. The Calvinists, in particular, were hardly more liberal than Philip II. They were the best organized, they dominated the Church and universities, and they proved adept at securing political power.

The crucial conflict boiled down to the clash between the Remonstrants and the Counter-Remonstrants, which arose from disagreement over the doctrine of predestination, a feature of Calvin's teaching. According to this doctrine, human beings are saved or damned by the will of God, which they can do nothing to alter; salvation cannot be earned. The quarrel came to a head in the clash of two Calvinist theologians at Leiden, Franciscus Gomarus, who upheld predestination, and Jacobus Arminius, who opposed it. As often happens in such circumstances, a disagreement over a comparatively narrow point of theology broadened into a conflict encompassing many other matters, political as well as religious, even the question of whether to make war or peace. The more liberal were the Remonstrants (the name derives from a protest, or 'Remonstrance', addressed by the Arminians to the Estates of Holland in 1610). Although a minority, they best represented most Protestants – and

OPPOSITE
A Boy in Fanciful Costume, 1633
Oil on panel, 21 x 17.7cm
Wallace Collection, London

This is clearly the same boy as in the portrait on pages 24–25, and similarly dressed-up, though whether it is by Rembrandt is doubtful.

LEFT
Philosopher in Meditation, 1632
Oil on panel, 11 x 13³/8in
(28 x 34cm)
Louvre, Paris

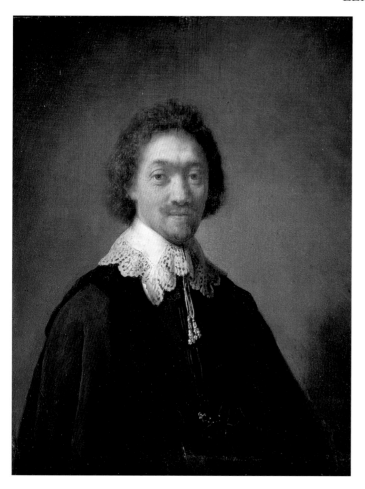

Catholics – other than the hard-line Calvinist supporters of Gomarus, who were known as the Counter-Remonstrants. However, it was the Counter-Remonstrants, strengthened by the accession of Calvinist refugees from the south, who gained control of the established Church and, vitally, the support of the Stadholder Maurice. It was in their interest that Maurice forced the Remonstrants out of the government in Leiden and other cities in 1618. The national Synod of Dort (Dordrecht) was dominated by the Counter-Remonstrants, and condemned all deviant sects.

This conflict brought down the long-serving grand pensionary Jan van Oldenbarneveldt, a Remonstrant and architect of the Twelve-Year Truce, who was disgracefully executed in 1619. Hugo Grotius, the great legal scholar, was sentenced to life imprisonment but escaped to France. Many other leading Remonstrants were persecuted or forced to flee abroad, and for a year or two the infant republic teetered on the brink of civil war.

The moment of danger passed, and the fanatical extremism of these years faded. Maurice died in 1625 and was succeeded by his wiser and more tolerant younger brother Frederik Hendrik (Frederick Henry). A more liberal element gained control of the larger cities, notably Amsterdam, where business was always more important than ideology.

These events took place while Rembrandt was still a

child. He was only 13 at the height of the crisis, and still in his teens when Prince Maurice died.

Of Rembrandt's family life we know little or nothing. A number of early paintings feature an elderly woman supposed to be his mother, though she looks rather too old. The most notable is a painting of about 1629 which was acquired by King Charles I of England, and is now in the Royal Collection at Windsor (see pages 82 and 83). It was not catalogued in England as a portrait of the artist's mother, though a Rembrandt self-portrait also owned by Charles was correctly identified, and some doubt still surrounds the identity of the subject. There is an indisputable drawing of Rembrandt's father (page 71), since it is inscribed with his name by a contemporary hand (though not the artist's). It was probably done around 1630, when the old man, whose eyes are tightly closed, was near death, and it suggests strong filial affection. Rembrandt always tended to exploit models close to home, and his brothers very likely also served him in that capacity, but there is no figure in his early works that can be definitely linked to them.

After Rembrandt left Leiden in or about 1631 we hear of little further contact with his family but, in view of the paucity of evidence generally, that is not reason enough to assume that some kind of breach occurred.

Clearly the young Rembrandt was bright, for at the age of seven, unlike any of his brothers (so far as we know), he was

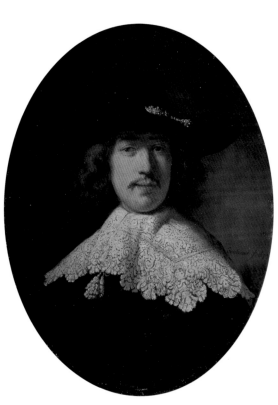

OPPOSITE
Portrait of Maurits Huygens, 1632
Oil on panel, 12¹/₄ x 9⁵/₈in
(31.2 x 24.6cm)
Kunsthalle, Hamburg

Maurits, brother of Constantijn Huygens, was secretary to the Council of State in The Hague.

LEFT
Portrait of a Young Man with a Lace Collar, 1634
Oil on panel, 27¹/₂ x 20¹/₂in
(70 x 52cm)
Hermitage, St Petersburg

sent to the Latin School, where he would have been instructed in the Calvinist interpretation of the Bible and also, of course, Latin, in preparation for the university. He was no Classical scholar, but his Latin was quite good enough for him to read it, as an adult, with reasonable facility. Most writers have assumed that he went on to the university at the age of 14, for the good reason that he was registered there in 1620. At most, he stayed six months, and it may be that he never attended classes at all. The earliest written account of Rembrandt, which appeared in a guidebook to Leiden written by Jan Jansz. Orlers and published in 1641, states that he left the Latin School, and terminated his formal education shortly before graduation (presumably in 1619). If so, why was he subsequently registered as a university student?

There were other, non-educational advantages to being a student, including the purchase of wine and beer tax-free and, more important, automatic exemption from service in the civic guard. (Rembrandt's father had suffered injury to his hand while in the guard, while his older brother Gerrit had had a more serious injury, though it was probably incurred at the mill and disqualified him from service in the guard.) For an artist – and Rembrandt's gifts in that vocation were already apparent – such a mishap, a not infrequent result of the unreliable behaviour of 17th-century muskets, would have been disastrous. It is significant that one of Rembrandt's first pupils, Isaac de Jouderville, was registered at Leiden University in 1632, at a time when he was a full-time painter

and member of the artists' guild, and resident primarily in Amsterdam. According to Orlers, however, since Rembrandt had no natural bent for formal education, 'his parents had no choice but to take him out of school and, in accordance with his wishes, apprentice him to a painter'.

His master was a local artist, Jacob Isaacsz. van Swanenburg. Interestingly, Jacob was a Catholic, a member of a well-established family in Leiden, one of the pre-1618 ruling oligarchy which included members of the government as well as prominent figures in the art world. Jacob's father had been the leading painter in Leiden for many years, largely due, it has been suggested, to his unrivalled access to useful patrons rather than to his artistic abilities; his son, likewise, though described as 'able', has made no impression on art history. With the ousting of the Leiden government by Maurice in 1618 and the imposition of Calvinist theocracy, the Swanenburgs and their relations, predominantly Remonstrants, were in dire straits professionally. Only one of them, described as the city under-secretary, was, to everyone's surprise, allowed to keep his job, provided he kept his head down, because he had proved himself so outstandingly efficient.

They were not, of course, the only ones to suffer in the purge. Anyone even suspected of Remonstrant sympathies was out, and that included the deputy head of the Latin School. It may be that the young Rembrandt, with his predominantly Catholic relatives, was also compelled to leave. Although there is no evidence to confirm that suggestion, it would provide an

REMBRANDT

answer to the question that has puzzled many of Rembrandt's biographers: if he did leave school early, as Orlers said, why did he leave when only months away from his final diploma?

Rembrandt remained with Swanenburg, who had only recently returned to Leiden after a prolonged stay in Italy, for three years. He must have learned the mechanical basics of his art and the infinite possibilities of paint, but he seems to have derived little from him otherwise except that, since Swanenburg still had highly-placed friends, including some in Amsterdam, he may have made some useful contacts for the future. There was not much studying to do, and only one Dutch book on art, though a famous one, Carel van Mander's *Het schilder-boeck* ('The Painter's Book'), was first published in 1604, second edition 1618. So far as we know, Rembrandt never copied any work by his first master, who in spite of his amiable character was chiefly known for his mildly pornographic diableries, somewhat in the manner of Hieronymus Bosch (he had left Italy in a hurry after the Inquisition had taken a critical view of a Witches' Sabbath) and no one has detected any sign of Swanenburg's influence in the early work of his most famous pupil.

Pieter Lastman (1583–1633) was an entirely different proposition. He too had spent several years in Italy, where he was well regarded though not as highly as another young northern painter there at the same time, Peter Paul Rubens. Like the painters of the Utrecht school, he had been strongly influenced by Caravaggio and the landscape painter Adam Elsheimer, a German though resident in Italy and himself indebted to Caravaggio. Lastman had returned to his native Amsterdam in about 1607 and was soon established as an eminent history painter – i.e. of religious and mythological scenes – in the grand manner. This was regarded as the highest form of painting, since it required not only the ability to paint a large range of subject matter – faces, figures, nudes, landscapes, animals, plants, etc. – but also a close knowledge of literary and artistic sources. Like Rubens, Lastman had a superfluity of eager clients at home and abroad, and he employed many assistants to help complete his hefty workload.

In 1624 Rembrandt worked and studied for six months in Lastman's studio in Amsterdam (presumably his first experience of the city), in St. Anthonisbreestraat, where many artists and dealers, including Rembrandt himself, lived then and later, behind the Zuiderkerk, the first custom-built Protestant church in Holland where Lastman had designed a window, and just within the shadow of the Montelbaan Tower. Lastman made a profound impression on the young Rembrandt. For several years, his influence is clearly evident in Rembrandt's works, and Rembrandt was still making copies after Lastman a decade later. It was at this time too that he first developed that love of Biblical subjects which would remain with him for life, an aspect of his art in which Rembrandt differed markedly from most Dutch painters.

Caravaggio
Death of the Virgin, 1605-06
Oil on panel, 145^1/$_4$ x 96^1/$_2$ in
(369 x 245cm)
Louvre, Paris

Caravaggio and Chiaroscuro

Caravaggio (1571–1610) was the greatest creative artist of
the post-Renaissance period in Italy, whose influence on the
course of art history was little less than revolutionary. He
recognized that the genius of the humanist Renaissance had
dissipated, degenerated into a mere intellectual exercise,
mannered, academic and without feeling. A figure of the
Virgin was no different from a figure of Venus; both were
equally bland and unconvincing. Caravaggio, who himself
drew some inspiration from Leonardo da Vinci, sought
greater realism and true feeling. 'Everything in art is trifling
that is not taken from life,' he used to say, and his early
pictures demonstrate his lovingly detailed depiction of
objects that are clearly grouped for the purpose in his studio.
He found his models on the streets of Rome, and by using
(for example) a prostitute found drowned in the Tiber as his
model for *Death of the Virgin*, he attracted the same kind of
shocked accusations of indecorum, if not sacrilege, as
Rembrandt did later. He paid close attention to gesture and
expression and, above all, employed light and shadow –
chiaroscuro – to remarkable effect, achieving striking
contrasts and dramatic figures, which contribute to a vivid
sense of reality and honesty.

Things (usually figures) that move are more difficult, and
as Caravaggio despised the usual way of conveying
movement by more or less fixed pictorial conventions, this

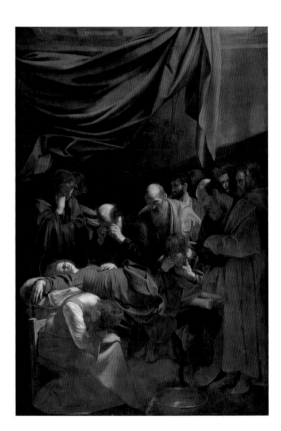

was a weakness that he never quite overcame. While his individual figures carry greater conviction than perhaps anything in art before him, in groups they are sometimes curiously isolated or unconvincingly related to each other, and the intense realism of the figures is not carried on to the background, which is often just an area of indeterminate darkness. Nevertheless, his work had an enormous effect not only on his immediate contemporaries but also on the whole of 17th-century painting, and especially on northerners, such as Elsheimer and, among Dutch painters, Gerard (Gerrit) van Honthorst and the Utrecht school.

Rembrandt returned to Leiden at the age of 19 and set up as an artist on his own. With his Catholic background, he was perhaps not particularly welcome in the city, at any rate in official circles. On the other hand, there was very little competition among painters, Leiden being something of an artistic backwater. There may not have been many commissions either. A number of small works, mainly portraits and genre groups, some possibly by pupils, later turned up in Leiden collections, but the only big commission we can be certain about came, probably in 1625, from Petrus Scriverius.

Scriverius was a friend and neighbour of the Swanenburgs, and had undoubtedly known Rembrandt as a boy in Jacob's studio. He was a humanist scholar (hence his preference for a Latin version of his name, which in Dutch was Pieter Schrijver) from a Remonstrant family, and a historian of remarkably generous disposition. He liked to encourage men of talent, especially writers, and on more than one occasion arranged for a man's poetry to be published without the author being aware of what he had done. Although he knew less about the arts, he was ready to extend support to young artists too. An engraving of him after a portrait by Frans Hals, which was published in 1626, bears the following inscription:

This is the portrait of a man who shunned office,
protected the Muses with his own money,
and loved the seclusion of his house.
A man who cannot be bought,
who devotes all his time to his fellow citizens,
condemning the faults and idle dreams of generations
*past, and who is burning to sing your praise, Batavians.**
Let those who have been bribed with gifts shout as loudly
as they please. He continues to write his truthful books with
a free hand.

Fighting talk. Clearly, he was a man regarded with the utmost suspicion by those who controlled Leiden. Among other indications of his sympathies, he had in the past been fined for commissioning a portrait engraving, with a poetic tribute by himself, of an imprisoned Remonstrant, and a few

*the ancient inhabitants of the Netherlands

RIGHT
The Stoning of St. Stephen, 1625
(details overleaf)
Oil on panel, 35¹/₄ x 48⁵/₈in
(89.5 x 123.6cm)
Musée des Beaux Arts, Lyon

FAR RIGHT
The Stoning of St. Stephen, c.1625
Pen and ink on paper, 3³/₄ x 3¹/₃in
(9.5 x 8.5cm)
City Art Gallery, Leeds

OPPOSITE LEFT
Pieter Lastman
Coriolanus and the Roman Women,
1625
Oil on panel, 31⁷/₈ x 52in
(81 x 132cm)
Trinity College, Dublin

OPPOSITE RIGHT
Palamedes before Agamemnon (The
Magnanimity of Claudius Civilis),
1626
Oil on panel, 35¹/₂ x 47³/₄in
(90.1 x 121.3cm)
Stedelijk Museum, Leiden

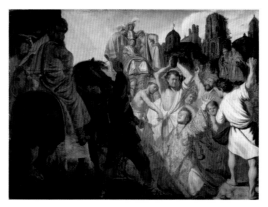

years later commissioned another painting that satirized the Synod of Dort as a hen house. His fame and status as a patriotic historian of the Netherlands protected him from serious persecution and he lived, with the aid of his wife's money, through the Dutch 'cold war', preserving his independence.

The first work Scriverius commissioned from Rembrandt was probably (it is not documented) the large painting of the first Christian martyr, *The Stoning of St. Stephen* (above and overleaf). Although this was a popular subject with painters of all faiths, Catholic and Protestant (and including Lastman), it is plausibly argued that Rembrandt's version

carried a political message, referring to the execution of the Remonstrant pensionary, Oldenbarneveldt. It is signed and dated 1625, i.e. one to two years after Rembrandt's return from Amsterdam. The painting, which was rediscovered in

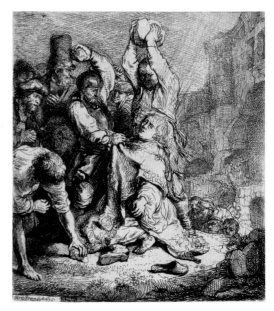

1962 and is the earliest painting universally accepted as his, demonstrates that Rembrandt was already well-versed in Italian art and in the work of northern artists who had spent time in Italy, and that he was already accomplished and ambitious. On the other hand it manifests some of the faults of other early paintings, being, for instance, so overcrowded as to confuse the sense of perspective.

Scriverius may well have commissioned a second large history painting, probably a companion piece, which apparently embodies a similar symbolic message. Although the subject has not been definitively settled, it is tentatively called *Palamedes before Agamemnon* (right). Palamedes was a Greek hero in the Trojan War who had the misfortune to antagonize Odysseus. Odysseus nursed his revenge for a long

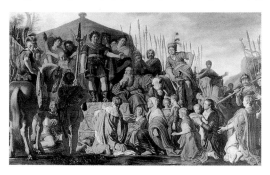

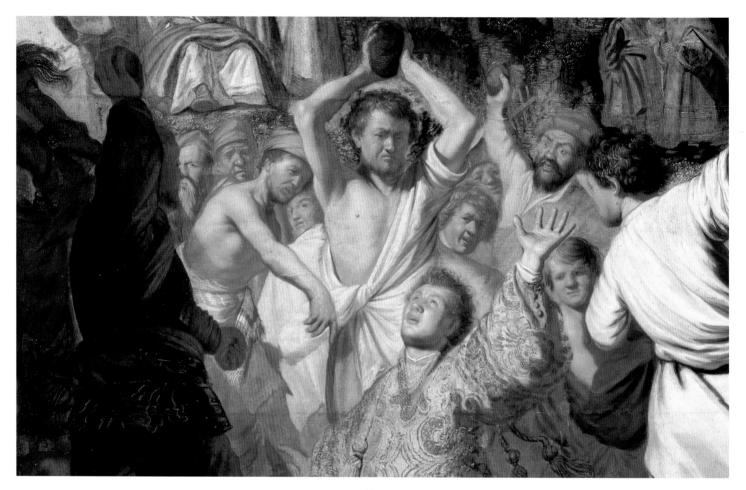

time, and finally achieved satisfaction when he successfully framed Palamedes for treason with a forged letter purportedly from Priam, King of Troy. Palamedes was condemned by Agamemnon and stoned to death: a judicial murder, in other words, like the execution of Oldenbarneveldt. Recently, however, it has been suggested that the scene depicted is quite different, and actually refers to the welcoming of his Gaulish prisoners as allies by the Batavian hero of the resistance to Rome, Claudius Civilis (the subject of one of Rembrandt's last official paintings, see page 385). The composition derives from Lastman's painting *Coriolanus and the Roman Women* (page 67, left), one of his best, of which Rembrandt made a drawing.

In spite of this and other evidence that Rembrandt's ability was noticed early, we know of no other commissions in a period of up to two years following his return from Amsterdam (assuming he returned in 1624), though there is no doubt that he was busy. What may strike us as surprising today is the vast number of paintings to be found in quite ordinary houses in Leiden in the early 17th century. One plumber and roofer who lived in a poor district of the town left 26 paintings when he died. A dyer, a little further up the social-economic scale, left 64, and a rich professor lived in a house big enough to contain, if not display, no less than 173, including several by well-known artists. In a society where art was so widely appreciated, it is hard to imagine that a young painter like Rembrandt would have struggled to find buyers, but we lack details. A number of smaller pictures, primarily genre scenes (e.g. *The Spectacle Seller*, *The Music Lesson*), which are known from this time, are the subject of disputes over attribution, in particular between Rembrandt and another promising young painter, Jan Lievens.

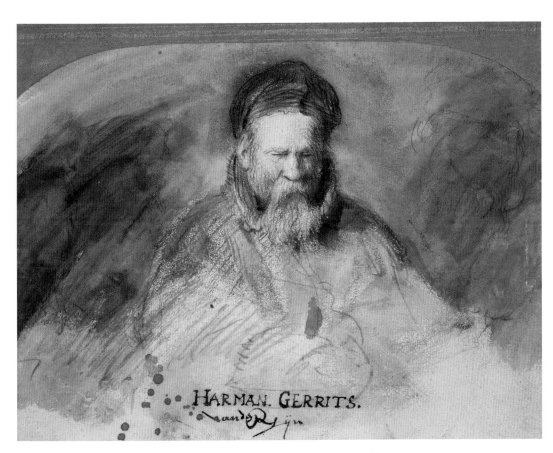

Harmen Gerritsz. van Rijn, c.1630
Red and black chalk with bistre wash,
7¹/₂ x 9¹/₂in (18.9 x 24cm)
Ashmolean Museum, Oxford

This affectionate (and undisputed)
portrait shows Rembrandt's father near
to the end of life, when he was perhaps
totally blind.

Chapter Three
The Young Painter

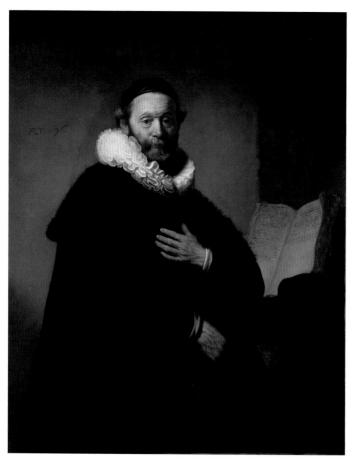

When Rembrandt returned to Leiden from Amsterdam in 1624 to set up as an independent painter, he joined up with Jan Lievens (1607–74), a painter a year younger than himself. They may have known each other earlier, but more likely Rembrandt sought out Lievens on the advice of Pieter Lastman, who had been the master of both young artists. Lievens, although the younger man, had preceded Rembrandt in Lastman's studio by many years, having gone to Amsterdam when he was only ten. He had remained with Lastman for two years before returning to practise in his native Leiden. Twelve seems an improbably early age for an artist to set up independently, however precocious, but he was still living at home and no doubt under parental guidance. Whatever the precise course of events, Lievens and Rembrandt were working together soon after the latter's return, and were probably sharing a studio, as stated by Jan Jansz. Orlers. It is on Orlers that this account of Lievens's early career is based, and as he was a patron of Lievens, he is perhaps unlikely to be mistaken in the matter.

Another young man whom Rembrandt knew in the Leiden years was Joannes Wtenbogaert (or Uytenbogaert). He belonged to a prominent Remonstrant family, which included one of the founders of the movement, and came to Leiden university because, in spite of its hostility to the Remonstrants, it was the only place for him to study. He lived with a relative, another prominent Remonstrant, who

was connected by marriage with Rembrandt's family, no doubt the origin of their association. He was not an artist, but he was extremely well connected. For example, one of his uncles was the Receiver of Taxes in Amsterdam for the Estates General, while a cousin was court painter at The Hague. Recent research suggests that Wtenbogaert may have been the conduit by which Rembrandt acquired useful patronage in both The Hague and Amsterdam.

But we know almost nothing for certain of Rembrandt's personal relationships at this time. Lievens had a reputation in later years, remarked on by several who knew him, as a very conceited man who took offence at any hint of criticism. Perhaps he was more modest in his youth, though his patron, Constantijn Huygens, does not seem to have thought so, and Rembrandt, though obstinate, determined, and sometimes irascible, was not by temperament quarrelsome; the similarity in their work suggests that they got on well, but in the future they were to take highly divergent paths. About the time that Rembrandt left to settle in Amsterdam (c.1631), Lievens went to England and then to Antwerp, where he remained for some years, acquiring a rather courtly style in the manner of Van Dyck, who was also in Antwerp. He eventually returned to Holland in about 1640 and made a good living as a painter of portraits and of officially commissioned allegorical scenes like those in Amsterdam's Town Hall.

OPPOSITE
Portrait of Johannes Wtenbogaert, 1633
Oil on canvas, 51¹/₈ x 40¹/₂in (130 x 103cm)
Rijksmuseum, Amsterdam

This is a portrait of one of the greatest of the Remonstrant leaders, to whom Rembrandt's friend of the same name was related.

LEFT
Christ Driving the Money Changers from the Temple, 1626
Oil on panel, 17 x 12²/₃ (43.1 x 32cm)
Pushkin Museum, Moscow

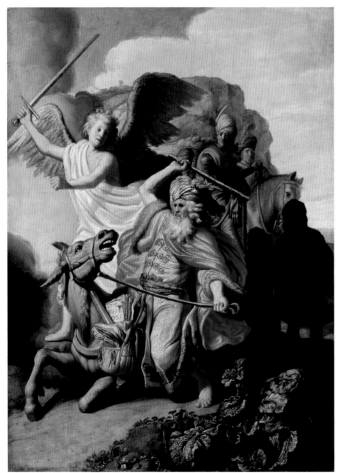

REMBRANDT

Most of Rembrandt's earliest paintings were only identified comparatively recently. Though their existence was known, and they were generally signed (usually RHL, 'Rembrandus Hermanni Leydensis') and dated, they bore so slight a resemblance to Rembrandt's later style that they were not attributed to him. They contradict, in nearly every respect, the brief, general description of Rembrandt's style outlined in the Introduction and there is little sign of the characteristics we think of as 'Rembrandtesque'. Colours are bright, even harsh, *chiaroscuro* is muted, the light stretches to the boundaries on all sides, and scenes tend to look uncomfortably crowded, partly because composition favours verticality rather than breadth. A notorious example of awkward composition is the panel painting of *Christ Driving the Money Changers from the Temple* dated 1626 (page 73) which is now acknowledged as a Rembrandt by the majority of scholars, although a few still hold to the opinion that the master could never have been responsible for such a nasty thing. It would certainly not have appealed to Carel van Mander, nor Pieter Lastman, but it is full of bare-knuckle energy, and Rembrandt could have argued that by populating his history paintings with rough, contemporary characters, he was merely returning to the old Netherlandish tradition represented by, for instance, Pieter Brueghel. He was still young and experimenting, stretching the boundaries, and in this particular case trying to establish

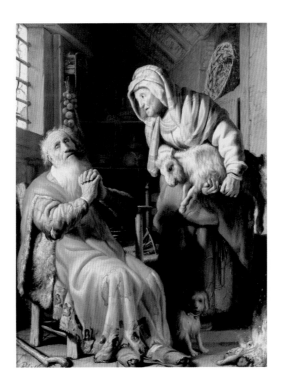

OPPOSITE
Balaam's Ass, 1626
Oil on panel, 24⁷/₈ x 18¹/₄in
(63.2 x 46.5cm)
Musée Cognacq-Jay, Paris

LEFT
Tobit Accuses Anna of Stealing the Kid, 1626 *(details overleaf)*
Oil on panel, 15³/₄ x 11³/₄in
(40.1 x 29.9cm)
Rijksmuseum, Amsterdam

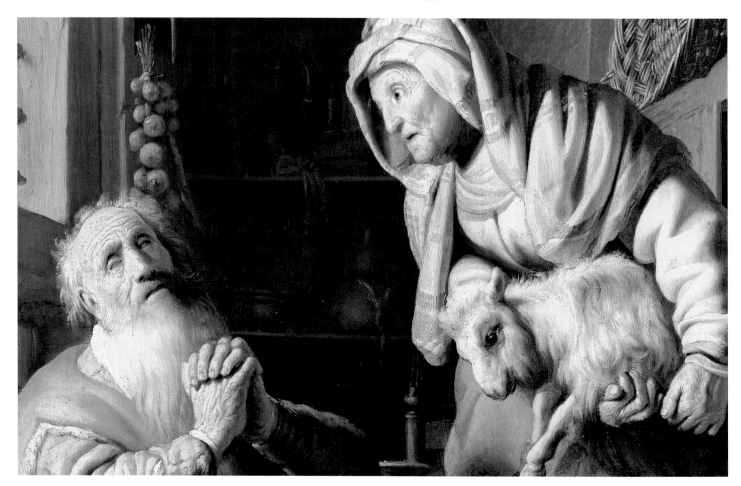

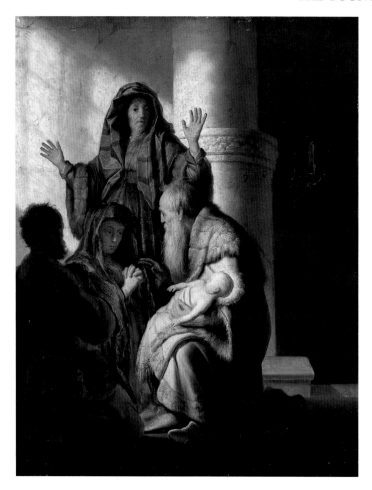

how much drama he could cram into a given space.

As we have seen, the debt to Pieter Lastman is clear in these early narrative paintings, though 'debt' is not quite the right word, for Rembrandt was engaged not so much in an act of homage as an unstated and perhaps unrecognized competition with his master. One of the first of Rembrandt's early paintings to be accepted into the canon was his painting of *Balaam's Ass* (page 74). The story, from the *Book of Numbers*, relates how the Moabite prophet and enemy of the Israelites is sent to curse them, but on the way is intercepted by an angel, who is visible only to the donkey. When the donkey stops to avoid the angel, Balaam beats it, until the angel gives the donkey the power of speech to berate its master for his violence. Balaam's eyes are then opened: he too sees the angel, who points out that by taking avoiding action the donkey has saved his life, the angel being about to strike the enemy of Israel with his sword. Balaam repents, and calls off his propaganda campaign. The donkey in Rembrandt's painting is an almost exact copy of the donkey in Lastman's version, which is dated 1622, i.e. not long before Rembrandt arrived in his studio, but, typically, Rembrandt has turned what was (to use the terms of the word processor) in 'landscape' format into 'portrait' format. Although in doing so he is forced to rearrange the figures in a way that fits the facts of the story rather less accurately, there are gains,

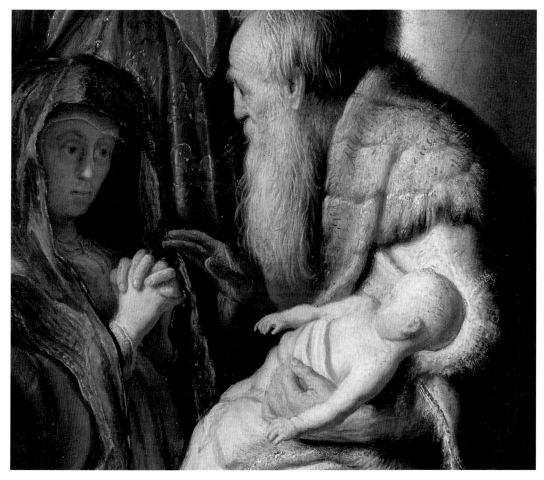

The Presentation of Jesus in the Temple (Hannah and Simeon), c.1627–28
Oil on panel, 21⁷/₈ x 17¹/₅in)
55.4 x 43.7cm
Kunsthalle, Hamburg

Nicolaes Ruts, 1631
Oil on panel, 45⁵/8 x 34³/8in
(116 x 87.3cm)
The Frick Collection, New York

Although this must have been one of his
earliest commissioned portraits,
Rembrandt already appears to be a
confident master of the form.

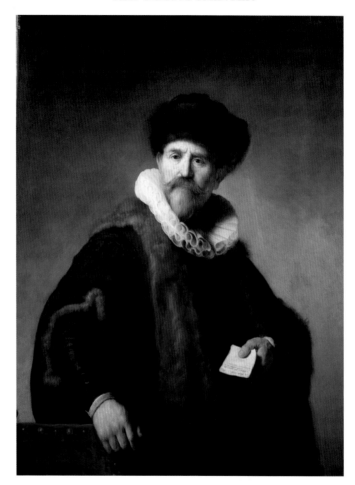

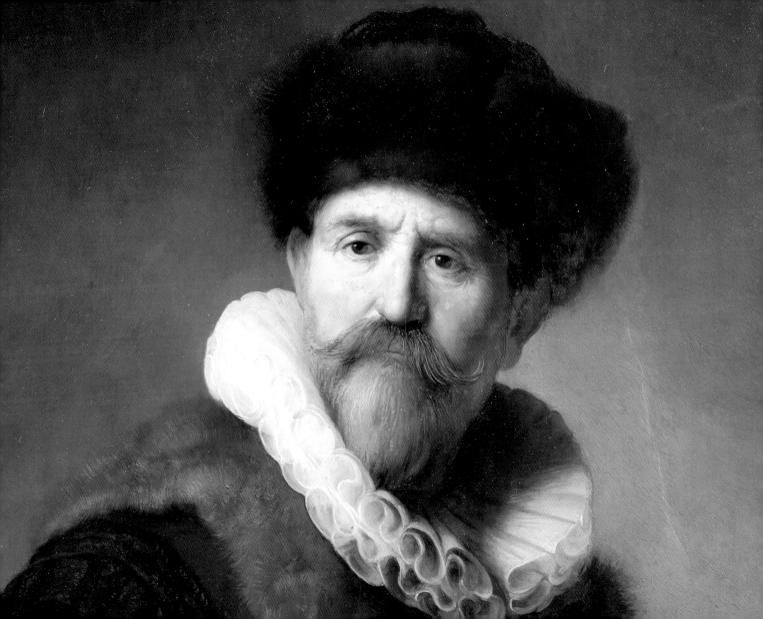

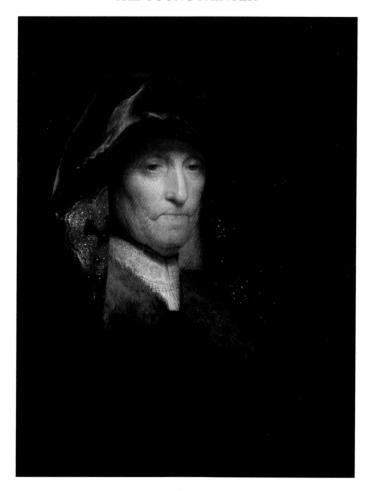

Old Woman: the Artist's Mother,
c.1629–30
Oil on panel, 23⁵/₈ x 17⁷/₈ (60 x 45.5cm)
Royal Collection, Windsor Castle

The first painting by Rembrandt to find
its way to England, where he was not
much appreciated until long after his
death.

OVERLEAF
An Old Woman Reading
(The Prophetess Hannah), 1631
Oil on wood, 23¹/₂ x 18³/₄in
(59.8 x 47.7cm)
Rijksmuseum, Amsterdam

Rembrandt's mother was probably the
model for this painting also.

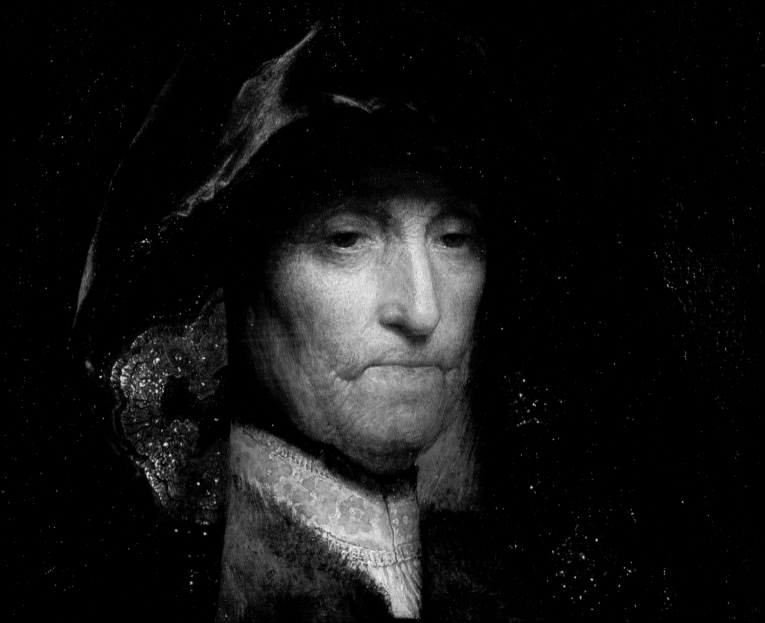

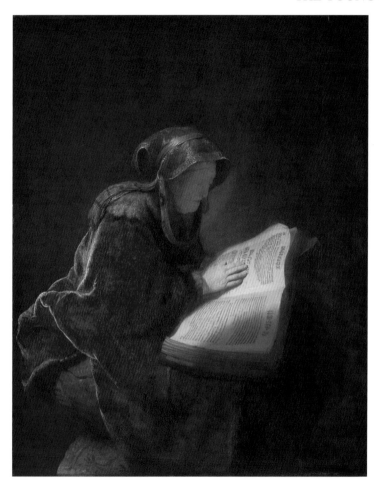

especially in added drama, as well as losses in Rembrandt's revised composition.

Probably the most famous painting of 1626 is the much more successful, strikingly vivid *Tobit Accuses Anna of Stealing the Kid* (pages 75, 76 and 77). The title, as in most of Rembrandt's subject paintings, was imposed later and titles often vary according to what book you are reading, a fact that can lead to confusion. In this case the actual incident that is the subject of the painting occurs at a later stage of the quarrel between Tobit and his wife to which the title refers . The *Book of Tobit*, in which the story is related, is in the Apocrypha, which had been excluded from the canon of sacred literature by the Synod of Dort. That did not prevent artists from continuing to plunder it for subject matter, as they had since the 15th century. It includes a vivid picture of home life that appealed to genre painters, but its lively incidents made it popular with painters in general and it provides the inspiration for several works of Rembrandt. The origin of the story of Tobit and his family appears to be a Persian folk tale; it therefore has nothing to do with the ancient Hebrews, and the Synod of Dort was quite correct to exclude it from the sacred canon, as, indeed, most Protestant Churches did.

Tobit is represented as a wealthy Jew who in old age has lost his fortune, as his tattered cloak and holed shoes suggest, and also, as a result of a freakish accident, his sight (to

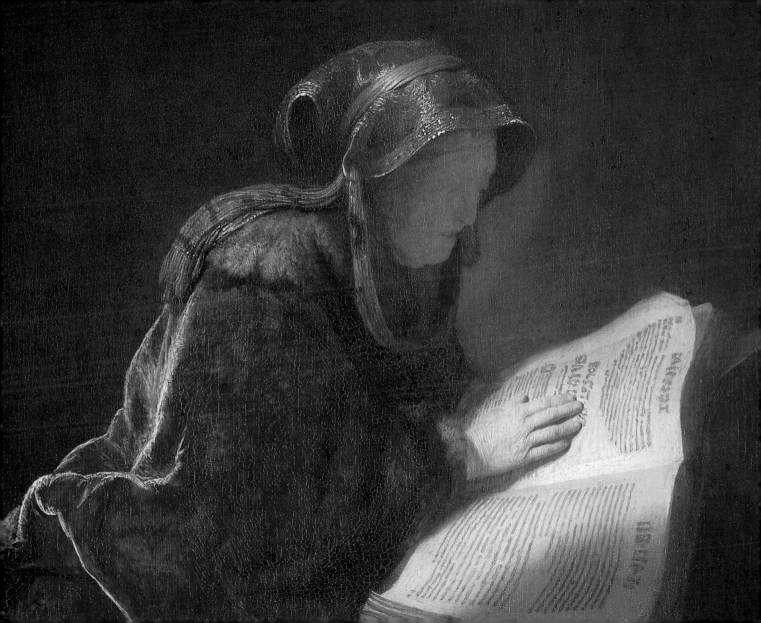

THE YOUNG PAINTER

Rembrandt, as to other painters, blindness was a frightful deprivation). To keep body and soul together, his equally aged wife Anna is forced to take in washing. One of her clients gives her a young goat in part payment and Tobit, hearing the kid bleating, jumps to the conclusion that Anna has stolen it. She turns on him, condemning him for his self-righteousness, which has brought them to their present plight. Her accusations strike home, Tobit is stricken and prays for God to release him from his wretched existence. Clearly this, Tobit's lament in response to Anna's accusations, is what forms the subject of the painting, and it is the first – perhaps the only – example of this theme in Dutch painting, although Rembrandt probably based the composition on a print by Jan van der Velde published in about 1620. The pose of Tobit, joined hands raised and head tilted, can also be found in near-contemporary prints, particularly one of a penitent St. Peter hearing the cock crow after he has denied Christ, by William van Swanenburg, whom Rembrandt probably knew of through his first master or through Scriverius (though he could hardly have known him personally as William died in 1612).

This is the earliest known painting that displays Rembrandt's true quality. He was barely 20 when he made it, but it has many characteristics of his mature art, not least his close and sympathetic interest in the elderly. The warm tones, the clear outlining of contours and the smooth, almost invisible brushwork, are the marks of his early style. The texture of the kid's coat is worthy of comparison with the sable hat of Nicolaes Ruts in Rembrandt's portrait of 1631 (pages 80 and 81).

The identity of Rembrandt's models for this painting are unknown, but they appear again in *The Presentation of Jesus in the Temple* (pages 78 and 79), which refers to the scene described in St. Luke's Gospel, Chapter 2, wherein the aged Simeon foretells the destiny of the infant Jesus. The woman seems also to be the model for the greatly admired *An Old Woman Reading (The Prophetess Hannah)*, pages 84 and 85, as well as the subject of a number of etchings. She was once generally believed to be Rembrandt's mother, though some recent scholars have reluctantly abandoned that attractive notion.

These two paintings mark a change in Rembrandt's style which, though hard to pin down with precision, seems to indicate a link with Utrecht.

The city of Utrecht, formerly the capital of an episcopal state and still to this day the main centre of Catholicism in the Netherlands, was a very different city from Leiden, not only in its affinity with Rome, which survived the Reformation, but in its possession of a brilliantly talented and influential school of artists. The most important of the Utrecht painters were Dirck van Baburen, Gerard (Gerrit) van Honthorst and Hendrick ter Brugghen, all of whom were

in Rome during the decade 1610–20, where they fell under the powerful influence of Caravaggio (one scholar sums up their enterprise as 'imagining how Caravaggio would have painted if he had been lucky enough to be Dutch'.) Their blend of Dutch and Italian styles achieved considerable success in Italy as well as in northern Europe. Honthorst, probably the most successful, who had shared the same patron as Caravaggio in Italy – and was known there, for his night scenes, as Gherardo della Notte – eventually became court painter in The Hague and, briefly, in London where he painted *Mercury Presenting the Liberal Arts to Apollo and Diana* (Buckingham Palace), the divine pair bearing the visages of Charles I and his queen, Henrietta Maria. Honthorst's religion (he was a Catholic), incidentally, was obviously no bar to his success at Protestant courts, nor to his serving as dean of the Utrecht painters' guild. Although it must be said that the Caravaggesque is not always obvious, especially in the later work of the Utrecht painters, it leaves its mark in the strong contrasts of light and shadow that were characteristic of the school in general.

All Dutch artists were affected by the Utrecht school, including the greatest – Vermeer of Delft, Hals of Haarlem, and Rembrandt of Leiden and Amsterdam. It is first evident in the chiaroscuro that Rembrandt began to employ from 1627, an early example being *The Presentatiion of Jesus in the Temple*. In that year, incidentally, the Utrecht painters

gained added fame as hosts to Rubens, officially on a diplomatic mission, whose relationship to Rembrandt, nearly 30 years younger, must be considered later. On this trip, whose unstated diplomatic purpose was an attempt to resolve the North-South division, Rubens did not visit either Leiden or The Hague, otherwise he and Rembrandt might have met.

Rembrandt's knowledge of what was happening in Utrecht may have come from Joannes Wtenbogaert, who arrived in Leiden from Utrecht in the autumn of 1626. It seems reasonable to suppose, as Gary Schwartz suggests in *Rembrandt, His Life, His Paintings* (1985), that Wtenbogaert, who moved freely in artistic circles in Leiden and

The Rich Man, from Christ's Parable, 1627
Oil on panel, $12^{5}/8$ x $16^{1}/4$in
(32 x 42.5cm)
Gemäldegalerie, Berlin

Amsterdam, would have done so also in Utrecht, and that what he had to tell of the Utrecht school must have stimulated a certain envy in Rembrandt. Whether this supposition is correct or not, it was at this time that Rembrandt adopted the technique of *chiaroscuro*, and the Carravaggesque device of a single light source (typically, a lighted candle), often emanating from a hidden source within the painting, or as a single strong shaft of light from outside it. The two devices are represented in *The Rich Man, from Christ's Parable* (page 87) and *The Presentation of Jesus in the Temple* respectively. Wtenbogaert may also have had something to do with the fact that the latter painting found its way into the collection of Prince Frederik Hendrik.

Rembrandt's most striking use of *chiaroscuro* at this period is to be seen in the inspired *The Supper at Emmaus* of c.1628 on paper-covered panel (left), though it must be said that the light and shade effects here are not obviously derived from Caravaggio, more from Rembrandt's imagination and experimental daring. It has been suggested that this picture, though of different dimensions, may have been intended, at least in Rembrandt's mind, as a pair with *The Presentation of Jesus in the Temple* since, among other similarities, both illustrate the revelation of the divinity of Christ, one at the beginning of his life, the other at the end. This subject – the reappearance of Christ at Emmaus after the Crucifixion, banishing the doubts of St. Thomas – did, however, engage

REMBRANDT

Caravaggio himself (among many others) and was dear to Rembrandt's heart. Perhaps his first real masterpiece (we shall return to it later when we consider his religious paintings in greater detail) in this early version, the intensely dramatic treatment suggests the work of a young artist keen to make an impression and, perhaps, to put one over on Jan Lievens.

The ability of the two young artists of Leiden was noticed early by their fellow townspeople, and a lawyer from Utrecht, who visited Leiden in 1628, and noted in his diary: 'The Leiden miller's son is greatly praised, but before his time'. Another indication of the growing reputation of the miller's son was the arrival in the same year of his first pupil.

Gerard (Gerrit) Dou was 14, but no tyro, for he was already known as a painter of stained glass. This activity required a good deal of work on ladders and scaffolding, and the intrepid young Gerrit had frightened his family with several mishaps. According to the well-informed Jan Jansz. Orlers, the boy's father insisted he should train as an easel painter as the only way to save him from broken bones or worse. It proved a wise step. Dou seems to have remained in Rembrandt's studio until his master left for Amsterdam, when he stayed behind to become one of the founders of the *fijnschilders* ('fine painters') school in Leiden and one of the most highly paid genre painters in Holland. He was so successful that one patron paid him 1,000 guilders a year just for the right of first refusal on new paintings, and later Dou

turned down the offer of a post at the English court. In his mature work, neither his style, technique, nor his intellect, only his commercial success, bear comparison with Rembrandt. He was by temperament a miniaturist, endlessly painstaking over the finest detail. Joachim van Sandrart (who wrote an account of Rembrandt in 1675) relates how, when visiting Dou's studio, he admired the minute finish of a broomstick only for the painter to tell him that it still required three days' work!

While Dou worked in Rembrandt's studio, however, he closely followed his master. There are several paintings in which experts have detected the hand of both master and pupil, and one or two that may have been painted by either man. A thoroughly Rembrandtesque painting of *Tobit and Anna Awaiting the Return of Tobias* (c.1630; London, National Gallery), which bears an inscription crediting it to Rembrandt, is now ascribed by most experts to Dou. Of special interest to us is Dou's *An Old Painter Writing behind His Easel* (page 91). This was a popular theme in art, and the old painter is obviously not Rembrandt, who was not yet 30, while the studio is also quite different from that in Rembrandt's painting (discussed below). But the props lying about closely resemble objects listed in the inventory of Rembrandt's possessions compiled in 1656. (Dou did make a painting of Rembrandt in his studio, probably in 1630, which is in a private collection.)

The Supper at Emmaus, c.1628
Paper on panel, 14³/₄ x 16⁵/₈in
(37.4 x 42.3cm)
Musée Jacquemart-André, Paris

... 'how greedily Rembrandt absorbed the lessons of the masters, only to depart from them in a stroke of shocking conceptual bravery.' (Simon Schama)

Rembrandt's studio was considerably less spacious and more scruffy than that of Dou's *Old Painter*, to judge from *A Young Painter in his Studio* (left). The studio in this small painting is singularly uncluttered, in fact practically empty, but for the massive easel in the right foreground. We see only the back, which is in shadow, since the light from the window would naturally be required to fall on the other side. The room is very dilapidated, with plaster coming off the walls: the bare patches are meticulously depicted. The artist stands in the left background, a small figure (Rembrandt was apparently short and stocky) wearing a large black hat that partly shades his face and a heavy, dull green coat or gown that suggests a lack of heating. His right hand holds the brush with which he is painting, his left hand clasps a large bundle of other brushes, the thumb hooked on to a palette and the little finger clutching a mahlstick (a stick with a padded top on which the painter may rest his forearm when working on intricate details). He has stepped back to regard his work from a distance, and he looks faintly tentative, undecided, even 'timid', as one critic calls him. Is he wondering whether the touch he has just made to the painting is satisfactory? Or, as some biographers have been tempted, perhaps rashly, to suggest, are we looking at a young man unsure about his professional future?

The studio was almost certainly shared with Jan Lievens, as well as Gerrit Dou and, in time, several other youngsters,

for Dou was Rembrandt's first but not his only pupil (the second was 14-year-old Isaac de Jouderville, who came initially for six months in 1628 and paid the relatively high fee of 50 guilders). It appears to have been just a hired studio, not a home, for Rembrandt still lived in his parents' house and, presumably, Lievens and the apprentices also lived at home.

Rembrandt's paintings in this period were on wood panels, usually oak, which could be bought in standard sizes. The panel had to be primed in three stages, the last being a thin coat of oil paint: such tasks were customarily undertaken by apprentices. Rembrandt seems to have made few preparatory drawings, sometimes perhaps none at all, and began by outlining his composition in monochrome paint on the primed surface. The actual painting of the colours seems to have begun at the back, moving gradually towards the front, i.e. (as a rule), sky or other background first, figures last. Painters usually sat in front of their picture, as in Dou's *Old Painter*, but it seems that Rembrandt at this period preferred to stand. There is no chair evident in Dou's painting of him nor in the Boston painting, nor in Rembrandt's etchings of the same subject, and clearly, as in the Boston picture, he liked to step back to keep the composition in view, so as not to lose contact with the whole while working on the detail (a practice strongly recommended by Leonardo da Vinci in his 'Treatise on Painting').

In 1629 Rembrandt and Lievens received a distinguished visitor to their studio. Constantijn Huygens (1596–1687) was the epitome of the cultured gentleman. He was a considerable and wide-ranging poet; he was fluent in practically every European language, including Greek and Latin; he was a composer who played the lute well enough to perform before the king of England; he had a profound knowledge of contemporary sciences (the great scientist Christiaen Huygens was his son); he had a scholar's comprehension of contemporary theology and philosophy; he was a connoisseur, and a perceptive one, of the arts, including painting. He was very good-looking, though with slightly disconcerting, hooded eyes, and his charm could be a potent weapon when dealing with the powerful and the famous, while his apparently genial character and air of aplomb enabled him to maintain friendly and profitable relations with individuals over a wide political/religious spectrum. He was perfectly self-assured and supremely confident of his own abilities, without being too arrogant. To cap it all, this paragon once demonstrated his athleticism by climbing the spire of Strasbourg cathedral to see the view.

Huygens's family was neither aristocratic nor rich, but he did not depend entirely for his income on his post as secretary to the stadholder (his father had been secretary to William the Silent). He invested wisely in land development; as a supporter of the French alliance he received a pension

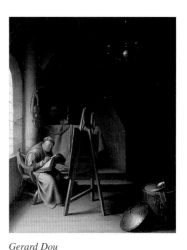

Gerard Dou
An Old Painter Writing behind His Easel, c.1631–32
Oil on panel, 12³/₈ x 9⁷/₈in (31.5 x 25cm)
Private collection

OPPOSITE
A Young Painter in His Studio, c.1629
Oil on panel, 9⁷/₈ x 12⁵/₈in (25 x 32cm)
Museum of Fine Arts, Boston

THE YOUNG PAINTER

RIGHT

The Repentant Judas Returning the Pieces of Silver, 1629

Oil on panel, 31¹/8 x 40¹/4in (79 x 102.3cm)

Private collection

OPPOSITE

Jan Lievens

Portrait of Constantijn Huygens, c.1628

Oil on panel, 39 x 33in (99 x 84cm)

Rijksmuseum, Amsterdam

OVERLEAF

Self-Portrait with Beret and Gold Chain, c.1630

Oil on panel, 27³/8 x 22³/8in (69.7 x 57cm)

Walker Art Gallery, Liverpool

(not publicized) from Cardinal Richelieu's government, and he had other smaller irons in various fires. He never rose particularly high in the world, or at court, but he served the House of Orange loyally for a remarkable 60 years (he lived into his 90s), while at the same time preserving his integrity and independence and maintaining friends of all parties and prejudices.

His company could be stressful, however. He tended to expect too much of people and he made few intellectual concessions. His brother Maurits, whose portrait Rembrandt painted in 1632 (page 60), once wrote to tell him that he had been reading his latest poems to their parents, and that none of the three had understood a single word.

Huygens already knew Lievens, who had painted his portrait (now in Douai Museum) two or three years before, and he must have known Rembrandt by reputation: there is some evidence that Rembrandt too painted his portrait later, but if so it is lost. (One 18th-century writer, not wholly reliable, says that Rembrandt walked all the way to The Hague, about 12 miles/20 km, to show a painting to 'a certain gentleman' there, presumably Huygens, and sold it for 100 guilders.) Soon after his visit to Leiden, Huygens wrote a memoir, of great interest to historians of the 17th-century Netherlands, which includes a section on art and artists. He leaves to the last 'a noble pair of young men from Leiden' who, he predicts, will exceed even the best of current Dutch

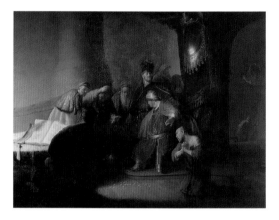

artists (the painter Huygens yearned for was Rubens, now cut off from Holland by the division of the Netherlands). He is rather scathing about the quality of their teachers (whom he politely does not name), insisting that their achievements are due entirely to their own gifts, and he digresses at some length on their humble origins, a sensitive point with Huygens personally. Although naturally reluctant to praise one more highly than the other, he does suggest that 'Rembrandt surpasses Lievens in the faculty of penetrating to the heart of the subject matter and bringing out its essence, and his works come across more vividly'. He remarks that a painting of

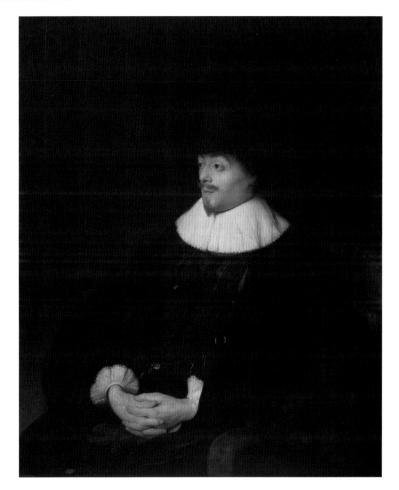

Judas returning the 30 pieces of silver (the price for his betrayal of Jesus) to the high priest 'can withstand comparison with anything ever made in Italy [or in antiquity]'. This is a judgment with which modern critics would hardly disagree if, as it must, it refers to Rembrandt's painting of *The Repentant Judas* (left), signed and dated 1629, and an early example of Rembrandt's narrative power and his unrivalled capacity for representing the most powerful emotions.

One thing puzzled Huygens about the gifted pair. Why did they not go to Italy, like most of the best northern artists, to study the works of Michelangelo, Raphael and the other great masters at first hand? Rembrandt's reply was that he was too busy. He had studied under masters who had made the Italian pilgrimage, and there were plenty of Italian prints to be seen in the Netherlands. This was perfectly true. It was no longer necessary to visit Italy in order to complete one's artistic education. Whether or not Rembrandt felt disinclined to make the long and risky journey, he knew and comprehended, none better, the Classical and Italian Renaissance tradition and throughout his life studied and copied Italian and other works. Those who accused him of ignorance in this area were simply wrong, and made the same mistake as Romantic posterity in underestimating his intellectual powers.

Rembrandt could hardly have found, or been found by, a

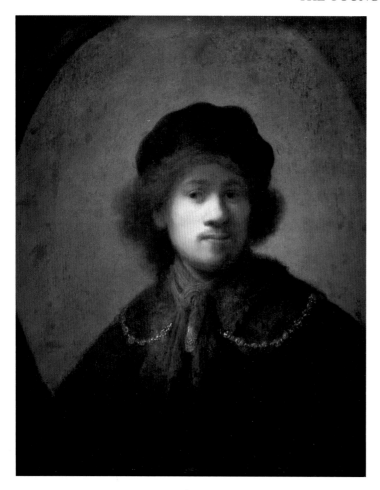

more useful patron. Whatever Prince Frederik Hendrik's appreciation of the arts, he left artistic matters to his discerning secretary, who was quick to form his own, firm opinions and equally quick to act on them. There is no documentary proof that Huygens was responsible for introducing Rembrandt to the court at The Hague but, whatever the role of Joannes Wtenbogaert, it seems certain that he was.

Also resident at The Hague were King Frederick of Bohemia and his queen (a daughter of James I of England), who had fled from Prague after the Battle of the White Mountain (1620) at the beginning of the Thirty Years War. On the death of their son in 1629, Robert Kerr, earl of Ancrum was sent to the Netherlands to convey the sympathy of King Charles I to his sister and her husband. Ancrum was a cultured man, a lover of the arts and a lifelong friend of the poet Donne, whose work had been translated into Dutch by Constantijn Huygens. While in The Hague, Ancrum received from Frederik Hendrik a painting by Lievens (now lost), which he subsequently presented to Charles I. When he returned to England he also took (probably) two works by Rembrandt, a self-portrait (shown here) and the supposed portrait of his mother now at Windsor Castle (mentioned earlier), which also found their way into the Royal Collection. Ancrum would certainly have met Huygens and we can safely assume that these two highly intelligent men of

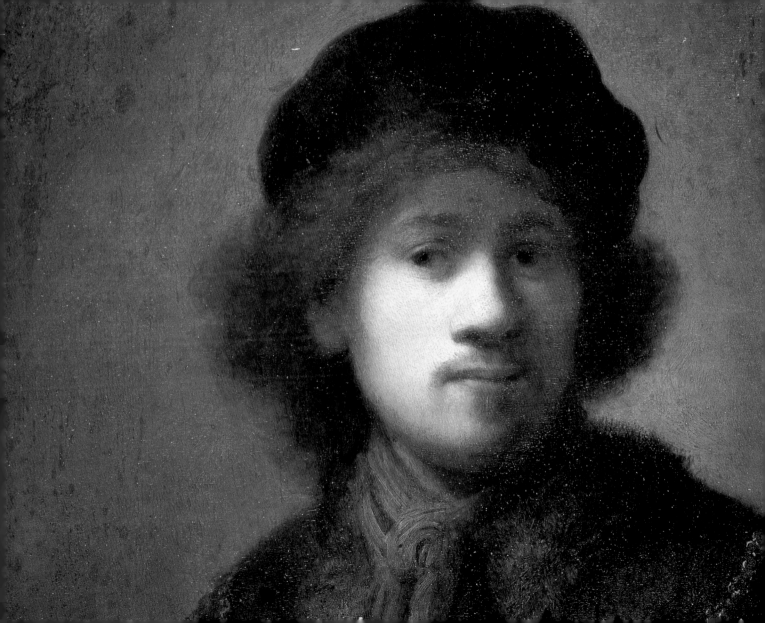

Samson and Delilah (The Capture of Samson), 1628
Oil on panel, 24¹/₈ x 15³/₄in
(61.4 x 40cm)
Gemäldegalerie, Berlin

Rembrandt signed and dated this painting later and put it at least a year too early.

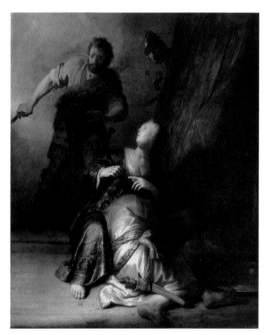

similar interests would have found each other rewarding company. Perhaps Huygens recommended Rembrandt directly to Ancrum, or the two works were presented by

Prince Frederik Hendrik along with the Lievens. In either case, Huygens must surely have been the prime mover.

Of similar age, background and training, the two young painters had similar aims and styles, and it is not easy in some cases to tell whether a given painting is by one or the other. Moreover, this confusion began in their own time. An inventory of paintings in the collection of the Prince of Orange, compiled in 1632, describes one picture (*The Presentation of Jesus in the Temple*, mentioned above) as 'done either by Rembrandt or by Jan Lievens'.

Today we consider Rembrandt one of the greatest artists who ever lived, while Lievens has all but sunk from sight, his name unknown to many people. During their lifetimes, there was no such disparity. Of the two, Lievens, the infant prodigy (just eight years old when he began his apprenticeship), was probably the leader in their early days in Leiden and overall probably the more successful, even in later times attracting more commissions that his former friend and partner. To our sensibilities, however, Lievens did his best work in Leiden.

In his memoir, Huygens presented Rembrandt and Lievens on more or less equal terms, though he pointed out that each was gifted in different ways (the puzzled clerk who compiled Frederik Hendrik's inventory ought to have consulted him). Orlers, the only other person who wrote an account of them in Leiden, paid far more attention to

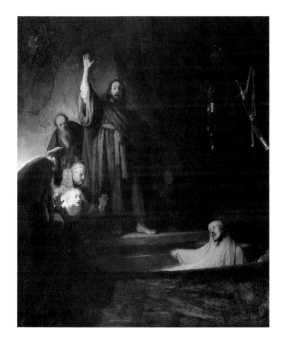

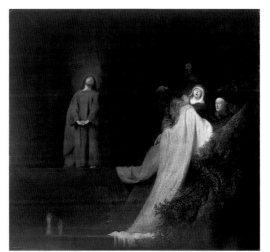

FAR LEFT
The Raising of Lazarus, c.1630–31
Oil on panel, 38 x 32in (96.4 x 81.3cm)
County Museum of Art, Los Angeles

LEFT
Jan Lievens
The Raising of Lazarus, 1631
Oil on canvas, 40^1/$_2$ x 44in
(103 x 112cm)
Brighton Museum and Art Gallery,
England

Lievens, of whom he was personally an active patron (he owned nine works by Lievens but no Rembrandts) as well as securing for him commissions from the city government.

There is no doubt that in these years Lievens was the more sought-after painter. Although a year younger, he had made a much earlier start as a professional than Rembrandt, and he probably regarded himself, as others did, as the leading influence. He was certainly a faster (though far from slapdash) worker: modern X-ray investigations show that Rembrandt was more painstaking, more inclined to rework and revise. It is likely that Lievens was the original proprietor

Two Scholars (or Two Old Men)
Disputing, 1628
Oil on panel, 28¹/₂ x 23¹/₂in
(72.3 x 59.5cm)
National Gallery of Victoria, Melbourne

The two old men are probably St. Paul
(facing us) and St. Peter. This painting
has caused much discussion: the scene
probably refers to remarks in St. Paul's
Epistle to the Galatians, Chapter 2, in
which Paul identifies their different
roles as apostles. The painting may
have been for a particular, though
unknown, patron.

of the studio they probably shared which, though assumed to
have been hired, may even have been in the house of
Lievens's father. He was also the more assertive character:
Huygens was the first but not the last to remark on his prickly
pride and inability to accept criticism. Possibly his personality
contributed to the greater impact he made on contemporaries,
while Rembrandt's association with Remonstrants like
Scriverius may have worked against him, especially when it
came to commissions from the Counter-Remonstrant
government of Leiden.

It is remarkable how often, in the last years before they
pursued their separate ways, Rembrandt and Lievens painted
(or etched) the same subject, which may suggest a rivalry
that was increasingly competitive. For example, each painted
a Capture of Samson in 1628–29 (both were owned by the
Stadholder). A year later each painted a very similar Christ
on the Cross, Rembrandt's rather more effective. There are
five versions of The Raising of Lazarus – a painting and an
etching by Lievens, a painting, etching and drawing by
Rembrandt – from 1630–32. In the case of Rembrandt's
painting, X-ray examination shows that he altered the
composition twice in the course of painting, conceivably
under the influence of Lievens's work. Incidentally, Huygens
had advised Lievens to leave history painting to Rembrandt,
which no doubt made him all the more determined to excel
in that area. They also used the same models. The elderly

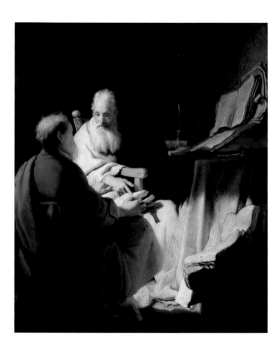

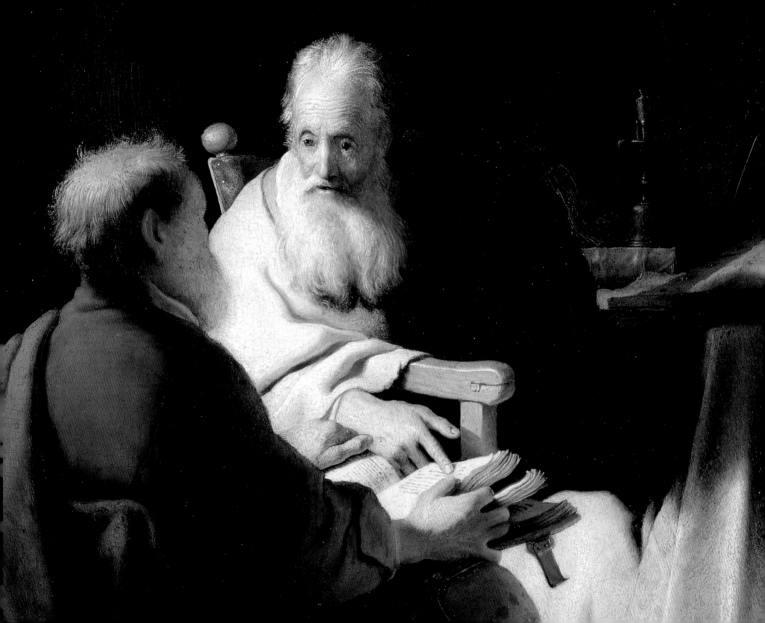

THE YOUNG PAINTER

Peter Paul Rubens
Self-Portrait, c.1622–23
Oil on panel, 33⁷/₈ x 24⁵/₈in
(86 x 62.5cm)
Royal Collection, Windsor Castle

man who sat for Rembrandt's supposed St. Paul, talking things over with St. Peter in the painting generally known as *Two Scholars* [or *Two Old Men*] *Disputing* (pages 98 and 99) and also for the Prophet Jeremiah in the Titianesque *Jeremiah Lamenting the Destruction of Jerusalem* (1630; Amsterdam, Rijksmuseum) also appeared in other Biblical roles in two paintings by Lievens and in many drawings by both artists. They sometimes used each other as models, and drew or painted each other's portraits. These tend to suggest that, competitive as they no doubt were, they were also friends, since Lievens's *Portrait of Rembrandt* (c.1629) appears highly sympathetic to the sitter, and the same might be said for Rembrandt's pen and ink sketch of Lievens in *The Artist in a Studio* (page 16), probably done a few years later.

Rembrandt's breakthrough can certainly be ascribed to the patronage of the court of the Prince of Orange, which Huygens was most likely instrumental in bringing about. Court patronage brought not only prestige, it also brought substantial financial reward and a distinct change of image. For the five paintings that Rembrandt made for the Stadholder in the course of the next few years, he received a princely 600 guilders each (the average painting for a Leiden collector earned about six guilders). Nevertheless, Rembrandt asked for more, characteristically remarking at one point that they were worth double.

Contact with court life naturally had an effect too. The wild-haired, narrow-eyed young rebel of the early self-portrait etchings, disappears, to be replaced by a young gentleman whose peasant's nose is less turnip-like and who wears a gold chain in the Liverpool *Self-Portrait* of about 1630. No doubt nursing his ambition to become the Rubens of the north, he aspired also to Rubens's social status – the artist as gentleman and diplomat – the image perfectly conveyed in Rubens's *Self-Portrait* of c.1622–23 at Windsor.

The *Christ on the Cross* (opposite left) suggests a connection with Rembrandt's major commission for Frederik Hendrik which consisted ultimately of five paintings on the Passion of Christ, begun in 1632. The Crucifixion picture was based on an engraving after Rubens, and both Rembrandt and Lievens painted their own versions. This may have been engineered by Huygens, and the choice of Rembrandt to paint the subsequent pictures of the Passion in emulation of Rubens's tremendous altarpieces in Antwerp, *The Raising of the Cross* and *The Descent from the Cross*, represents Huygens's judgment on the two Crucifixions.

The central event in the Christian religion, the Crucifixion was a subject to which Rembrandt returned throughout his life, chiefly in drawings such as *Calvary* (c.1635; Berlin, Staatliche Museen) and in a famous etching, *The Three Crosses* (different states on pages 360, 361 and 376), which Kenneth Clark chose to close his book on

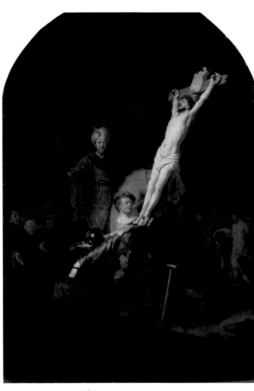

FAR LEFT
Christ on the Cross, 1631
Oil on canvas placed on panel,
36$^1/_2$ x 28$^1/_2$in (92.9 x 72.6cm)
Church of Le Mas d'Agenais, France

LEFT
The Raising of the Cross, c.1633
Oil on canvas, 37$^7/_8$ x 28$^5/_8$in
(96.2 x 72.2cm)
Alte Pinakothek, Munich

The Raising of the Cross, c.1633
(details)

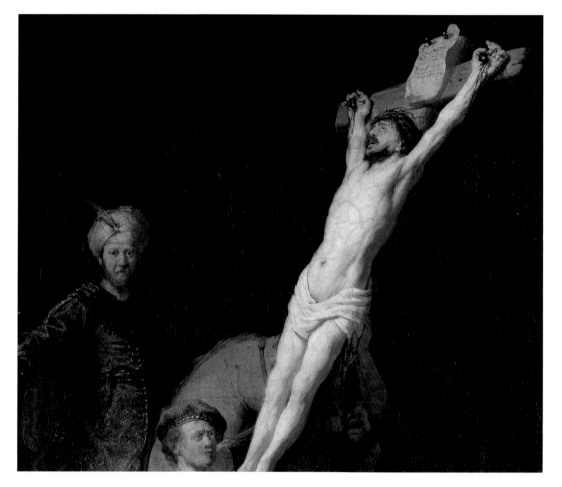

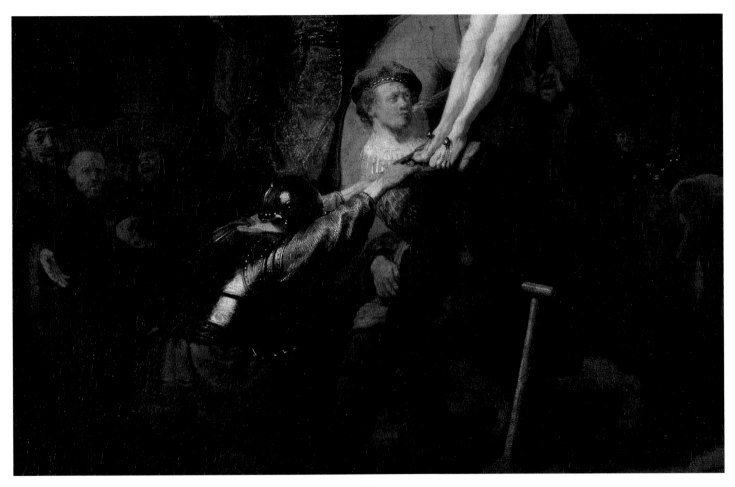

RIGHT
The Descent from the Cross, c.1633
(details on pages 106 and 107)
Oil on wood, 35¹/₄ x 25⁵/₈in
(89.4 x 65.2cm)
Alte Pinakothek, Munich

FAR RIGHT
The Entombment of Christ, c.1636–39
(detail on page 108)
Oil on canvas, 36¹/₄ x 26³/₈in
(91.9 x 67cm)
Alte Pinakothek, Munich

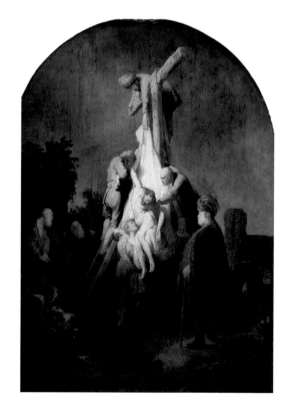

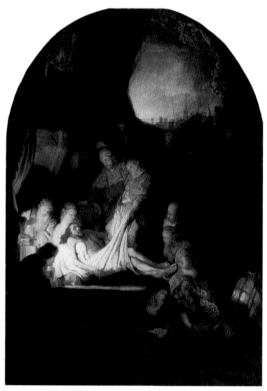

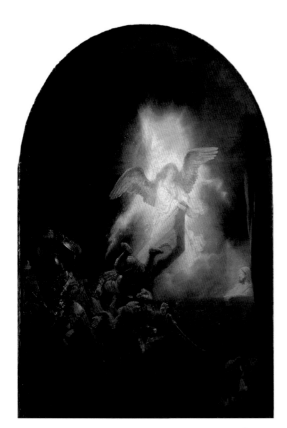

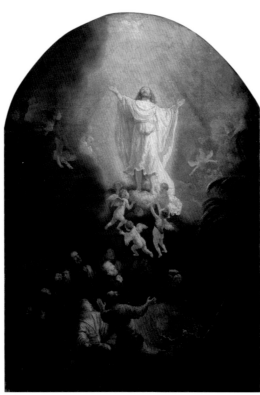

FAR LEFT
The Resurrection of Christ, c.1639
(detail on page 109)
Oil on canvas on panel, 36³/8 x 27¹/8in
(92.5 x 68.9cm)
Alte Pinakothek, Munich

LEFT
The Ascension of Christ, 1636
Oil on canvas, 36¹/2 x 26⁷/8in
(92.7 x 68.3cm)
Alte Pinakothek, Munich

The Descent from the Cross (details)

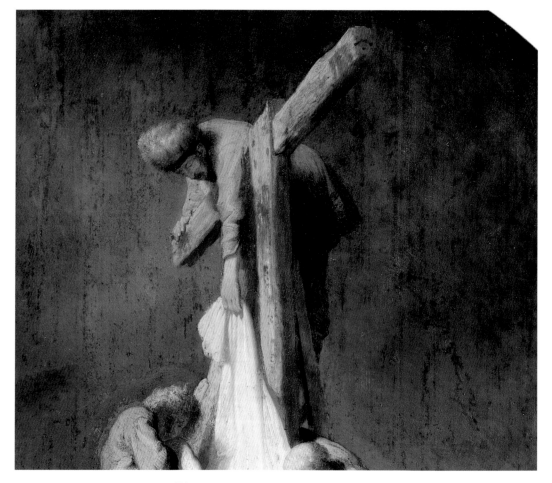

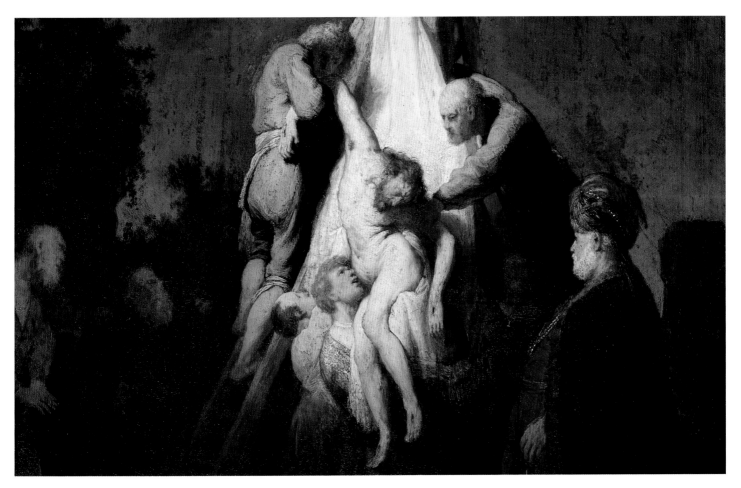

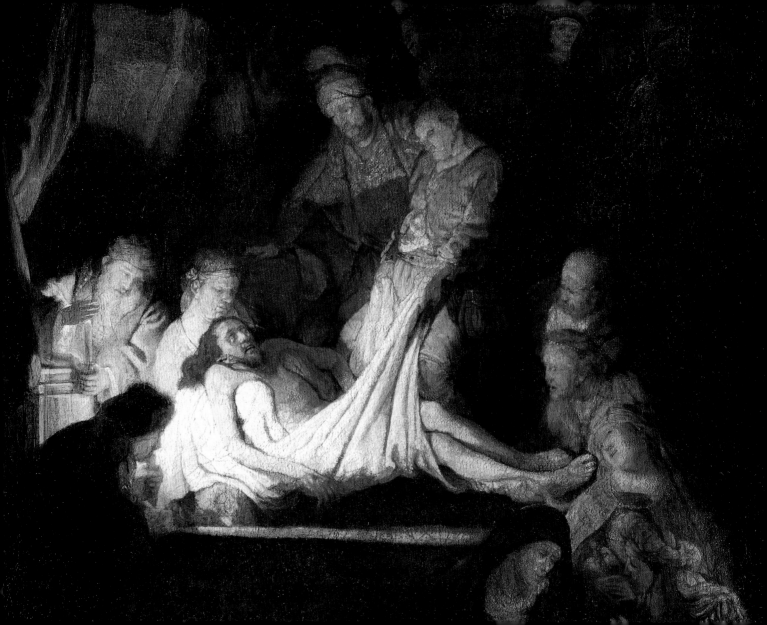

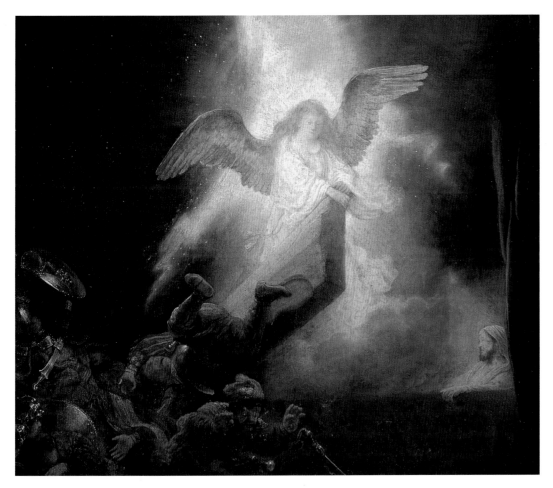

OPPOSITE
The Entombment of Christ (detail)

LEFT
The Resurrection of Christ (detail)

The Descent from the Cross
Hermitage, St. Petersburg

Rembrandt on the grounds that it left him with nothing more to say.

The five pictures (all are now in the Alte Pinakothek in Munich) were not ordered at the same time but, even if they were not originally intended as such, they make up a coherent series and they are all round about the same size. On the whole, art historians have been lukewarm towards these paintings. However, even if they were never among Rembrandt's greatest works, they were unfortunately worked over at a German court in the 19th century by a restorer whose incompetence was matched only by his conceit.

While an indisputable coup, this large commission became in time, as so many other artists have found in similar circumstances, something of a burden, and overall, though not a failure, it was not the great success for which, no doubt, Rembrandt had hoped. As it happens, the only samples we have of Rembrandt's correspondence are connected with this project: seven letters to Huygens explaining why he had fallen behind schedule. (The particular doctrinal difficulties that Rembrandt faced in the Passion series will be examined further when we look at his religious pictures in general.)

In the end, five pictures (not counting the 1631 Crucifixion) were completed. The first two, *The Raising the Cross* and *The Descent from the Cross*, were delivered probably in 1633 and may have been designed to hang with

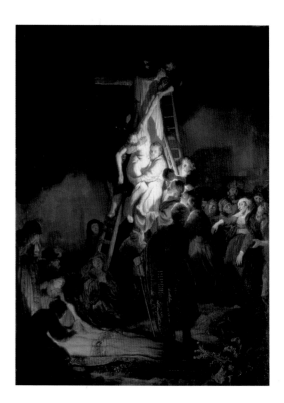

Geronimo

Chiricahua Apache

Geronimo

(Goyathlay)
ca. 1829–1909

Apache leader

A symbol of Native American resistance and warrior spirit, Geronimo acquired a reputation as a fearless fighter while wreaking vengeance on Mexican troops who had murdered his wife, children, and mother. When U.S. miners, settlers, and soldiers intruded on Chiricahua Apache lands in Arizona, Geronimo and his people resisted U.S. efforts to settle his people on reservations, and were denounced as murderous renegades by angry whites. Hunted relentlessly by U.S. soldiers and Apache scouts, Geronimo was finally persuaded to surrender in 1886, and was shipped as a prisoner of war to internment camps in Florida, Alabama, and finally Fort Sill, Oklahoma. In his later years, Geronimo converted to Christianity, sold autographed photos of himself, and rode in President Theodore Roosevelt's inaugural parade. Despite his notoriety, the old warrior was never allowed to return to his tribal homeland. He died a prisoner of war at Fort Sill in 1909. Yet Geronimo's legend as a warrior survived. In 2011, the U.S. military operation that eliminated Al Qaeda leader Osama bin Laden was code-named "Geronimo."

NATIONAL
MUSEUM
:: OF THE ::
AMERICAN
INDIAN

www.AmericanIndian.si.edu

RIGHT
**Self-Portrait with Hat and Gold Chain,
1633**
Oil on panel, 27^1/$_2$ x 20^7/$_8$in
(70 x 53cm)
Louvre, Paris

OPPOSITE
**Amalia van Solms (Princess of
Orange), 1632**
Oil on canvas, 27 x 21^7/$_8$in
(68.5 x 55.5cm)
Musée Jacquemart-André, Paris

the original *Christ on the Cross*. The latter, however, seems
to have gone to France at an early stage (perhaps originally
to the little principality in the Vaucluse from which the
House of Orange took its name), and it may have been
regarded as too uncompromisingly a Catholic icon for a
Protestant capital. Although the first two paintings were
commissioned by Huygens on the Stadholder's behalf, the
later paintings were ordered by Frederik Hendrik personally
after the first two had been delivered. *The Ascension of
Christ* is signed and dated 1636, and the Stadholder was
slightly disappointed with it, according to Huygens, finding it
too dark (Rembrandt advised hanging it in a strong light),
and more conventional than he had expected: the possible
reasons for this are discussed in Chapter Fourteen. *The
Entombment* and *The Resurrection*, the composition of which
was apparently based on a painting by Pieter Lastman, were
not completed until three years later. Patrons are seldom
completely satisfied, and it is possible that it was Huygens,
rather than the Stadholder himself, who was critical, as for
reasons largely obscure he was becoming less admiring of
Rembrandt. Still, commissions from the Stadholder – they
also included Rembrandt's portrait of Frederik Hendrik's
wife, Amalia van Solms (opposite) – were few, and if
Rembrandt hoped to become a court painter, settled in some
comfort at The Hague, he was disappointed. So far as the
paintings of the Passion are concerned, perhaps unrealistic

expectations were raised by the connection between Rembrandt's Crucifixion and Rubens's painting of a generation earlier, for the Passion cycle echoed the great altarpieces in Antwerp that first established Rubens's international fame. But there was really no comparison. The Antwerp altarpieces were designed for a great Catholic cathedral, whereas Rembrandt's panels were designed for a private, Protestant residence. The former were about 20 times larger.

Chapter Four
Amsterdam

Thomas de Keyser
Constantijn Huygens and His Secretary, 1627
Oil on panel, 36³/₈ x 27¹/₄in
(92.4 x 69.3cm)
National Gallery, London

Rembrandt in Leiden in 1631 could have taken some satisfaction from reviewing the first five or six years of his career. He had found a market in his home town both for history and genre paintings and, more important (and much more profitable), he had moved on to work for the court in The Hague, which in turn resulted in increasing the number of his clients both in Leiden, The Hague and elsewhere. He had made his first sale in Amsterdam, through the dealer Hendrick Uylenburgh, in 1628. His painting, described in the next chapter, of a wealthy Amsterdam merchant Nicolaes Ruts (pages 80 and 81) was commissioned while he was in Leiden (probably his first commissioned portrait although, looking at this accomplished work, that is hard to believe). Several foreign visitors had bought, or had been given, his paintings.

On the other hand, his future, if he remained in Leiden, looked less bright. In the first place, the city, after its brief boom, was entering a period of recession. Moreover, the Guild of St. Luke, the artists' guild, did not exist in Leiden (nor yet in Amsterdam, in fact), and the city, unlike Utrecht and some others, made no effort to protect local artists against competition from non-residents. This and the declining fortunes of the Leiden burghers inclined Rembrandt to contemplate a move, and Amsterdam was the obvious choice. The relatively greater success of Jan Lievens may possibly have increased his restlessness, and a move to Amsterdam was

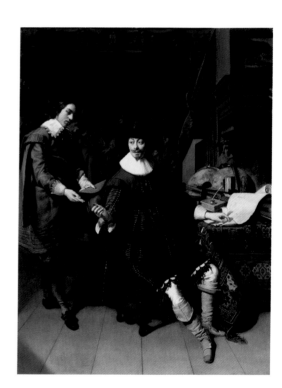

114

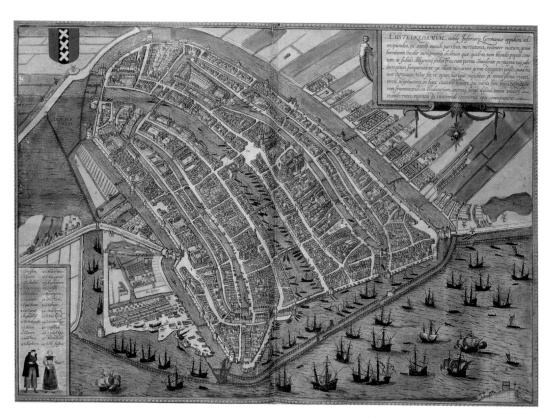

Joris Hoefnagel
Map of Amsterdam from Civitates Orbis Terrarum, *c. 1572*, by Georg Braun and Frans Hogenburg
Colour engraving
The Stapleton Collection

By the time Rembrandt arrived in the city, Amsterdam was much larger and still growing.

Andromeda, c. 1630
Oil on panel, 13¹/₂ x 9⁵/₈in
(34.1 x 24.5cm)
Mauritshuis, The Hague

not likely to affect his relations with The Hague in any way, though as it happened it looked as though his prospects there were also in decline. Other artists, notably Gerard van Honthorst, the leading Utrecht painter, were rising in favour, and it is clear from Huygens's letters on the subject that Frederik Hendrik (or himself) was a little disappointed by the paintings in the Passion series. (In fact court patronage did dry up almost completely after Huygens's enthusiasm for Rembrandt waned, and Frederik Hendrik personally would commission only one further painting from Rembrandt.) Still, even The Hague was a backwater compared with the teeming metropolis of Amsterdam. It was significant that when Rubens had been appointed court painter to the Spanish governor of the Netherlands, he had chosen to live in Antwerp, rather than Brussels, so that he might paint for merchants as well as princes.

While the future in Leiden looked dim, Amsterdam offered a much brighter prospect. Perhaps curiously, competition was comparatively slight. The great artists of the previous generation were either dead or failing (Pieter Lastman was still at work in 1631 but died two years later). Several younger artists had established reputations: they included the portraitist Thomas de Keyser, ten years older than Rembrandt and initially an influence on him although soon the influence was all the other way; Nicolaes Eliasz. Pickenoy, 15 years older and at one period a neighbour, who

in the year of Rembrandt's *The Night Watch* himself painted one of the Amsterdam militia companies. There were one or two others, even less distinguished, but the market was so large that, as Rembrandt soon happily discovered, plenty of opportunities for a newcomer existed. There was also, whether or not it occurred to him, likely to be a much larger pool of potential pupils, another significant source of income for an established artist. Rembrandt himself had some useful contacts, such as the dealer Uylenburgh, in Amsterdam, and his patrons in The Hague and Leiden no doubt recommended him to their Amsterdam friends. In fact it appears that Rembrandt's (known) commissions in his first year in Amsterdam outnumbered his overall total to date. But although he made a dramatic and immediate impact in some circles, he made little progress in others. Most notably, he never gained the patronage of the city's rulers, which would have more than compensated for the loss of patronage in The Hague.

The miller's household in Leiden was further depleted by Rembrandt's move to Amsterdam. The miller himself, Rembrandt's father, had died in April 1630 and his eldest son followed less than two years later. That left Rembrandt's two older brothers, Adriaen and Willem, who had their own households, and a younger brother, Cornelis, who disappears early from view and may already have left home. The other two maintained the traditional family trades, Adriaen as a

miller, Willem a baker and corn dealer, and no doubt they worked in some kind of partnership. The house also contained two unmarried daughters and their mother, who died in 1640, ten years after her husband, whereupon Adriaen moved back into the family house. The family owned some property, which brought in rent, and Rembrandt himself

The Abduction of Proserpina, c.1632
Oil on panel, 33$^{1}/_{3}$ x 31$^{1}/_{3}$in
(84.8 x 79.7cm)
Gemäldegalerie, Berlin

(See also The Rape of Europa, *pages 120 and 121)*

RIGHT
Diana Bathing, c.1631
Etching
Rembrandthuis, Amsterdam

FAR RIGHT
Seated Woman, c.1631
Etching, 7 x 6¹/₄in (17.7 x 16cm)
Rembrandthuis, Amsterdam

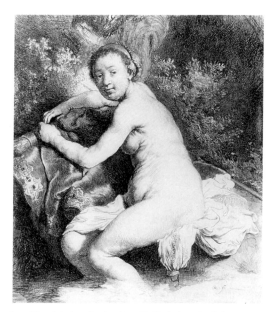

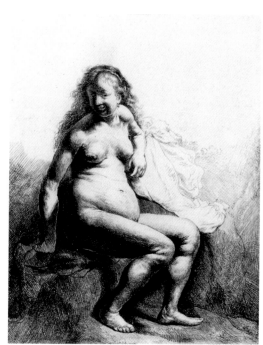

bought a plot, described as 'a well-situated garden lying outside the White Gate', at Leiden in March 1631, not long before he left his birthplace. This suggests either that he was not then planning to move to Amsterdam, or if he was that he intended to make it only temporary. Alternatively, and perhaps

more likely, he bought it as extra security for the family. By 1631 he was earning a good living and, allowing for the precarious nature of the times, none of his close relations was in any danger of destitution.

Rembrandt moved to 'the golden swamp', as Constantijn Huygens called the city of Amsterdam, at some date between March 1631 and July 1632. The date of his move cannot be pinpointed more closely than that, but it was probably some time between July and December 1631, since Lievens, who departed from Leiden for England before the end of that year, is said to have left after his long-time partner.

Amsterdam had grown from a small medieval fishing village, perched on islands in a swamp, near the mouth of the Amstel river. The city, which had already expanded far beyond the old walls, was approaching the peak of a period of extraordinary growth in which in the course of less than two generations it multiplied in size four times over. What had been fields beyond the walls when Rembrandt had lived there six or so years earlier, was now built over. By 1630 the population exceeded 150,000 and was still growing fast. Amsterdam was in fact taking on its modern appearance, for the general form of the city has, marvellously, hardly changed, if one ignores the inevitable middle-aged spread.

Amsterdam's significance as a commercial centre in the first half of the 17th century is hard to exaggerate. It dominated world trade to an extent hardly exceeded by any other city in history, from ancient Tyre, to medieval Venice, or Victorian London and modern New York.

On the face of it, this seems strange. As a port, Amsterdam did not seem particularly well situated, being about 60 miles (100km) from the open sea on a river mouth off a shallow inlet of the Zuider Zee. One of its inhabitants described it in the 1630s as 'a city that floats amid swamps and marshes, where the burden of so many buildings is held up by forests of wooden pilings, and where decaying pines support the most prosperous mercantile centre in Europe' (the supports for the foundations of the Town Hall, as any Amsterdam schoolchild used to know, numbered 13,659 wooden piles, or juffers, each one the size of a ship's mainmast and in fact these 'decaying pines' have decayed remarkably little.) Amsterdam did have some potential advantages as a commercial centre. For instance, it benefited from the trade of the cities of the Rhineland, for which it was the natural outlet, and in any case the causes of commercial prosperity, or the lack of it, do not invariably spring from geographical or economic circumstances. As mentioned earlier, the sudden prosperity of Amsterdam was a direct result of the demise of Antwerp. In the 16th century Antwerp was the commercial capital of northern Europe, relatively as dominant as Amsterdam became in the next century. Then the northern Dutch imposed their long-maintained blockade, and by 1630 circumstances had changed dramatically. Antwerp

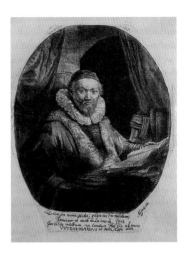

Johannes Wtenbogaert, 1635
Etching, 9⁷/₈ x 7⁵/₈in
(25 x 18.7cm)
Rijksmuseum, Amsterdam
(See also page 72)

The Rape of Europa, 1632
Oil on panel, 24¹/₂ x 30¹/₃in
(62.2 x 77cm)
J. Paul Getty Museum, Malibu

In history paintings of this period,
Rembrandt's practice was to focus
attention on the drama by painting
small, concentrated groups of figures in
a large, expansive landscape.

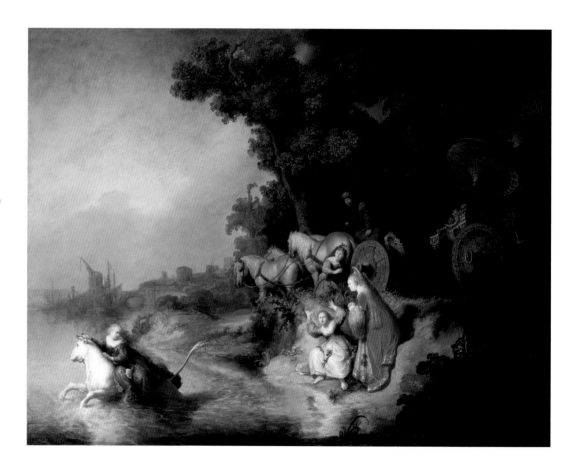

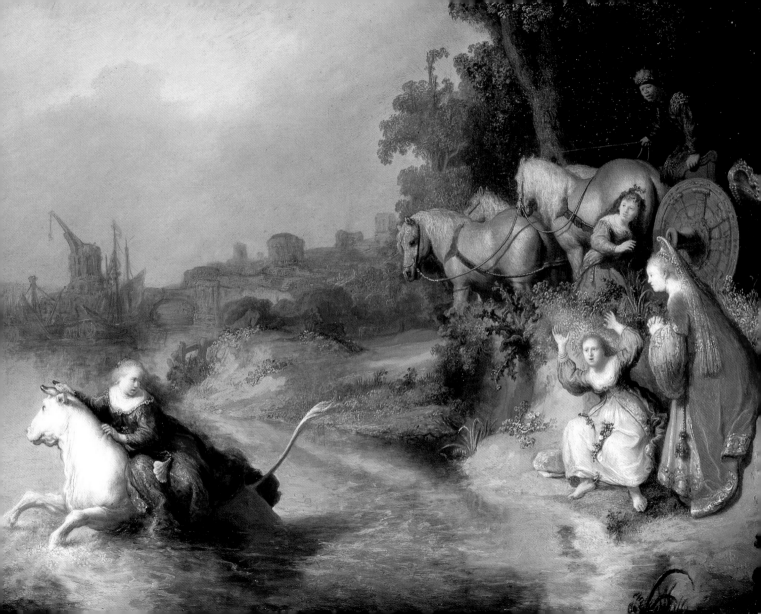

had stagnated, becoming, in the unsympathetic view from Amsterdam, just 'a sorry lackey of Spain, full of monks and short of money'. Other factors that contributed to the massive fortunes of Amsterdam's merchants included the persistent famine conditions of the late 16th and early 17th centuries, which enabled them to make extraordinary fortunes in the Baltic grain trade. Deserved benefits sprang from its reputation as a relatively liberal, Protestant city, which attracted talent from many backgrounds and many places, not only from the Netherlands (north and south, and especially, of course, from Antwerp), but also from much of Europe. Nicolaes Ruts, for example, was born in Cologne of Flemish ancestry, and it has been estimated that only one quarter of Amsterdam's population was native-born.

By comparison with their forbears, who traded in such utilitarian goods as grain, hides, timber and fish, the spacious warehouses of the Amsterdam merchants were crammed with luxuries – silks, furs, jewels and spices. These mercantile moguls measured their fortunes not in thousands of guilders, not even in tens of thousands, but in hundreds of thousands. Such was their financial clout that they could buy out any business anywhere. They could sell exports at lower prices than the same goods cost in their country of origin, and thus undermine domestic production. Buyers in Amsterdam could get French wine cheaper than in France, English cloth cheaper than in England.

Holland may have been a republic, but no more than medieval Venice was it a democracy. It was dominated by a self-perpetuating mercantile oligarchy consisting of a number of extended families, who generally lived on St. Anthonisbreestraat (abbreviated to 'the Breestraat' meaning 'Broad street' though it was not then, as now, a four-lane throughway) or in the fine, tall, fancifully gabled houses – equivalents of the Italian Renaissance *palazzi* – rising along the trio of concentric canals (not completed in Rembrandt's lifetime) that form the basis of the modern city. These people controlled the city's wealth and its government, and they ran affairs chiefly in their own interests. Amsterdam dominated Holland and Holland dominated the United Provinces: there was no one who could truly hold the Amsterdam city fathers to account, and Amsterdam's taxes provided over one-quarter of state revenue.

The business of Amsterdam was business. Descartes remarked that he could live in the city virtually unnoticed because everyone, except himself, was in business and was exclusively occupied in furthering his own prosperity. But, whatever Descartes thought, these mercantile magnates were not only interested in the material world. They also prided themselves on their culture. They patronized artists, though chiefly to provide portraits of themselves, they purchased books, such as Carel van Mander's immensely influential *Painter's Book* and Salomon de Bray's *Architectura Moderna*,

published in the year of Rembrandt's arrival in the city, and they supported the new academy, the Athenaeum Illustre. It was not then called a university owing to the fierce resistance of Leiden; two of its founders were Remonstrants who had been driven from their professorial chairs in Leiden.

Rembrandt might have been expected to find Amsterdam a more politically sympathetic place than Leiden. The two cities stood at opposite poles. In Leiden the strict and belligerent Calvinist Counter-Remonstrants controlled the town council, as they had other towns, but in Amsterdam, their position had been weakened even before the death of Prince Maurice, and after the accession of the more liberal Frederik Hendrik, the Amsterdam oligarchy came to be dominated, not by Remonstrants certainly, but by men who had no time for Calvinist zealotry, which they held responsible for various economic misfortunes. These men took a far more relaxed view of religious differences, and saw no reason why Remonstrants should not worship as they chose, or indeed, if rich and capable, hold office in government. Weekly, they were most furiously denounced in the Calvinist pulpits, but words did not bother them particularly. When the preachers incited a riot against the burgomasters – those 'libertines', 'Turkish slaves', 'disturbers of Israel' (the preachers had a limitless store of epithets) – it was suppressed by the city militias, but these bodies themselves held many strict Calvinists among their number,

and it was necessary to ask the Stadholder to put in a calming appearance in the city. Pro-Calvinist rebels in the militia then took their quarrel to the States General, anticipating the support of cities like Leiden, Haarlem and Delft, but their action only antagonized Frederik Hendrik, and led to their arrest and a subsequent purge of the city companies. Thereafter, one or two firebrands having been expelled, the most fiery of the Calvinist preachers found their congregations generally included one or two quiet but formidable-looking men, who merely sat and listened impassively, but this alone was apparently enough to ensure moderation in the pulpit.

By the time Rembrandt settled in the city, the contest was practically over, and Amsterdam contained, besides a Remonstrant church, a Jewish synagogue, Lutheran and Mennonite meeting places, and a large number of supposedly clandestine Catholic churches, their existence in reality quite widely known. Members of nearly all these faiths were among Rembrandt's early portrait subjects, perhaps the most notable being the venerable defender of religious freedom, Johannes Wtenbogaert (page 72), one of the authors of the Remonstrance of 1610.

Simon Schama, in a chapter on early 17th-century Amsterdam in his book *Rembrandt's Eyes* (1999), has the brilliant notion of describing the city in terms of the five senses, and he begins with the sense of smell. The smells of a

AMSTERDAM

place are something that cannot be recorded in words or pictures and can never be recaptured in the most painstaking physical reconstruction of earlier times – and if they could, might well be prevented by the fear of offending contemporary noses. Hygiene, after all, is a modern invention, and it has been flippantly remarked that if we all smelled as our ancestors did, the future of the human race would be gravely endangered. The smell of human beings to whom a bath was at best an occasional ceremony, clad in thick woollen clothes in a tightly-packed city, would probably seem insufferable to us, but these sensations are largely a matter of what one is used to.

By no means all the smells of a 17th-century city would be unpleasant even by our standards, and a fresh on-shore breeze treats Rembrandt's Amsterdam to the occasional invigorating salty tang of the sea, while the countryside is no more than an hour's walk from the city. At the harbour, on the inlet linking the Zuider Zee with the IJssel, where the number of ships is so great that more than one visitor was prompted to observe that their masts look like a forest, the salty smells mingle with others less enlivening. But beyond the stink of drifting rubbish at the harbour edge, made up of men's discards, bilge, small dead fish of interest only to gulls, crustacean corpses and rotting seaweed, rises a more accommodating scent, from the huge stacks of timber awaiting the shipbuilders. A foresty fragrance arises from

still-green wood, mostly oak or beech, being aged for a season or longer, some of it pre-shaped into the curve of a hull, and Scandinavian fir trunks, future masts, have a clean, piney scent.

Behind the timber stacks, more earthy smells begin to swamp the prevailing rotten-fish aroma, above all from the boats that, permitted to travel only by night, carry tons of animal excrement off to fertilize nearby orchards and vegetable fields, where it helps to produce extraordinary crops of cabbages and beans. The canals, which give Amsterdam its peerless character, are less carefully kept than 400 years later, and their greenish waters are not free from the occasional, decomposing corpse of cat or dog.

Different streets or sections of the city are still the home of particular trades. Soap-boilers, candlemakers and other renderers of tallow, dyers, tanners and sausage makers, all contribute to their own insalubrious local atmosphere, but the yeasty air of bakers' shops brings relief and encourages the fast-vanishing appetite, while herbalists provide useful little bags of lavender, rosemary and other sweet scents as a mobile defence against grosser assaults on the nostrils. In residential areas, peat smoke hangs comfortably in the air, but the most exotic odours are encountered in the neighbourhood of the East India Company's storehouses. The aroma of spices – of pepper, cloves, cinnamon, nutmegs, those simple little seeds and fruits for which western Europe's merchants and sailors

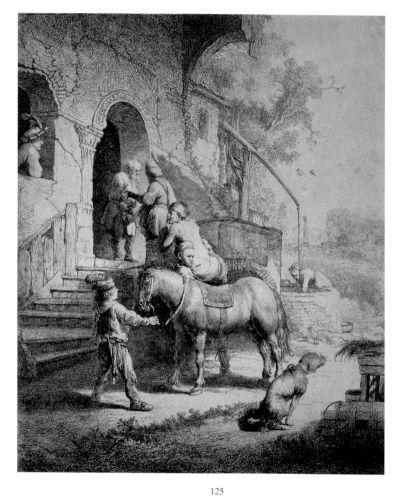

The Good Samaritan, 1633
Etching, 10^1/$_8$ x 8^1/$_4$in (25.7 x 20.8cm)
Wallace Collection, London

*Is this the first example in art of a dog
relieving itself?*

Ecce Homo, 1634
Oil on paper, 21^1/$_2$ x 17^1/$_2$in
(54.5 x 44.5cm)
National Gallery, London

This monotone sketch was probably
done as a study for an etching.

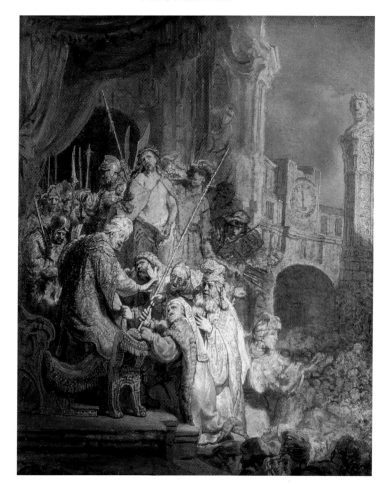

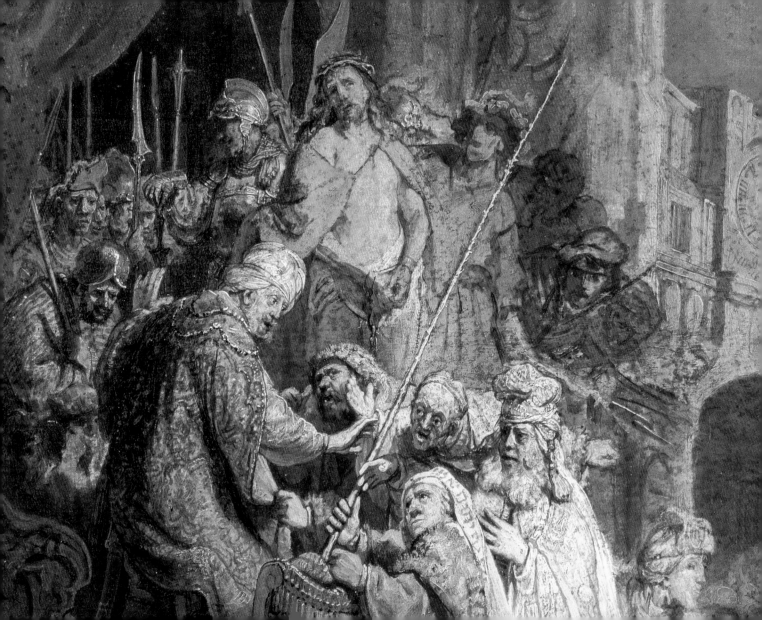

David and Uriah, or Ahasuerus,
Haman and Harbona, c.1660
Oil on canvas, 50 x 46in (127 x 117cm)
Hermitage, St. Petersburg

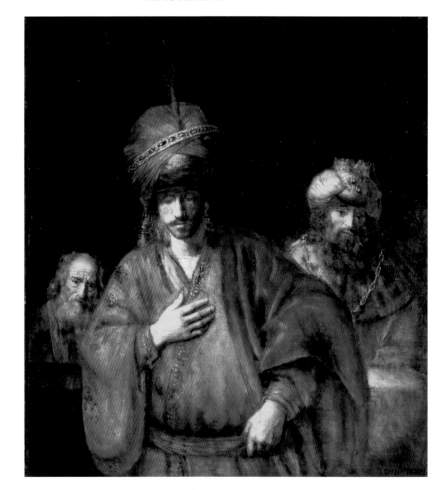

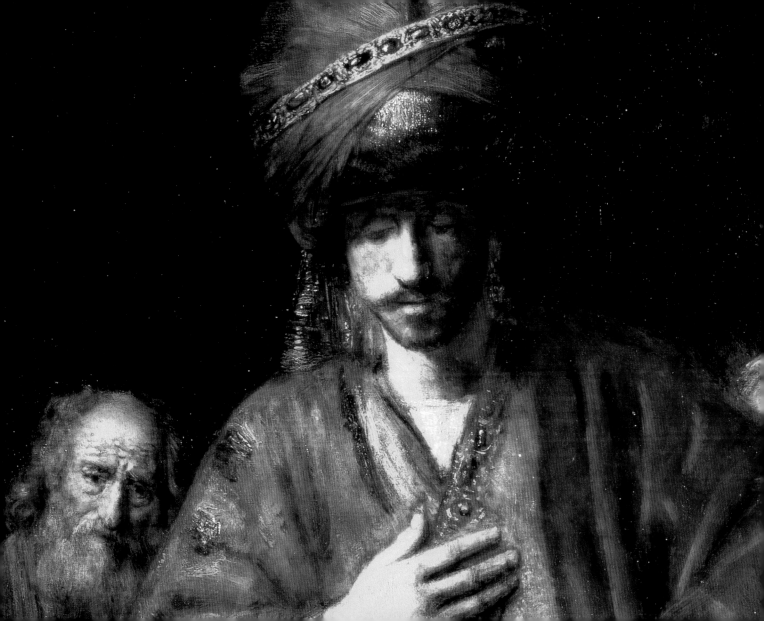

RIGHT
Maerten Soolmans, 1634
Oil on canvas, 82^1/$_2$ x 53in
(209.8 x 134.8cm)
Private collection

This rich young Amsterdam couple were
newly married when Rembrandt painted
them. The dandyish Maerten Soolmans
apparently came from Leiden and was
probably a personal acquaintance of
Rembrandt.

FAR RIGHT
Oopjen Coppit, 1634
Oil on canvas, 82^1/$_3$ x 52^7/$_8$in
(209.4 x 134.3cm)
Private collection

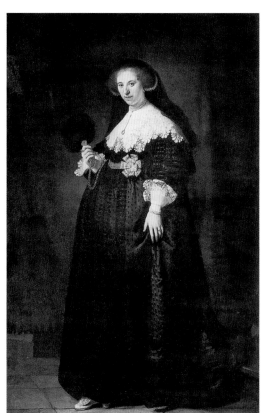

had been fighting and dying for over a century – is almost palpable.

Every morning, conscientious housekeepers and servants wash down the floors and walls with a lye made from wood ash, but even the best-kept houses, those solid red-brick and timber mansions along the new canals that stand up to six storeys high, suffer from the symptoms of damp, the inevitable consequence of Amsterdam's location on low-lying, marshy ground. In this environment, there is some advantage to paintings on wood panels rather than on canvas, and libraries are a particular worry, although advances in the glass industry are making glazed bookcases more widely available in the fight against mildew and 'foxing'.

Seventeenth-century cities could be as noisy as modern ones in spite of the absence of motorized transport, for cart wheels, horses' hooves, and wooden shoes combine to make a fair clatter on cobbles. Carts often get stuck on the abruptly peaked bridges over the canals, creating traffic jams and noisy irritation. But the predominant noise in Rembrandt's Amsterdam is the sound of bells, from scores of churches and innumerable chiming clocks. Practically no one yet wears a watch, but no one can remain in doubt of the time, for this is a city of business, requiring routines to be kept; clock faces adorn every tower and on the hour the air is filled with a rather discordant clangour. (Among the places where it might be drowned out by a greater racket are the foundries, most of them for making guns but others making the bells themselves). The churches also contribute organ music, played twice a day in most churches in spite of the Calvinists' suspicions that the custom is tainted with popery. They are even more displeased that music features so prominently in domestic entertainment (as the Dutch painters so often demonstrate), and most children of reasonably well-provided homes learn to play an instrument and even – this really infuriates the righteous – go to dancing classes. Woodworking of every kind is a major activity, not only in the shipyards and building sites, and you are seldom far from the sounds of the carpenter's saw and chisel, the sharpener's grindstone, the blacksmith's anvil, the weaver's loom and the coffin maker's hammer. Above all, you never escape from the sound of human voices, the roaring rhetoric of the preachers in the churches, the chants of the street sellers with their pies and pickled herrings, the ladies selling pancakes from giant copper pans on their portable stoves, the jokes and insults of the market stallholders in the Dam, the noise of drinkers in a thousand inns and taverns, and the confident tones of the merchants, discussing the news and making deals in a dozen different languages, in the exchanges and markets. All this was Rembrandt's world.

Chapter Five
At the Uylenburghs

Saskia with a Veil (Saskia Uylenburgh, the Wife of the Artist), 1634
Oil on panel, 23⁷/8 x 19¹/4in
(60.5 x 49cm)
National Gallery of Art, Washington, D.C.

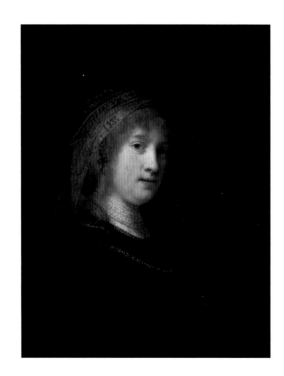

Rembrandt was no great traveller. When he told Constantijn Huygens that he was too busy to visit Italy his explanation must have seemed a bit thin, even if true on a practical level, and we may suspect that he felt no great desire to make such a journey. From 1631 or 1632 he remained in Amsterdam for the rest of his life. We know he made one or two journeys inside the United Provinces, mostly inside Holland, where distances between the main cities tend to be quite short, all of them for some specific reason (such as marriage, which took him briefly to Friesland). Otherwise, so far as we know, he never ventured beyond the borders.

There are stories of his visiting other lands, in particular England, on two different occasions, stories that some of his English admirers have been reluctant to abandon. But the evidence is unconvincing. The first visit is ascribed to 1640 and rests on the existence of four drawings, two of them bearing that date, of English scenes: two of old St. Paul's, one of Windsor Castle and a fourth of St. Albans. If it were necessary for an artist to have actually visited all the places that he made pictures of, then much of Western art would not exist. Moreover, Rembrandt could undoubtedly have seen engravings of all the buildings concerned in Amsterdam; none of these drawings really looks as though it was done from nature, and none is quite accurate.

The second story has him in Hull in 1661–62, making

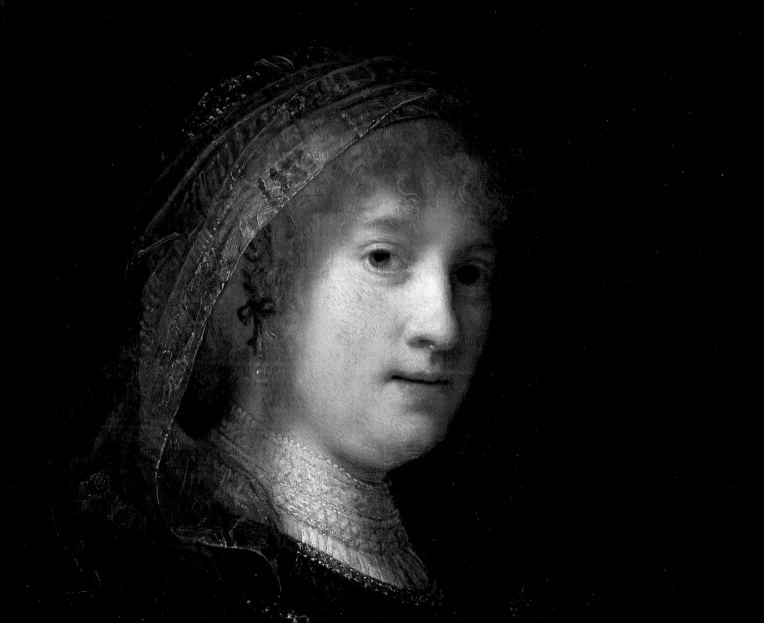

AT THE UYLENBURGHS

OPPOSITE
Self-Portrait in Fancy Dress, 1635–36
Mauritshuis, The Hague

*A military guise was popular, especially
in The Hague. In a slightly earlier
painting, now in Kassel, Rembrandt
appears in an iron helmet.*

portraits of sailors. There was plenty of traffic between Hull and the Netherlands in the 17th century, but there is no evidence of Rembrandt making such a voyage. The story comes from George Vertue (1684–1756), regarded as the first English art historian. Vertue's extensive writings, even after they were put into better order by Horace Walpole as *Anecdotes of Painting in England* (1762–80), are decidedly gossipy. He first recorded Rembrandt's presence in Hull over 60 years after it supposedly occurred and over 50 years after the artist's death, and his informant was a man who had been less than ten years old at the time. Non-proven is the kindest verdict a jury could deliver.

On the other hand, it could be justly said that there are long periods in which we do not know exactly where Rembrandt was, though we can usually make reasonable assumptions. For instance, he is first recorded in Amsterdam in July 1632, when he was visited by a notary (lawyer) representing a group in Leiden who, for reasons connected to some private financial scheme similar to a tontine, wished to know his state of health (the notary reported favourably). He was then living in the large and comfortable house of Hendrick Uylenburgh in St. Anthonisbreestraat (almost next door to the Rembrandt House, now a museum, where the artist lived from 1639 to 1660). Rembrandt brought with him from Leiden at least one pupil, who had perhaps already graduated to the rank of assistant, Isaac de

Jouderville, and he presumably lived there too.

Uylenburgh was a well-known art dealer whom Rembrandt had known in Leiden perhaps as early as 1628. About 20 years older, he was probably responsible for Rembrandt's first public sale, to Joan Huydecoper, who paid 29 guilders for a portrait and, when recording the transaction in his accounts, misspelled Rembrandt's name as 'Warmbrandt' (later corrected in Huydecoper's hand). In 1631 Rembrandt lent the dealer, no doubt as an investment in his business, the substantial sum of 1,000 guilders, evidence of his professional success in Leiden. They became friends, partners in what was a small but successful firm, and eventually relations by marriage.

Uylenburgh had an unusual background. His family came from Friesland; his father was for some years a cabinetmaker, and his brother a court painter to the king of Poland. He grew up, may even have been born, in Poland. Later he lived in Denmark for a time before returning to the Netherlands and setting up an international business as an art dealer in Amsterdam, co-operating with many artists and supported by various partners, and importing heavily from Italy. His gallery/sale room was described by an Italian artist as 'Uylenburgh's famous academy', and it became the largest operation of its kind in the city, engaged in a wide range of activities that included buying and selling works of art in general, producing new works by Rembrandt, his pupils and

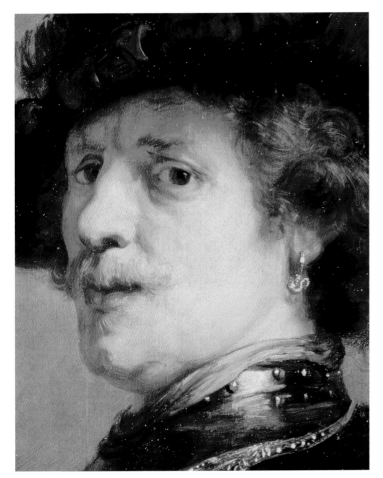

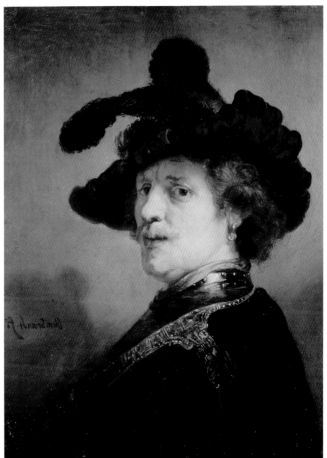

AT THE UYLENBURGHS

OPPOSITE

Susanna van Collen, Wife of Jean Pellicorne, and Her daughter Eva, c.1632–34
Wallace Collection, London

This is a companion piece to the painting on page 14. Whereas the son receives a stuffed bag of money (representing the family inheritance), the daughter receives only a coin (her dowry).

others, seeking commissions for portraits, making, publishing and selling etchings, training pupils and apprentices and giving lessons to amateurs, carrying out appraisals and valuations, cleaning and varnishing paintings, and so on. In most of these activities, of course, Rembrandt was closely involved. Uylenburgh was a somewhat slapdash businessman, and in establishing his business he had to borrow heavily, so that his entire stock, including paintings by Rembrandt or copies of them, was in effect mortgaged. We do not know how much, if at all, Rembrandt benefited from the profits of Uylenburgh's 'academy', but it is clear that he learned much from Uylenburgh (including, perhaps, the willingness to place what some clients, though not we, would have regarded as high prices on his work), and when the partnership eventually broke up (in 1636), the effect was on the whole deleterious to both.

Rembrandt was a man of broad sympathies, and we know that he was strongly attracted to, though probably not a member of, a fundamentalist Christian sect called the Mennonites; this surely can be traced to his friendship with Hendrick Uylenburgh, who was a member of the Mennonite congregation in Amsterdam. The group took its name from its founder, a priest from Friesland named Menno Simons (died 1561), who had become an Anabaptist during the Reformation. Anabaptism gained a notorious reputation after the excesses of the theocratic and licentious 'Kingdom of

Münster', eventually suppressed with great savagery by the Church. Menno, a moderate, was chiefly responsible for restoring its reputation.

Besides rejecting the rite of infant baptism (which explains the name Anabaptism), the Mennonites also rejected state service of any kind, civil or military, the swearing of oaths of loyalty, and indeed all 'worldly' behaviour (among their contemporary descendants are the Amish of western Pennsylvania who resolutely pursue a pre-industrial lifestyle). More than any other group, Mennonites believed that salvation depends on the individual, and that every individual has direct contact with the Word of God through the Bible, which he or she must interpret with the guidance of the Holy Spirit. They thought that non-believers were inevitably damned, and they remained very much on the margin of established religion. They had a tendency to dissipate into innumerable sub-sects, and in order to preserve the purity of the faith members were frequently ostracized, at least temporarily. They were persecuted in Holland until the rise of the Remonstrants when society, in Amsterdam at least, became more tolerant. They had supporters, if not members, in the highest ranks of society, especially after 1631 when two of the burgomasters were sympathizers, and some of them interacted with people of other faiths quite freely. Indeed, they seem to have been much less rigid in practice than some of their doctrines suggest; a man such as

Uylenburgh had non-Mennonite friends as well as clients.

A sizeable minority of Uylenburgh's creditors were Mennonites, and there were several others who were members of the city council. One of them was Joan Huydecoper, the first man to buy a Rembrandt from Uylenburgh, who, significantly, was burgomaster in 1654 when Uylenburgh's financial difficulties were eased by the very favourable treatment he received from the council.

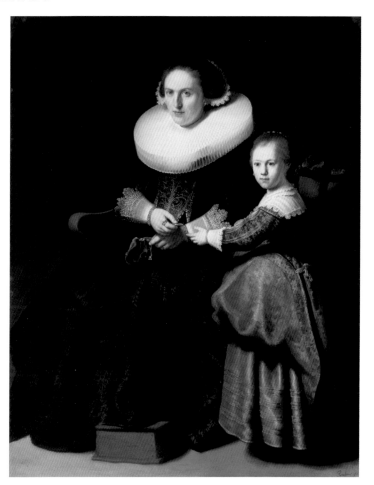

Chapter Six
Success

During his first four years in Amsterdam Rembrandt produced commissioned portraits at an average rate of about one per month, a remarkable output in view of the care he took over his paintings, which modern X-ray examinations show to have been even greater than had been generally realized, and given also that painting portraits was far from being his only activity. No wonder that he was slow to finish the Passion series. Although in later years he was less in demand, he never ran out of patrons, and in the 1630s he must have been easily the most sought-after portrait painter in Amsterdam. This does not surprise us, as we would probably not quarrel with the common assertion that Rembrandt was the greatest portraitist in the whole history of Western art. Naturally, not all of his contemporaries shared that view and such a judgement must of course be largely subjective: Rembrandt is the kind of portrait painter who appeals particularly to us. In any case art is not a competition and the ranking of artists by talent or accomplishment is never of much significance. More important is the question of what makes Rembrandt a great portrait painter, and to that simple question there is no simple answer.

The most frequent critical comment on a portrait – any portrait – is that it does, or does not, look like the sitter. Perhaps there was a time when that was the sole criterion, but if so it would be hard to say when, for even in the Renaissance there was an instinctive feeling that a portrait ought to be more than an accurate representation of a person's physical appearance. It ought to convey 'character', to suggest not only what a person looks like but also what he is like. We tend to take a rather supercilious attitude to the work of court painters, out to flatter their powerful employers, even perhaps to Van Dyck's magnificent portraits of King Charles I and others of equal merit. More than that, we place great importance on the interplay between painter and subject. If the end product is a work of art, and that is the objective after all, then it should tell us something about the artist as well as his sitter.

This idea would have been foreign to Rembrandt's contemporaries, but it is nonetheless largely satisfied by Rembrandt, which helps to explain why we admire his work even more than they did. Yet it is difficult to say how this duality is achieved: there is no single explanation, for Rembrandt's work cannot be reduced to systems, and his portraits, while they obviously have much in common, are nevertheless individually unique. Furthermore, there is that aspect of Rembrandt's art, which we shall return to in other connections, that obscures the boundaries between the traditional categories of artists' subject matter (portrait, history, landscape, the nude, etc.), so that it is often virtually impossible to place a certain work in one category or another. Nor would it be possible to divide the portraits into coherent groups (say, of 'women', or 'old men'); more

REMBRANDT

pertinently, such classification would signify very little.

That the subjects of Rembrandt's commissioned portraits were relatively ordinary people, largely members of the Dutch bourgeoisie, gave him an advantage over the court painter whose subjects, generally courtiers, tend to acquire a certain sameness, especially when the painter is not of the very first rank. (Think of Amsterdam-trained Sir Godfrey Kneller's 'Beauties', those endless lookalike ladies of high society in late 17th-century England that adorn the walls of Hampton Court Palace.) Even if the faces and clothes are different, the subjects of second-rate painters bear a certain similarity; in fact, the avoidance of monotony is one of the universal problems of portrait painters. Frans Hals, the most notable portrait painter among Rembrandt's Dutch contemporaries, overcomes the problem largely by varying pose and gesture, but this device itself can easily come to seem repetitious or unnatural. Rembrandt uses practically no gesture at all. The great majority of his subjects appear in calm and reflective mode; even facial expressions are modest and restrained, as if they are holding back as much as they are giving. Yet the relationship between subject and painter is an intimate one. Rembrandt's subjects appear in one sense remote from us, in another sense immediate and vividly real. They shelter behind no barrier, they wear no mask. The observer is in a way an intruder who has usurped the place of the painter, and takes over his intimate yet distanced

relationship with the subject. Rembrandt's subjects are, as it were, removed from worldly distractions in order to bring them into more intimate focus. They are separated from the material world by the generally neutral background, which is generally devoid of detail, and additionally by the heavy frame which, as we can deduce from examples where he rather quaintly went so far as to paint a frame around the picture, he preferred to be hefty and obtrusive, further divorcing the subject from distracting mundane details.

Rembrandt achieves variety by other means, some of them obvious enough, such as the use of exotic costumes (though these are obviously not appropriate for the majority of commissioned portraits), and also by conveying a sense of a certain indefinable mood, which the observer finds himself mysteriously drawn into (Rembrandt was well aware that a portrait is not simply a two-way relationship between painter and subject; there is a third party involved – the observer). In short, Rembrandt achieves variety by concentrating on psychology. His portraits convey character.

This is almost a cliché in any commentary on Rembrandt, who is routinely commended for the psychological insight that makes his depiction of 'character' so effective. But what do we really mean by this? Everyone agrees that you can't judge a book by its cover, equally you can't know what a person is like by what he or she looks like. If a person's character cannot be judged by regarding

**The Shipbuilder Jan Rijksen and His
Wife Griet Jans, 1633**
Oil on canvas, 45 x 66¹/₂in
(114. 3 x 168.9cm)
The Royal Collection, Windsor Castle

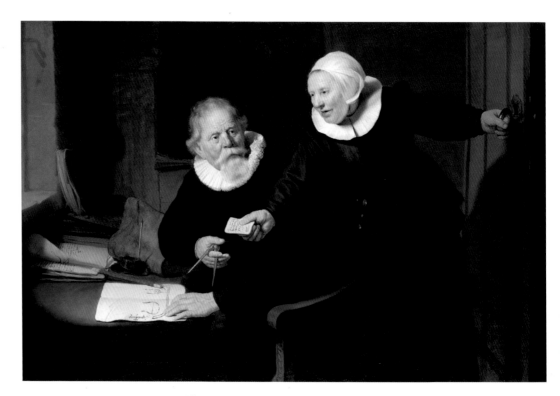

140

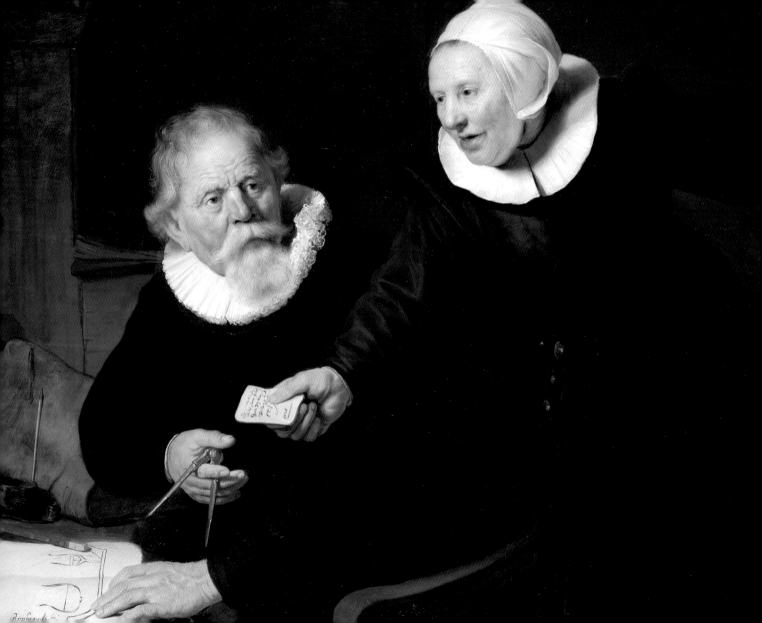

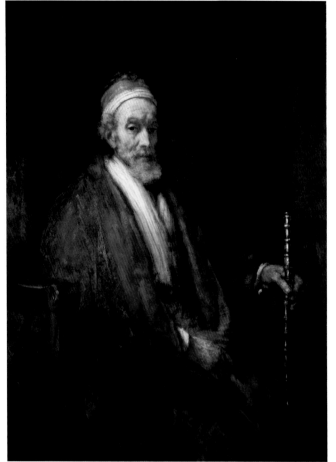

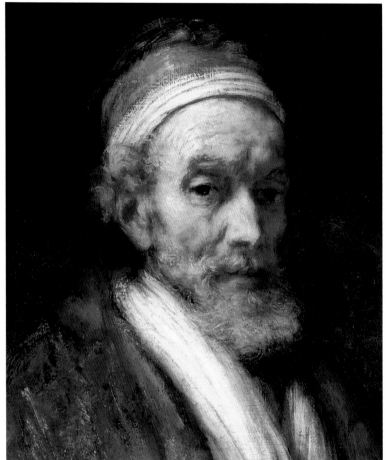

his or her actual face, how can it be revealed by a painting, no matter how gifted the artist?

Confusion arises from the meaning we attach to the word 'character'. It is not possible to recognize a person's character from an image of the face without further information, specifically, without knowing them already. If a woman says approvingly of a portrait of her husband that 'it's just like him', she means that she recognizes in the picture characteristics of her husband already familiar to her. Known characteristics may thus be recognized from an image, but an image cannot convey unknown characteristics, except in a very limited way. That is why artists often relied on symbolic devices or props, such as a book for a scholar, armour for a soldier, etc. A painter such as Rembrandt represents 'character' in a more general way, in the sense we mean when we speak of 'an interesting character', or of someone 'showing great character'.

This may explain why we tend to find portraits of important historical characters more interesting than portraits of anonymous people. We look at them in the light of what we know about them from other sources. In the case of Rembrandt's subjects we usually know nothing about them. Yet, against the odds, Rembrandt succeeds in making them extremely interesting to us. They are 'characters', whom we almost feel that we know. How is this done?

The short answer might be that Rembrandt achieves his effect by a combination of unsurpassed professional proficiency and his broad, humane sympathy for human beings. But that is another of those statements that do not actually take us very much further.

Rembrandt uses comparatively few of the traditional devices of the portrait painter. He does not rely heavily on symbols or gesture, and he never idealizes his subjects in the way that, for example, Van Dyck idealized the weedy Charles I as a magnificent monarch, and placed him on a horse to disguise his lack of inches. His methods are far more subtle.

Above all, it is Rembrandt's handling of light and shadow – *chiaroscuro* – that creates mood and character. Sometimes, it is so adjusted to emphasize a certain feature of the face above the others. In his portrait of the elderly Jacob Trip (opposite), which was painted in the year of that wealthy magnate's death, he invests his subject with an air of formidable authority merely by subtle adjustments of *chiaroscuro* and composition and by adopting a relatively low viewpoint. The sitter's ramrod-straight position, echoed in the stiff verticals of the chair and the stick, emphasize the uncompromising character and unbendable will of this 17th-century arms dealer. (There are other contemporary portraits of Trip, one by Aelbert Cuyp, but none of them captures the aspects of his character evident in Rembrandt's painting.) Yet there is also something Biblical about this figure, a reminder

OPPOSITE
Portrait of Jacob Trip, 1661
Oil on canvas, 51³/8 x 38¹/4in
(130.5 x 97cm)
National Gallery, London

143

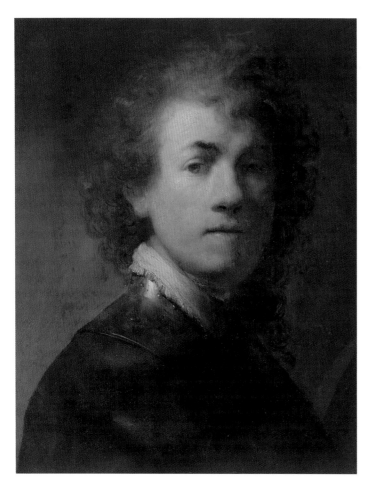

that Rembrandt's way of depicting saints and prophets as very human, contemporary figures sometimes also worked in the other direction. This is especially evident in his later years, when the portrait of this formidable man, much of it painted in his 'broad', late style was done.

As a rule, in Rembrandt's portraits, the light is concentrated on the face, the most important part of the painting. But the face is also patterned with shadows, around the eyes, below the cheekbones, along the nose, around the mouth, and sometimes the whole of the upper part of the face is shadowed by a hat brim. Very often, the subject is turned slightly towards the viewer, so that one half of the face is lighter and the hard line of the farther cheek is dissolved, in harmony with the general softening of tonal borders (a striking example is the *Self-Portrait with Gorget* of c.1629 (left). This has the effect of concentrating attention on the individual features rather than the face as an integrated whole. The features themselves are not expressive; the gaze is fixed, the mouth immobile, the eyes are watching, but there is no direct communication. What gives the face character is entirely the *chiaroscuro*, the play of light and shade, plus the handling of the paint. Another surprisingly important feature is the background, to which, although it usually appears superficially as little more than a dark blankness, the face is somehow united and is to an extent defined by it. As Michael Kitson observed, 'it is remarkable

how much more aggressive – and less interesting – the faces in Rembrandt's portraits appear if they are looked at with the backgrounds masked off'.

The subjects themselves are individuals, who are unique in themselves but are also representatives of humanity. Taken altogether, Rembrandt's portraits may be seen as a kind of memorial to humanity, imbued with a consciousness of the human tragedy and of the ubiquitous presence of God. Rembrandt's paintings have been compared with the writings of his near contemporary, the philosopher Spinoza, who taught that the human mind is part of the infinite intellect of God. To quote Kitson again, 'The mystery which permeates Rembrandt's shadows is ultimately a metaphor for the immanence of God.'

Thanks to his extraordinary gifts, Rembrandt can convey more character in his portraits than perhaps any other artist. He suggests qualities that we can sense, though not in a very precise or objective way, as we might do if the subject was someone known to us personally. When we look at a Rembrandt portrait, we feel that we are looking at a real person, a 'character', and it is the restrained, introspective pose that Rembrandt opted for at a very early stage in his portraits of old people and which, during his middle and later years, gradually became characteristic of all his portraits, even his self-portraits, that is largely responsible for this effect. Rembrandt's subjects are (usually) looking at us, but

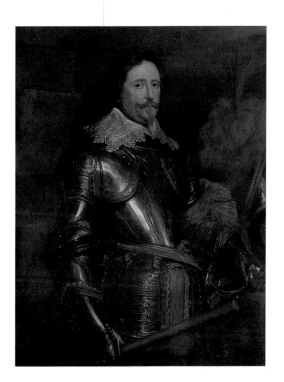

OPPOSITE
Self-Portrait with Gorget, c.1629
Oil on panel, 12⁵/8 x 12¹/₅in
(32.2 x 31cm)
Germanisches Nationalmuseum,
Nuremberg

LEFT
Anthony van Dyke
Portrait of Frederik Hendrik,
c.1631–32
Oil on canvas, 45 x 38in
(114.3 x 96.5cm)
Baltimore Museum of Art

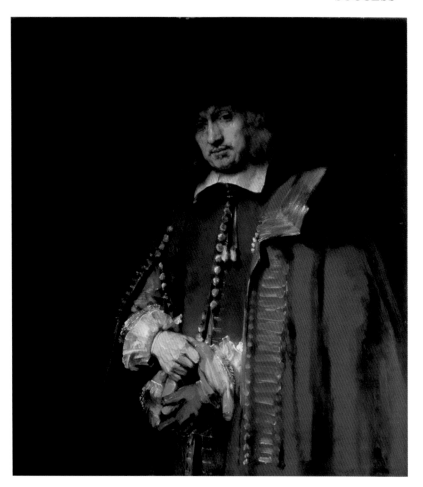

they are also looking at themselves. It gives them a kind of timelessness in marked contrast to the 'arrested-action' type of portrait, a snapshot of the moment, that was so strongly favoured by Frans Hals among many others. Of course, many of Rembrandt's sitters were by profession men of thought rather than action – scholars, preachers and so forth – but he extended the treatment to people of all kinds.

This tradition in portrait painting did not originate with Rembrandt, though it was previously uncommon. One of the first, and certainly the most famous portrait in this manner is Leonardo's *Mona Lisa* and something very like it is to be found in some of Titian's portraits (such as the intriguing *Portrait of a Young Man*, c.1520, at Garrowby Hall, Yorkshire). Rembrandt's connections with these two predecessors, incidentally, are interesting and various and perhaps, especially in the case of Leonardo, have not always been fully recognized.

There are a great number of Rembrandt's portraits from these years scattered around museums and private collections, some of them hard to trace, and others making their way through salerooms. Many of them are of people whom we cannot identify. A notable exception is the portrait of Nicolaes Ruts, mentioned earlier as probably Rembrandt's first commissioned portrait. It once belonged to the great financier J.P. Morgan who may have had some fellow-feeling for this sharp-eyed, wealthy and necessarily bold 17th-

Portrait of Jan Six, 1654
Oil on canvas, 44 x 40^1/$_8$in
(112 x 102cm)
Six Collection, Amsterdam

(See Chapter 12)

Portrait of Marten Looten, 1632
Oil on panel, 35⁷/₈ x 29¹/₈in (91 x 74cm)
County Museum of Art, Los Angeles

century merchant in his fur-trimmed (it is fabulously costly Russian sable) cloak and hat, although Ruts eventually ended up bankrupt whereas Morgan left some $65 million. The painting may well have contributed to the strong demand for Rembrandt portraits in his first years in Amsterdam, for it shows that in 1631 he was in total command of the qualities outlined above, and his perfect confidence in his abilities is proclaimed in every brushstroke.

Ruts was of Flemish origin, coming from a refugee Mennonite family, although he himself became a member of the official Calvinist Church. Considering their small numbers in the population as a whole, a substantial proportion of Rembrandt's early patrons were Mennonites, or had Mennonite associations, no doubt the result of Uylenburgh's connections. Soon after Nicolaes Ruts, Rembrandt painted Marten Looten (left), another half-figure portrait and a somewhat similar pose to that of Johannes Wtenbogaert. Looten was related to Ruts although, oddly enough, he was a Mennonite (no fancy furs for him) who had come from a Flemish Calvinist background. Rembrandt is also known to have painted two or three individual portraits that are known today only from mention in documents as well as an unnamed Mennonite couple. This too is perhaps lost but is sometimes identified with the double portrait of Jan Pietersz. Bruyningh and His Wife (1633; Boston, Gardner Museum), although, if true,

Madame's fancy bodice must surely have raised Mennonite eyebrows.

Besides these examples of known Mennonites, Rembrandt also painted the portraits of several Remonstrants, hardly surprising in view of his career in Leiden and in particular the influence of Petrus Scriverius on his early career. Exactly who and how many it is impossible to say because of the difficulty in identifying so many of the subjects of Rembrandt's portraits, not to mention the difficulty, in the case of relatively routine and unsigned paintings, of establishing their authenticity.

The most notable of Rembrandt's Remonstrant patrons, and the subject of one of his most impressive portraits of this period, was *Johannes Wtenbogaert* (page 72); he should not be confused with the younger Joannes, a relation. A great hero of the Remonstrants, Johannes Wtenbogaert was himself largely responsible for drawing up the Remonstrance itself in 1610. He had been tutor to Prince Frederik Hendrik and adviser to Oldenbarneveldt. He spent most of his long life (he was a vigorous 76 when Rembrandt painted him in 1633) in the defence of a liberal Protestantism, and for a few years had been forced into exile by the Calvinist authorities. He returned to The Hague after the accession of Frederik Hendrik but, although deeply revered, he was never quite so influential again. The three-quarter-length portrait, done in Amsterdam while the subject was on a visit there, is signed

and dated, and for once we have corroboration from the subject himself. Wtenbogaert, who was notoriously reluctant to have his portrait painted, recorded in his diary, '13 April 1633. Painted by Rembrandt for Abraham Anthonisz.' (Abraham Antonisz. Recht was another famous Remonstrant leader, whose daughter married the son of Arminius). He stands with one hand pressed to his heart, a sign of his devotion to the Book, which lies open on a stand behind him. Although, as usual with Rembrandt's representations of documents, the writing is deliberately illegible, we can assume it is indeed the Bible, since the light that illuminates the face also lights up the open pages. The strength of the face is accentuated by the ruff, and the eyes confront the observer with utter candour. Strength, loyalty and honesty are powerfully projected.

This kind of pose, as Rembrandt discovered, not only suited scholars and preachers but was also appropriate for the merchants who formed the largest social group among his subjects at this period. Tough and ruthless businessmen they may have been, but they also had pretensions to culture, good taste and scholarly interests. Wtenbogaert's other hand clasps a pair of gloves, a symbol of fidelity, and this device appears in many other portraits, notably in one of Rembrandt's greatest, the much later portrait of Jan Six (pages 146 and 147).

Portraits of Wtenbogaert were popular or at least rare enough to be in demand, and that may have been why Rembrandt made another portrait of him, this time an etching, two years later (see page 119). The old preacher, approaching 80 but still looking strong and healthy, is seated at a desk covered in books and papers. The print bears an inscription in Latin underneath it by Hugo Grotius, who was still, and remained until his death, in exile, although he did make a brief visit to Amsterdam around the time that Rembrandt arrived there.

Although Rembrandt produced portraits at such a rate, and therefore when, as in a book, a large number are seen together, they have a certain air of routine, they are always highly proficient and never completely uninteresting. The quality does not vary much and insofar as it does, it may well be due to the sympathy, or lack of it, felt by the artist for the person he was painting, a point that will arise again later. Another probable Remonstrant subject is the *Young Man at His Desk* (right), a half-length in profile with the sitter's head turned towards the observer, mouth slightly open, looking as if he has been suddenly interrupted. The subject is copying from a book, and the 'pose' (he is emphatically not 'posing' for his portrait) is not that of a merchant, though he might perhaps be a merchant's secretary. More likely, he is an official such as a town clerk, and a tentative identification is Daniel Mostart, a current town clerk of Amsterdam, who was a Remonstrant.

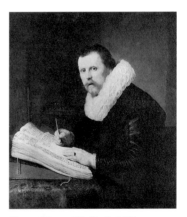

Young Man at His Desk, 1631
Oil on canvas, 41 x 36 in
(104 x 92cm)
Hermitage, St. Petersburg

Young Man Sharpening a Pen
Oil on canvas, 40 x 32in
(101.5 x 81.5cm)
Gemäldegalerie, Kassel

Another portrait, again of a man seated at a desk and caught in an interrupted action, which is dated to the same year, seems to have particular biographical interest. This is *Young Man Sharpening a Pen* (left). The informality of the pose, and the fact that the 'young man' (well, youngish: anyone who is not otherwise identifiable and is obviously not an 'old' man tends to be described as 'young') is writing a letter addressed to Rembrandt, seems to suggest a close personal connection between artist and subject. Unfortunately, no one has been able to suggest who the young man could have been, and to make things worse, although the painting is signed and dated, some doubt has been expressed as to the authenticity of the signature.

Rembrandt's subjects included married couples, either in paired single portraits or in double portraits such as *Jan Pietersz. Bruyningh and His Wife*, mentioned above. One of the most interesting is another 'arrested-moment' picture, the double portrait of *The Shipbuilder Jan Rijksen and His Wife Griet Jans* (pages 140 and 141), the husband identified in Rembrandt's hand as 'Jan Heykensz. [Rijksen]'. Jan Rijksen and his wife were both members of big shipbuilding families in Amsterdam. The husband, who has been working at his desk on plans and holds dividers in one hand, is interrupted by his wife, who hands him a written message, which we may assume has just been delivered to the house. To emphasize the momentary nature of the incident, her left

hand still holds the door handle. The painting is less smoothly finished than Rembrandt's contemporary portraits of rich merchants (incidentally enabling the progress of his brushwork to be followed more easily), and in its informality and illustration of daily activity (not to mention a possible narrative content unknown to us) inclines towards genre: a good example of Rembrandt's blurring of the categories. The delivery of a letter as a device to unite two figures was, in itself, not original to him. It was used, for instance, by Thomas de Keyser in a painting of 1627 which Rembrandt would surely have seen, *Constantijn Huygens and His Secretary* (page 114) and by many others.

The Shipbuilder and His Wife was nevertheless a remarkable departure, given the nature of the painting, far removed from conventional husband-and-wife portraits. Presumably the highly original approach was submitted in advance for the client's approval. In general, these commissions did not offer much scope for originality, and the invariable black clothes, which were fashionable with people of all religious tendencies at this period, must have made Rembrandt restive, though he never compromised his professional standards.

One or two other subjects offered something a bit extra. As a result of his wedding, Rembrandt was patronized, though only briefly, by the cream of Amsterdam society. The portraits of Maerten Soolmans and his wife Oopjen Coppit (both page 130) show an aristocratic couple, and although they too were necessarily studies in Calvinist black and white, they went in for rather more exquisite lace and, in the case of the husband, amazingly swagged garters and shoes bearing the most absurd silver rosettes, as big as dinner plates, to which Rembrandt – one senses with delight – devoted his finest brushwork, having one of his subject's feet turned outwards, to paint his stylish footwear from different angles.

The portrait of Nicolaes Ruts may have been partly responsible for the flood of portrait commissions in Rembrandt's early years in Amsterdam, but the picture that really established him as the foremost painter of the city was a group portrait, *The Anatomy Lesson of Dr. Nicolaes Tulp* (pages 154 and 155), his first really large canvas. It must have been commissioned very soon after his arrival in the city, and it seems that Rembrandt was especially favoured by the medical profession, since he counted several members of it among his later clients (perhaps due to the influence of Dr. Tulp himself), even when he became less fashionable in Amsterdam society at large. Group portraits had long been popular, and they form a major category in Dutch painting. They were usually commissioned for a particular civic body (in this case the Surgeons' Guild), whose members contributed individually for their inclusion in the painting. Such paintings posed very severe problems, not least of

SUCCESS

composition, because of the conflict between the desire of the individuals who paid for the work to be properly portrayed, and the desire of the civic body which owned it for a satisfying work of art. Hitherto the problems had not been tackled very successfully, and earlier group portraits usually amount to little more than a row of heads so that, as Samuel van Hoogstraten remarked, 'one could, in a manner of speaking, behead them all with a single blow'. Rembrandt's gift for lively expression may have made the form more attractive to him than to others, and the way in which he found dramatic solutions to the problems of composition is just one more demonstration of his genius.

Human anatomy was a popular subject, and lectures and demonstrations by well-known authorities, such as the medical professors at Leiden, attracted an audience not only of medical students and surgeons but also interested gentlemen-amateurs and indeed the paying public, who sometimes brought a picnic and were entertained with musical interludes. Not for nothing did anatomy lectures take place, like modern surgery, in a 'theatre'. On the other hand, the subject had a certain religious significance for people of that time which it would not have had today. A work of nature – the human body – was closely associated with the work of God – the human soul – and as Dr. Tulp, a devout Calvinist, explained how the muscles of the arm cause movement of the fingers, he would have explained it as a demonstration of God's creative omnipotence. The

figure at the back in Rembrandt's picture, who originally may have worn a hat, like Dr. Tulp, giving him extra authority, appears to gesture towards the corpse while looking at us; he is delivering the traditional message, which in earlier pictures is sometimes made by a blatant placard, like that held by a skeleton in the anatomy theatre at Leiden proclaiming *Nosce te ipsum* ('Know thyself', a maxim dear to Rembrandt). However wonderful the workings of the body, it must end in death and decay.

Among Rembrandt's predecessors who had essayed the subject were Nicolaes Eliasz. Pickenoy and Thomas de Keyser. The latter's *The Anatomy Lesson of Dr. Sebastian Egbertsz. de Vrij* (opposite below) features a skeleton, with six figures grouped around it, meticulous likenesses no doubt but each treated with equal emphasis (a requisite if each one was contributing the same proportion of Keyser's fee!) and, despite the addition of gesturing hands that attempt to break up the static composition and relate the figures to each other, the painting does not really amount to more than a record of an occasion.

Rembrandt owed nothing to Keyser, but a possible model for his painting was Rubens's *The Tribute Money*, also a study of crowded and closely attentive heads, which was painted about 30 years earlier but was widely known through numerous painted copies and prints from an engraving by Lucas Vorsterman.

A dissection of a human body, the subject of Rembrandt's painting, was much rarer than a mere dry-bones anatomy lesson, largely owing to the difficulty of getting hold of a fresh corpse. Accordingly it was of greater interest, though it may be that this particular case was a private demonstration. At any rate, it was not a great historic occasion, for it was not even Dr. Tulp's first dissection. Although the painting looks far less artificial than others of the type, for all its lively immediacy, it is not an accurate representation of the actual event, and was probably painted only partly from life. We know, for instance, that dissections invariably began with the opening of the chest, not with the left arm, as here, and it seems certain that some of the onlookers, who were all wealthy members of the Surgeons' Guild, were inserted later. The man standing at the back and the man looking slightly cramped at the extreme left may have been late additions because they sent their payments in late, and the latter figure is possibly by one of Rembrandt's expanding number of pupils.

Anatomy was one area of science in which Amsterdam outshone Leiden, and Nicolaes Tulp (1593–1674), son of a merchant, was the outstanding medical practitioner of his

FAR LEFT
The Anatomy Lesson of Dr. Joan Deyman in its Proposed Frame, c.1656
Pen and brown ink, brown wash and red chalk
4^1/4 x 5^1/8in (10.9 x 13.1cm)
Historisch Museum, Amsterdam

This, and the painting of the subject, are discussed on page 307 et seq.

BELOW LEFT
Thomas de Keyser
The Anatomy Lesson of Dr. Sebastian Egbertsz. de Vrij, 1619
Oil on canvas, 53^1/8 x 73^1/4in (135 x 186cm)
Historisch Museum, Amsterdam

The Anatomy Lesson of Dr. Nicolaes Tulp, 1632
Oil on canvas, 66³/₄ x 85in
(169.5 x 216cm)
Mauritshuis, The Hague

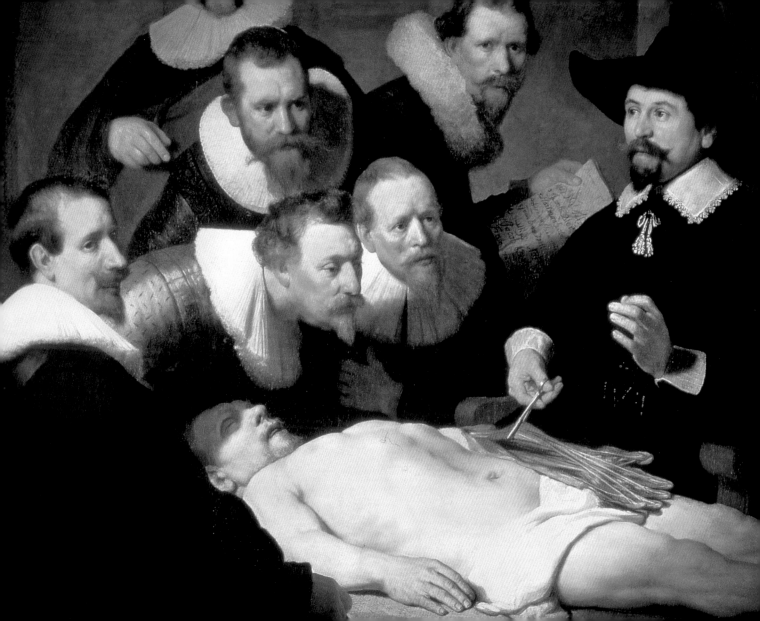

SUCCESS

day. In Rembrandt's painting he is, as Kenneth Clark remarked, 'the image of the persuasive Harley Street man'. His baptismal name was Claes (or Nicolaes) Pietersz., a name he always retained, though his grand house near the newly built Westekerk bore a prominent stone tulip (*tulp*) on the gable. Although tulips were present in Holland by this time, they were still an oriental rarity, and Dr. Tulp may have first seen them in the botanical gardens in Leiden when he was a university student. At nearly 40 years of age, he was an accomplished and interesting though not entirely likeable person, author of an influential treatise on anatomy and prelector (roughly equivalent to professor and head of department) of the Surgeons' Guild. He was very rich and, in addition to his professional success, in later years held important civic offices in Amsterdam, being several times burgomaster.

All the individuals in the painting, who, including Dr. Tulp, would have actually commissioned it, can be identified. Their names appear on the paper held by the man farthest to the right, except for that of the shockingly corpse-like corpse, a native of Leiden named Adriaen Adriaensz. Kint who had been hanged for robbery with violence. Dissections had been formally permitted since the turn of the century (Dr. Tulp would have witnessed them as a medical student), but they were strictly controlled by the Guild; one of the conditions was that the corpse had to be that of an executed criminal.

The painting represents a revolution in Dutch group portraits. Before Rembrandt, the best that anyone had achieved in uniting the group so as to make a painting that was also a satisfying work of art was the rather unconvincing glances and gestures of the spectators of Keyser's *Anatomy Lesson*. Rembrandt's composition builds on a tight, integrated inner group of the three intent heads that form a triangle, the eyes fixed on Dr. Tulp's work with 100-per-cent concentration as he manipulates the dissected muscles of the arm to make the fingers curl up, while his own left hand imitates the action. Not all of those present are paying such close attention and among those who are, not all are looking at precisely the same point. The man at the back with the paper looks at Dr. Tulp's gesturing hand, another at the text at the feet of the corpse, another at the instrument with which Tulp manipulates the muscles and tendons. Their faces seem to be illuminated by light reflected from the glaringly sallow corpse, over the tones of which (as Sir Joshua Reynolds recognized in the 18th century) Rembrandt took such trouble, mixing at least five pigments. The body is set at an angle to the surface of the picture, instead of lying parallel, which was the usual design in what tended anyway to be an excessively wide picture due to the need to get in many more individuals than Rembrandt had to include on this occasion. The corpse is thus daringly foreshortened (though not so daringly as in Rembrandt's painting of another dissection, that of Dr.

Deyman, 24 years later), and the usual convention which called for the head of the dead person to be covered is abandoned by Rembrandt with equal boldness, forcing us to see the body as a human being rather than a depersonalized object of research. For the other four spectators, Rembrandt has been compelled to concentrate chiefly on his task of providing genuine likenesses, and the overall aesthetic effect would be improved if the man at the extreme left had never been added. The book at the feet of the corpse is the 'bible' of human anatomy, *De humani corporis fabrica* ('On the Structure of the Human Body'), by the Renaissance 'father' of the science, Andreas Vesalius or Andries van Wesel (1514–64; he was a native of Brabant). The suggestion of an architectural background probably locates the scene in the temporary anatomy theatre of the Surgeons' Guild in one of the towers of the Anthonismarkt. In a sense, Rembrandt has turned the intrinsically rather dull form of the group portrait into a 'history' painting.

The painting hung in the Amsterdam Surgeons' Guild headquarters in the Nieumarkt until 1828 when the guild, hard-pressed for cash, sold it to the king. Since then it has graced the walls of the Mauritshuis. It was not Rembrandt's first masterpiece, for in some ways *The Supper at Emmaus* and *The Repentant Judas* are no less remarkable, but it was a masterpiece in the more literal sense, in that it was widely seen and established him indisputably as a master of his art.

Chapter Seven
Marriage

Rembrandt probably met Saskia, a younger cousin of Hendrick Uylenburgh, soon after he came to live in his house in Amsterdam, and he may possibly have met her on an earlier occasion, when she was only a child. Saskia was born in 1612 in Leeuwarden in Friesland, the youngest of eight children. Her father, Rombertus Uylenburgh, a lawyer by training, was one of the leading men of Friesland, burgomaster and pensionary of Leeuwarden. In July 1584 he was in The Hague as the representative of Friesland and, having been invited to dine with William the Silent, had the harrowing experience of witnessing his host's assassination. He briefly played a role in politics at national level, and was a member of the delegation sent to England in 1585 to seek the support of Elizabeth I against Spain.

Saskia's mother died when the child was eight, and her father followed four years later, leaving her an orphan at 12. He also left a substantial estate, divided equally among the children. Saskia's brother-in-law,

Gerrit van Loo, was appointed her official guardian, and she seems thereafter to have led a rather nomadic existence among the households of her – fortunately numerous and prosperous – relations. They included two cousins in Amsterdam, a city she first visited in about 1622. The one she knew best and presumably stayed with more often was not Hendrick but Aaltje, a daughter of her uncle, who was married to Johannes (Jan) Cornelisz. Sylvius, also a native of Friesland but for many years minister of the Oude Kerk (then called the Groote Kerk) in Amsterdam. One of the most prominent Calvinist preachers in the city, Sylvius seems to have been a sort of second guardian. He became a friend, and Rembrandt made a portrait etching of him (1634), a serious, elderly (he was 70), scholar in a skull cap, hands resting on a Bible. He did another (right) several years after after his death, a rather remarkable work in which the old preacher leans from the framing oval in which he appears as if in a pulpit, the shadow of his protruding hands and of the Bible he holds falling on the paper outside the border, a very Baroque touch of illusionism. It bears a panegyric by the poet Caspar Barleus, concluding with the plea: 'Amsterdam, keep his memory alive; you were illuminated by his righteousness and now he graciously represents you to God'.

We know exactly when Saskia and Rembrandt became engaged because of an inscription, inserted at a later date, below a drawing of her, the earliest one surviving, *Saskia in*

REMBRANDT

a *Straw Hat* (opposite). It reads: 'This is drawn after my wife, when she was 21 years old, the third day after we were betrothed – 8 June 1633'. The portrait is aptly described by Christopher White as 'a love drawing', and Kenneth Clark thought it 'one of the sweetest drawings in the world'. Saskia appears in a large, floppy, countrywoman's hat, no doubt chosen by her future husband and decorated with flowers. One hand supports her cheek, the other holds a flower. She gazes affectionately, and a little knowingly, at the artist.

To mark it as something special, the drawing is done in silverpoint. This technique requires special paper or, as in this case, parchment, which is covered with a smooth, opaque, ivory coating made from bones, sometimes faintly coloured. The drawing is done as with a pencil, but with silver wire instead of graphite. The effect is richly delicate and seductive, and it is indelible. Silverpoint was a popular technique during the Renaissance (it was the medium for some of Leonardo's sublime drawings of horses). It was becoming uncommon by Rembrandt's time, but one or two other Dutch artists did use it for portraits, including, Jacques (Jacob) de Gheyn, father of the young man of the same name whose portrait by Rembrandt (overleaf) aroused the indignation of Constantijn Huygens on the grounds that it was a poor likeness and a rotten painting. (Huygens thought little of Rembrandt as a portrait painter, one of the few points on which we would regard his judgment as faulty; however,

OPPOSITE
Saskia in a Straw Hat, 1633
Silverpoint on parchment, 7^1/4 x 4^1/4in (18.5 x 10.7cm)
Staatliche Museen, Berlin

LEFT
Johannes Cornelisz. Sylvius, 1646
Etching
Metropolitan Museum of Art, New York

159

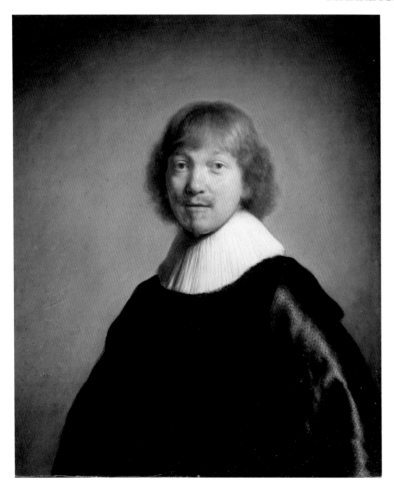

that was in 1632, and he may have changed his opinion later.)

As part of the legal requirements, the consent of Rembrandt's surviving parent had to be formally given, and his mother duly appeared before a Leiden notary to pronounce her consent to the marriage of her son, 'the honourable Mr. Rembrandt Harmensz. van Rijn', signing her name with an X. She did not attend the wedding. The happy couple, as we can surely call them on the visual evidence alone, were married on 22 June 1634 from the house of Gerrit van Loo and his wife in the church of St.-Anna-Parochie, a village in Het Bildt, Friesland.

There is no doubt that Rembrandt's marriage represented, for him a large upward step in the social hierarchy. Saskia's family belonged to the higher ranks of the bourgeoisie; her brothers were all trained lawyers with responsible positions, the only exception being an officer in the army, and her sisters were married to professors, civic officials and men of property. They belonged to a class far removed from the millers, bakers and shoemakers of Rembrandt's family. However, Saskia's relations seem to have welcomed the match. Rembrandt was, after all, an educated man, and if his face was that of a peasant his dress was (sometimes) that of a gentleman; indeed he had court connections. Additionally – no small consideration – he was a fashionable artist with what looked like being a highly successful and lucrative career ahead of him. He was, of course, a little older than his wife,

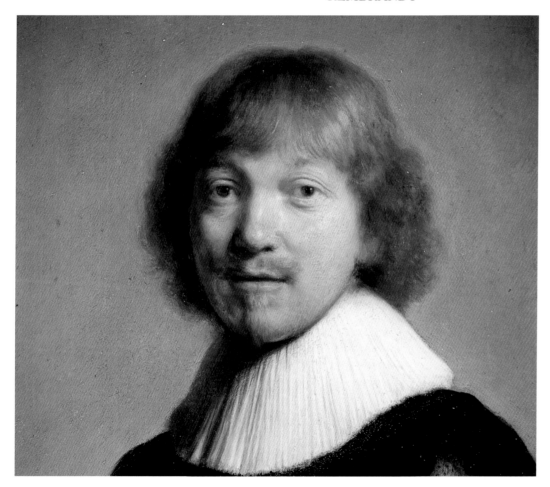

Jacques (Jacob) de Gheyn III, 1632
Oil on panel, 11³/₄ x 9⁵/₈in
(29.9 x 24.5cm)
Dulwich Picture Gallery, London

Self-Portrait, 1633
Oil on panel, 22 x 18¹/₂in (56 x 47cm)
Gemäldegalerie, Berling-Dahlem

but that was not uncommon and anyway life was precarious; comparatively few people died of old age.

Strangely enough, Rembrandt's own family seems to have been, on circumstantial evidence, the ones who viewed the union with less than total enthusiasm. From Leiden to Het Bild was admittedly a long journey, across the Zuider Zee, yet it seems surprising that none of Rembrandt's family (so far as we know) attended the wedding. Nor was any one of them present at the baptisms of Rembrandt and Saskia's children, although from Leiden to Amsterdam was not such a long way. Rembrandt's in-laws were confirmed Calvinists, whereas his family, with their Catholic background, were inclined to the Remonstrants, yet it seems rather unikely that religious differences alone could have been the reason for their disapproval of the marriage. No one can suggest any other reason (inverted snobbery?) and perhaps we should again remind ourselves that judgments are generally best made on the basis of solid, documentary evidence, and not merely on its absence.

Although we have no direct evidence of Rembrandt's state of mind, there is every reason to believe that he and Saskia were deeply in love, and he painted and drew her endlessly in many guises and situations. One of the earliest portraits, more formal than the drawing of her in a straw hat and done a few months later, is *Saskia with a Veil* (pages 132 and 133), on an oval panel, a head and shoulders portrait in

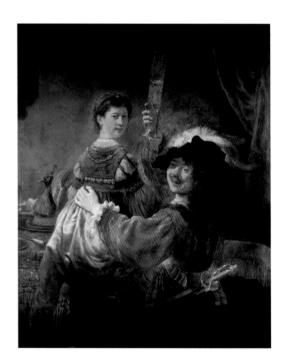

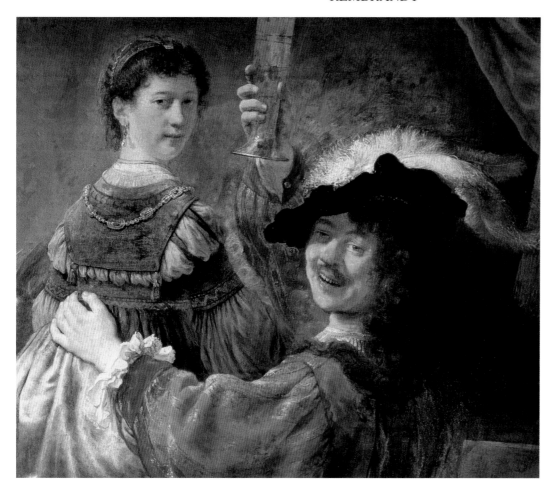

***Self-Portrait with Saskia (Scene of the
Prodigal Son in the Tavern), c.1635***
*Oil on canvas, 63³/8 x 51¹/2in
(161 x 131cm)
Gemäldegalerie, Dresden*

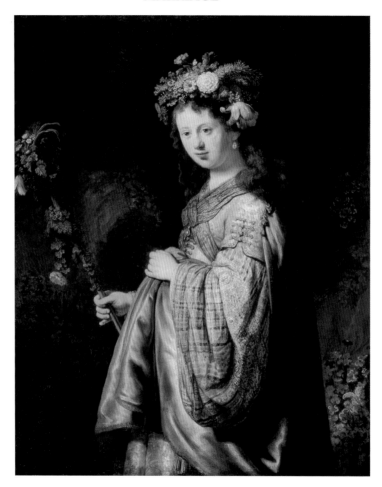

Saskia as Flora, 1634
Oil on canvas, 49¹/₅ x 39³/₄in
(125 x 101cm)
Hermitage, St. Petersburg

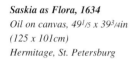

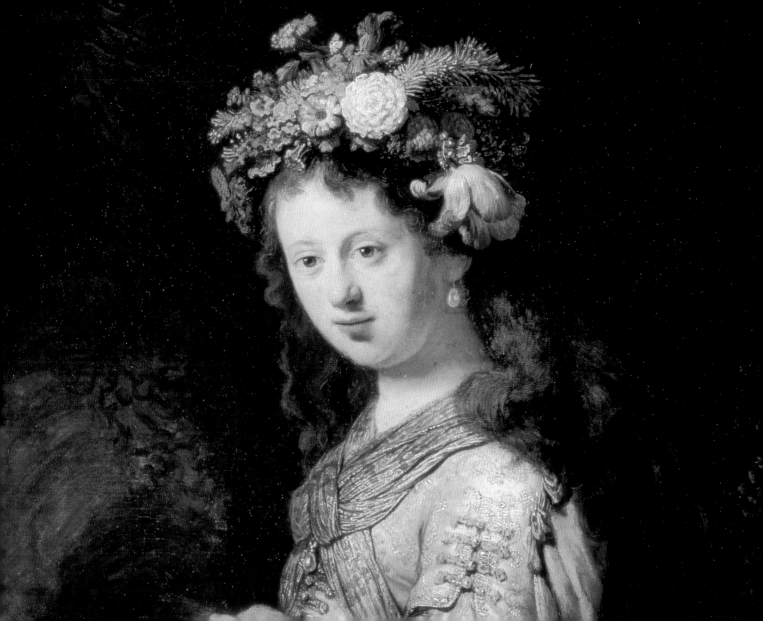

RIGHT
Saskia Laughing, 1633
Oil on panel, 20⁵/₈ x 17¹/₂in
(52.5 x 44.5cm)
Gemäldegalerie, Dresden

OVERLEAF
Saskia van Uylenburgh in Arcadian
Costume (Saskia as Flora), c.1634–35
Oil on canvas,48⁵/₈ x 38³/₈in
(123.5 x 97.5cm)
National Gallery, London

There is some doubt about the sitter,
and the signature has been added by
another hand. X-rays show that this
portrait was adapted from a Judith with
the Head of Holofernes, a bunch of
flowers being substituted for the bloody
head.

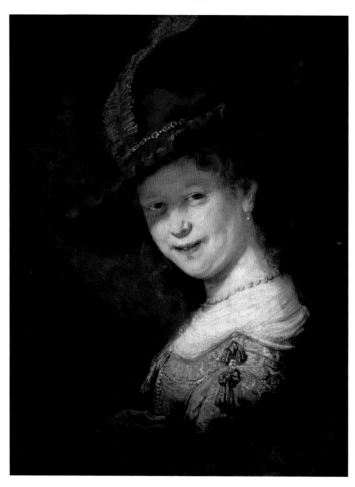

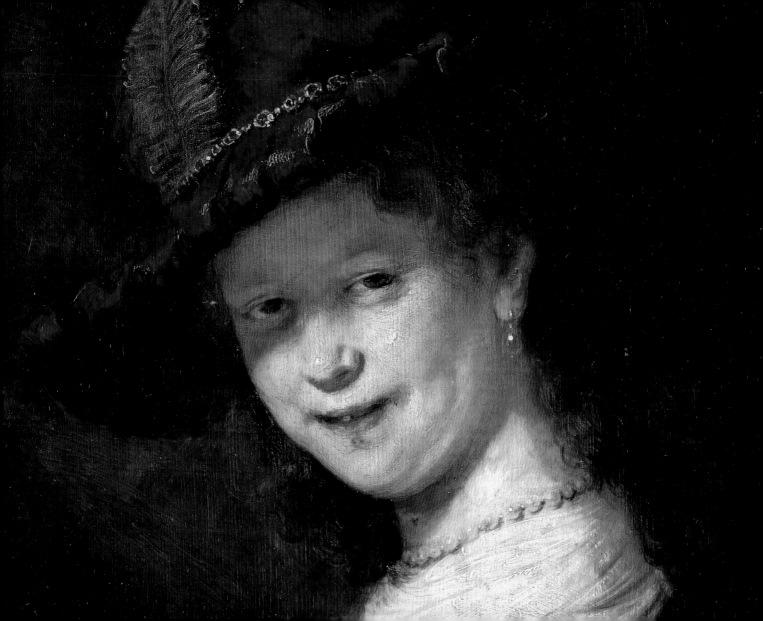

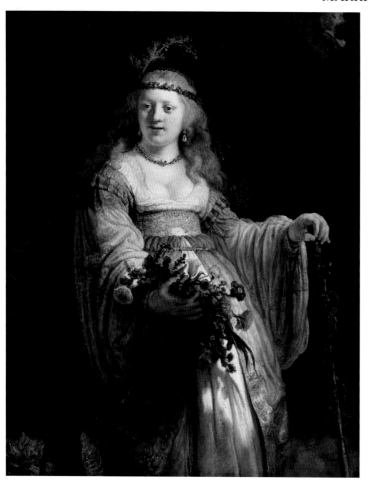

profile with the head turned towards the observer and the light coming, as Rembrandt's light usually does, from the left. It might be a companion piece for a self-portrait but for the fact that she is facing right, whereas in all paired husband and wife portraits of that time, it was by convention the husband who faced right. If Rembrandt ever did make a such a pair of portraits, the most likely candidates are his *Self-Portrait* of 1633 (page 162) and the portrait of *Saskia Laughing* of the same year, also in Germany (pages 166 and 167). But there is no very strong reason for thinking so except that the atmosphere is similar and both are clad in exotic hats and costumes from Rembrandt's large collection of jumble. In fact the two pictures seem to have been originally of different shapes, which disqualifies them as a deliberate pair. The Saskia picture is, however, especially endearing as, below the large hat brim that lightly shades her eyes and brow, she is smiling with unfeigned amusement, obviously enjoying the play-acting. It is one of Rembrandt's most impressive portraits.

While he may never have painted paired portraits, Rembrandt did paint himself and his young wife together, and another witness to their jolly relationship is the painting usually called simply *Self-Portrait with Saskia*, undated but probably 1635 (page 163), in which she perches on his knee looking back at us over her shoulder. Her expression is hardly more than compliant, but Rembrandt, a large ostrich feather

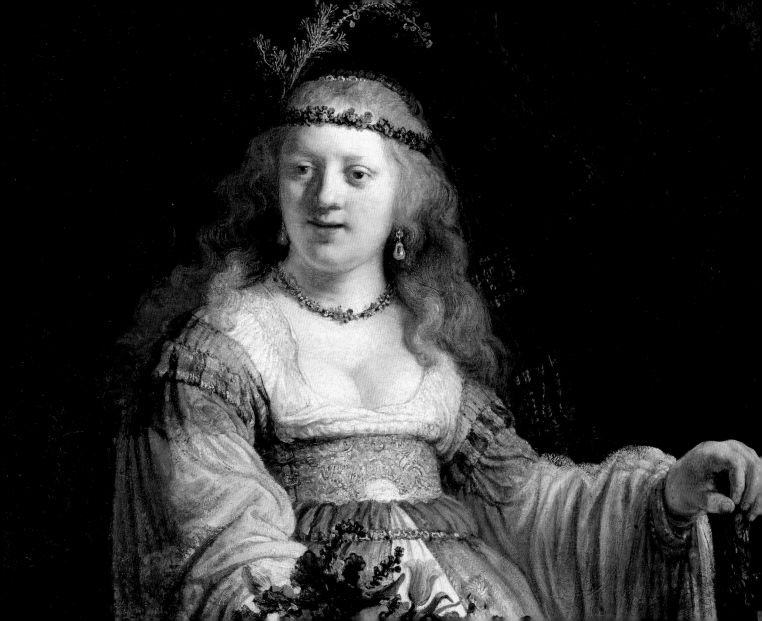

RIGHT and OPPOSITE
***The Polish Nobleman or Man in
Exotic Dress, 1637***
Oil on panel, 38^1/$_8$ x 26in (96.8 x 66cm)
*National Gallery of Art, Washington,
D.C.*

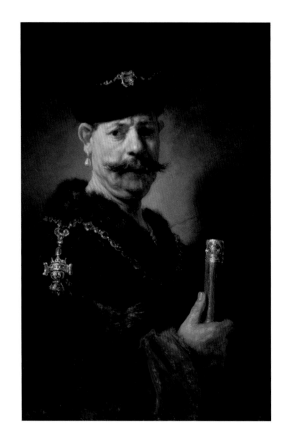

in his hat and a lengthy sword slung from his belt, is
laughing merrily and greatly resembles a Frans Hals-type
roisterer as he hoists a flute glass of impressive proportions.
Rembrandt as jolly toper is certainly a surprising
manifestation, and it has been plausibly suggested that the
picture was not intended as a double portrait of himself and
Saskia but carried a moral message: they were standing in for
a picture of the Prodigal Son squandering his inheritance in a
tavern with a courtesan (St. Luke's Gospel, Chapter 15), a
fairly standard subject. The picture has been altered and
retouched by cruder hands, but X-ray examination tends to
confirm the hypothesis.

The long arguments in which art historians engage, over
whether a certain figure in a painting is a portrait of the artist
or of someone close to him, arise with many artists besides
Rembrandt. A point that is sometimes taken insufficiently into
account is that a painter such as Rembrandt (particularly
Rembrandt, we might say) frequently used people around
him, and indeed himself, in the absence of other models,
simply for convenience, as the approximate basis for a certain
face or figure or pose, without intending an actual likeness of
that person. For example, It has been said that Rembrandt's
portrait generally known as *The Polish Nobleman* or *Man in
Exotic Dress* (left) is 'an idealized self-portrait ... got up in
fancy dress'. The painting was acquired by Catherine the
Great in the 18th century from the collection of Johan Ernst

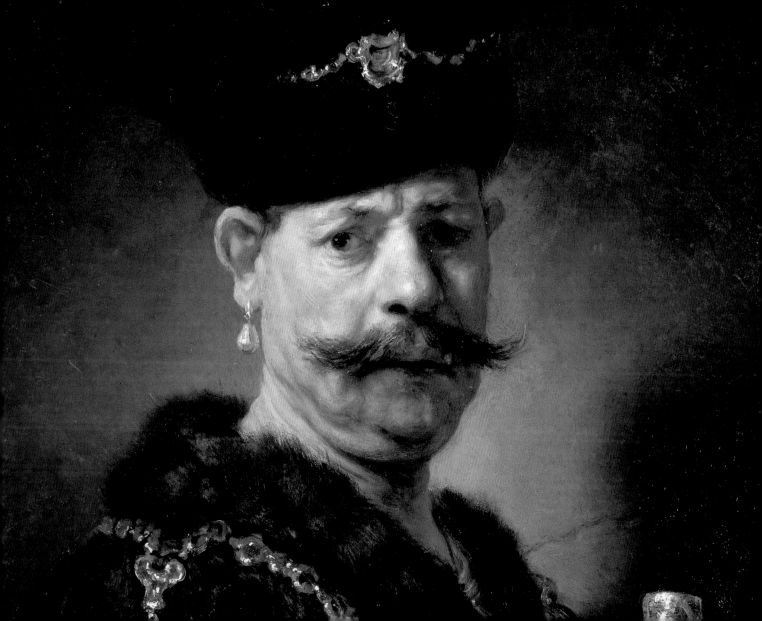

Portrait of Saskia, 1634
Ink and wash on paper, 2³/₈ x 2³/₈in
(6 x 6cm)
Pushkin Museum, Moscow

Three Heads of a Woman (probably all
Saskia)*, c.1637*
Etching, 5 x 4in (12.7 x 10.3cm)
Rembrandthuis, Amsterdam

Gotzkowski, a Prussian of Polish descent. He is known to
have bought pictures in the Netherlands on behalf of
Frederick the Great but, since no one else has turned up as a
possible subject, it may well be that Rembrandt started with
his own face. Whether he consciously painted an 'idealized
self-portrait' is another matter. As almost any painter would,

he grew rather tired of the plain, unvarying costume of his
clients, and welcomed the chance of a little 'fancy dress', but
he could not expect most of his patrons to be seen so garbed.
Apart from these commissioned portraits, however, it is often
difficult to decide precisely who or what is the subject of a
picture. For example, is the painting of *Saskia as Flora*,
discussed below, a portrait of Saskia dressed up as Flora, or is
it a mythological picture featuring a Classical goddess for
which Saskia was the model? More blurring of the
boundaries.

As we know from the inventory of his possessions made
at the time of his bankruptcy, Rembrandt was a collector on a
grand scale, and it may be true that the vast amount of clothes
and props he could not resist buying (and which perhaps
contributed to his decision to buy such a huge house – the
Rembrandthuis – in 1639) partly accounted for his financial
problems. Besides such items as might be found in any
artist's studio, such as plaster casts, busts, a skull, assorted
sculptures and including, apparently, flayed and pickled limbs
possibly connected with Vesalius, he had weapons and
armour, gems and jewellery, shells and coral, porcelain, a
trumpet, a stag's antlers, puppets from Java, gourds and an
elephant's tusk from Africa, and numerous costumes and
headdresses of various kinds, many with an oriental flavour
and including two complete oufits from South America.
According to the Italian writer on art, Filippo Baldinucci,

who wrote a biography of Rembrandt in 1686, he was a frequent customer at auctions, and this is borne out by records of auction sales, where his name often appears as a purchaser. There 'he acquired clothes that were old-fashioned and disused as long as they struck him as bizarre and picturesque, and those, even though at times they were downright dirty, he hung on the walls of his studio among the beautiful curiosities which he also took pleasure in possessing, such as every kind of old and modern arms – arrows, halberds, daggers, sabres, knives and so on, and innumerable quantities of exquisite drawings, engravings and medals, and every other thing which he thought a painter might ever need'. One of his purchases was a painting by Rubens.

Perhaps it would be unfair to call him a spendthrift, although Joachim von Sandrart, his first biographer (1675), did so, but he certainly had little idea of domestic economy. No doubt Saskia, herself accustomed to a very comfortable lifestyle and, through her dowry, a substantial contributor to the couple's total income, did not discourage him. The dowry was not entirely straightforward, however, as the arrangement was that Rembrandt could not touch the capital; not long after the wedding he went to Rotterdam where he granted power of attorney to Gerrit van Loo in order to claim the interest, and also to collect on certain outstanding debts to Saskia. In spite of this cautious arrangement, some members of Saskia's

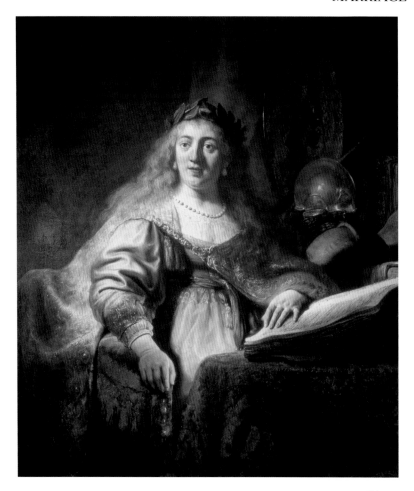

family became restive at the couple's alleged high spending, and accused them of squandering Saskia's inheritance dangerously in extravagant and ostentatious living. They responded with spirit, claiming to have plenty of money, as indeed they surely must, but the quarrel caused permanent damage and, many years later, when Rembrandt and Saskia's son Titus, then aged 14, made a will, his father ensured that it contained provisions expressly to prevent any of his mother's relations ever benefiting from it.

The plainness of ordinary dress may have contributed to a contemporary liking for 'dressing up' among others as well as Rembrandt. The pastoral was a popular form, in both painting and poetry, and the Utrecht painters were particularly fond of dressing their models as shepherds and shepherdesses. They may have had some influence on Rembrandt. One of the best-known of his pictures of his wife is the charming three-quarter-length *Saskia as Flora* (pages 164 and 165), the ancient goddess of flowers and the Spring, which recalls the first drawing of her in a straw hat. She wears another robe from the dressing-up box, a luxuriant headdress of flowers, and carries a *thyrsis* (a staff) wreathed in blossoms. Her left hand holds up her full skirt, perhaps to avoid getting the hem dirty, though also suggesting pregnancy, an appropriate state for a goddess of fertility. With her comfortable, homely Dutch features, Saskia was not the Classical ideal, but here she has her own innate dignity and a good deal more charm than any

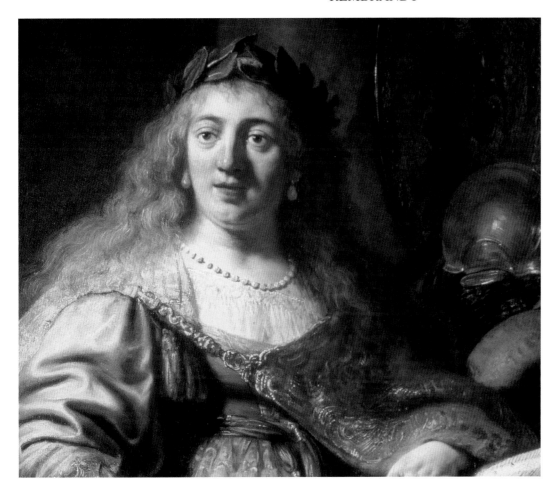

Saskia as Minerva
Oil on canvas
Private collection

Though attributed to Rembrandt, this painting is now generally excluded from the canon.

run-of the-mill Roman goddess. Not long afterwards (possibly earlier: it bears the date 1635 but the date is not written by the artist and may be wrong) there is a second, alleged Saskia as Flora (*Saskia van Uylenburgh in Arcadian Costume*) pages 168 and 169), very richly painted. These paintings must have been popular for they were copiously copied by various hands. The identity of the model has been questioned in both cases, but the first seems indisputably Saskia and the second quite possibly, though X-ray examination has shown that the subject was originally *Judith with the Head of Holofernes*, based on a painting by Rubens, and in place of a bunch of flowers, the lady was holding Holofernes's severed head. (In the Book of Judith, in the Apocrypha, the heroine saves Israel from Assyrian invasion by cutting off the head of the enemy commander, Holofernes.) The likeness, never something that Rembrandt was too pedantic about, is perhaps closer to the model – identity unknown but she is certainly not Saskia – for *Bellona, the Goddess of War* (1633; New York, Metropolitan Museum). Whoever this young lady was, she looks a good deal more comfortable in flowers than in armour (or, one imagines, grasping a bloody head).

Rembrandt made many intimately domestic drawings of Saskia, often in bed (where the unfortunate young woman must have spent a great deal of her short married life), sick or sleeping, and once or twice holding a baby. He made many drawings of young children in the 1630s but, sadly, they cannot have been his own.

For the first two years of their marriage, Rembrandt and Saskia remained in the Uylenburgh house on the Anthoniesbreestraat. Their first child, named Rombertus after his grandfather, was born there. He was baptized in December 1635, with Aatje and Sylvius as witnesses. It was a bad year for plague in Amsterdam, and he died two months later.

By that time, Rembrandt and Saskia had finally moved out of the Uylenburghs' house and had rented a newly built house in the Nieuwe Doelenstraat, facing the River Amstel. They stayed there less than two years before moving to a place called the Sugar Factory, near the Amstel, presumably for its former function, some time in 1637.

A daughter, Cornelia, probably named after Rembrandt's mother, was baptized in June 1638. Baptism usually took place as soon as possible after birth, and for good reason: Cornelia lived for three weeks. A second daughter, given the same name as her dead sister, was baptized in July 1640 and lived for a fortnight. To lose three infants in a row would seem unbelievably cruel today; in the 17th century it was not uncommon, and with infant mortality so high, people were to some extent inured to disasters that would devastate most modern parents in the Western world. A fourth child, another boy, Titus, was baptized in September 1641. Titus would grow to adulthood, though he would not outlive his father.

REMBRANDT

Success breeds success, money generates more money. As Rembrandt's name and ability became well-known, he could sell as many pictures as he could paint, and he (or Uylenburgh) could, presumably, charge above-average prices. His reputation also brought him eager pupils: he quite regularly had as many as 50 at any one time – a one-man art school. The old, formal system of apprenticeship had not been altogether abandoned, at least by the Guild, but Rembrandt's pupils cannot be called apprentices, as there was no official contract of apprenticeship, and anyway he did not by nature take kindly to formal systems and official bodies. The actual teaching load was probably shared by former pupils who had become assistants or independent painters in the Rembrandt manner.

Among Rembrandt's pupils were some of the best Dutch artists of the next generation, though no great masters, and others from farther afield, from Denmark and Germany as well as the Netherlands. They included young boys, youths who had worked under an earlier master, and even, to judge by Rembrandt's etchings and students' drawings of art lessons, what would now be called 'mature' students.

The finest of Rembrandt's pupils was probably Carel Fabritius, who was with him from about 1641 to 1643. Unfortunately he was killed in a great explosion at Delft in 1654, when he was only 32, and the number of his surviving works that are undisputed is smaller than Giorgione's.

Attribution is complicated by the existence of his younger brother, Barent, who was probably also a pupil of Rembrandt, and remained closer to the master in style. Although some works attributed to Carel are much in Rembrandt's manner, he reversed Rembrandt's practice by placing dark objects before a light background, and in general is closer to his own supposed pupil, Vermeer, than to Rembrandt.

Ferdinand Bol was the son of a Dordrecht surgeon, and several of his earlier works, such as *A Lady* (London, Kenwood), have been understandably credited to Rembrandt at various times. Jacob Backer became an Amsterdam portrait painter in the 1650s and combined elements of the styles of Rembrandt and Frans Hals, especially the latter's brighter palette. Gerbrandt van den Eeckhout, son of an Amsterdam goldsmith, was a disciple who later became a friend. He was influenced not only by his friend and master but, in a group of late works, by an entirely different painter, Gerard Ter Borch.

Govert Flinck had studied in Leeuwarden before arriving in Rembrandt's studio, possibly motivated by Rembrandt's success to acquire facility in the Rembrandtian manner. A Mennonite, he stayed on to become an assistant if not partner and, painting at first in Rembrandt's manner but becoming more 'Flemish' in accordance with changing taste, he became an uncomfortably successful rival to his old master, taking over many of his patrons. Samuel van

Hoogstraten shares with him and others the distinction of having his works mistaken for genuine Rembrandts, and it was Hoogstraten who provided Arnold Houbraken (his own pupil) with much information for his biography of Rembrandt published in 1718.

For those who came hoping to learn Rembrandt's manner and to profit similarly, there were two major obstacles. The first was their own native capacity. Many of them painted good pictures, or at least very passable imitations of Rembrandt, but none possessed the genius of insight that made Rembrandt unique. Learning techniques was all very well. But none of Rembrandt's followers could, or ever did, produce such brilliantly novel and successful conceptions as *The Anatomy Lesson of Dr. Nicolaes Tulp* or even *The Shipbuilder and His Wife*. The second problem was that Rembrandt's manner was not static. Those who arrived in his studio in the 1640s encountered a different Rembrandt from those he had taught in the 1630s. His style changed slightly in the mid-1630s, much more dramatically in the 1640s, when, as we shall see, he largely abandoned the Baroque style of the previous decade.

Most if not all of Rembrandt's pupils must have lived at home and worked in his studio by day, and he was forced to rent a warehouse on the Bloemgracht to accommodate them all. Houbraken, whose biography was the first by a

Dutchman and the least unsatisfactory so far (although it gives a rather disagreeable picture of Rembrandt), tells us that Rembrandt divided up the space in his studio, or the warehouse, with partitions, to enable each pupil to work undisturbed in his own cubicle. This caused a small disciplinary problem on at least one occasion, when a young man was working with a female model. If the lad were working on a nude, it was acceptable that the model might be undressed, but when Rembrandt, noticing that the others were taking a great interest in what was happening behind that particular partition, came to investigate, he discovered that both model and artist were in an equal state of nudity. The errant pupil, a quick-thinking fellow, explained that his subject was Adam and Eve, but Rembrandt was not pleased. He kicked them out, remarking that 'because you are naked you must get out of Paradise'.

Houbraken, it must be said, repeats many stories about Rembrandt that are clearly based on the kind of gossip that is always part of the legacy of a great man, arising among those who knew or claimed to have known him. He wrote at the time of a Classical revival inimical to Rembrandt's art, and his general picture of his subject presents us with an irascible and stubborn character with a great love of money (Rembrandt's pupils, says Houbraken, used to paint money on the floor for the laugh they had when he bent eagerly to pick it up). Other evidence suggests that his

picture, if exaggerated to a point not far short of
malignance, is not entirely divorced from the truth.

One way in which art students learned was by copying
the works of their masters. We do not know whether
Rembrandt employed pupils or assistants in his own work,
but since there are few indisputable traces of other hands in
his paintings, he probably did so very seldomly, if at all. On
the other hand, if we believe Houbraken, he derived
considerable income, perhaps up to 2,500 guilders per
annum, from the sale of his pupils' assignments; in other
words the copies they made of his own works, on top of the
fee they paid for tuition. He had no need to employ
assistants in the way of a Renaissance fresco painter like
Raphael, who was forced by the nature of the medium to
employ many hands to do the painting. But honest copies
can pose problems for later generations of students. A
certain dealer with whom Uylenburgh did business owned
one painting by Rembrandt as well as six copies of it. They
were all clearly labelled 'after Rembrandt', and thus
perfectly legitimate – they were naturally sold for less than
the original – but a few centuries later, matters tend to be a
good deal less orderly, hence the constant ascription, denial,
reclamation and rejection of problematical works, the
claims that keep Rembrandt experts busy, and sometimes
arguing fiercely, from one decade to the next.

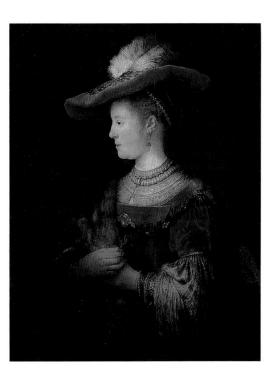

Saskia in a Red Hat, c.1634–42
Oil on panel, 391/5 x 31in
(99.5 x 78.8cm)
Gemäldegalerie, Kassel

So many exotic costumes adorn
Rembrandt and his sitters that it hardly
seems possible that they all came from
his collection, large though it was.
Given his interest in the theatre, some
may have been borrowed from the
Musyck-Kamer of Jan Hermansz. Krul.

Ganymede and Danaë

If not a single painting by Rembrandt had survived, he would still be counted a great artist on the basis of his etchings, of which about 400 survive. Some connoisseurs have claimed that he expressed as much in his etchings and drawings as he did in his paintings.

Paintings, etchings, drawings: Rembrandt recognized this hierarchy, and he seems to have regarded the categories of subject matter, in spite of his tendency to blend them, as more suited to one form or another. For example, his paintings of religious subjects or portraits often include an element of genre but, especially by comparison with his Dutch contemporaries, pure genre scenes are very rare in his paintings, but quite common among his drawings, especially during the 1630s, when he took a particular interest in what was going on around him in the streets of Amsterdam. Old folk, beggars, children and mothers, street traders, are common subjects. Landscapes, especially natural landscapes (as distinct from imagined ones), are very rare among his paintings, but they form a large proportion of his etchings and drawings. Since there are no obvious technical reasons for this selectivity, we can assume that it was the result of a form of idealism. Although early commentators tended to disregard his religious paintings, for Rembrandt they were the most important, and in portraying the Holy Family as if they were ordinary, 17th-century Dutch folk, he was expressing a Protestant sensibility, the very reverse of

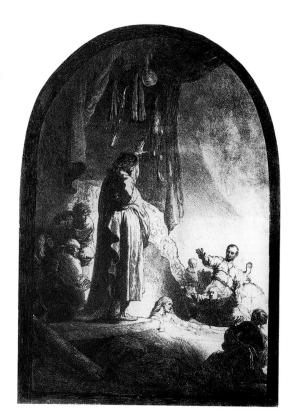

blasphemous, and a system of values comparable with the theory of Classical idealism that he was accused of scouting.

Rembrandt's mastery of etching has always been acknowledged. He probably learned the basics from his first master, Swanenburg, and some of his early efforts in Leiden show him still finding his way. In spite of the command of the medium already evident in, for instance, a Self-Portrait of 1629, done with dashing flare and confidence, at first he was inclined to try to reproduce the qualities of painting, and it was not until the mid-1630s that he finally grasped the full potential of the medium, raising it to heights rarely equalled.

From their early days, Rembrandt and Lievens etched as well as painted, often competitively (or so it appears). By 1631 they were reproducing their own paintings as prints, and they did it together, after their paintings of the same subject. An example is *The Raising of Lazarus* (page 97 right). Lievens, in his largest-known etching, reproduced his painting of the subject in a much lighter print, in which the composition is the same as in his painting but, being a print, reversed. Rembrandt, characteristically, could not resist making changes from his own painting (page 97 left), and his version (opposite) is still larger and arch-shaped. In this etching, the blaze of light is even more brilliant, and the composition is dominated by the powerful figure of Christ, whose uplifted hand seems almost physically to raise the pallid figure of Lazarus from his grave.

Etching, like engraving, is a form of print-making by an intaglio ('cut in') process – making lines or indentations in a metal (in Rembrandt's time invariably copper) plate from which, when inked, an image can be printed. The difference is that whereas in engraving lines are cut with a sharp tool called a burrin or graver, in etching, the metal is bitten out with an acid. In the oldest type of engraving, on wood blocks (prints from which are called woodcuts), it is the untouched parts of the plate that print, while in other kinds of engraving and in etching, the reverse is true – it is the incised pattern that prints.

In making an etching, the first step is to coat the copper plate with a waxy, acid-resistant ground. The etcher uses a needle to expose the metal where he wants it to print. The plate is then dipped in an acid bath, and the parts where the needle has exposed the copper are eaten away. In the method perfected by Rembrandt, the plate is taken out as soon as the lightest parts are bitten, and the lines intended to be faint are 'stopped out', to prevent them from being bitten further when the plate is redipped in the acid. The process is repeated for medium and darker lines. Finally the plate is cleaned of the remaining ground, inked, and the surface wiped clean. Rembrandt sometimes left parts smeared with ink or used his fingers to create smudges or bands, to achieve different effects. Damp paper (Rembrandt used many different kinds, including delicate, imported Japanese paper)

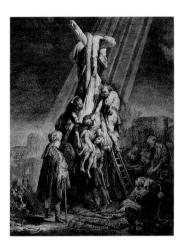

Rembrandt, with Jan Gillisz. van Vliet
The Descent from the Cross, 1633
Etching, 20^{1}/8 x 15^{7}/8in (51.2 x 40.2cm)
British Museum, London

is placed on the surface, and plate and paper are passed through the rollers of a press that resembles an old laundry mangle. Being damp, the paper is forced into the etched lines in the plate and picks up the ink in them.

It all sounds a little laborious, but the actual etching, if the etcher is as skilled as Rembrandt, could be relatively quick. In his complicated and detailed etching of *The Descent from the Cross* (right), after his painting for the Stadholder, something went wrong with the plate and he was forced to start all over again with a blank plate. There is an old story that Rembrandt's charming etching of *Jan Six's Bridge* (opposite), a Van Gogh-like fenland scene was completed, to win a bet, in the time it took his host's servant to go the village to buy mustard and come back again.

Etching was comparatively new. Although the earliest-known example dates from 1513, the technique was not fully developed until the early 17th century, the great age of etching, by such technically inventive artists as Jacques Callot (1592–1635), whose interest in beggars Rembrandt shared, the Amsterdam artist Hercules Seghers (1589–c.1638) whose paintings and etchings of landscapes surely influenced Rembrandt (he owned eight of Seghers's paintings) and, above all, by Rembrandt himself. It became the chief method of printmaking in the 17th century, while line-engraving, the oldest form of intaglio printing, gradually became restricted mainly to 'reproductive' prints, i.e. made

by a craftsman-engraver reproducing a painting or other work of art (such as a sculpture) by another artist.

All manner of subtle pictorial effects could be achieved in etching, hardly fewer than, though different from, painting in oils. They did not of course include colour; all prints were necessarily monotone. Colour could only be added by hand (though Seghers sometimes used a coloured paper, say blue, combined with yellow ink, and then touched in by hand in red, for brickwork etc.).

Another advantage is that the etching needle can make a much finer line than even a sharp quill pen. Rembrandt made full use of this in achieving minute detail and, in his landscape etchings especially, effects of space.

Rembrandt also employed the engraving technique known as drypoint, usually in combination with etching. This is the simplest kind of engraving on a metal plate, employing an instrument that is thicker than a burrin and makes a relatively deep and broad groove. Its significant characteristic is that it leaves a 'burr' of metal on the edge of the groove, which, if not smoothed off, can be employed for a variety of effects in printing. It can create a stronger – or softer for that matter – contour, or, if heavily inked and pressed, an impression of denseness, for instance of foliage. A good example is *The Omval* (page 184), a landscape etching of a view of a strip of land of that name from across the Amstel, with, to the left and in the foreground, engraved in drypoint,

REMBRANDT

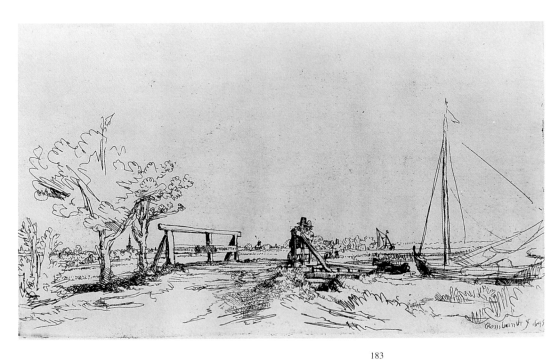

Jan Six's Bridge, 1645
Etching, 3rd state, 5 x 8⁷/₈in
(12.9 x 22.4cm)
Pierpont Morgan Library, New York

The Omval, 1645
Etching, drypoint
Pierpont Morgan Library, New York

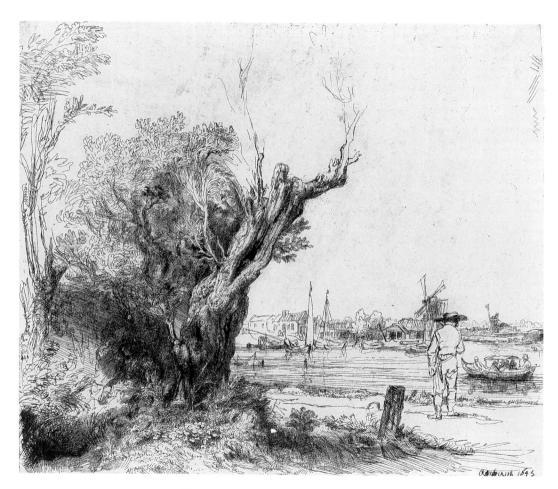

REMBRANDT

a bosky copse, in the depths of which a pair of lovers can just be made out. Being difficult to control precisely, drypoint sometimes produced a visual effect that was entirely uncalculated and unexpected, which some would find disconcerting but may well have been an attraction to a bold and innovative spirit like Rembrandt.

The great advantage of a print is that it can be mass-produced. Naturally Rembrandt's etchings could be bought much more cheaply than his paintings, there being only one painting against dozens, indeed hundreds, of prints. Rembrandt's etchings were no less popular than his paintings, and sold widely. The exact number depended on various factors, especially the technique. An engraving generally lasted longer than an etching, but with drypoint you would be lucky to get as many as 50 decent impressions.

Prints also existed in several stages, called 'states'. When the artist pulls the first proof from the press, that is the first state. He may then perhaps decide that something is not quite right and alters the plate accordingly. Prints from that are the second state. In Rembrandt's case there are sometimes six, seven or even eight states, often radically different and made over a span of many years.

While it is not difficult to summarize the main qualities of Rembrandt's art, it is very difficult to fit him into a stylistic straitjacket. He lived and worked during the Baroque period, but it is not without reason that we tend to regard the

Baroque as a Catholic – indeed, predominantly Italian – style, fired by the passion of the Counter-Reformation and generally antipathetic to the Protestant north. Certain features of Rembrandt's art can be described as Baroque, yet Rembrandt even at his most Rubenesque cannot truly be described as a Baroque painter. For example, his emphasis on emotional expression is thoroughly Baroque, but his subjects generally do not show it openly; they are, as we have seen, more inward-looking. One of his defining characteristics is honesty, not merely in his people but in the way he conveys atmosphere, light, and the feeling of things, and in that sense we may call him a Realist. And since he sometimes takes models from antique sources, we could call him a Classicist. Our desire to classify and categorize, though indispensable, can also create unnecessary confusion, and Rembrandt is a prime example of an artist who cannot be fitted into one neat and tidy box. Still, it is generally agreed that he was at his most Baroque during the 1630s, when he occasionally brought off effects that Bernini himself would not have scorned. Nor perhaps, and more pertinently, would Rubens, that formidable predecessor who was such a powerful and complex influence.

Just as Rembrandt produced different states of an etching at different times, so he painted different versions of the same subject or a subject well known from the work of other artists. In fact, 'history' painters generally reproduce the

185

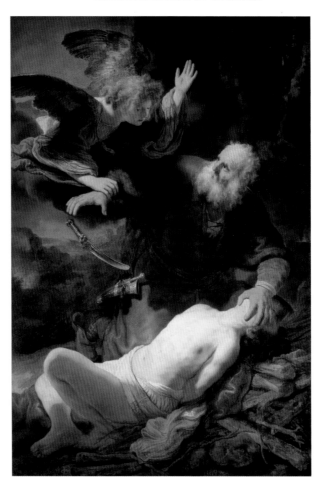

The Sacrifice of Isaac, 1635
Oil on canvas, 76^{1}/5 x 52^{1}/4in
(193.5 x 132.8cm)
Hermitage, St. Petersburg

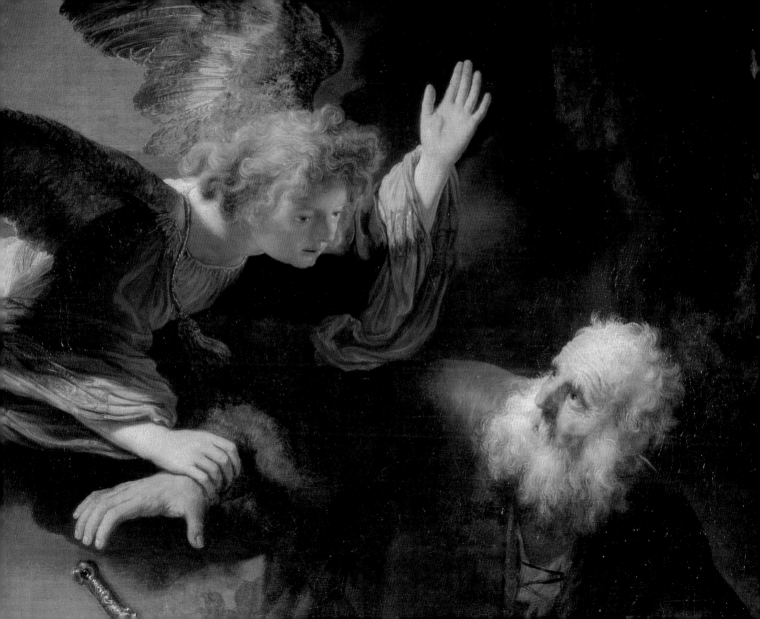

same subject matter, and a totally new subject is rare in the 17th century. Rembrandt was one of the few who actually created one and thus expanded the canon although, like other great artists, he invariably brought something new and striking to a familiar story. Among his paintings of the 1630s is one that was very popular among artists and, being highly dramatic, especially among Baroque artists: *The Sacrifice of Isaac*, as related in the Book of Genesis, Chapter 22. In Rembrandt's painting (pages 186 and 187), Abraham is about to demonstrate his total obedience to God's commands by sacrificing his only son, Isaac, only to be stopped in the nick of time by an angel, who indicates a ram, caught in a nearby thicket, as an acceptable substitute. Rembrandt exploits the intensity of the situation to the full. He chooses the instant when the angel seizes Abraham's wrist (in Genesis, incidentally, the angel is merely a disembodied voice, not much use to a painter), so that the knife falls to the ground. Abraham's left hand completely covers the boy's face and forces his head back to expose the utterly vulnerable throat, on which the angel's gaze is fixed and towards which the tip of the falling knife points. This is a truly fearful invention, and it is Rembrandt's own, though the composition may have been derived from a painting by Pieter Lastman. It is also, like many of his history paintings of this period, related to Rubens, an engraving of whose vigorous, swirling version of the subject (1620; Paris, Louvre) Rembrandt must have seen.

(Rubens actually painted the subject twice.) Another feature of this and other paintings of the period that may be accountable to Rubens is their, for Rembrandt, greater size.

There is another, slightly different version of Rembrandt's painting in Munich, which is described as 'revised and repainted [or 'painted over']' by Rembrandt. That may well be true and, if so, the painter was no doubt one of his pupils, probably Govert Flinck.

From disembodied voice to disembodied hand: *Belshazzar's Feast* (pages 190 and 191) is based on the grim ghost story told in the Book of Daniel, Chapter 5. Belshazzar, King of Babylon, presiding at a great feast with a thousand of his lords, commands the golden vessels taken from the Temple in Jerusalem to be brought that the company may drink wine from them. There suddenly appears a human hand, which inscribes mysterious words on the wall, MENE, MENE, TEKEL, UPHARSIN. The apparition fills the king with strange dread, and he scours the city for someone who can translate the words. None can, until the Queen suggests summoning Daniel, one of the Jewish captives, with a reputation for wisdom. Daniel interprets the message, which is that Belshazzar has been weighed in the balance and found wanting. The same night he is killed.

Again, Rembrandt draws from this tale a moment of intense drama. The startled faces, the King's terror-stricken face and his outstretched gold-clad arms carry the eye in a

single compelling line culminating in the fatal message on the wall, depicted upper right in a blaze of eerie brilliance, which is echoed by Belshazzar's turban. In terms of sheer theatre, Rubens himself could not have bettered the effect.

The scene, usually interpreted as a warning against luxurious living, is uncommon in Dutch art, although there is a record of a large, unidentified painting of Belshazzar sold at an auction in Amsterdam in 1625. Again, a vaguely similar composition can be found in a work of Lastman. Although Rembrandt in this period generally tended to prefer a large number of small figures in a large space, he has made no attempt to show a banqueting hall capable of seating 1,000 men and their wives and mistresses, but has gone to the opposite extreme, bringing the figures claustrophobically close to the surface of the picture. Unusual features are the use of Aramaic script, reading top to bottom and right to left, for the mysterious warning of doom and the strikingly Titianesque figure of the woman (surely too richly attired to be a waitress?) spilling her drink on the right. The painting has been cut down somewhat from its original size.

The Apocryphal addition to the Book of Daniel furnished another, more fashionable subject, that voyeur's favourite, Susanna Bathing or Susanna Surprised by the Elders, of which Rubens painted several versions. Rembrandt's relatively small panel was probably painted in 1634 (pages 192 and 193). Whereas most artists treated it as an erotic

rape, Rembrandt here chooses the moment when Susanna, while bathing, becomes aware that she is being watched from the bushes by the two elders, who subsequently threaten her with an accusation of adultery unless she yields herself to them. A sensual man not without a streak of voyeurism himself, Rembrandt was clearly fascinated by the subject, though his Susanna is notable not so much for her erotic appeal as for her vulnerability. In a later, larger painting (page 194), which was probably begun about the same time though not completed until 1647 (it was once the property of Sir Joshua Reynolds), Susanna's pose, of which there is a very polished preparatory drawing, is much the same, but the elders have emerged from their hiding place and one already has his hands on her.

Among the immigrants to Amsterdam from Antwerp were a number of Sephardic Jews who had previously been forced from their homeland in Portugal: many had names like De Castro, Mattos, Pinto and Rodriguez. They tended to settle in the area of the Breestraat, buying up the houses of merchants moving to the newly developed, more fashionable districts. Jews formed a small and therefore vulnerable minority, but they could expect a reasonable amount of tolerance, even protection, from Remonstrants in Amsterdam. Nor were all the Calvinists bigots. Still, many spoke out against the Jews, who did labour under certain disabilities. It is said that one reason why they gained their legendary

Belshazzar's Feast, c.1636-38
Oil on canvas, 66 x 82³/₈in
(167.6 x 209.2cm)
National Gallery, London

OVERLEAF
Susanna Bathing, 1634
Oil on panel, 18¹/₂ x 15¹/₄in
(47.2 x 38.6cm)
Mauritshuis, The Hague

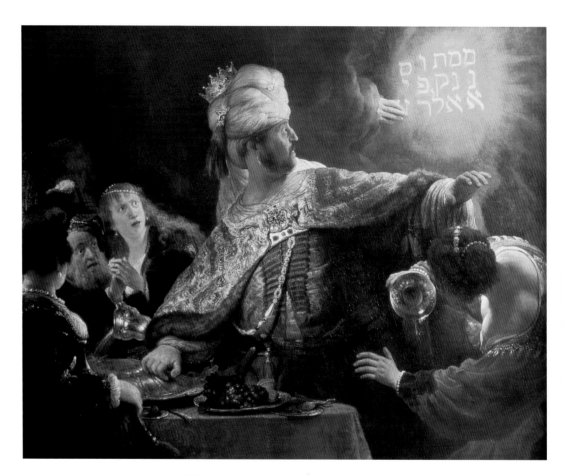

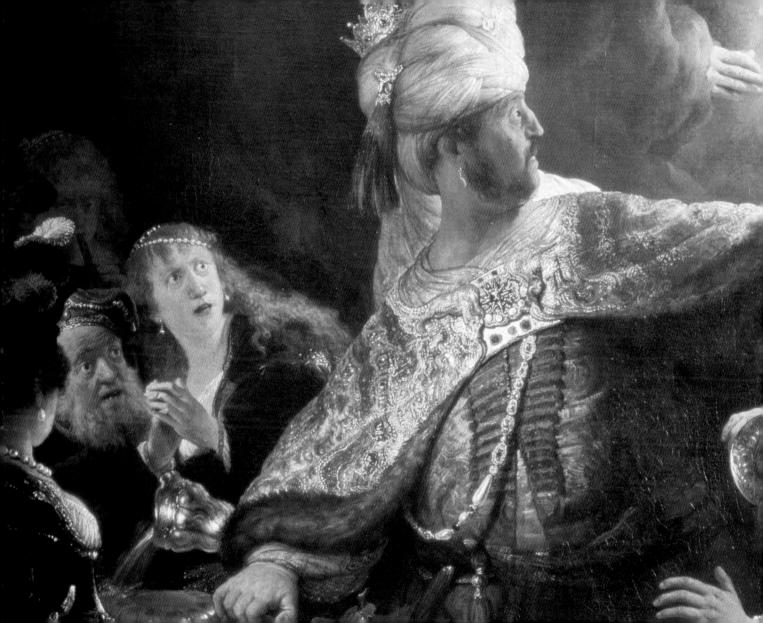

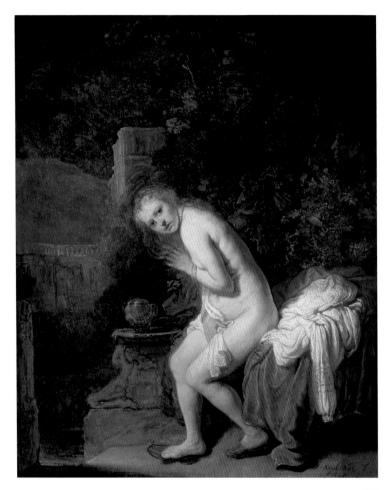

control of the Amsterdam diamond trade was that it was such a minor business then that it had no guild, membership of such organizations being generally barred to Jews. Rembrandt, needless to say, was sympathetic to the Jews, even fascinated by them, and seems to have been on friendly terms with several individuals, most notably Samuel Menasseh ben Israel, at one time a near neighbour. The form of the inscription on the wall in *Belshazzar's Feast* undoubtedly came from him, since it appears almost identically in a book Menasseh published in 1639. Admittedly, that is later than the painting, but he was acquainted with Rembrandt much earlier: Rembrandt made a portrait etching of him in 1636. He painted a number of other Jews, trying their best to appear as Dutch burghers, as well as poor Jews whom he sought out in the poorer streets. In the 1650s Rembrandt illustrated a book by Menasseh, which was written in Spanish. Menasseh was a formidable intellectual, a teacher (one of his pupils was the philosopher Spinoza) and rabbi, who knew ten languages and could write in five, including English. One of his last enterprises, completed shortly before his death, was a mission to England to persuade Oliver Cromwell to readmit the Jews, excluded since 1290, readmitted (though without formal proclamation) from the time of Menasseh's mission in 1655.

Rembrandt was far more deeply committed to the Christian Bible than he was to Classical antiquity, so it is

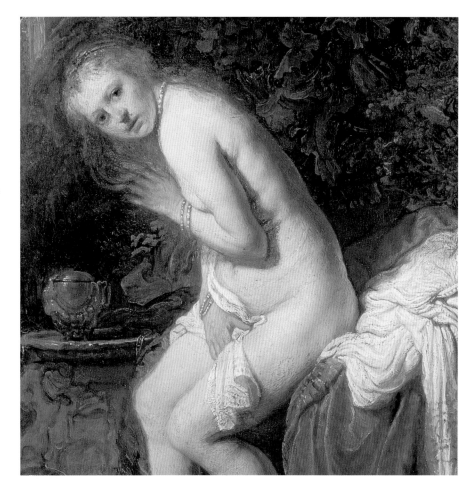

hardly surprising that among his history paintings religious subjects greatly outnumber mythological ones. There are less than half a dozen mythological subjects among his etchings, and two of those were commissioned. Among his paintings, there are perhaps a score at most, and many, probably the majority (frequently of course we have no details beyond the work itself) of those were commissioned rather than chosen. Many of them date from between 1630 and 1636.

Rembrandt's attitude to Classical idealism is discussed below, together with his studies of the nude, for which Graeco-Roman mythology offered the painter a fertile field.

Probably his earliest mythological painting is a small panel of *Andromeda* (page 116), the princess who, as the result of characteristic Olympian jealous feuding, is tied to a rock as a snack for a sea monster, but is rescued by the hero Perseus. A naked girl in chains was inevitably a popular subject, but there is nothing very erotic about Rembrandt's Andromeda, who is no nude Venus but a naked Dutch peasant girl. She looks off to the right apprehensively, perhaps because she sees, beyond the frame, the monster approaching, while Perseus has not turned up yet. That neither monster nor hero is included is very unusual, although the formidable research of Dutch Rembrandt scholars has turned up at least one possible source in a 9th-century manuscript, a copy of an antique original, that was held in the library of Leiden university and was published by

RIGHT
Susanna and the Elders, 1647
Oil on wood, 30¹/₈ x 36¹/₂in
(76.6 x 92.7cm)
Gemäldegalerie, Berlin

This painting was begun fourteen years earlier, and was based quite closely on a work by Pieter Lastman.

OPPOSITE
The Storm on the Sea of Galilee, 1633
Oil on canvas, 63 x 50in
(161.7 x 129.8cm)
Isabella Stewart Gardner Museum, Boston (stolen in 1990)

Hugo Grotius with prints by Jacques de Gheyn II. Her isolation, while foregoing the violent drama, increases the sense of her vulnerability.

The Abduction of Proserpina (page 117) was another sex-and-violence subject sometimes exploited for its erotic impact. Proserpina was the Roman goddess of the Underworld, assimilated from the Greek Persephone (though in origin she may have been a Celtic goddess of fertility). She achieved her role as a result of being carried off by Hades (ruler of the Underworld and incidentally her uncle)

while she was gathering wildflowers in Sicily. Rembrandt's painting, commissioned by Prince Frederik Hendrik and based partly on a print after Rubens, captures the violence but suppresses the erotic content by excluding nudity.

A painting of a similar scene, *The Rape of Europa* (pages 120 and 121) also avoids nudity. Zeus, in his guise as a great white bull, strides into the sea with Europa on his back and she, wearing a flowing red dress, looks forlornly towards her lamenting companions on the receding shore.

In these paintings Rembrandt organizes the drama into tight groups of small figures in a spacious, wild, imaginary landscape. Although this preoccupation is not confined to mythological paintings – another example is his *Storm on the Sea of Galilee* (right, but missing because stolen) – an even more striking one is *Diana Bathing* (1634; Anholt, Museum Wasserburg), where the composition is complicated by the inclusion of two separate stories on the same moderately sized (29 x 37-in/74 x 94-cm) canvas, which includes a couple of dozen nude figures altogether (some partly obscured), confined in a band occupying the bottom third of the canvas, below looming banks of trees and a glimpse of the sky. On the left is the story of Actaeon, a hunter who accidentally catches sight of the goddess bathing. He is turned into a stag and torn to pieces by his hounds. In the painting, drops of water have already fallen on Actaeon and metamophosis has just begun, for he is sprouting antlers. On

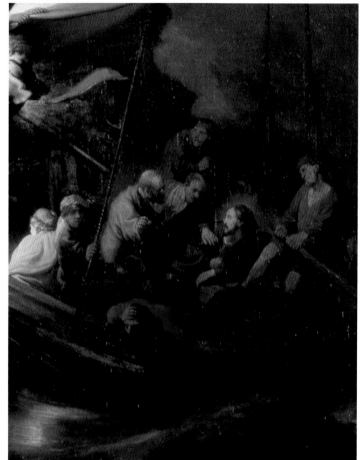

GANYMEDE AND DANAE

The Abduction of Ganymede, 1635
Oil on canvas, 67¹/₃ x 51¹/₅in
(171 x 130cm)
Gemäldegalerie, Dresden

the other side of the canvas appears the somewhat similar
predicament of the nymph Callisto, who is discovered to
have infringed her conditions of employment by getting
pregnant by Jupiter, who caddishly disguised himself as
Diana to get near enough. She too is to be turned into an
animal, a she-bear, by Juno, Jupiter's wife, and ultimately is
no doubt destined for a fate similar to Actaeon's. However,
she is saved by Jupiter who turns her into a constellation (the
Great Bear) instead. In Ovid's telling, Callisto's pregnancy is
discovered when she has to undress in order to bathe with her
fellow-nymphs in a forest pool. Rembrandt opts for a more
violent denouement, as Callisto is forcibly stripped to reveal
her swelling belly, and the brutality of the scene is
emphasized by the standing nymph, who is laughing
gleefully at Callisto's disgrace, her expression mimicking
Actaeon's grisly hounds on the other side of the canvas,
already seeing their master as a potential meal.

It was a common device in the Middle Ages and the
Renaissance to show several stages of a story in the same
picture, but Rembrandt's combination of two totally different,
if connected, stories appears to be unprecedented. The work
must have been commissioned, and if not by the court then
by some aristocratic patron, but its significance remains a
mystery.

Kenneth Clark, perhaps the greatest British art historian
of the 20th century, who delivered the commemorative

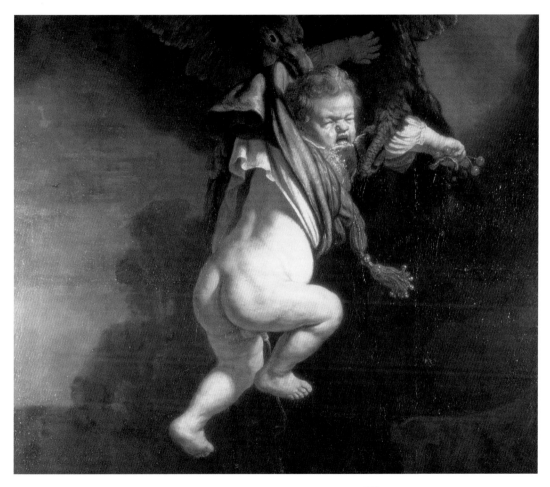

GANYMEDE AND DANAE

speech in the Rijksmuseum, Amsterdam, on the 300th anniversary of Rembrandt's death, posited the attractive and stimulating hypothesis that Rembrandt was, among other things, a rebel. But what was he rebelling against? In the present context, he was reacting against the all-prevailing concept of Classical idealism, as upheld by the Neo-Platonists of Renaissance Florence, which in Rembrandt's eyes offended against nature, indeed against reality – a reaction that was connected with his sympathy for ordinary, toiling, suffering humanity, so far removed from the near-perfect creatures of Classical art. Here he is advancing a tradition whose beginnings we may detect in Leonardo's 'humanized' Madonnas, and which was carried further by Caravaggio.

Besides that, Rembrandt objected to the spin put upon pagan antiquity by Christian, and particularly of course Catholic, propagandists. The myth of Ganymede provides an example.

According to the Greek myth, or the most common of its several variants, Ganymede was a beautiful shepherd boy, and therefore highly attractive to the sexually insatiable Zeus, who was determined to have him. Zeus sends his favourite bird, the eagle, to seize the lovely youth while he is looking after his father's flocks, and bear him away to Mount Olympus, where he becomes cup-bearer to the gods, while presumably also fulfilling more intimate duties.

Renaissance artists had found a moral, Christian interpretation of the myth, seeing the kidnapped youth as a soul fleeing the corrupt Earth, seeking Heaven and the embrace, not of a lustful old pagan deity, but of God the Father. There is obviously an echo of the Resurrection in this conception. But Rembrandt treats the subject quite differently. His Ganymede is neither a Classically beautiful youth, nor an ascending cherub, but a robust, squalling toddler, who is howling with rage and terror in the eagle's grip and pissing himself in panic ('the most memorable micturation in northern history painting' – Schama).

According to Kenneth Clark's famous but controversial theory, Rembrandt was protesting against the idealism (or unreality) of Classical art, but also, at least in the case of *The Abduction of Ganymede* (see previous pages), against Graeco-Roman morality, and the perpetuation of both these undesirables in Renaissance Italy. Clark suggested that he had in mind a drawing by Michelangelo (a homosexual) of this subject. While admiring Michelangelo's design, Rembrandt felt 'a Protestant-Christian revulsion against the sexual practices of paganism that Michelangelo's version clearly implied: for Rembrandt never looked at a motive without pondering on the full implications of the subject'.

A preparatory sketch shows that Rembrandt was delighted by the design, the dark wings of the eagle spanning the canvas, with the light illuminating the child's bawling

REMBRANDT

face and the Baroque curves of his chubby body. But he was out to shock, just as he was himself shocked by the morality that underlay Michelangelo's drawing. The child's failure to control his bladder makes that clear enough: we can imagine early observers stepping back in consternation and disapproval.

Clark found another example of Rembrandt's adoption of a similar shock tactic in his 1633 etching of *The Good Samaritan* (page 125). In the right foreground is a large, rather scruffy dog in the process of defecating, 'I suppose ... the first time this necessary action in our daily life had been recorded in art'. Besides giving us a jolt, this is meant to 'remind us that if we are to practise the Christian virtue of humility, we must not avert our eyes from the humblest of natural functions'. According to Clark, the first person to recognize Rembrandt's message was Goethe.

Rembrandt did not paint 'the Nude'. In fact the Dutch language in the 17th century had no word for 'nude', only naked, and that is what Rembrandt's nudes are: painfully realistic naked women, with swelling bellies, hanging breasts, and the marks of their garters on their legs. Critics complained that they were ugly, and not only contemporary critics. One or two etchings dated to the early 1630s, such as the *Seated Woman* and *Diana Bathing* (both page 118), do still seem gross, but they were not so to Rembrandt nor, he implied, should they be to us. Classical idealism, for

Rembrandt, had perpetrated much the same corruption of our vision of the human body as the works of Hollywood and the advertising industry have today. We should love people for what they are, not for the degree to which they resemble a Neo-Platonic marble or an airbrushed image.

The most sensual nude, and the nearest that Rembrandt came to a Classical nude, although it is not really very near, is the Titianesque *Danaë* (overleaf), variously known by one of nearly a dozen other names. It was painted in and dated around 1636 but was considerably reworked in the 1640s.

Danaë was a beautiful princess whom her father kept locked away in a purpose-built bronze underground chamber because of a prophecy that he would be killed by Danaë's son. However, like so many beautiful princesses, she had caught the eye of Zeus, who succeeded in reaching her through a hole in the roof in the form of a shower of gold (she later gave birth to Perseus, who did indeed eventually kill his grandfather, although by accident). Painters found the scene of Danaë's seduction irresistible. The shower of gold was usually represented in the form of gold coins, but to some this suggested a sordid commercial transaction, and in Rembrandt's painting she is shown, front-on and welcoming, bathed in a marvellous golden light emerging from curtains that have been invitingly parted to facilitate its passage. Some believe that Saskia was the model for Danaë, but this seems very unlikely, if only because that respectable young

Danaë, 1636
Oil on canvas, 72⁷/₈ x 80in
(185 x 203cm)
Hermitage, St. Petersburg

This painting has been described under about a dozen different names, although Danaë is now the most strongly established.

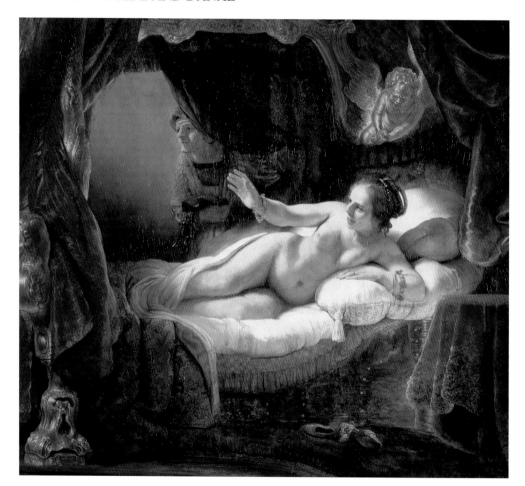

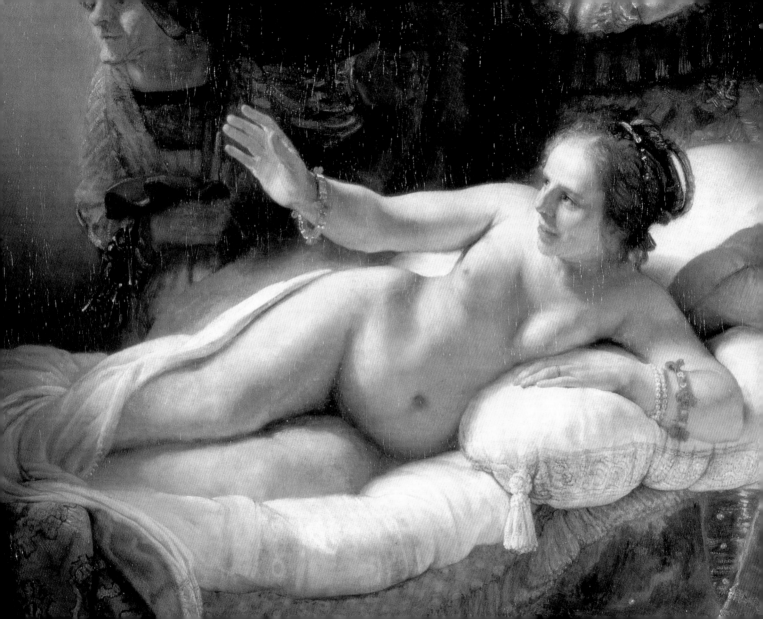

GANYMEDE AND DANAE

OPPOSITE
The Blinding of Samson, 1636
Oil on canvas, 80³/4 x 107in
(205 x 272cm)
Städelsches Kunstinstitut, Frankfurt

lady would surely have never allowed herself to be shown in such a pose.

According to Gary Schwartz, Danaë may be the unidentified painting that Rembrandt offered as a gift to Constantijn Huygens in 1639 (the more generally favoured candidate is *The Blinding of Samson*, opposite, discussed in the next chapter). Huygens politely declined the offer, partly on the grounds of its size.Assuming he was merely being too modest to accept such largesse, Rembrandt sent the picture anyway. It is not quite clear whether Huygens then reluctantly accepted it or whether he, somewhat embarrassingly, sent it back. It was later acquired by Catherine the Great of Russia who, no mean seductress herself, would have felt no misgivings about its alleged immorality. Under later, more straitlaced regimes, it was confined to a dark and obscure spot among the galleries of the Hermitage. A French critic who found it there, not without some difficulty, in the 19th century, described it as 'an indecent subject painted in a still more indecent manner'.

Although Protestants had tried to reintepret the myth as a kind of Immaculate Conception *avant la lettre*, it is impossible to believe that Rembrandt gave any credit to such a notion. His *Danaë* never lost its power to shock, ultimately with disastrous consequences. In June 1985 a demented individual, having (according to some reports)

inquired of the guards which of the Rembrandts in the Hermitage was the most valuable, walked up to it, slashed it with a knife, aiming at the groin, then flung a bottle of acid all over it. About one-third of the painting was irretrievably destroyed, and unfortunately it was the most important part, since he had aimed at the body of Danaë. The painting reappeared 12 years later, and in a way the restorers had worked miracles. Nevertheless, the restored painting is a shadow of its former self; certain details had gone for ever, and lost too was Rembrandt's miraculous shower of golden light.

Chapter Nine
Rembrandt's House

By the end of the 1630s the beginnings of a change in Rembrandt's style were becoming apparent. One crude and imperfect way to describe it is to say that he ceased trying to emulate Rubens and became more himself. It may also have had something to do with the apparent severance of his connection with Huygens, for after the rejection of the painting, whether it was *Danaë* or *The Blinding of Samson*, little further contact between them is recorded after 1639 and, strangely, Huygens, the first man to recognize Rembrandt's genius, seems to have ignored him for the rest of his career. Probably more significant than this personal rupture (if it was a rupture), was the fading away of court patronage. Frederik Hendrik had always leant towards the Flemish school, and, although one or two commissions for Rembrandt did materialize from The Hague in the 1640s, the Stadholder, perhaps prompted by Huygens, had concluded that Rembrandt was not another Rubens and that other painters were more congenial.

Whether of not the failure of court patronage had anything to do with it, Rembrandt was becoming more self-conscious, and his style more thoughtful and more personal. Inevitably, perhaps, that led to a drift away from the fashionable world, a tendency no doubt encouraged by his growing inclination to follow his own way, regardless of commercial demands. None of this happened dramatically, not in an instant, not in a single year. But portrait

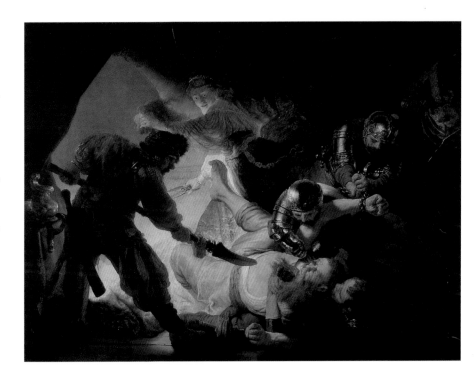

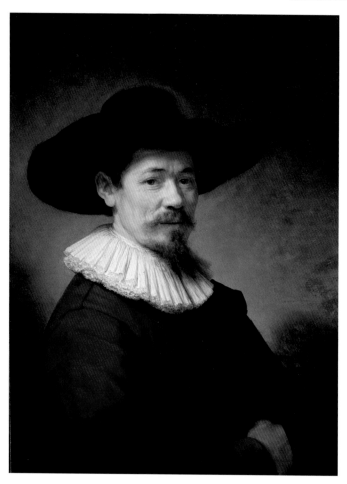

commissions grew somewhat fewer, and a greater proportion
of them were of personal friends and acquaintances, which (it
is tempting to suggest) with Rembrandt is often an indicator
of quality.

The much-admired portrait of Herman Doomer (pages
204 and 206) is a case in point. Doomer was a rural
craftsman who had settled in Amsterdam and become a
successful frame-maker, in which capacity he worked for
Rembrandt. There is a companion portrait of Doomer's wife
Baertjen Martens (1640; St Petersburg, Hermitage), and we
know from her will that these paintings were the family's
most treasured possessions. They were left to the eldest son
on condition that he had copies made for his siblings. The
portraits, especially of the husband (one of Rembrandt's
best), make it almost equally clear that in spite of what we
assume to have been a considerable social and intellectual
divide Rembrandt had a genuine liking for Herman Doomer
and his amiable-looking wife. Their son Lambert (16 years
old at the time Rembrandt painted his parents) became his
pupil and assistant, and the paired portraits were probably
part of the business arrangements between Herman and
Rembrandt.

Another couple painted by Rembrandt at this time were
Nicolaes van Bambeeck and his wife Agatha Bas (opposite).
Although they were neighbours, and the husband probably
knew Rembrandt through Uylenburgh's business in which he

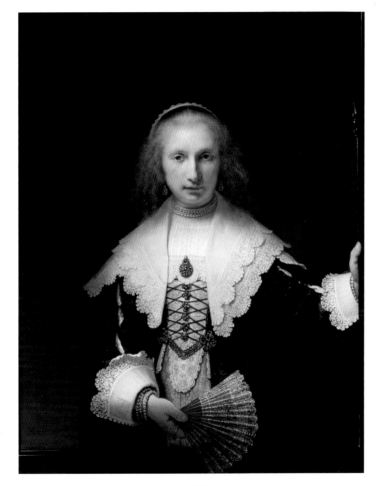

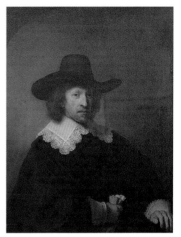

OPPOSITE
Portrait of Herman Doomer, 1640
(detail on page 206)
Oil on panel, $29^{5}/_{8}$ x $21^{3}/_{4}$in
(75.2 x 55.2cm)
Metropolitan Museum of Art, New York

LEFT
Agatha Bas, 1641 *(detail on page 207)*
Oil on canvas, $41^{3}/_{8}$ x 33in
(105.2 x 83.9cm), Royal Collection,
Buckingham Palace, London

ABOVE
Nicolaes van Bambeeck, 1641
Oil on canvas, $42^{7}/_{8}$ x $32^{3}/_{4}$in
(108.8 x 83.3cm)
Musées Royaux des Beaux-Arts, Brussels

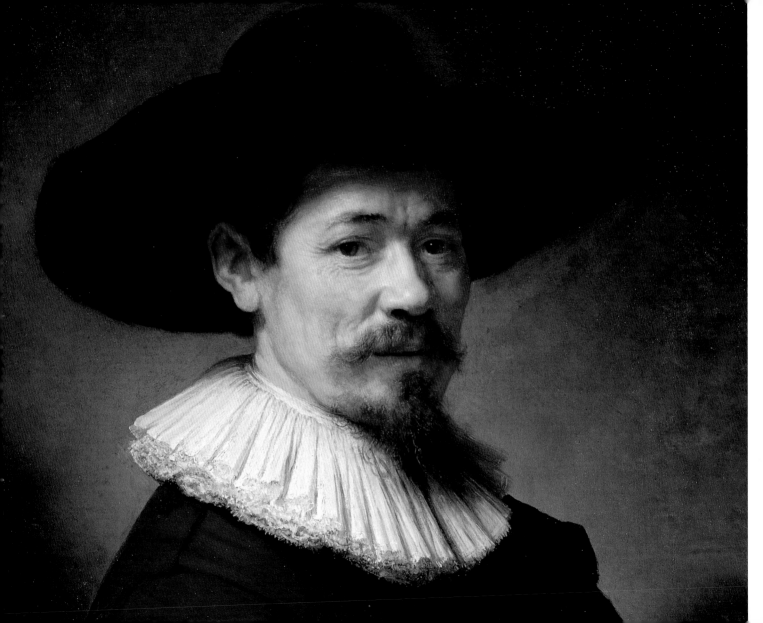

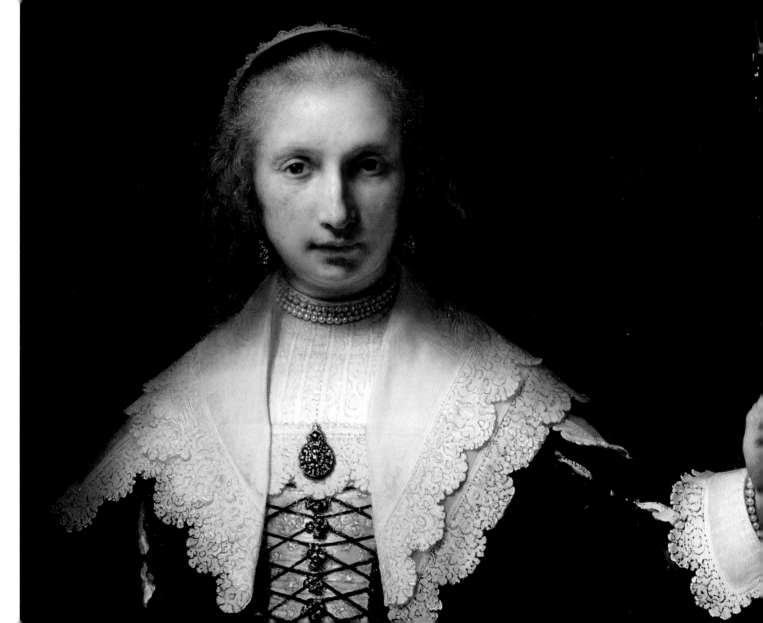

OPPOSITE
Double Portrait of Cornelis Claesz.
Anslo and His Wife, Aeltje Gerritsdr.
Schouten, 1641
Oil on canvas, 69^1/$_4$ x 82^5/$_8$in
(176 x 210cm)
Gemäldegalerie, Berlin

was another investor, it is unlikely that their relationship was any closer than that. He was a well-to-do cloth merchant, like many others who sat for Rembrandt, but his wife belonged to the Amsterdam elite, her father being a former burgomaster and a governor of the East India Company. This posed a minor problem of etiquette for the painter: husbands, of course, came first, but in this case the wife's superior background could not be entirely ignored. Agatha appears appropriately submissive, as a good wife should, and plainly dressed, but touches of gold and satin hint unmistakably at her wealthy background and, to our eyes now, her portrait is much more interesting than her husband's.

When painting so many portraits of people who invariably dressed in similar ways, in black and white exclusively, and who naturally had a fairly clear expectation of what their portraits should look like, Rembrandt's constant problem was to find means of giving them individuality. With his endless ingenuity, he never seems to have run out of ideas, even if they were sometimes borrowed (all good artists were, and indeed still are, borrowers); at this time he shows a particular interest in contriving illusionist effects.

We have seen that on one or two occasions, having painted a picture he also painted a frame around it, and in these portraits he does something similar. Agatha Bas is shown frontally, and she is framed in an opening, like an empty picture frame, arched at the top and cutting her off at

about hip level. The fan in her right hand overlaps this frame, and her left hand rests on the side. Most of this hand is concealed by the frame, and all we actually see is a thumb curling around it. Simon Schama thinks that this thumb 'is one of the most extraordinary things Rembrandt ever painted, for it manages, in its utterly convincing solidity, to make its owner uncannily three-dimensional, materially present in some place between here and there, between reality and illusion'. The effect is furthered by the blank but glowing space, suggesting depth, within the frame behind her. (Unfortunately, these effects do not show up well in reproduction.)

One subject who was probably both a friend of and an influence on Rembrandt was the Mennonite preacher Cornelis Claesz. Anslo. The Mennonites did not have ordained ministers and their services were led by the most effective preacher among the congregation. Anslo was a merchant and shipowner, trading in cloth and other goods, chiefly in the Baltic region; as Rembrandt's portrait with its oriental carpet and fur-trimmed cloaks suggests, he was, unlike Herman Doomer, a fairly wealthy man. According to a biographical note written over a century later by his great-grandson, Anslo 'filled the office of teacher or minister of the Mennonites out of love and dependability, [earning] neither a salary nor any other material advantage'. In 1767 this descendant still owned Rembrandt's large *Double Portrait of*

Cornelis Claesz. Anslo and His Wife, Aeltje Gerritsdr. Schouten (right), in which the preacher is shown explaining a text from the Bible, which lies open before him, to his wife who, as their great-grandson put it, is 'depicted with incomparable art [listening] attentively and with visible concentration'. The great poet Joost van den Vondel, who had earlier belonged to the same congregation as Anslo and heard his sermons, urged Rembrandt to 'paint Cornelis's voice', something rather harder to depict than his wife's attentiveness! The figures occupy barely more than half the width of the canvas, the remainder being centred on the great Bible, propped up for extra prominence and more highly lit than anything else bar the faces and hands, which emphasizes the importance of the Scriptures for sects such as the Mennonites. There is a preparatory drawing for the painting dated 1640 (Paris, Louvre), and an etching loosely based on it. This includes a detail that has intrigued scholars: a picture (not present in the drawing) hanging on the wall behind Anslo has been reversed, so that we see only its back. If this is in deference to the Mennonite aversion to images, why not just remove it? And is it not rather odd to include a painting or image, even reversed, in another image? Symbols in Rembrandt are relatively few compared with some contemporaries, but naturally there are many that we do not understand and others that we do not recognize as such.

In spite of his own humble origins and his strong,

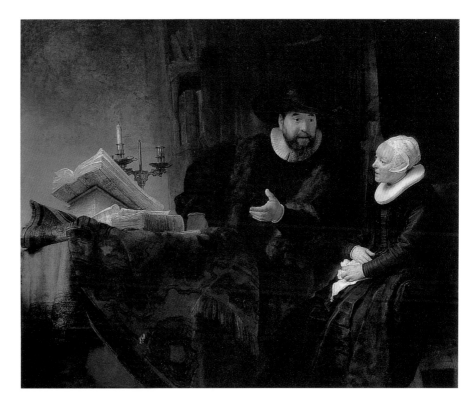

RIGHT
Self-Portrait with a Dead Bittern, 1639
Oil on panel, 47¹/2 x 34³/4in
(120.7 x 88.3cm)
Gemäldegalerie, Dresden

OPPOSITE
Girl with Dead Peacocks, c.1639
Oil on canvas, 57 x 53¹/3in
(145 x 135.5cm)
Rijksmuseum, Amsterdam

instinctive sympathy with the poor and disadvantaged, Rembrandt, being human, also had aspirations to gentility and, as we shall see in the next chapter, he was painting himself about this time as a well-established, self-confident gentleman about town. He was, after all, very successful, and by this time he enjoyed an international reputation. A French painter, completely unconnected with him, sent his compliments to 'Mynheer Rembrandt' via a mutual acquaintance, and an English visitor in Amsterdam, writing of the thriving state of Dutch painting in 1640, mentioned only one artist by name – Rembrandt.

This tendency to upward social mobility, which was no doubt strengthened by material success and by marriage to a girl of the gentry class was demonstrated early in 1639 when Rembrandt became, at last, a householder. He bought a large house (now the Rembrandthuis) in the Breestraat, next door to the house where he had spent his earlier years in Amsterdam with the Uylenburghs. When Rembrandt left the Uylenburghs in 1635, they had moved out too, though not far, and the dissolution of the combined household suggests that Uylenburgh, for whatever reasons, may have been less delighted by Rembrandt's marriage to his cousin than might have been supposed.

In May Rembrandt and Saskia, pregnant with her third child, moved into their mansion, which had been built in the year of Rembrandt's birth (though not completed until 1607).

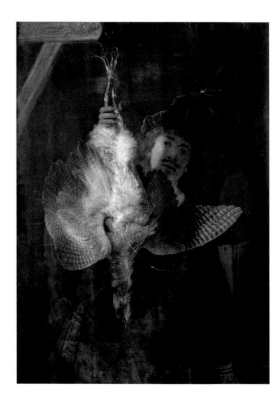

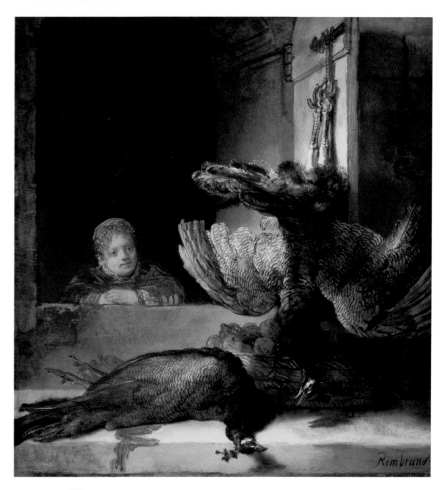

Rembrandt, and no doubt Saskia too, must have been delighted. But there was a snag. He could not afford it. The total price was 13,000 guilders and, under the terms of the purchase, Rembrandt agreed to pay one-quarter of that amount in three instalments, within one year. He was to pay the remainder as and when he wished within a maximum of six years. On the outstanding sum he would pay interest at five per cent. As things turned out, Rembrandt was never able to fulfil these commitments.

Unfortunately, there is a slight mystery here which is likely to remain unsolved because we do not have enough data on Rembrandt's finances. We do not know, for example, exactly what the income he derived from Saskia's inheritance amounted to; it may well have been less than Rembrandt had anticipated. Nor do we know exactly how much money he made from his various professional activities and his presumed investments. It is certain that, since splitting with Uylenburgh, who came to prefer Govert Flinck as a portraitist, his commissions had diminished, and his position as the outstanding artist of Amsterdam was no longer assured. On the credit side, he was picking up some aristocratic patrons, landowners like those who moved in the circle of the Graeffs, the most powerful in Amsterdam. His *Self-Portrait with a Dead Bittern* (left) in which he appears as a hunter with his trophy, and the *Girl with Dead Peacocks* (right) suggest that he was becoming acquainted with

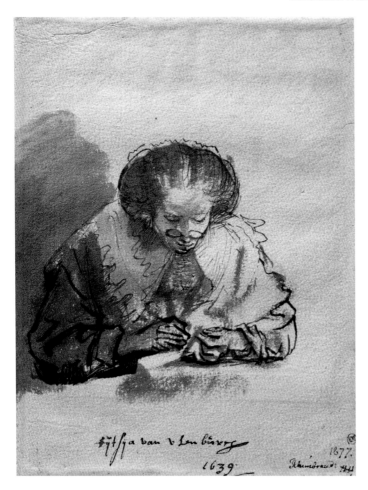

country-house society. These connections, as well as gaining him the commission for several portraits and, indirectly, for the picture known as *The Night Watch*, may also have nurtured his view of himself as a member of the gentry.

It would seem that Rembrandt was very well-off, and his prospects, if somewhat changed, were still undoubtedly good; but 13,000 guilders was a great deal of money, many times what the average burgher would have paid for his comfortable but less pretentious house, which would have been little more than half the width of Rembrandt's expansive frontage. As we know, Rembrandt was not by nature economical, far from it, but the suggestion that his spending on unessentials was disastrously subversive of his wealth is hardly convincing, even though his collection of props and fancy dress was enough to furnish a large theatrical costumier. In his last exchange of letters with Constantijn Huygens, regarding delivery of the last two Passion paintings in 1639, Rembrandt requested (27 January) that 'whatever His Highness grants me for the 2 pieces, I may receive this money here as soon as possible...' In a second letter, he pressed for a fee of 1,000 guilders for each painting, having received only 600 guilders each for the previous ones (he did not get it). So it is clear that in the month in which he signed the contract for his house and needed to think of raising the money for the deposit, Rembrandt was experiencing some kind of cash-flow

problem. It was to prove a chronic condition.

The Breestraat itself was changing, slipping slightly down the social scale as the aristocrats moved out to be replaced by wealthy and cultured Jewish merchants from Portugal via Antwerp, among them their rabbi and Rembrandt's friend, Menasseh ben Israel. Later, the name of the street would be changed from St. Anthonisbreestraat to Jodenbreestraat (*Joden* meaning 'Jews'). There were still artists there, however: another neighbour was the painter Nicolaes Eliasz. Pickenoy.

Visitors tend to agree that today Rembrandt's House, as a memorial to its most famous resident, is something of a disappointment. When it was converted into a museum many years ago, the interior, already no doubt much changed from Rembrandt's time, had to be completely rebuilt to accommodate crowds of visitors, and the visitor today has no sense of its being the home of a 17th-century artist. There are of course many interesting Rembrandt memorabilia, including a splendid collection of etchings, but as Anthony Bailey wrote (*Rembrandt's House*, 1978), 'If you go hoping to find Rembrandt's house much as he lived in it, with oil paint on the studio floor, grease on the kitchen ceiling, his smock hanging behind a door, and children's toys on a bed, the let-down may be considerable.' Even the façade is different, as at some time the original stepped gable was replaced by a uniform upper storey topped by a Classical pediment (the suggestion that this enlargement took place before Rembrandt moved there has not gained wide acceptance although it may have been done at some time after he moved out but before his death). The street itself is, understandably, entirely different today. It is a broad urban highway, achieved by flattening many buildings. Perhaps we should be grateful that Rembrandt's House has survived in any form.

In July 1640, within three months of moving in, Saskia's third child, Cornelia II, was born. In August she died, to be followed the next month by Rembrandt's mother, who was buried in the Pieterskerk, Leiden. Almost exactly a year later, in September 1641, Saskia's fourth child, a boy, was born, the only one of her children to survive infancy. He was named Titus after Saskia's favourite sister, Titia, wife of François Coopal. She seems to have spent a good deal of time with the family, and there is a charming drawing of her in reed pen and wash (opposite), bending over her sewing with pince-nez perched on the end of her nose.

Saskia did not live to see her only surviving child take his first steps. In 1639 Rembrandt had made an etching that, a few years later, must have been seen as a grim omen, *Death Appearing to a Wedded Couple from an Open Grave* (page 214). A well-dressed young couple – they might be Saskia and Rembrandt five or six years earlier – are greeted

OPPOSITE
Portrait of Titia van Uylenburgh, 1639
Reed pen and wash
Nationalmuseum, Stockholm

by the skeletal figure of Death, ascending from a pit. The husband appears to be introducing his wife, who holds a flower, to this figure. Death, leaning on his scythe, shows her an hourglass indicating that time has run out.

Saskia's final illness may have begun with the birth of Titus. In the small etching, *Saskia Ill*, not dated but undoubtedly 1642 and the last portrait of her, her face bears no resemblance to the plump and healthy girl Rembrandt had married. With painful, inescapable honesty, Rembrandt records the shadow of death in her gaunt features and tired eyes. She died in June and was buried in the Oude Kerk.

The terms of Saskia's will, made a few days before her death, suggest her total confidence in Rembrandt. Their joint estate amounted to over 40,000 guilders, which confirms that they were still very comfortably provided for and makes one wonder why Rembrandt was forced to buy his 13,000-guilders house almost entirely on credit. By law, half of the combined estate belonged to Rembrandt and half to Saskia; again, we cannot tell how much represented Rembrandt's income and how much came from his wife's inheritance. Saskia left her half to Titus, under a trustee-type arrangement which allowed Rembrandt to use it until Titus came of age or married, provided the capital value remained intact. This concession would cease should Rembrandt marry again. He was to be the sole guardian of Titus, and the official body that normally administered the estates of

Death Appearing to a Wedded Couple from an Open Grave, 1639
Etching
Metropolitan Museum of Modern Art, New York

orphans was expressly barred from interference. Rembrandt was also formally excused from rendering an account of his administration of the estate or compiling an inventory of possessions. As is, sadly, so often the case, several provisions of the will, which were clearly intended to make things as easy for him as possible, proved in time to have the contrary effect.

As many experts have warned, it is inadvisable to make judgments about an artist's life and feelings from the evidence of his or her art. In the case of Rembrandt in particular, perhaps because his numerous self-portraits tend to encourage such speculation, it can only be misleading. Rembrandt's self-portraits at a given time, so far as we can tell, bear no relation to what one would expect him to be feeling about himself or life in general, often the opposite. It must be added that Rembrandt's biographers, having issued these wise warnings, have generally proved themselves incapable of obeying them!

Many writers have speculated why, during this period particularly, Rembrandt should have been so absorbed by the story of Samson, the great warrior-hero of the Old Testament. Of course, since we do not know the early provenance of the paintings concerned, except that they all ended up eventually in Germany, it is possible, though unlikely, that the actual subjects were specifically commissioned. Samson was especially popular with Baroque

214

artists because the stories about him offered so much drama – rage, violence and high emotion.

Samson, notoriously, was let down by a woman, in fact two women, most famously Delilah, who betrayed him to the Philistines for a bribe, but also, at an earlier stage, by his wife. Herself a Philistine, she was regarded by the author of the story in the Book of Judges as a deliberate plant by Samson's enemies. She wheedled out of him the answer to the riddle which he posed to the guests at their wedding feast and duly passed it on, enabling them to win their wager with Samson but provoking him to war.

Was Rembrandt afraid that Saskia would betray him to the 'Philistines' – the upper-class Calvinists of her family? It would not be surprising if, at first anyway, he felt insecure, even threatened, among such people, superior to him in class though not in intellect; but to suppose that the Samson and Delilah theme is evidence that Rembrandt was not happy with his marriage is surely to jump to a too-facile conclusion.

Moreover, Rembrandt's first painting based on the Samson story, *The Capture of Samson* (page 96), dates from his Leiden days. It was based on a sketch in oils by Jan Lievens, whose subject, the most popular one among painters, is the pivotal moment when the sleeping Samson is deprived of his hair (the secret of his great strength) and taken prisoner by a Philistine snatch-squad. It is not a particularly well-known painting today, but it is among the

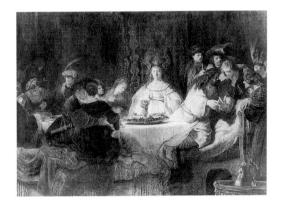

best of Rembrandt's early works, and the figure of the leading Philistine, approaching the sleeping Samson on tiptoe, wonderfully conveys a turbulent emotional combination of excitement, caution and apprehension.

When, despite her giving away the riddle, Samson returns from slaughtering a few Philistines to reclaim his bride, he is met by her father who explains that, thinking Samson hated her, he has given her to the best man instead. He offers his younger, prettier (according to him) daughter in exchange. Samson is not appeased, though the text does not say he went so far as is suggested in Rembrandt's painting of *Samson Threatening His Father-in-Law* (above right), a

ABOVE
Samson Threatening His Father-in-Law, c.1635
Oil on canvas, 62³⁄₈ x 51³⁄₈in (158.5 x 130.5cm), Gemäldegalerie, Berlin

ABOVE LEFT
Samson Posing the Riddle at His Wedding Feast 1638
Oil on canvas, 49⁵⁄₈ x 68⁷⁄₈in (126 x 175cm), Gemäldegalerie, Dresden

Peter Paul Rubens with Frans Snyders
Prometheus Bound, 1618
Oil on canvas, 95¹/₂ x 82¹/₂
(242.6 x 209.5cm)
Philadelphia Museum of Art

painting which, in spite of the general popularity of Samson, seems to be the first picture of this particular incident, at least in Dutch art. It is original in other ways too. A furious Samson shakes his great fist in the face of his father-in-law who, however, amounts to no more than a disembodied head sticking out from the casement, one hand gripping the shutter, ready to close it smartly. As usual, Rembrandt's Biblical figures are strikingly human and contemporary.

Altogether more theatrical is *The Blinding of Samson* (page 203), one of the most shocking pictures ever painted: 'Only a genius could have done anything so consistently horrifying' (Clark). Samson, illuminated, like Danaë, by the light streaming in through parted curtains, struggles on his back in the grip of soldiers. One of them has a wrist chained. Another, pinned beneath him, has his forearm across his throat. A third is in the act of plunging a knife deep into his eye, which spouts brilliant red blood. No less horrific in a different way is Delilah as she makes off, brandishing scissors in one hand, Samson's shorn hair in the other, and glancing back at Samson with an expression of devilish glee on her undeniably beautiful face.

The violence is accentuated by the generation of tremendous energy achieved largely through the contrary backwards crash of Samson and simultaneous forward rush of Delilah, who races in the opposite direction, into the glaring light beyond the curtain. These fierce diagonals are

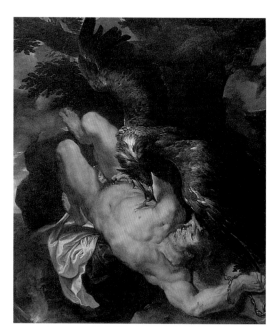

balanced by the dark, threatening, statuesque figure with a levelled halberd in the left foreground. The painting is often cited as an example of Rembrandt at his most Baroque, though Kenneth Clark made the objection that its jagged

movement and the absence of unifying flow contradict the purist's definition of Baroque. This, rather than *Danaë*, is also said to have been the picture that Rembrandt pressed as a gift on the reluctant Constantijn Huygens in 1639.

Notwithstanding its many original features, Rembrandt's *Blinding of Samson* had antecedents, most recently Rubens's *Prometheus Bound* (opposite), in which the eagle rips out its daily ration of liver while carelessly planting one of its talons in Prometheus's eye, and before that a similar subject by Titian. Engravings of both pictures would have been available to Rembrandt.

The last and perhaps best of this group of Samson pictures is *Samson Posing the Riddle at His Wedding Feast* (page 215 above left). This takes the moment when, as described above, Samson puts his riddle to the wedding guests: 'Out of the eater came forth meat and out of the strong came forth sweetness' (Book of Judges, Chapter 14). The answer, leaked by his bride, was of course the dead lion, slain by Samson, in whose carcass a swarm of bees had made honey. The painting was praised for the authenticity of its Eastern costumes and furnishings (couches instead of chairs), not something Rembrandt was at all pedantic about as a rule, and many observers have particularly admired the figure of Samson, a leonine creature himself with his mane of hair, and the telling gesture of his hands as he turns to expound the riddle.

There is also, however, something that might be considered mildly shocking about this painting since, as all critics agree, the composition is based on the great New Testament masterpiece of Leonardo, *The Last Supper*; the Philistine bride, a powerful, isolated figure presiding over the feast like a great, bland queen bee and directing her blank, slightly pop-eyed stare straight at us, is based on Leonardo's Christ. Since Rembrandt never visited Italy he had not, of course, seen Leonardo's fresco (or what was left of it), but he had seen a 16th-century engraving, of which he had made a fairly free copy. The animated wedding guests, 12 in number like the Apostles, also owe something to Leonardo's design, although the arrangement is more complicated. The face of the Philistine bride, incidentally, seems to be the face of Saskia.

To our loss, Rembrandt kept no diary and wrote no memoirs, but he did leave a remarkable pictorial autobiography, a record unlike any other artist before or since. He painted self-portraits at the rate of about one per year on average, though less during his middle period than in youth and when old. On top of that, he produced innumerable self-portrait etchings and drawings.

Why? Rembrandt was no exhibitionist. No doubt he was as interested in himself as most people, but that is hardly the explanation. The self-portraits are not, as those of certain other artists (Dürer, perhaps, even Rubens, who actually

Leonardo da Vinci
The Last Supper, 1495–98
Fresco. approx. 29 x 15ft (8.8 x 4.6m)
Santa Maria delle Grazie, Milan

REMBRANDT

painted very few), an attempt to create an image, to picture himself as something he aspired to be rather than what he actually was. He did not attempt to disguise his rubbery features or his big, shapeless nose – 'the ugly and plebeian face by which he was ill-favoured', as Filippo Baldinucci described him (1686). On the contrary, what makes his self-portraits so sympathetic is their unblemished honesty. Rembrandt, as one of his modern biographers wrote, 'seems to open his heart to us. We have the feeling that he is keeping nothing back'.

It was largely this cumulative image that resulted in the popular idea of the artist as an independent, incorruptible, uncompromising individualist, a conception that appealed especially to the Romantics and is still current today. Yet in a way, as applied to Rembrandt, this is the opposite of the truth. The end result of Rembrandt's 40 years of self-analysis is not 'the artist as genius', it is 'the artist as Everyman'.

Rembrandt's aim, above all others, was to give visible form to human feelings. He was also, as we know, a major portrait painter, and self-portraits make up a sizeable proportion of them. For the artist, and especially for Rembrandt, self-portraits have considerable advantages, largely resulting from the reduction of the three-way relationship – between artist, subject and observer – to just two, since artist and subject are the same. When the subject is a third person, various considerations are involved which

restrict the artist's freedom of manoeuvre, but when the subject is himself, he is in full control of the production. He can wear what clothes he likes, adopt any pose or any expression, tinker with the lighting, and so on. Additionally, he is not under any obligation to produce an accurate likeness. He can treat himself either as the subject, or as a model. And finally, if the purpose of a portrait is to convey the character of the subject (as well as his or her appearance), who is better equipped to do so than the subject himself?

Self-portraits were particularly common in Rembrandt's early years in Leiden. No doubt the egotism of youth was partly responsible, but they are not all like the elegant young gentleman of 1629 (page 42), or of the same year wearing a gorget (page 54), or the picture of c.1630 in the Walker Art Gallery in Liverpool (page 94). Some, like the etchings mentioned below, are much less prepossessing, for there were other, more important motives at work. At that date he did not yet have a supply of wealthy burghers queuing up to have their portraits painted. He needed a subject, and the most convenient one available to him was no farther away than a mirror. He needed practice too. In a series of small etchings dating from about 1630–31, Rembrandt portrays himself leering idiotically, aghast with sudden shock, frowning ferociously, snarling with rage, etc. This is surely not only an angry young man expressing himself. He was

219

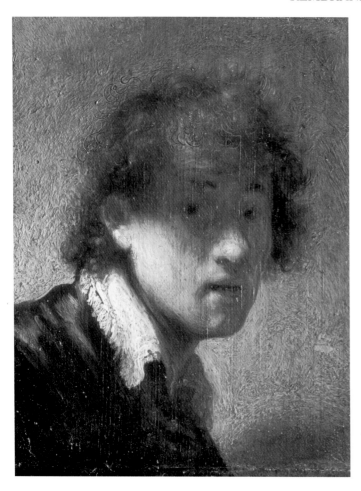

also experimenting with extreme emotions, to see just what they did to the features, and how the tightening of skin, wrinkling of eyes, curling of lip, tensing of jaws could be reproduced.

This also helps to explain the astonishing variety of Rembrandt's self-portraits within a brief span of time. No more than a year separates the smooth and superior young gentleman in a plumed hat from the sensitive, unconfident, untidy young artist with shaded eyes (left) and the 'cackling simian' of a 1630 etching. Indeed, as one Rembrandt expert remarked, if someone comes across two Rembrandt self-portraits that strongly resemble each other, it is safe to assume that one of them will turn out to be a student's copy.

As with other works, although we usually know exactly where they are to be found today, the early history of the self-portraits is hard to trace. Rembrandt eventually seems to have given up landscapes, partly at least because they did not sell very well, but he never gave up self-portraits. Although he did few in his middle years, from 1650 onwards they became almost as frequent as in his youth. Although he also did many quick drawings of himself, the self-portrait paintings are as finely worked as any other subject, and he seems to have had no greater difficulty finding customers for them than he did for his history paintings. Since they also include etchings, we must assume that they were comparatively popular.

Not long before his move to Amsterdam, the moustache, having made shadowy appearances earlier, became a permanent fixture, though in other respects his features remained infinitely variable. Throughout the 1630s, most of the self-portraits show him more in the role of model than subject. In many cases it is difficult to be certain that they really are self-portraits, and perhaps that does not matter very much. The significance of role-playing is confirmed by the frequency of his adoption of exotic costumes. It was at this time that Rembrandt's production of commissioned portraits

OPPOSITE
Self-Portrait as a Young Man, 1629
Oil on panel, 6^1/8 x 5in (15.5 x 12.7cm)
Alte Pinakothek, Munich

LEFT
Raphael
Portrait of Baldassare Castiglione, before 1516
Oil on canvas, 32^1/4 x 26^3/8in
(82 x 67cm)
Louvre, Paris

FAR LEFT
Rembrandt after Raphael
Portrait of Baldassare Castiglione, 1639
Pen and brown ink, brush and brown wash, white body colour
6^3/8 x 8^1/8in (16.3 x 20.7cm)
Graphische Sammlung Albertina, Vienna

Titian
Portrait of Ariosto (Man with a Quilted Sleeve), c.1512
Oil on canvas, 32 x 26¹/₈in
(81.2 x 66.3cm)
National Gallery, London

was at its height, and it might seem reasonable to suppose that the prevalence of rich and colourful clothes in paintings of himself was a reaction to the uniform black-and-white of all his commissioned portraits, and that he dressed up Saskia as Flora for the same reason. The fact that some of these fancy-dress portraits are etchings, however, throws some doubt on that supposition.

We have seen how one of the problems for portrait painters is to find a design or a pose for their sitters which is not merely a routine reproduction of a dozen others, and also the way in which Rembrandt solved the problem in his pair-portraits of Nicolaes van Bambeeck and his wife Agatha Bas. He employed another fertile device in 1639, although this time it was not invented but borrowed. A big art collection was auctioned in Amsterdam, and among the outstanding items was Raphael's *Portrait of Baldassare Castiglione* (page 221 right). Rembrandt always attended such sales, and although not even Rembrandt could contemplate buying a Raphael, he took the opportunity to sketch a copy of the painting (page 221 left). It fetched 3,500 guilders, and it was bought by a well-known international dealer, Alphonso Lopez. He was probably an acquaintance of Rembrandt's as Rembrandt had seen another gem of his collection, Titian's *Portrait of Ariosto* (left). (Actually, it seems that the subject is probably not Ariosto, and the painting is sometimes called *Man with a Quilted Sleeve*.) The combined effect of the

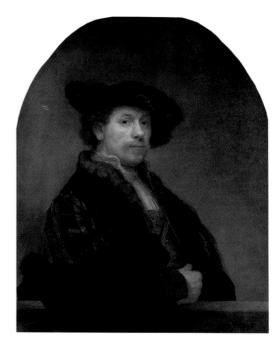

Raphael and the Titian appeared in Rembrandt's self-portrait etching, with Van Dyck beard, of 1639 (opposite) and in his *Self-Portrait* of 1640 (above), in both of which the leading

arm rests on a ledge. (In the Raphael, as it happens, the position of the arm is not quite the same, but it is in Rembrandt's copy, which he perhaps made from memory when he got home.) In other respects, Rembrandt's 1640 self-portrait is not very Titianesque. The *chiaroscuro* is very much his own, and he has moderated the rich Venetian colours. He adds a little touch of Baroque illusionism in having the sleeve flop over the ledge on which he leans.

The London portrait is quite deliberately impressive. Great men are seldom unaware of their greatness and, in spite of his humility, Rembrandt knew that he possessed gifts beyond the ordinary. In this painting, a half-length only a little less than life-size, he manifests his conviction of his worth. As usual it is signed simply with his first name, 'Rembrandt', in the manner of some of the Italian Renaissance masters. No other Dutch master signed his works in that way.

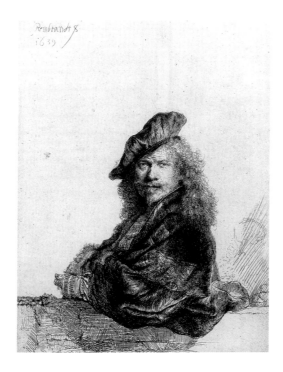

OPPOSITE RIGHT
Self-Portrait, 1640
Oil on canvas, 36⁵/₈ x 31¹/₂in
(93 x 80cm)
National Gallery, London

LEFT
Self-Portrait, 1639
Etching and drypoint, 8 x 6³/₈in
(20.5 x 16.4cm)
Rijksprentenkabinet, Rijksmuseum,
Amsterdam

Chapter Ten
The Night Watch

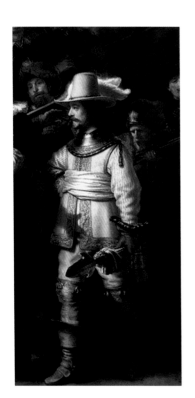

In the same year that Saskia died, 1642, Rembrandt completed what is probably his most famous, most written-about, and second-largest painting. Known, quite inappropriately but – since the name dates from the 18th century – now unalterably, as *The Night Watch*, it is a group portrait of members of a company of the Amsterdam civic guard. It has had a wildly fluctuating reputation, and if it is not at present the best-loved of Rembrandt's works, it is still generally regarded as representing 'the apogee in Rembrandt's painting' (Christopher White) and 'the crowning glory of ... all of Baroque art' (Simon Schama). It also marks something of a watershed in Rembrandt's career.

The greater the fame of a work of art in a public gallery, the greater the danger of demented attack, and *The Night Watch* has also suffered the attentions of a lunatic with a knife, though fortunately with less disastrous consequences than the Hermitage's *Danaë*.

The significance of the civic guard dated from the crisis of May 1578, when Amsterdam, a little belatedly some would say, abandoned its loyalty to King Philip II and embraced the cause led by William of Orange. The existing city council was expelled and a new council elected. Of course there was little that we would regard as 'democratic' about this. What actually happened was that the companies of the civic guard each chose a representative, and these elected a new council, which naturally consisted of their own members. The long-term result

was to confirm the grip of the Amsterdam oligarchy on the government, with membership of the militia companies as the main, if not the only, path to power. The system lasted, though not without a few crises, for over 200 years.

Originally, the purpose of the civic militia was purely military – to defend the city – and it acted also as a police force in cases of serious disturbance. The 20 companies were divided into bowmen and musketeers (strictly, arquebusiers). Their headquarters, or *doelen*, were large buildings originally intended primarily as shooting ranges but also comprising banquet hall, tavern, etc. There were three of these, one of which, the Kloveniersdoelen, backed on to the Amstel only a few doors away from Rembrandt's (rented) house in the Nieuwe Doelenstraat. There *The Night Watch* would hang for over 70 years, together with seven companion paintings of other companies by other artists. The building had been much enlarged in the 1630s and the new Great Hall, some 65$\frac{1}{2}$ft long x 33ft wide (20 x 10m), with a ceiling nearly 16$\frac{1}{2}$ft (5m) high, was the most spacious chamber in the whole of Amsterdam.

By this time the original, military purpose of the civic guard had almost disappeared. Although it retained some policing duties and still maintained its military traditions and ceremonial, the company was largely an upper-crust social club, while at the same time being the nearest approach to a representative assembly that the city contained. The captains

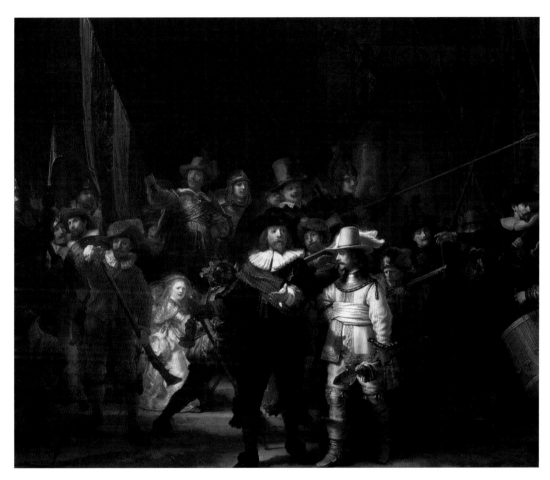

The Militia Company of Frans Banning Cocq, known as The Night Watch, 1642
Oil on canvas, 143 x 172³/₈in (363 x 438cm)
Rijksmuseum, Amsterdam

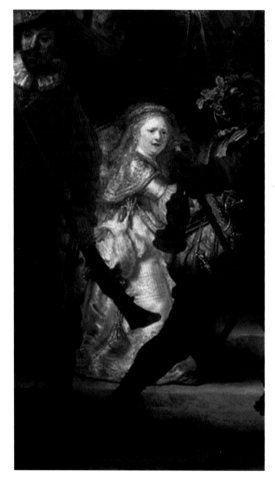

The Night Watch (details)

and lieutenants of the companies reported to one of two colonels, and through them the views of the members of the companies, numbering about 4,000 altogether and including most of the leading burghers, might be heard.

We have already noticed the fashion for group portraits of members of the same profession, committee, or other group, and Rembrandt had announced himself in Amsterdam by painting one of the most notable examples hitherto, *The Anatomy Lesson of Dr. Nicolaes Tulp*. The eight paintings of the militia companies, of which *The Night Watch* was one, were commissioned to decorate the new Great Hall of the Kloveniersdoelen. Rembrandt's commission probably dated from 1640, and the painting thus occupied him for about two years. The prime mover in such an enterprise was the captain of the company and, in this case, probably the governors of the *doelen*, and the picture was paid for by the captain, his lieutenant and other members of the company who featured in the painting, the size of their contribution being reflected in the prominence of their portraits. Rembrandt is said to have received a total of 1,600 guilders, with the members contributing an average of 100 guilders each. A shield in the background lists 18 names (they were added later), and although there are 26 figures in the painting (some partly obscured), several are 'extras'. There still seem to be 19, not 18, musketeers present although there is uncertainty in one case.

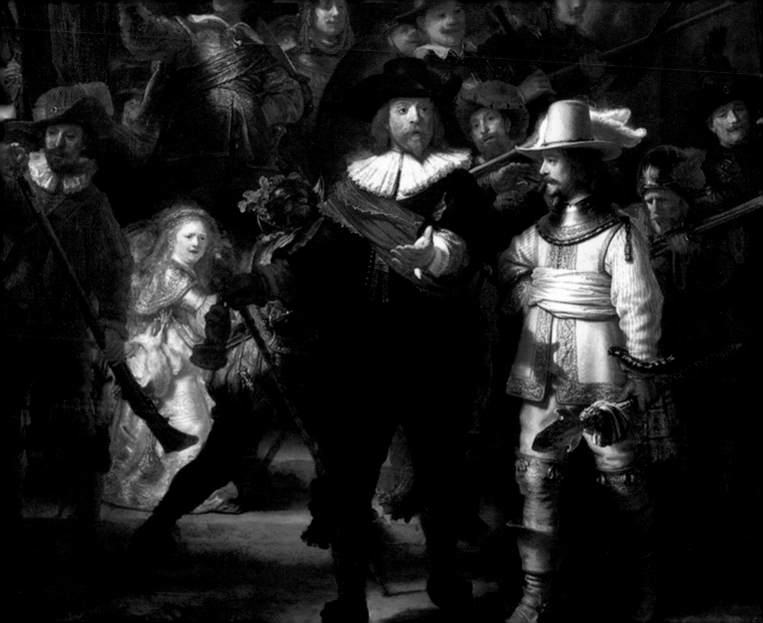

The Night Watch (details)

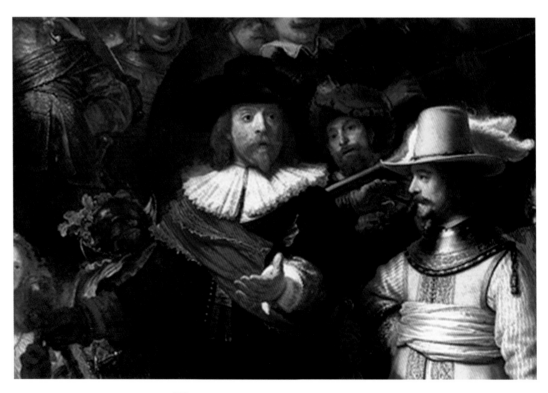

The captain of this company was Frans Banning Cocq, who appears in the centre foreground, mouth slightly open in speech and gesturing forearm brilliantly foreshortened, at a moment when, according to a note in his family album, he is giving an order to his lieutenant to move the company out. The lieutenant, Willem van Rutenburgh, on his left was, like his captain, a patrician of rather recent creation, his family having made its fortune in the grocery business, and Rembrandt gives him almost equal prominence with Banning Cocq by means of the bright creamy yellow of his leather coat (how disappointing it would have been for Rembrandt if the musketeers had worn a uniform!), contrasted with Banning Cocq's more conventional black, although its plainness is alleviated by a gorgeous red sash. Several men are checking their weapons, but they are more likely going to a shooting match than any fiercer engagement.

According to Kenneth Clark, Captain Banning Cocq 'is said to have been the stupidest man in Amsterdam and,' he adds not unjustly, 'he looks it.' It is a pity that the central focus of the painting is not a more prepossessing face, but Banning Cocq's alleged stupidity did not prevent him from becoming a doctor of law at Poitiers, nor from being fantastically rich and, ultimately, a powerful figure in the Amsterdam hierarchy. He was a not untypical representative of the city's *nouveaux riches* of the early 17th century, for his father had been a humble apothecary, or pharmacist, who did

The Night Watch (detail)

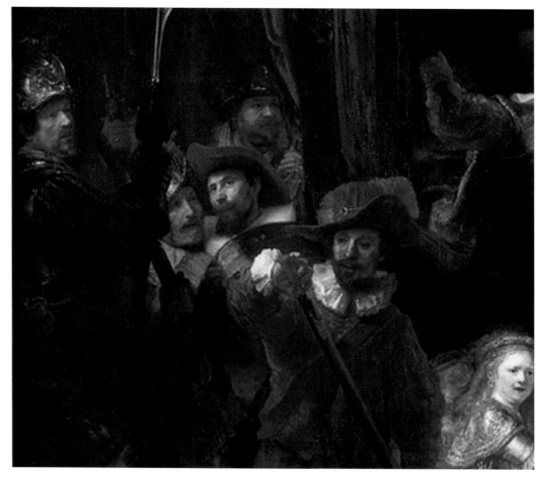

very well and married an heiress (the source of the Banning in the family name). Frans inherited a fortune, which was greatly augmented by his marriage to a daughter of the powerful Overlander family. She brought him property and titles as well as cash in the bank, and he had no need to occupy himself with earning a living but rose steadily through the Amsterdam hierarchy, eventually becoming a burgomaster.

It seems unlikely that those who commissioned Rembrandt's *The Militia Company of Captain Frans Banning Cocq*, as it should really be called, had not done some research into the accomplishments of their chosen artist. They must have been familiar with the painting of Dr. Tulp's anatomy lesson, and therefore they must, or should, have known that Rembrandt was unlikely to produce a conventional group portrait of the kind that, as Samuel van Hoogstraten remarked of the companions to *The Night Watch* in the Kloveniersdoelen, look like packs of playing cards. Rembrandt was prepared to sacrifice portraiture to composition, without compromise, and this is a brilliant invention, nothing like any other group portrait. Far from a placid assembly of faces, it is a picture of action and energy, 'a work so explosively animated that it threaten[s] to march across the room', as the company advances into sunlight from the dim recess of the archway behind. Some of the figures are much more clearly portrayed than others, and

there are a number of other figures – dwarves, children, the almost obligatory dog – that have nothing to do with the commission but were introduced by Rembrandt exclusively for pictorial effect. Past writers looked for symbolism, but there is comparatively little, except for such incidentals as the bird tied to the belt of the young girl with prominently displayed claws, which represents the badge of the company, or the great arched doorway at the back that, while anchoring the composition, may also represent the gates of the city that the militia companies were sworn to defend. It is fundamentally a naturalistic painting, while also being an extraordinarily complex design in movement, light and colour, all drawn together by the most finely detailed *chiaroscuro*. Such a painting, which has not a dull moment, in which all the figures are moving yet the composition remains stable, is the result of pictorial skill of the highest order combined with deep and perceptive study.

The painting has always had its critics. Classicists naturally thought it incoherent and indecorous, and even Hoogstraten, who admired it greatly, thought it could have been a little lighter. Yet the painting as it is today makes one wonder how it could ever have been thought a night-time scene. This must have been the result of age, hastened by sharing an atmosphere with large and smoky peat fires. The picture has now been cleaned, and looks again as it did in the early 18th century, when someone describing it remarked

that 'strong sunlight prevails in the picture'. That was about the time it was moved to the old Town Hall, when it was trimmed on all sides but particularly on the left, where nearly 24in (60cm) was removed. Such cavalier behaviour may make us break out in a cold sweat, but it was actually quite frequent practice to cut down a painting to make it fit a different space. In this case, the effect was to unbalance the composition slightly: originally, the archway at the back was in the centre, not towards the left. A copy of the original made in about 1650 shows what else has been lost – a couple of minor figures and clear evidence that the space in front of the arch into which the musketeers are advancing is a bridge over a canal.

Together with its seven inferior companions, the painting reached its third and final home in the Rijksmuseum at about the beginning of the 19th century, and soon afterwards more myths about it began to proliferate. It was said that *The Night Watch* was a grave disappointment to those for (and of) whom it was painted, including Captain Banning Cocq, that some had refused to pay the agreed fee because they did not appear to full advantage, and that this fiasco undermined Rembrandt's reputation in Amsterdam, causing the diminution in his fortunes in the later 1640s. How do these legends get started? This one held its ground for over a century, in spite of the fact that it rested on no shred of evidence. What we do know about its reception supports an

opposite view. Captain Banning Cocq, for instance, had two copies made, one for himself, one for a family album, so he can hardly have disliked it. Rembrandt was undoubtedly taking a gamble in supposing that Banning Cocq and his men would prefer to see themselves, not as mere faces on a canvas, but as part of a great drama, integrated within a dynamic manifestation of martial spirit. But the gamble worked.

We cannot know why Rembrandt put such effort into this particular picture, surely not, after all, a subject to inspire him? Perhaps the most convincing view of the matter is that this is, over and above its many other important characteristics, a painting about painting, a tremendously ambitious personal statement that proclaims the greatness of the art that Rembrandt practised. No doubt it was also a bid for business, for the patronage of the city to replace the lost patronage of the court, and in that respect it was arguably less successful. But 17th-century Amsterdam was not 16th-century Rome and public patronage there hardly compared with that of the Catholic Church. So large a project as the eight paintings for the Kloveniersdoelen was almost unique.

Close examination reveals some fascinating details. At the very back of the painting, behind the left shoulder of the ensign carrying the company's gold and blue standard, appears a part of a face that its possessor cannot possibly have paid to have included as it consists of no more than one

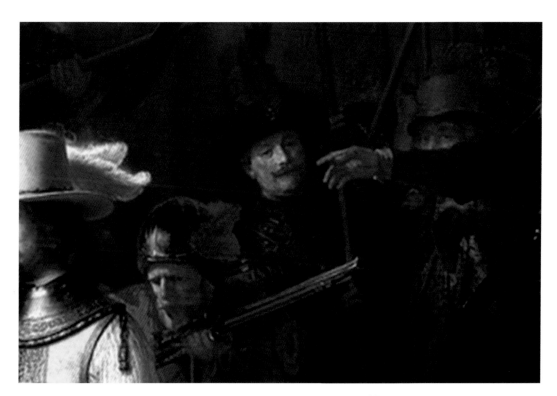

The Night Watch (detail)

The Three Trees, 1643
Etching, 8³/₈ x 11in (21.3 x 27.9cm)
Fitzwilliam Museum, University of
Cambridge

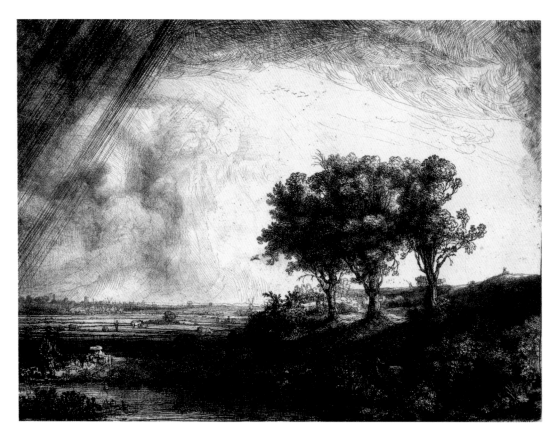

eye, turned towards the standard, and the beginning of what might be a rather bulky nose. The head is topped by what looks like the type of beret worn by painters. The spectator would hardly notice it but for a stray beam of light that falls upon that shrewd, observing eye.

By completing *The Night Watch* Rembrandt had, in a manner of speaking, got something off his chest. He never again painted a picture which seized the spectator's attention by force of the tremendous action going on, nor, with one exception, did he ever again paint a picture quite so large. There were no more theatrical, Baroque spectaculars on this scale. It was as if the relationship between the painting and the spectator was reversed. The 'inwardness' of Rembrandt's art became even more pronounced, and the spectator had to seek out its qualities rather than witness their proclamation. This introspective mood is already evident in the London *Self-Portrait* of 1640. It would be wrong to say that his industry declined, for he was always the most fertile and productive of painters, and if the pace did slacken during the 1640s that was not, as we shall see, entirely because he was underemployed. His interests underwent a subtle change, and he began to look elsewhere, for instance at the scenery around him.

From about the time that Rembrandt moved into his house in the Breestraat he seems to have taken a much closer interest in his surroundings. Perhaps it was the result of

becoming a property owner, for there is nothing like buying a house to excite a proprietorial interest in the neighbourhood. After the death of Saskia, he must have been lonely, with time on his hands, and perhaps he felt a need to get away from people. At any rate, he took to taking occasional country strolls, which was comparatively novel behaviour. Two or three generations earlier, the idea of going for a Sunday walk to enjoy the view and the fresh air would have seemed very strange (sometimes dangerous). But now Rembrandt would have seen plenty of his fellow citizens out for a stroll, following the Amstel to the south, to the farms and villages in the vicinity of Amsterdam. We tend to assume he went alone on these walks, but this may not have always been the case. A note on a drawing of one of his favourite places by a fellow artist, Philips de Koninck (some of whose landscape drawings are easily confused with Rembrandt's), suggests that he may have accompanied him on at least one occasion, and his pupil Lambert Doomer may have been with him on his one extended sketching tour to eastern Holland.

No doubt Rembrandt had made local sorties often enough before, and the beginnings of his interest in landscape date from the late 1630s, before the purchase of his house and well before the death of Saskia, but now he looked at his surroundings with a more observant, more interested eye. In a sense he 'discovered' his environment for the first time, since most of his earlier landscapes (chiefly drawings but

also a few paintings) tended to be generalized or imagined views, often of mountains with dramatic storm clouds making great light effects, rather than particular places. Most might have been set more or less anywhere, whereas the landscape drawings and etchings of the 1640s show a close and sympathetic awareness of particular locales, both in the villages and countryside, and in the city itself. This change in attitude which can be traced in his landscape etchings to a certain extent echoes the changes in his painting that occurred after *The Night Watch*. However, the landscape etchings of the early 1640s are mostly quite simple (*The Three Trees*, page 234, is a dramatic exception) and must have had a relaxing effect after the demanding labours of *The Night Watch*.

Although his most frequent course must have been south along the Amstel or east along the Diemerdyke, the raised embankment beside the IJ, he was occasionally to be found farther afield, perhaps on business or visiting friends, in Haarlem in 1651 and, earlier, on a longer trip to the east, when he travelled as far as Arnhem on the Rhine, taking in Utrecht and Amersfoort and the little town of Rhenen, south-east of Utrecht. The intensity of his analysis of the area in which he lived, says Christopher White, 'has only been equalled by Cézanne in Aix-en-Provence'.

Since these landscapes, all dating from a relatively short period, were predominantly drawings and etchings, they help to explain the reduction in the output of paintings during this period. Most of Rembrandt's biographers have wondered why he should have preferred the medium of etching or drawing to painting for landscapes. One obvious, if unhelpful, answer is that his etchings are superior: the medium suited his intentions better. It is significant that naturalistic (as opposed to imaginary) landscapes are markedly less common in the paintings, although we should not jump to conclusions here as it is possible that he made many more of these than we would suppose from the few survivals. The inventory of his possessions made in 1656 mentions a number of small landscape paintings that cannot be traced, and one or two of these are described as 'done from nature'. The *Landscape with a Stone Bridge* (right) and the *Winter Landscape* of 1646 (page 238) are comparatively rare examples in this category. The latter, which is quite small, cannot have been exactly 'done from nature', which the cold weather (one can almost feel the icy chill in the air) would have made impracticable, but it is undeniably naturalistic and, being relatively broadly painted, it may have been a sketch rather than a finished painting. It is significant that, although the landscape is the subject, there is human interest too, as indeed there is in most of Rembrandt's landscapes (occasionally the human figures rather obscure the view!), for, whatever the medium, human beings were always his most fundamental interest.

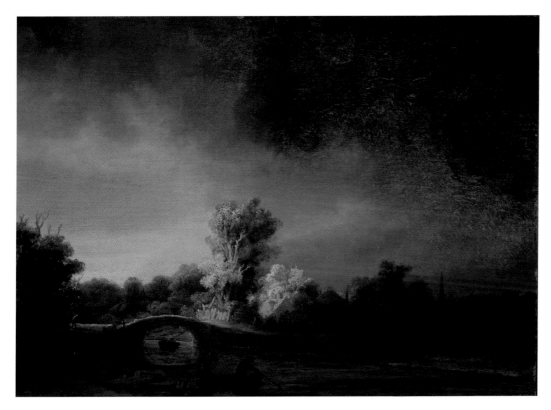

Landscape with a Stone Bridge, c.1638
Oil on panel, 11⁵/₈ x 16³/₄in
(29.5 x 42.5cm)
Rijksmuseum, Amsterdam

Winter Landscape, 1646
Oil on panel, 6⅝ x 9in (17 x 23cm)
Gemäldegalerie, Kassel

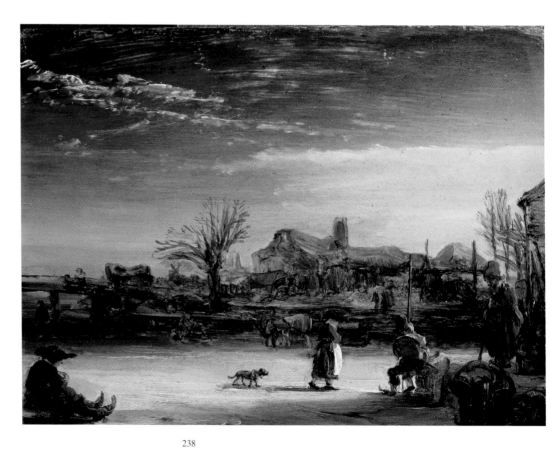

But, so far as Rembrandt's landscape paintings as a whole are concerned, they are seldom based on a study of nature and they are not even very 'Dutch'. In general, the sense of the open air, and the balance of light and space and air, are brilliantly captured in etchings, but are virtually absent from the paintings, partly though not entirely because of the different characteristics of the medium. The paintings form a small but distinct category of their own not shared by any other Dutch, or for that matter any European artist, except perhaps by certain pupils, for it is possible that some of those attributed to him may have actually been the work of Govert Flinck. They were not, it would seem, particularly popular in his own time. Shortly after Rembrandt's death, a painting that cannot be identified but was possibly the *Landscape with a Castle* of c.1640 (Paris, Louvre) was valued at a mere ten guilders. If, as some writers surmise, Rembrandt adopted landscape as a hopeful alternative to portraits, the move was not a success. The poor market must be at least part of the explanation why Rembrandt gave up landscapes almost entirely after 1654. This again raises the question of those landscapes – a dozen paintings in all – that have disappeared since being named in the inventory of 1656. Interestingly, several landscapes by Govert Flinck listed among the possessions of contemporary Amsterdam collectors, are also lost. One painting previously assigned to Rembrandt, which has recently been reattributed to Flinck, may not be the only example.

As usual, Rembrandt adopted an unconventional approach to landscape painting, one unrelated to Classical tradition. A typical 17th-century Dutch landscape by say, Jacob van Ruisdael, has trees on both sides, opening out a vista in the centre. Rembrandt places his subject – a mill, a church or, most typically, a farmhouse, in a clump of trees – in the middle distance, with a wide, flat, relatively featureless expanse in front (as in the *Winter Landscape*). As Michael Kitson remarked, these works provide a surely unparalleled visual source for the Dutch agrarian economy in the mid-17th century.

The simple, purely naturalistic style Rembrandt adopted was closer to the early Dutch masters of landscape, such as Esaias van der Velde (c.1591–1630), than to contemporary Dutch landscape painters, such as Jan van Goyen (Esaias van der Velde's pupil) and the greatest of them, Jacob van Ruisdael. They were moving towards a more Romantic style, temperamentally closer to the type of imaginary landscapes that Rembrandt was leaving behind.

In his landscape etchings, nearly all done between about 1640 and 1653, Rembrandt gradually refined his style, and made increasing use of drypoint, with which, in spite of its being basically a linear medium, he created an effect akin to that achieved by pen and wash in his drawings. He used

many different kinds of paper, with a special liking for absorbent Japanese paper, creamy or greyish rather than dazzling white, which made the most of the soft, blurring effects of drypoint. Because of the technical problems, etchings were not of course done outdoors but in the studio, although Rembrandt may sometimes have started on the prepared metal plate with the subject in front of him. That was more easily done with drypoint, a more practicable method than etching out of doors. The drawings, however, or at least some of them, may well have been done entirely from nature, though the majority were probably finished in the studio, perhaps worked up from a sketch made on the spot with a metalpoint pencil.

Some etchings, such as *Jan Six's Bridge* (page 183), derived from visits to the country houses of his patrons, but he found most of his subject matter in districts that he could reach in about one hour's walk from home. It probably took a little longer than an hour to reach the village of Diemen, one of his favourite subjects, to the south-east of Amsterdam. Despite the changes of the last three-and-a-half centuries, many scenes that Rembrandt drew and etched can still be recognized today. *The Omval*, mentioned previously, is one example. The distinctive tower of the church in *View of Diemen* (c.1650) is an unmistakable landmark, as is the church in his view of Harlem in the etching known as *The Goldweigher's Field* (page 242), and many others are equally

easily identified (though in an etching they are of course reproduced in reverse). Most of the etchings are difficult to date exactly. Style is often the only guide – but not always a very reliable one.

Although the term *stilleven* ('still life') does not occur until 1656, examples of 'fruit' or 'flower pieces', 'breakfast pieces' (simple food and drink on a table) and the moral-message type known as a *vanitas* were well established in northern Europe much earlier (a *vanitas* – from the Latin – was a reminder of the vanity and brevity of life, incorporating such motifs as a skull, a burned-down candle or an hour-glass running out – as in Rembrandt's etching, *Death Appearing to a Wedded Couple from an Open Grave*). In fact still lifes were popular in ancient times, and although chiefly associated with the Netherlands, they were far from unknown in Italy and southern Europe. Among their antecedents, no doubt, were the paintings of plants in medieval manuscripts on the curative qualities of herbs.

This is another minor class of painting which on present evidence we would assume Rembrandt hardly broached, but we know, again from that invaluable 1656 inventory, that a small number of what were presumably still lifes were executed or, as the inventory says, 'touched up', by Rembrandt, implying that the basic painting was done by a pupil or assistant. Of course, if Rembrandt did not sign them, like the missing landscapes, they may still be

ABOVE
The Goldweigher's Field, 1651
Etching
Rijksprentenkabinet, Rijksmuseum,
Amsterdam

RIGHT
The Slaughtered Ox, 1655
Oil on panel, 37 x 27¹/₅in (94 x 69cm)
Louvre, Paris

adorning a gallery or private house unrecognized.

Actually we cannot be sure that all those in the inventory were strictly still lifes. Several are described as a *vanitas*, while others were of 'hares', 'greyhounds', and 'a bittern'. Rembrandt's *Girl with Dead Peacocks* can surely be classed as a still life, since the peacocks are so much more prominent than the girl, and so, at a pinch, can the *Self-Portrait with a Dead Bittern*, but if the paintings of hares and greyhounds mentioned in the inventory were of living animals, they would fall into a different category.

Whether regarded as a still life or an animal painting, the most sensational picture of the type ever painted by Rembrandt, or perhaps by anyone else, is surely *The*

REMBRANDT

Slaughtered Ox (left), which is signed and dated 1655. Another version in the Glasgow Art Gallery (right) is somewhat smaller and more smoothly, even pedantically painted, with a maid in the background scrubbing the floor instead of peering from a doorway as she does in the Louvre version. It bears a questionable signature and is not dated, though it must be at least 12 years earlier, probably more, and is generally thought to be the product of Rembrandt's studio but not the work of the master himself. It would be very interesting to know more about it, because the most notable features of this painting are the startling originality of the concept and the curiously disquieting effect on the emotions of this massive, flayed carcass which still makes manifest the colossal strength and mass of the living beast.

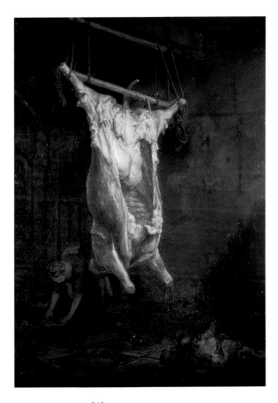

243

The Slaughtered Ox
Oil on panel, 28⁷/₈ x 20³/₈in
(73.3 x 51.8cm)
Glasgow Art Gallery and Museum

Girl Leaning on a Window Sill, 1645
Oil on canvas, 32¹/₈ x 26in
(81.6 x 66 cm)
Dulwich Picture Gallery, London

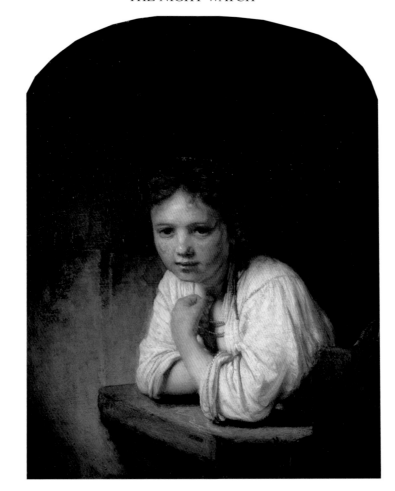

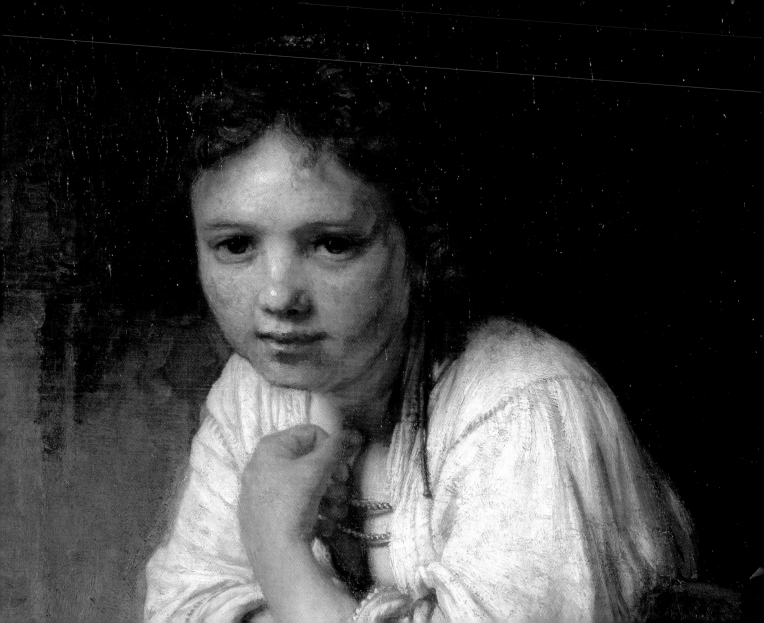

Chapter Eleven
Two Women

In the early 1640s, Rembrandt clearly needed more help at home. Saskia was ill for a long time before she died in 1642, and since there was no suitable relative willing and able to fill the breach, Geertge Dircx was hired as Titus's nurse. She was the widow, still young, of a ship's bugler, and she probably joined Rembrandt's household in 1641. After Saskia's death she became his mistress. According to Samuel van Hoogstraten, who was Rembrandt's pupil in the 1640s, 'He had as wife a little farm woman from Ransdorp [in Waterland, north Holland], rather small of person, but well made and plump'. Rembrandt must have been fond of her, for he gave her a diamond ring and other pieces of jewellery that had belonged to Saskia. That was unwise, for they belonged ultimately to the Uylenburgh estate and were left in Saskia's will to Titus. In 1648, at Rembrandt's insistence, Geertge made a will leaving everything, not only the jewellery, to Titus. That she readily agreed to such an arrangement argues that, at the time, she must have been confident that Rembrandt was going to marry her. But soon afterwards their relationship deteriorated. The will proved an insufficient safeguard, and Rembrandt's impulsive gifts were to involve him in serious trouble – on two fronts.

Already, in 1647, Saskia's family had become alarmed at Rembrandt's behaviour and asked him to give an account of Saskia's estate, which he was in charge of while drawing temporary benefits from it. After taking legal advice, in order to satisfy the Uylenburghs he was forced to compile an inventory of her estate at her death – the task from which Saskia's will had expressly excused him. It took him two months and it was not the last of the matter.

Geertge has generally been roughly treated by Rembrandt's biographers, perhaps unfairly. Since she eventually became his enemy, she forfeited the sympathy that she deserved. As in all these affairs, it is not at all clear where the blame lies. In 1649 she was compelled to leave Rembrandt's house, presumably against her wishes, because she had been replaced in his affections by Hendrickje Stoffels. Feeling betrayed, she sued him for breach of promise, citing the diamond ring as evidence of a promise to marry her. Rembrandt did not attend the hearing but sent Hendrickje to testify on his behalf that Geertge had left the household under a voluntary agreement. Geertge was now living in a rented room with no known means of support beyond what Rembrandt gave her under that separation agreement, to the terms of which, whether ungenerous or not, she had undoubtedly agreed. They were: a flat sum of 160 guilders plus 60 guilders a year for life and a promise to support her further if she should get into difficulties. Rembrandt may have thought he was being quite generous; he probably had no particular animus against Geertge at the time and might even have preferred her to remain, were it not that the situation in the house had clearly become impossible. However, Geertge

found her means insufficient to pay the rent and, to Rembrandt's alarm, pawned some of the jewellery he had given her. He now made her an increased offer: 200 guilders in cash and an annuity of 160 guilders. The cash was to be used to reclaim the Uylenburgh jewellery, and Geertge had to undertake not to pawn it again and also to renew her pledge not to change her will, ensuring that the jewellery would return to Titus.

Geertge, who said she was ill, rejected this offer, and made a nasty scene in Rembrandt's house. The case returned to the court. Again Rembrandt failed to attend, incurring another fine for his absence, but he did turn up for a third hearing a week later. The court raised the annuity to 200 guilders, but otherwise took Rembrandt's side, and the settlement must have been a relief to him since all other claims against him were rejected.

Fate was not on the side of the unfortunate Geertge. To collect her money from Rembrandt she gave power of attorney to two male relatives, who conspired against her instead. Some assume Rembrandt was a party to their conspiracy, but on little apparent evidence. Geertge's relatives persuaded some of her neighbours to testify to her allegedly disgraceful lifestyle. That probably was not difficult as there may well have been some truth in the allegations, which implied loose morals and mental instability. Moreover, Geertge had apparently broken the terms of the agreement by again pawning the Uylenburgh jewellery. All the same, it looks like a criminal conspiracy, which Rembrandt may have been aware of without taking an active part in it. He was genuinely convinced that Geertge was unblalanced. Meanwhile, through Geertge's relatives, who held her power of attorney, he was able to regain the pawned jewellery.

The upshot of this unsavoury affair was that Geertge was sent to an instutution which, though intended to be charitable, was really more like a kind of reformatory or workhouse, in Gouda. There she remained for some time. Then, one day, a woman who had been a friend of hers called on Rembrandt to say that, with the support of other friends of Geertge, she was going to Gouda to try to get her released. This alarmed him, and he warned her off in no uncertain terms, also writing to the authorities in Gouda to persuade them that Geertge should not be released. The friend seems to have persisted anyway, and eventually secured Geertge's freedom early in 1656, after nearly five years in confinement. Having revoked the power of attorney to her relatives, Geertge promptly resumed her litigation against Rembrandt, but her death a few months later brought the whole wretched affair to an end.

The troubles with Geertge suggest another reason for Rembrandt's comparative barrenness during the late 1640s. He must have been badly affected because, so far as we

TWO WOMEN

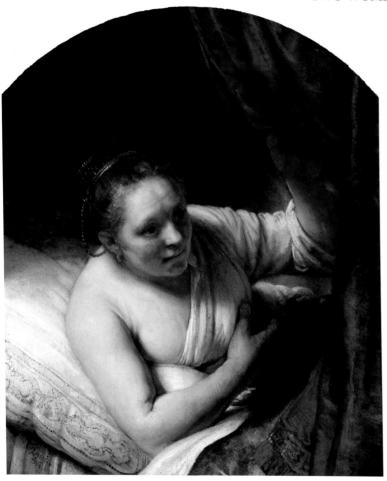

know, he did not complete a single work of any kind in the crisis year of 1649, although in other periods of his life private problems do not seem to have affected his productivity: it was said of him that if an emperor called on him he would not interrupt his work to greet him. We should not leap to moral judgements, for no one can know exactly what went on between Rembrandt and Geertge, nor whether she pawned the jewellery out of greed or necessity, nor how unbalanced she really was, but it is a pity that the one episode in Rembrandt's life that we know about in some detail seems rather discreditable.

Coincidentally or not, no certain portraits of Geertge exist. Two drawings, one showing a figure in the folk costume of Waterland but from the rear, are believed to be of her on the basis of inscriptions (by an unknown hand) on the back that say as much, and there cannot be much doubt that Rembrandt, while he may never have painted a genuine portrait of her, must have used her as a model.

Many Rembrandt experts now agree on the likelihood that she was the model for the well-known *Young Woman in Bed* (left and right). Plump and healthy-looking, she pushes aside the curtain and leans out to look at something or someone off to our right. This young woman is certainly not Saskia. She is not Hendrickje Stoffels either, and the whole feeling of the picture is too intimate for her to be merely a model. Much hinges on the date. It is now unreadable. However, in the

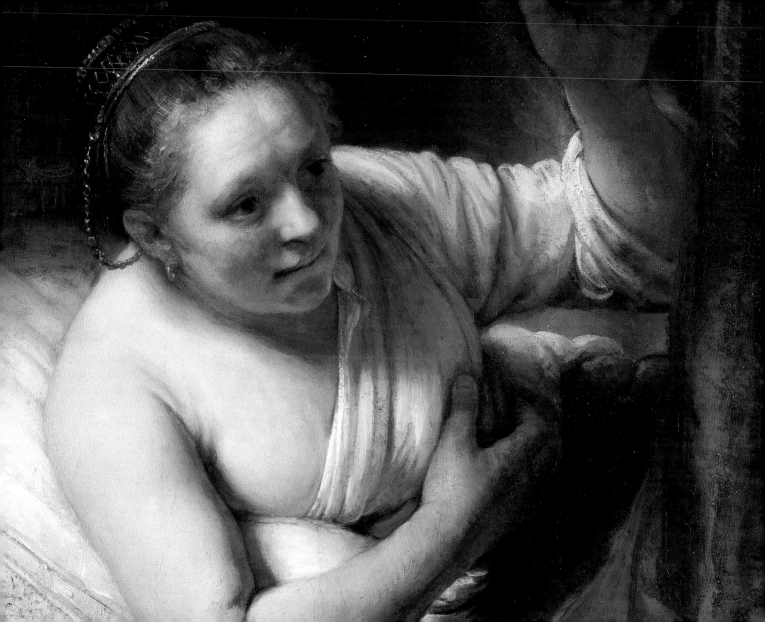

Het Ledikant (The French Bedroom),
1646
Etching, 5 x 8⁷/₈in (12.5 x 22.4cm)
Pierpont Morgan Library, New York

Cleveland Museum is a delightful portrait, dated 1757, by the Swiss painter Jean-Etienne Liotard, of François Tronchin, then the owner of Rembrandt's painting, which shows his most admired possession mounted on an easel close to the desk at which he is sitting. Remarkably, the date on the Rembrandt is – just – readable in this copy. It is 1647, which, if it is correct, makes the Geertge hypothesis almost a certainty.

REMBRANDT

Rembrandt was a sensual man with a healthy interest in sex. Like many other citizens of Calvinist Holland he owned a collection of well-known erotica by Italian and French artists, and he made erotic etchings of his own – erotic, that is, in the sense that they depict the sexual act. They do so with characteristic frankness and they are literally 'shocking', but hardly titillating – less so than some of his nudes though there is no accounting for tastes – and they are certainly not pornographic. They have little in common with the sleek, smooth and revealing bodies of Italian Renaissance erotica. And, for whatever reason, they were all done in the mid-1640s, during Rembrandt's affair with Geertge.

The best-known are probably *The Monk in the Cornfield* (right), on an old anti-clerical theme, and *Het Ledikant* (*The French Bedroom*), left, suggesting another familiar theme, the randiness of the French. This print is renowned for the fact that the woman appears to have three arms, one right and two left. Originally, her right arm clasped her lover's waist while her left lay supine on the bedsheet. Then Rembrandt seems to have added a second left arm, partly obscured by her knee, that clasps the man's waist like the right arm, but he left the supine arm where it was. It seems most unlikely that such a painstaking artist as Rembrandt would make so simple a mistake, especially as this is an etching, not a drawing done in a fraction of the time and perhaps never finished. Is it intended to suggest the rising intensity of the woman's

passion? No explanation that has been advanced to explain it is entirely convincing.

Rembrandt was a man who needed a wife, a fact that may have been evident to Geertge Dircx and so encouraged her to think that he would marry her. There were always objections to this arrangement. In the first place Rembrandt, even if he was beginning to relinquish the social ambitions encouraged by his marriage to Saskia, was an eminent man. To marry so far beneath him would have certainly raised eyebrows, and perhaps resulted in making him a social outcast with consequent loss of patrons. For all the talk of him being a natural rebel and a man who preferred (as he once said) liberty to honour, Rembrandt had no desire to affront the society in which he lived. A second objection was that if he married again he would lose the income he derived from Saskia's estate, and since his financial difficulties had grown steadily ever since he bought the house on Breestraat, he could not easily contemplate such a reduction. The third objection was decisive. A rival had appeared on the scene, and she had replaced Geertge in Rembrandt's affections.

Hendrickje Stoffels entered the house as a servant at some time before 1649, exactly when we do not know, but by the time we first hear of her she was almost certainly Rembrandt's mistress. She was about 20 years younger than he (and a few years younger than Geertge), pretty, with a good, robust, little figure, large dark eyes, fair hair and a fair

The Monk in the Cornfield, c.1646
Etching
Rijksprentenkabinet, Amsterdam

OVERLEAF
Bathsheba, 1654
Oil on canvas, 56 x 56in (142 x 142cm)
Louvre, Paris

The most humane, perhaps most beautiful nude in European art. (See page 255 et seq.)

251

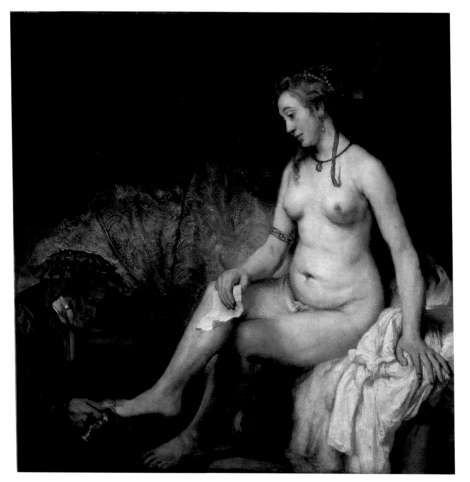

complexion. She came from Bredevoort, in the east, a region of much military activity during the Thirty Years War. Her father was a professional soldier, a sergeant, and two of her brothers (she was the youngest of six children) were also in the army.

The life that Rembrandt and Hendrickje shared for nearly 20 years was not, of course, uniformly happy. In fact, most of the meagre surviving evidence, which consists largely of affidavits and legal documents of various kinds, suggests that it was beset by constant tension and trouble. Such evidence tells us nothing of the times in between, nothing of day-to-day companionship, and we cannot doubt that Rembrandt's relationship with Hendrickje was, for him, extremely fortunate, whether he knew it or not (and he probably did). Though he never married her, no doubt for the same reasons that had prevented him from marrying Geertge, he more than once expressed a wish, even an intention, to do so.

Rembrandt was never the easiest of men, and as he grew older he became increasingly taciturn and irascible. Moreover, the Geertge Dircx nightmare seems to have had a permanent effect on him, for although he soon renewed work, he was from this time less sociable, more withdrawn from the world. The young gallant with the plumed hat and 'attitude' had disappeared for good. That he survived in no worse shape, and that he was yet to paint many of the greatest of his pictures, must to some extent be due to Hendrickje.

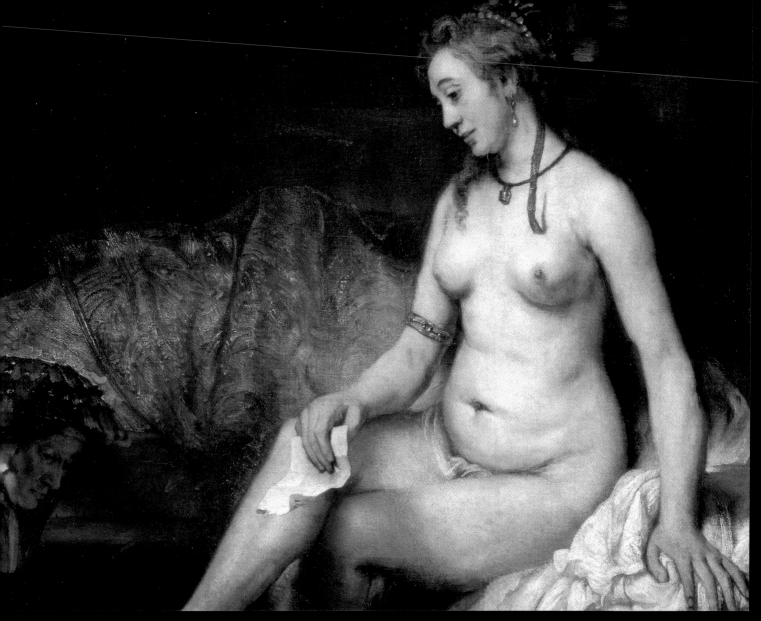

Self-Portrait by a Window, 1648
Etching, drypoint needle and burrin,
6¹/₄ x 5¹/₈in (16 x 13cm)
Rijksprentenkabinet, Rijksmuseum,
Amsterdam

From all that we know, only a cad would say a word against her. She was one of those rare people who are both loving and lovable, agreeable, undemanding, thoughtful,

supportive and kind, 'one of the sweetest companions a great artist has ever had' (Clark). In fact she was just what Rembrandt needed. Of course she was not up to the mark socially or intellectually. She could neither read nor write. But that hardly mattered.

Amsterdam was a fairly easy-going place by contemporary standards, but this was a Calvinist republic, and it was the 17th century – the last of the European religious wars had only just come to an end. Hendrickje was a member of the Reformed Church, which took a censorious view of sexual liaisons outside marriage. In 1654 she was summoned by the council of the Church to answer a charge of 'practising whoredom with Rembrandt the painter'. She did not go, the summons was repeated a few days later, she still did not go. After three unanswered summonses, representatives of the council called on her, and following their visit she did at last attend. As she was now six months pregnant, it was difficult to deny the charges, and she admitted all. She received a severe warning, was ordered to repent, and was banned from attending the Communion service. The ban apparently stood for the rest of her life and was equivalent to being excommunicated from the Roman Catholic Church. However, she was never again harassed by the Church. Three months after the hearing, she gave birth to a daughter, Cornelia.

Rembrandt painted few nudes, partly no doubt because such a subject was regarded as morally dubious. Nudity was

all very well for sophisticated Italian aristocrats, it was a different matter for Dutch burghers. A strong connection was made between nudity and immorality, and this was not exclusively a matter of prudery. Those who modelled for nude pictures were usually professionals, and as in later ages, the

women concerned often followed more than one profession. It was not entirely unreasonable to compare some contemporary nudes with the pictures of the inmates of brothels shown to a customer so that he could make an informed choice while being relieved of his money in advance. Indeed, to indulge in pure speculation, the painters of some nudes that are clearly meant to be provocative may have been consciously playing the role of publicity agent, if not pimp.

It may be true that one reason why the Reformed Church decided to call Hendrickje to account after she had been living openly with Rembrandt for five years, was the shock of seeing Rembrandt's *Bathsheba* (pages 252 and 253). It is a large painting, 56-in (142-cm) square, in which the seated Bathsheba, whose feet are being dried by a servant, takes up more than half the canvas, and it was probably painted to order. We don't know whose order, though one possibility, as we shall see, is Jan Six, whose portrait Rembrandt had painted the year before.

The story comes from the Second Book of Samuel, Chapter 12. King David, while taking the evening air on the roof of his house, spots the beautiful Bathsheba taking a bath. He sends a message inviting her to come to him. Of course she obeys, and David subsequently gets rid of her husband, a soldier, by ordering him to be placed in the thick of battle.

Rembrandt paints Bathsheba after she has received David's message but has not yet decided how to react,

Model in the Artist's Studio, c.1654
Pen, brown ink and wash on paper,
8 x 7¹/₂in (20.5 x 19cm)
Ashmolean Museum, Oxford

The model is Hendrickje, and the reason for her partial undress may not be just to pose for Rembrandt, for among the objects on the table is what appears to be a baby's cradle.

Bathsheba Bathing, 1642
*Oil on panel, 22¹/₂ x 30in
(57.2 x 76.2cm)
Metropolitan Museum of Art, New York*

*'The composition is unsatisfactory and
altogether this painting does not
inspire great enthusiasm for its qualities
as a work of art.' (Gary Schwartz).
Many experts have therefore doubted its
authenticity, although there is some
circumstantial evidence in favour of
Rembrandt's authorship.*

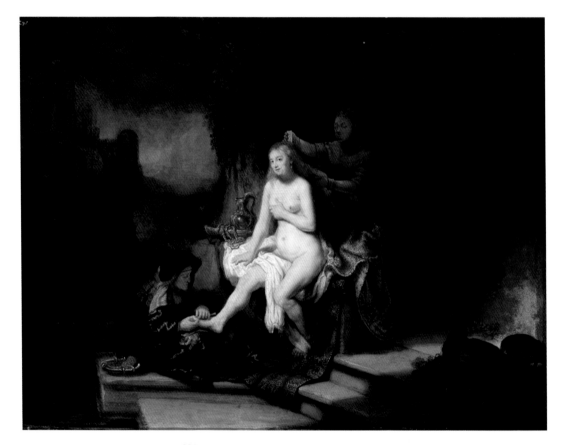

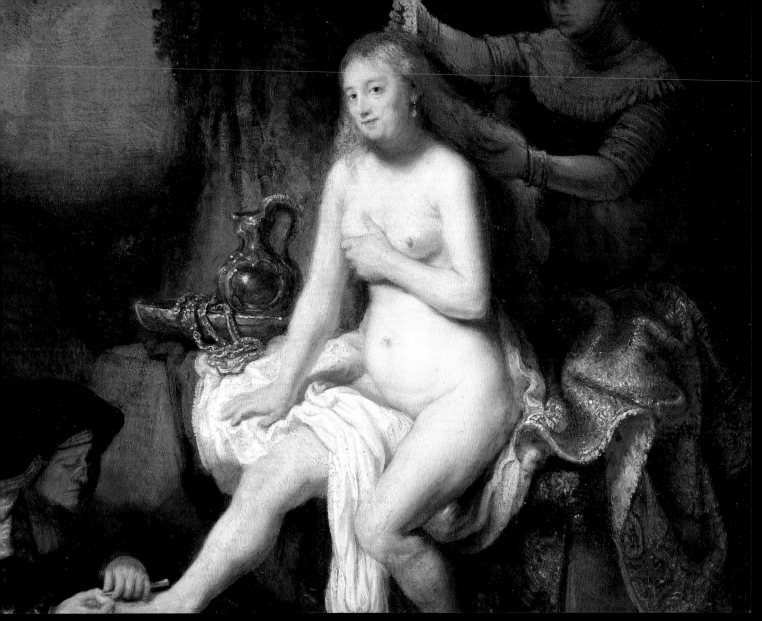

Portrait of Hendrickje Stoffels, 1659
Oil on canvas, 40^1/$_8$ x 33in
(101.9 x 83.7cm)
National Gallery, London

The signature is false and the date
cannot be right, and although the facts
alone do not completely discount it, this
attractive portrait is no longer
widely accepted as a Rembrandt.

whether to disobey the king or break the marital vows she has made to her husband, Uriah the Hittite. The composition is based on an engraving after a Classical relief of a young woman having her feet attended to by an older woman, but in the print the subject is fully dressed, and Rembrandt's Bathsheba is modelled on Hendrickje. She is a sumptuous figure, easily Rembrandt's most beautiful (also his last) nude, broad-hipped and round-bellied in the contemporary fashion, but a young woman in her prime. By painting her completely nude, Rembrandt places the observer in the same position as King David, the lustful voyeur.

It was customary to portray Bathsheba as a seductress, as Rubens did and as Willem Drost, a pupil of Rembrandt's, also did in the same year as this picture. In fact Rembrandt himself had painted a *Bathsheba Bathing* (pages 256 and 257) 12 years before that is more or less in that flirtatious tradition. But there is no trace of coquetry in Rembrandt's great painting of 1654. What makes this one of the most seductive and affective pictures that Rembrandt ever painted is Bathsheba's expression, head tilted down, beset by mixed emotions, her eyes seeing the inevitability of a tragic outcome, perhaps even the fate of the House of David – for, the Prophet tells us, 'the thing that David had done displeased the Lord' – whatever action she takes. The Classical relief on which the composition was based showed a bride on the eve of her wedding, and that spirit is preserved here, but with the

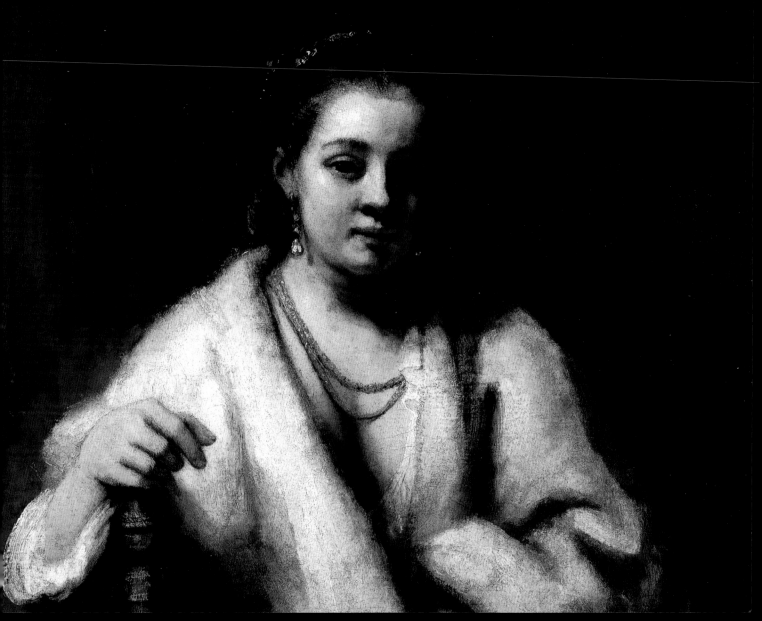

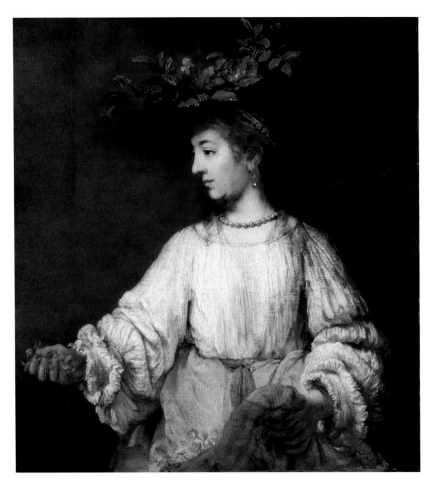

sacrifical element emphasized. Michael Kitson called the painting 'one of the most profound commentaries on human sexuality in the history of art', and no one would quarrel with that.

There are six or seven portraits of Hendrickje dating from the 1650s in galleries around the work, many of them disputed, partly because, unlike the portraits of Saskia, none of them is actually inscribed with her name. One of the most attractive is the *Portrait of Hendrickje Stoffels* (pages 258 and 259), although the signature is false, the date inscribed next to it, 1659, is certainly too late, and the authenticity of the painting itself is doubtful. There are more, especially drawings and etchings, in which she may or may not be the model, such as *Model in the Artist's Studio* (page 255), and a charming drawing of her curled up on a couch, *A Young Woman Sleeping* (page 262), done with a few superbly judged strokes of a reed pen.

It comes as a slight shock to discover that Rembrandt also painted Hendrickje as *Flora* (opposite), a role particularly associated with his wife Saskia. But that was nearly two decades earlier, much had happened in the meantime and many, many paintings had found their way from Rembrandt's easel. In any case, he was the least sentimental of men.

Another painting, *Woman Bathing in a Stream*, is now alternatively called *Hendrickje Bathing* (pages 262 and 263), as it is generally agreed that the model is Hendrickje. The rich,

red and gold cloak behind her suggests that this may have begun as a Biblical subject, possibly of another Susanna or Bathsheba, though the pose and the contentedly contemplative expression do not suggest either of these. It is very broadly painted, with dashing brushstrokes, and only the head and limbs have received detailed attention, but as it measures about the normal size of a full-scale work, it cannot be regarded as a sketch. Nor can it have been unfinished, as Rembrandt signed it, which suggests that he was content with its present state and, presumably, was hopeful of selling it. The figure, having discarded her cloak, wears only a shift with a plunging neckline, and she raises her skirts about as high as modesty will permit as she wades into the stream. She provides support for the common assertion that a partially clothed figure is more sensuous than a nude, but the dominant feeling here is not erotic but intimately affectionate. Gary Schwartz in his seminal book *Rembrandt, His Life, His Paintings*, admitted that this 'is to my eye one of the freshest and most original of Rembrandt's works in oil', a view with which it is easy to sympathize; he adds the caveat that many an art historian has made such a judgment about a particular work that later turns out to be a copy, a forgery, or the work of a different artist!.

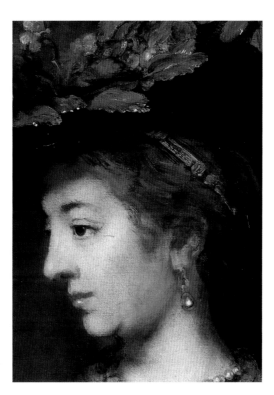

Flora (Hendrickje Stoffels), c.1654
Oil on canvas, 39³/8 x 36¹/8in
(100 x 91.8cm)
Metropolitan Museum of Art, New York

RIGHT
A Young Woman Sleeping (Hendrickje Stoffels), c.1654
Reed pen and brown wash on paper
9⁵/8 x 8in (24.6 x 20.3cm)
British Museum, London

OPPOSITE
Woman Bathing in a Stream (Hendrickje Bathing), 1654
Oil on panel, 24¹/3 x 18¹/2in
(61.8 x 47cm)
National Gallery, London

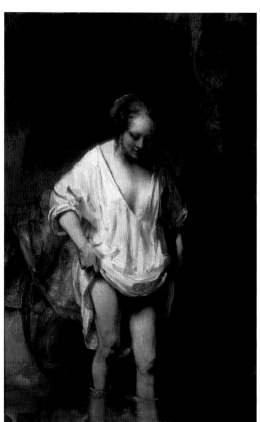

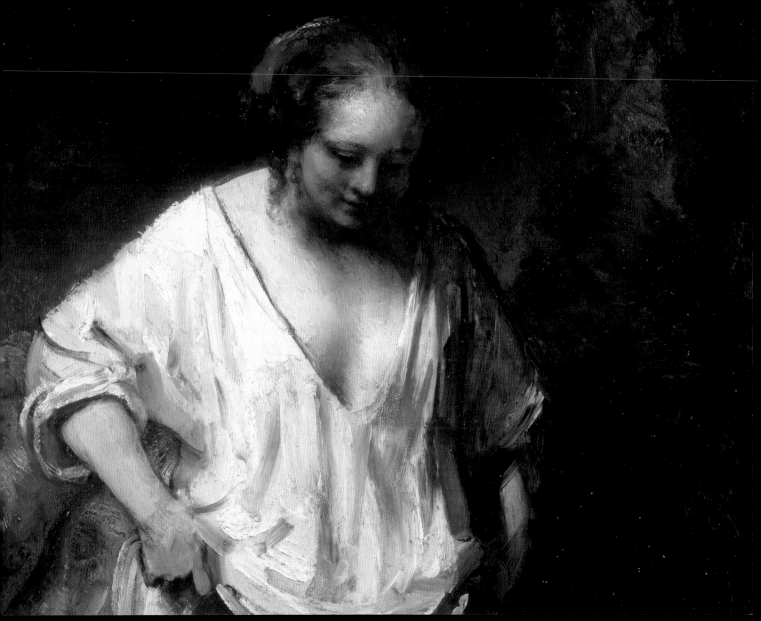

Chapter Twelve
Portraits and Patrons

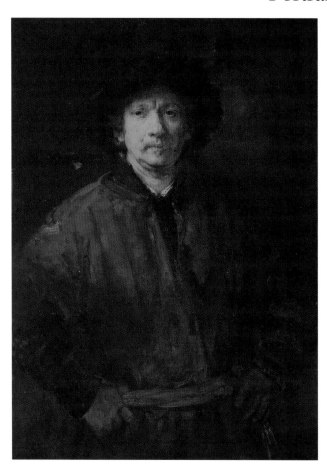

The impression of confidence and self-satisfaction one senses in the London *Self-Portrait* of 1640 remained evident throughout the following decade, but things changed with the crisis of 1649, when self-assurance was replaced by anxiety and doubt. A trace of it was already apparent in the etching *Self-Portrait by a Window* of the previous year (page 254), and it is evident in an alleged *Self-Portrait* of c.1650 in Washington (National Gallery). Sadly (for this is a rather fine painting) the signature and date are forged and the painting itself has been excluded from the canon since its authenticity was questioned by the great Rembrandt scholar Horst Gerson in 1968.

During his last two decades, Rembrandt's self-portraits become more numerous, of greater variety, and grander. The keen self-analysis that had marked the 1640 self-portrait but had been largely in abeyance since, was renewed. Other painters, of course, also did self-portraits, though not so frequently nor so searchingly as Rembrandt, and although they liked to portray themselves as ordinary gentlemen, as Rubens did, more often they presented the image of a painter surrounded by studio props and other symbols of his profession. Rembrandt painted and drew himself in many guises, but although his studio was not short of props, nor the tools of his trade, he never painted himself in that heavily symbolic manner. Although he ejoyed dressing up and playing a role, the face was always his chief subject, all the

more so as he grew older and found it more interesting, as we may surmise he did from the marked fondness for elderly subjects in general, their faces marked with the harshness of experience, that he showed from an early age.

Although he dispensed with the usual symbolic paraphernalia, Rembrandt did sometimes portray himself as a painter, the obvious option, really, since that was how he looked while painting the portrait . In the three-quarter-length Self-Portrait of 1652 (opposite) he wears his painter's smock, the first time he has done so since his days in Leiden. The worried look has disappeared, and he confronts the viewer face to face, almost eyeball-to-eyeball, with a stern, uncompromising expression that may be just intense concentration but seems not far removed from aggression. It has been suggested that the new confidence proclaimed in the Vienna picture stems from Rembrandt's acquisition of several important new patrons, especially Jan Six (see below), although it is questionable whether Rembrandt ever had any doubts about his own genius. His hands are firmly planted on his hips, thumbs tucked into his belt. It is the same pose as a drawing, Self-Portrait in Working Costume of c.1656 (right), in which he wears the same hat with a brim as in the etched Self-Portrait by a Window. The title of the 1656 drawing, however, is really a misnomer, because, for once, he is not interested in the face at all; in fact it is not recognizably his.

OPPOSITE
Self-Portrait, 1652
Oil on canvas, 44¹/₈ x 31⁷/₈in
(112.1 x 81cm)
Kunsthistorisches Museum, Vienna

LEFT
Self-Portrait in Working Costume, c.1656
Drawing
Rembrandthuis, Amsterdam

OVERLEAF
Self-Portrait (Ellesmere Portrait), 1657
Oil on canvas, 21 x 17¹/₃ (53.5 x 44cm)
National Gallery of Scotland, Edinburgh

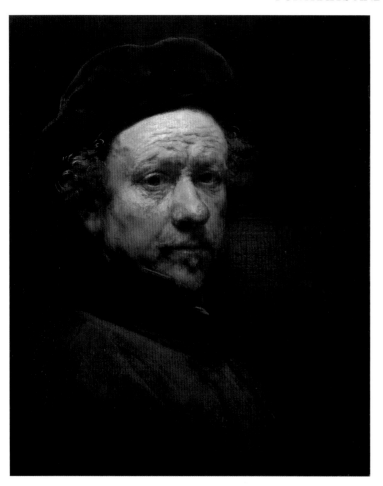

The Vienna self-portrait shows him with no evidence of his profession beyond his smock and without any kind of supernumerary adornments, not even his fur stole, and, equally, without pretensions – art, one might say, at its most artless. Even plainer, if that were possible, and equally honest, is the *Self-Portrait* of 1657 (left and right), known after its owner as the Ellesmere portrait, in which the tiniest details of the face are reproduced with a photographic accuracy that is, in a curious way, quite disconcerting. That may be partly due to the fact that the face occupies most of the canvas – a result, it seems, of the picture having been cut down at some time.

The *Self-Portrait* of 1658 in the Frick Collection (pages 268 and 269) is far from plain. This is the most monumental of all Rembrandt's self-portraits and the most colourful. He is seated (there is other evidence that from about this time he was more accustomed to work sitting down), and wears richly exotic, vaguely oriental dress, mostly gold, with a red silk sash. The picture offers support for Kenneth Clark's intimation that Rembrandt sensed something king-like in himself, and other critics have referred to this portrait as godlike. He sits legs apart, as a king might do, taking up most of the canvas, and holds a cane that could as well be a sceptre. This happened to be a particularly bad time for Rembrandt, but there is no trace of resentment, grief or self-pity. He appears in total control, serious, calm and

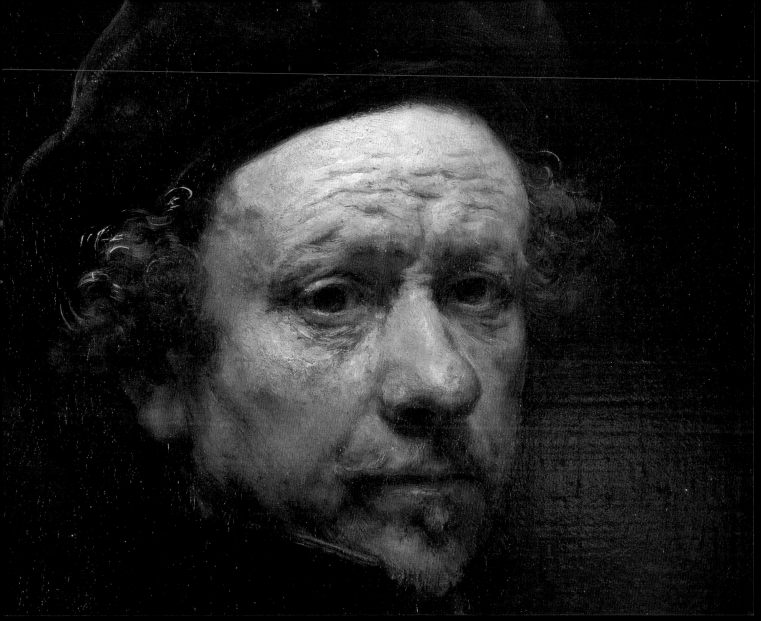

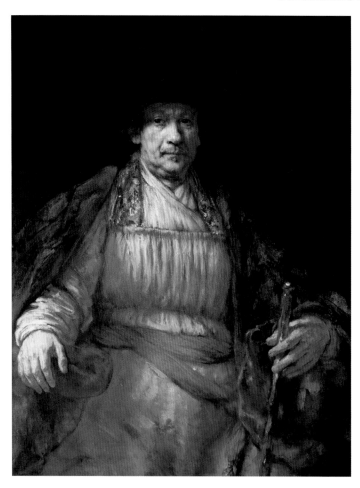

philosophical, almost as if the picture were some kind of compensation, an effort to boost his own morale. A perhaps more likely explanation for the sheer scale and grandeur of the Frick portrait is that it was intended for a rich, even a royal, collection.

The Frick portrait is the last we get of Rembrandt in quite that mood. In the *Self-Portrait* of 1659 in Washington (pages 270 and 271) he looks again sad and worried. He has lost weight, his face is gaunt, and it has been suggested that he may have been ill. Our almost total ignorance of his everyday life is such that we have no way of knowing his state of health. Fortunately, this phase did not last long, for in the early sixties he seems to have returned to health and indeed to have put on a good deal of weight. In the Louvre *Self-Portrait* of 1660 (page 272) he is still thin in the face, but by 1663 he is quite plump, as the *Self-Portrait* at Kenwood House (page 273 right) demonstrates. Incidentally in both this and the Louvre self-portrait, he again holds palette and brushes, and he is wearing his much-favoured fur stole (to be seen for the last time seen in an alleged *Self-Portrait* in the Uffizi Gallery, Florence, one of the few Rembrandts in Italian collections, page 273 left).

Rembrandt portrayed himself in many guises. One identity he assumed more than once was St. Paul, a favourite saint in the Reformed Church, and perhaps additionally attractive to Rembrandt because of his denigration of the law

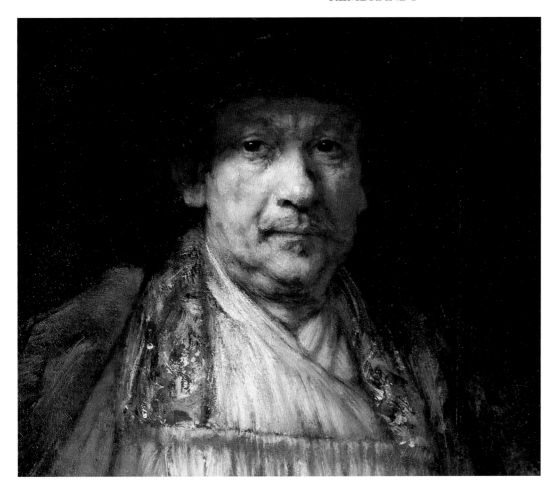

Self-Portrait, 1658
Oil on canvas, 51^1/$_2$ x 40^1/$_8$in
(131 x 102cm)
Frick Collection, New York

OVERLEAF
Self-Portrait, 1659
Oil on canvas, 33^1/$_4$ x 26in
(84.5 x 66cm)
National Gallery of Art, Washington,
D.C.

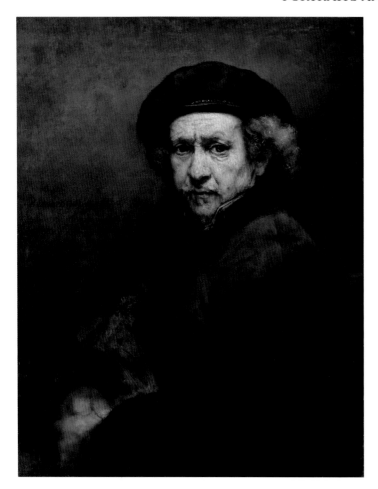

as compared with the mercy of God. The *Self-Portrait as St. Paul* of 1661 (page 274), which is identifiable by the sword (its hilt is just visible under his cloak) and the book, traditional emblems of St. Paul, dates from soon after the Louvre portrait, and he is still thin. His expression also remains rather sad, but is touched with wry humour, as if all too aware of the weakness of humanity but not without hope of ultimate salvation. Yet this is certainly a very different St. Paul from the formidable figure in *Two Scholars Disputing* of 1628.

In the Kenwood portrait Rembrandt is once more a figure of authority, less regal than in the Frick portrait but consciously aware of his own qualities, perfectly at ease, and faintly quizzical. It is painted in Rembrandt's freer, late manner, and one hand, whose position he moved at a late stage of the painting, is hardly distinguishable under a rough sloshing of paint. Whether, as has been suggested, this is really meant to indicate the whirling motion of the painter's hand is open to discussion, and argument on that score is connected with another much-discussed puzzle, the meaning of the two large circles, segments of which are represented on the wall behind him. Do they represent the circle of thought (the supremely intelligent, immobile face) and the circle of action (the whirling hand)? Or, more prosaically, are they indications of the circular wall maps that at this time were frequently mounted on the wall in the households of the

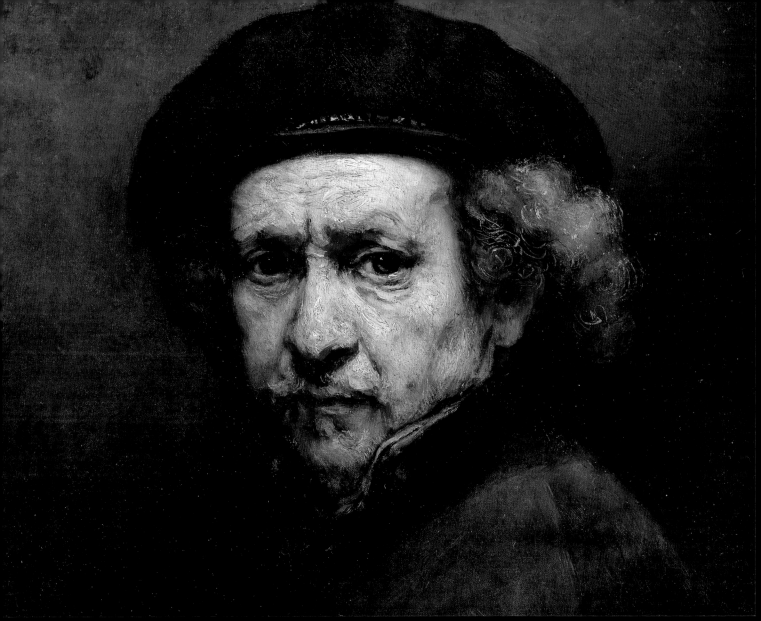

RIGHT
Self-Portrait of the Artist at His Easel,
1660
Oil on canvas, 43⁵/8 x 35⁵/8in
(110.9 x 90.6cm)
Louvre, Paris

OPPOSITE LEFT
Self-Portrait, 1660
Oil on canvas, 28 x 21¹/4in (71 x 54cm)
Galeria degli Uffizi, Florence

OPPOSITE RIGHT
Self-Portrait with Two Circles,
c.1661–62
Oil on canvas, 45 x 37in (114.3 x 94cm)
English Heritage, Kenwood House,
London. The Iveagh Bequest

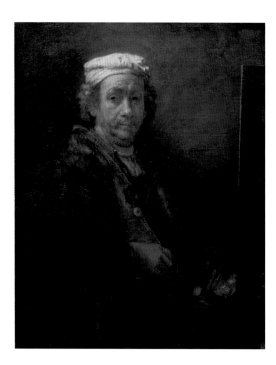

ocean-going Dutch. Or were they reminders of the well-known anecdote about Giotto, related by Carel van Mander, whose work Rembrandt would have known well. Asked by a messenger for something by his hand to show the pope, a potential patron, the great pioneer of the Italian Renaissance drew a perfect circle freehand, saying, 'Show the Pope that!' Was Rembrandt making a similar gesture?

Rembrandt's interest in his own face continued until very near the end of his life. One of the most extraordinary is the *Self-Portrait Laughing* (Zeuxis), page 275 right, which has also been cut down at some time. There is usually a hint of humour, if not an actual smile, in Rembrandt's self-portraits, but he had not painted himself laughing outright since he was a young man in Leiden experimenting with facial expressions. What makes this so strange is that he was a very old man. At first glance he looks almost senile, though in the last great *Self-Portrait* of 1669 (pages 276 and 277) it is obvious that neither his mind nor his hand had deteriorated, and he was also at the very nadir of his fortunes – old, bankrupt and alone. What on earth had he got to laugh about? Various rather feeble explanations have been suggested. In the end we must fall back on the old cliché that art and life are two separate things and neither is a reliable guide to the other.

It is evident that in some of Rembrandt's self-portraits, he is modelling for a role, whether (as in his portrait of himself

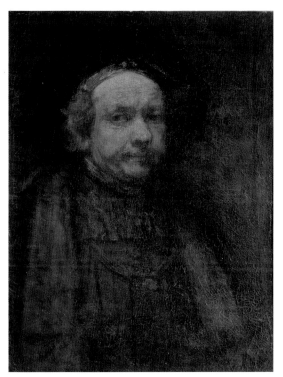

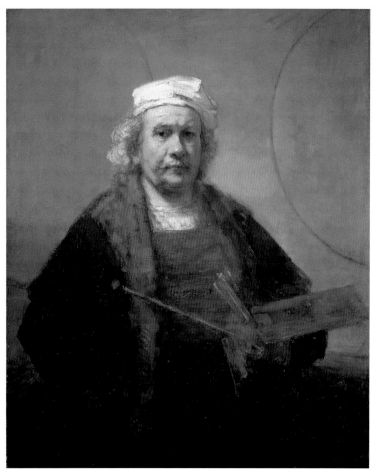

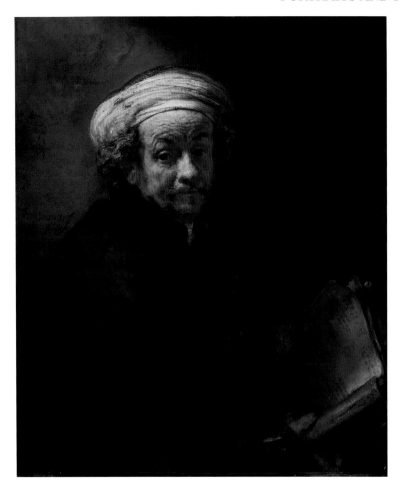

as St. Paul) he makes the fact clear or not. In the Kenwood self-portrait, for example, he may have seen himself as a modern version of Apelles, the renowned court painter of Alexander the Great, of whom a story was told similar to the one about Giotto and the perfect circle. It is now quite widely accepted that the 1668 portrait of himself laughing while apparently in terminal decline falls into this category, and that Rembrandt is representing himself as another ancient Greek painter, Zeuxis, famous as the artist who painted such realistic grapes that birds came and pecked at them. In a story again retailed by Mander, Zeuxis is said to have died because he was laughing so much at the grotesque old woman he was painting that he choked to death, a fate surely unlikely to have overtaken Rembrandt with his remarkable sympathy for the faces of the very old. Some support for this belief derives from the fact that the same subject, an uncommon one, was painted by one of the last of Rembrandt's pupils, Aert de Gelder, in 1685 (right).

There is very little contemporary documentation of Rembrandt's self-portraits: not one was mentioned in the list of his possessions made in 1656, and they are seldom mentioned by 17th-century writers. Rightly or wrongly, they appear to us as somehow separate from his other works, and their volume alone makes them something unique among artists. In fact, Rembrandt may be said to have created a new speciality in painting.

It has sometimes been assumed that self-portraits were less 'commercial', that customers would have been hard to attract, but this does not seem to be true. The fact that none were to be found still lying about in Rembrandt's studio in 1656 suggests that they must all have been sold. Surely a painting such as the Frick self-portrait, to name the most obvious example, must have been done with a destination in mind. It is significant also that a number of them eventually ended up in princely courts. In fact the first Rembrandt painting to be seen abroad, in England at the court of Charles

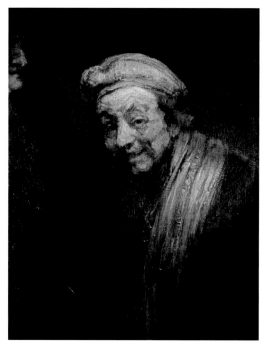

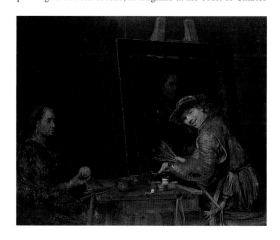

OPPOSITE
Self-Portrait as St. Paul, 1661
Oil on canvas, 36⁵/₈ x 31¹/₈in
(93.2 x 79.1cm)
Rijksmuseum, Amsterdam

LEFT
Self-Portrait Laughing (Zeuxis), c.1669
Oil on canvas, 32¹/₂ x 25⁵/₈in
(82.5 x 65cm)
Wallraf-Richartz Museum, Cologne

FAR LEFT
Aert de Gelder
The Artist as Zeuxis, 1685
Oil on canvas, 56 x 66¹/₂in
(142 x 169cm)
Städelsches Kunstinstitut, Frankfurt

OVERLEAF
Self-Portrait at the Age of 63, 1669
Oil on canvas, 33⁷/₈ x 27³/₄in
(86 x 70.5cm)
National Gallery, London

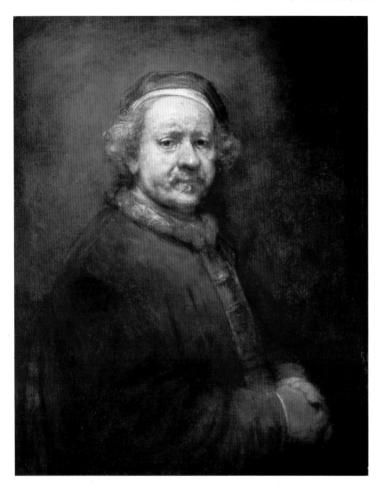

I, was a self-portrait. Although the unbusinesslike Rembrandt could surely have had nothing to do with such a ploy, an artist who wished to make a name for himself might have acquired a slight advantage if his face were known to potential patrons as well as his name.

One of the possible reasons why Rembrandt's friend and patron Jan Six came to regard him less highly after 1654 was his own changing preferences, which led him to favour Classicism and Italian art. That was part of a general trend in Europe towards a calmer, more withdrawn, and more consciously elegant approach that affected all forms of painting, even those with no connection to Classicism. In any case, Classicism was never totally abandoned during the Baroque period, and though there were few painters other than Nicolas Poussin who wholly fulfilled Classical principles, there were many whose work can hardly be described as either Classical or Baroque, but contained aspects of both.

The Baroque artist is more emotionally engaged. He attempts to involve the spectator's feelings with the aid of powerful, twisting movement, vigorous gestures, and strong colour. Classicism is more orderly and restrained. It operates within disciplined boundaries, rejects flamboyant emotional effects and treats colour as a subservient aspect of form, not as its equal. That does not mean it is cold and unfeeling. On the contrary, the requirement to convey an idea by strictly

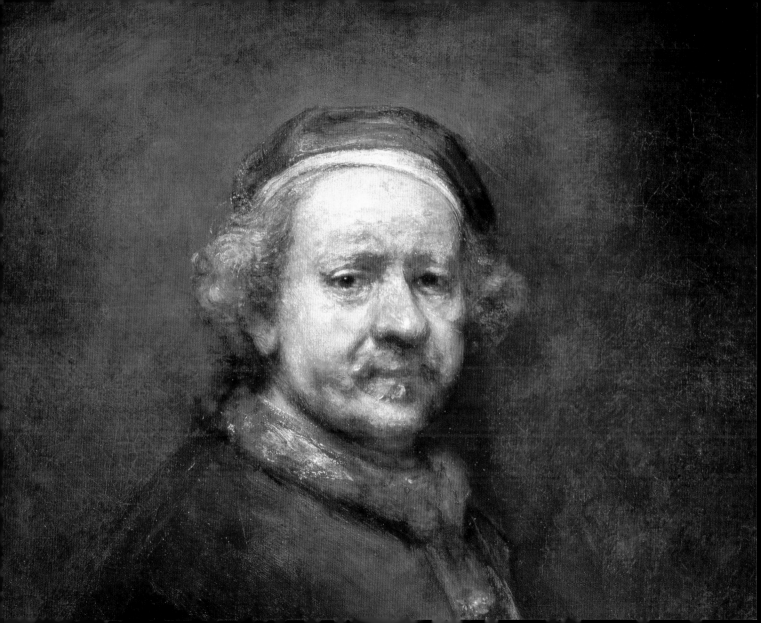

disciplined means gives it powerful emotional force, assuming that it is done well.

In the case of Rembrandt, there were personal reasons for a certain withdrawal from the more commercial side of his profession, no doubt connected with his realization that he could not live up to, or no longer desired, the more exalted social life to which, partly under Saskia's influence, he had aspired.

We know that, far from being the simple, ignorant fellow he was once assumed to be (Joachim von Sandrart said he could barely read Dutch, let alone Latin), Rembrandt had an excellent knowledge of Classical art through his contact with Lastman and others and through his immense collection of engravings. He had at least six portfolios of engravings after Raphael, the 'god' of the 17th-century Classicists, and a large book of drawings and engravings of Andrea Mantegna, the strictest Classicist of 15th-century Italy. As research continues, it becomes clear that Rembrandt used Classical and Renaissance models with great frequency, and no doubt more often than we shall ever know, because by the time the model became absorbed in his own style and suffused with his humanity, its debt to a Classical source was no longer recognizable.

Contemporaries or near-contemporaries who condemned the failure of Rembrandt, and others, to obey Classical principles often picked on the nude. Rembrandt was certainly

unrespectful of the rules of anatomy, and to this day he is sometimes accused of denigrating the human body, for which there is no difficulty in producing supporting evidence. On the other hand, his greatest and, after *Danaë*, most famous nude, *Bathsheba*, is indisputably beautiful although (and to an extent because) she is not a Classical figure. Moreover, significantly or not, the composition of this painting was based on a Classical relief!

Most of what we know about Rembrandt's friendships depends on circumstantial evidence or the chance remarks of early biographers, which is usually insufficient to make firm judgements. It does appear that he had comparatively few contacts with fellow-painters, which is especially surprising because good painters were so thick on the ground in 17th-century Holland and a substantial proportion of them were his former students. We hear that Gerbrandt van den Eeckhout, a pupil and later an assistant in Rembrandt's 'academy', retained close relations with him, and the landscape painter Roelant Roghman was described by Houbraken as 'a great friend'. Otherwise, his pupils tended to move away, either literally, by returning to their home towns, or, like Govert Flinck and Ferdinand Bol, by adopting a more 'fashionable' style and, in the case of these two especially, becoming embarrassingly successful rivals. Then, too, not everyone had the patience and gentleness of Hendrickje to put up with Rembrandt's growing irascibility

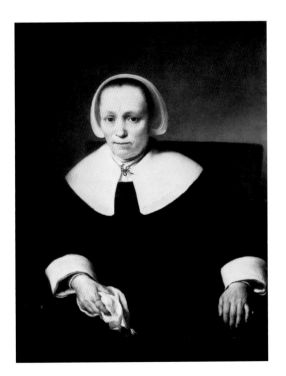

in his later years. Rembrandt etched a portrait of Jan Asselijn (right), a landscape painter (in the Italian style, nothing like Rembrandt's), whose brother, a poet, was also friendly with Rembrandt, and also of a well-known Amsterdam painter of seascapes, Jan van de Capelle, nearly 20 years younger than Rembrandt. Capelle was also an industrialist and, judging by the size of his art collection, a rich man. He owned many works, mainly drawings or etchings by Rembrandt, including a portrait of himself (now lost). Various other people are known to have been in contact with Rembrandt, but the nature of their relationship is unclear.

Jan van de Capelle was a manufacturer of dyes and may therefore have been connected with Jan Six, patron and friend of Rembrandt, whose family business was dyeing.

The amazingly intimate knowledge of family relationships in Amsterdam society in the early 17th century demonstrated in Gary Schwartz's 1985 book on Rembrandt reveals that most of Rembrandt's patrons were interconnected by blood, marriage and/or profession. The names Huygens, Trip, Van Beuningen, Coymans, Hinlopen, De Geer, Wtenbogaert, Scriverius, De Gheyn, Deyman, Cocq, and Six, all names of Rembrandt patrons or sitters, can be found within one extended clan.

Jan Six was an important and influential patron during the decade from 1645 to 1654. Born in 1618, he was considerably younger than Rembrandt, but they seem to have

LEFT
Ferdinand Bol
Portrait of a Lady with White Collar and Cuffs
Oil on canvas
Rafael Valls Gallery, London
BELOW
Jan Asselijn, c.1647
Etching, $8^{1}/_2$ x $6^{5}/_8$in (21.6 x 17cm)
Musées de la Ville de Paris

Asselijn was a fellow artist, brother of the poet Thomas Asselijn.

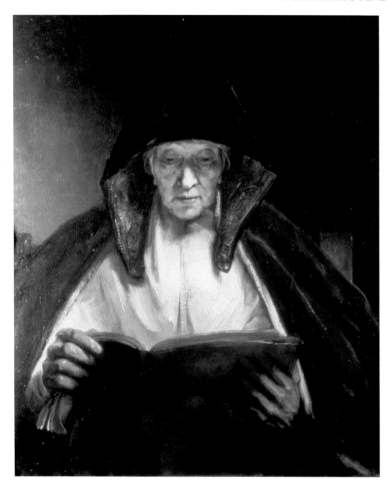

been quite close friends, although there is not much documentary evidence of the relationship. This was broken off, rather mysteriously and, it seems, permanently, in about 1654–55, but in the preceding decade Rembrandt was a fairly frequent visitor at Six's country house at Jaaphannes on the Diemerdyke.

The Six family was of high-born French Huguenot origin, Jan's grandfather having emigrated to Holland as a refugee and subsequently grown rich as a merchant in Amsterdam. Though active in the family dyeing works, at least until 1652, Jan was not at heart a businessman, but an intellectual, acquainted with Spinoza and Descartes, friend of the poet Vondel, 'the Dutch Milton', and with some aspirations himself as a poet, fond of all the arts and a keen collector. An inscription on his 1654 portrait by Rembrandt says, 'This was my appearance, Jan Six, who worshipped the Muses from Youth'. Eventually, after Rembrandt's death, he became a burgomaster and a powerful figure in Amsterdam.

Rembrandt made portraits of Jan Six and also of members of his family, including a *Portrait of a Man* (c.1650) widely believed to be Jan's flaxen-haired elder brother, Pieter, now in the Faringdon Collection at Buscot Park (England), and possibly their mother, Anna Wijmer, a woman renowned for her wisdom, who some believe is the impressive sitter in Rembrandt's painting of *An Old Woman Reading* (left and right), if not also of a much earlier

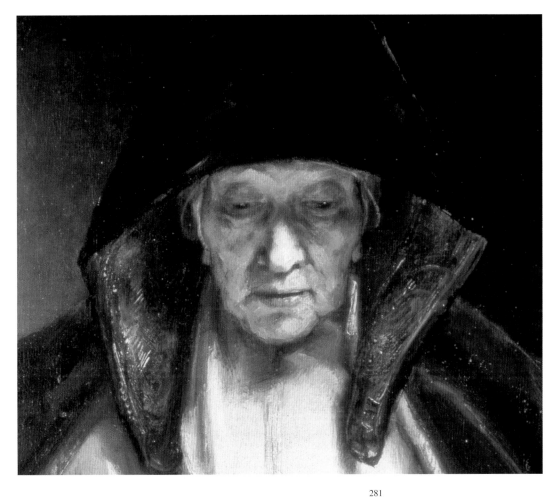

An Old Woman Reading, 1655
Oil on canvas, 31¹/₂ x 26in (80 x 66cm)
Collection of the Duke of Buccleuch,
Drumlanrig Castle, Scotland

RIGHT
Portrait of Jan Six, 1647
Etching, 9⅝ x 7½in
(24.5 x 19.1cm)
British Museum, London

OPPOSITE
Medea, or The Marriage of Jason and Creusa 1648
Etching and drypoint, fourth state
9½ x 7in (24 x 17.6cm)
Pierpont Morgan Library, New York

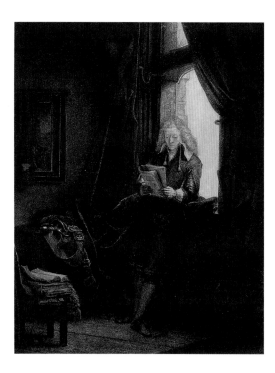

portrait of a middle-aged woman, which is dated 1641.

Rembrandt's first portrait of Jan Six was the etching of 1647 (left), with lavish tonal values achieved in drypoint, a work of such quality that it was taken as the standard by another patron, who in his commission to the artist required that his own portrait 'be of the quality of the portrait of Heer van Six'. Unusually, two or three preparatory drawings for this etching have survived, and they show that the concept changed, probably at the instigation of Six himself. The final etching shows the subject as very much the young aesthete, hair flowing over his shoulders as he leans on a window sill reading a book (has anyone yet written a monograph on Rembrandt's use of books as objects in his paintings?). The earliest drawing shows that he was originally intended to be more the young, tidily bewigged, hunting-shooting squire, in a similar but less indolent pose and withstanding an affectionate assault by a boisterous hound.

The following year, Six published his poetic tragedy *Medea*, which had been performed in Amsterdam in 1647, and asked Rembrandt to design a frontispiece. The result was an etching of a scene that, rather oddly, does not occur in the play (see opposite). Rembrandt also contributed drawings to Six's personal album, one of Homer reciting his tales, the other of Minerva, goddess of wisdom, and since there is some resemblance to the elderly woman in the 1655 portrait, it has been suggested that this too is a tribute to the Six matriarch.

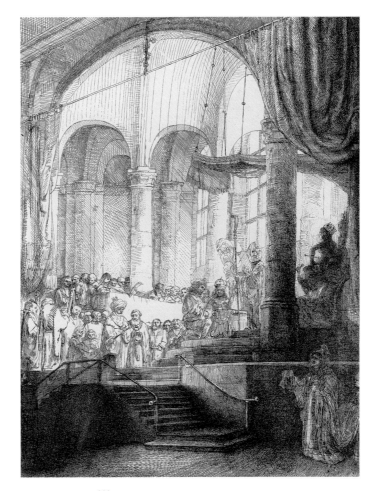

Six also bought from Rembrandt two paintings of a much earlier date, *Simeon in the Temple*, which cannot be identified for certain, and *St. John the Baptist Preaching* (page 284), a tour de force in monochrome with the assembled crowd representing a cross-section of the world's people, including (for instance) Native Americans. There is a rough sketch of the picture inside a drawing of a characteristically hefty frame that Rembrandt apparently designed for the picture at the time Six acquired it. He also owned a fine colourful profile portrait on panel of Saskia in her finery, painted in about 1634 or maybe later (page 179).

In 1653, as money problems crowded in on Rembrandt, his friend and patron lent him the considerable sum of 1,000 guilders, presumably to pay off other creditors. It was interest-free, but otherwise we do not know the conditions of the loan, if any, and not long afterwards Six asked for his money back. When Rembrandt was unable to comply, Six sold the debt off to another Amsterdam magnate at a discount, landing Rembrandt with another importunate creditor. Far from bringing relief, Six's loan only added to his troubles.

Nevertheless, we could say that Jan Six got his money's worth out of the artist, for soon after receiving the loan Rembrandt painted his wonderful three-quarter-length *Portrait of Jan Six* (pages 146 and 147). Only a handful of portraits, led by the *Mona Lisa*, have attracted such

RIGHT
St. John the Baptist Preaching. c.1634
Canvas laid down on panel,
24³/8 x 31¹/2in (62 x 80cm)
Gemäldegalerie, Berlin

OPPOSITE and OVERLEAF
Simeon with the Christ Child in the
Temple, c.1669
Oil on canvas, 38³/4 x 31¹/4in
(98.5 x 79.5cm)
Nationalmuseum, Stockholm

This painting was begun in 1661 and
was commissioned by a business
associate. The painting of the same
subject (pages 78 and 79), possibly
purchased later by Jan Six, was painted
in Leiden for Constantijn Huygens
about 30 years earlier. The two pictures
offer a striking example of Rembrandt's
changing style.

superlatives: 'a great painting ... the most direct and vivid of all his great portraits' (Kenneth Clark), 'one of his greatest masterpieces' (Michael Kitson), 'a remarkable example of outstanding technique and portrait interpretation blended into a great work of art' (Christopher White), 'without any question the greatest of all his portraits, and arguably the most psychologically penetrating of all seventeenth-century portraits' (Simon Schama).

The subject stands slightly to one side of the canvas, as if about to move forward, a magnificent red coat trimmed with gold braid slung from one shoulder. Though his face is in

repose, he is pulling on his gloves, and seems to have just come in, but he has been intercepted, and the interruption may or may not be entirely to his pleasure. The head is slightly inclined as if he is listening, impassive but alert, to the reason for the interruption. His hat lightly shadows his brow. The dark background and the low viewpoint contribute to an impression of a man of considerable force of character.

The portrait is evidence enough that the relationship between painter and subject was more than merely a professional one. If Rembrandt had not known Jan Six well, he could hardly have succeeded so triumphantly in the extraordinarily difficult task of showing us both the private man and the public citizen – Jan Six as he was as well as how he appeared – while at the same time preserving an air of dignified, slightly mysterious restraint, mysterious because while this is clearly a portrait of a thinking man, we do not know what he is thinking.

In galleries it is sometimes difficult to get near enough a Rembrandt portrait to appreciate technically the fine detail of light and shadow in a face, playing on the slightest line and contour, and no photograph can compensate. Yet some parts of the *Portrait of Jan Six* are painted very broadly, in the manner of *Hendrickje Bathing*. The strips of gold braid along the edge of the coat are each suggested with a single broad brushstroke over the red of the fabric. The vigorous,

impressionist brushwork of the hands and gloves suggests actual movement – it is not certain whether Six is taking his gloves off or putting them on and thus whether he is coming in or going out – and there is even something of the same treatment in the planes of the face.

The painting, which is relatively large for a Rembrandt portrait and almost square (allowing for available space to the left of the figure), has remained to this day in the possession of Jan Six's descendants.

Curiously, the completion of the portrait practically marks the end of the friendship. Lending money has been the death of many a relationship, especially if the loan is not repaid. And then, Six's tastes, in common with the general trend, were moving strongly towards the more fashionable, 'finished' style and, although he held on to the Rembrandt paintings he owned, ultimately he may have come to sympathize with those contemporaries who deplored the vulgarity of Dutch artists who presented a Greek goddess as an undressed peasant woman. Then again, since giving up his business affairs in 1652, Six had begun to move rapidly up the social ladder, whereas Rembrandt was withdrawing further from fashionable society. But, much as we would like to know why they fell out, the lack of evidence means that any explanation can be little more than speculation.

Within a year, Six married a daughter of Nicolaes Tulp.

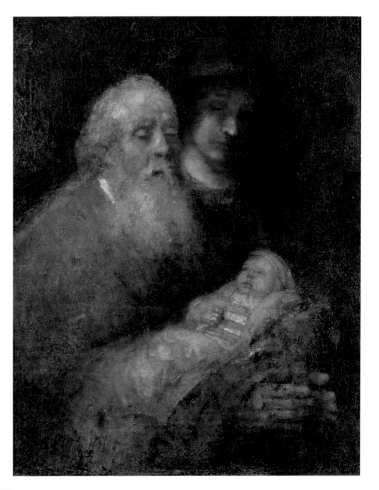

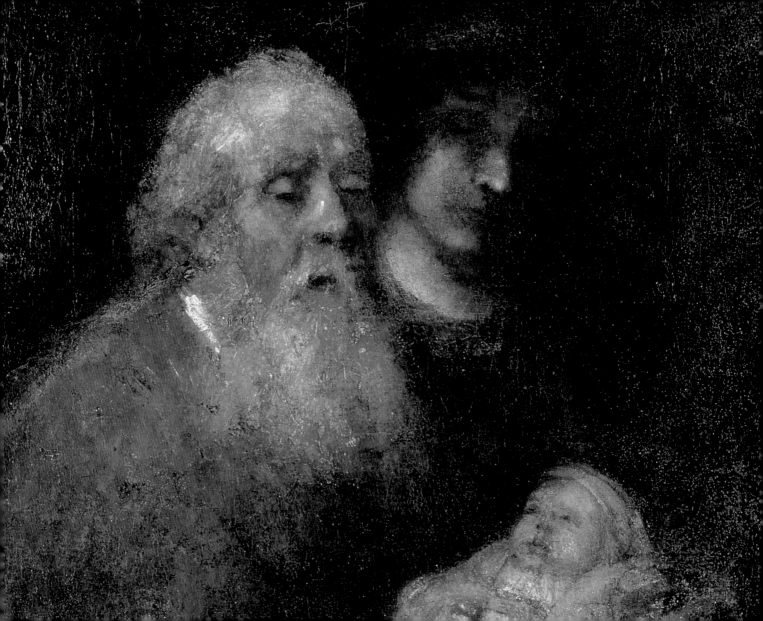

Naturally, he commissioned a portrait of his bride. And who painted the portrait? Not Rembrandt, alas, but his egregiously ubiquitous ex-pupil, Govert Flinck, who was more closely attuned to Amsterdam's liking for a more elegant, 'Flemish' style (see right).

Flinck had several contacts among the leading men of the city council, which helped him to gain the commission to decorate the new Town Hall with a series of history paintings. Rembrandt's contacts were fewer and generally at a lower level: the highest seems to have been Jacob Hinlopen, a mere alderman. Circumstantial evidence suggests that Jan Six's marriage may have been more helpful to Rembrandt than would appear, in reintroducing Rembrandt to the circle of the now-powerful Nicolaes Tulp, for in the next few years he received several commissions from eminent medical men. Arnout Tholincx, a highly placed medical administrator who was married to another of Tulp's daughters (and also related by marriage to Hinlopen), was both painted and etched by Rembrandt in about 1656. In the same year Rembrandt painted *The Anatomy Lesson of Dr. Joan Deyman* (see Chapter 13). Deyman had succeeded Tulp as prelector of the Surgeons' Guild, and his daughter married into the Six family.

Another physician, whose portrait Rembrandt etched in 1647 (page 291 right), Ephraim Bueno (Bonus) was a Portuguese Jew with scholarly interests, but we may be sure that he became known to Rembrandt through Menasseh ben Israel, not through the incestuous circle of civic bigwigs.

Govert Flinck never finished his work on the Town Hall because he died in 1660, not long after signing the contract. The question then arose, who would take over? From our point of view there was only one possible candidate, and Rembrandt did have many supporters, but the vital vote went against him. (Eventually, as we shall see, he did paint one of the eight projected pictures – and was never paid for it.)

In 1652 Rembrandt acquired a patron from an unexpected place, one that made him especially proud and for whom he clearly determined to make a special effort. The patron was Don Antonio Ruffo, an Italian nobleman whose titles included the intriguing 'Lord of Nicosia'. He lived in Messina in Sicily and never seems to have travelled far beyond it, not beyond Italy at least. Nevertheless, through various agents and dealers he was an avid collector of contemporary paintings from all over Europe, and his collection eventually exceeded 200. Whether or not there were any Rembrandt paintings in Italy, few would have seen them, but there were hundreds of prints, which were greatly admired and much copied. Don Antonio already owned two or three paintings by a Utrecht artist who had worked in Sicily, and would surely have known Rembrandt's name. He had a merchant friend who did business with Amsterdam, and through him Rembrandt was asked to provide a figure

Govert Flinck
Margaretha Tulp, 1655
Oil on canvas, 54³/8 x 40³/4in
(138 x 103.5cm)
Staatliche Museen, Kassel

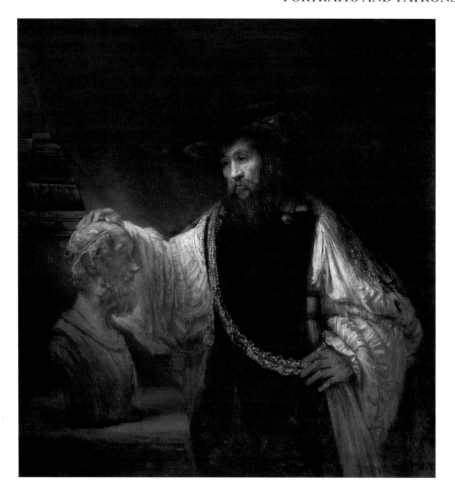

painting. Otherwise, although 'a philosopher' may have been mentioned later, the subject, unusually, seems to have been left entirely to Rembrandt's discretion.

Rembrandt must have been gratified, not only by this proof of international admiration (and from Italy, the fountainhead of modern art!), but also by the more mundane consideration that Don Antonio was prepared to pay him 500 guilders, perhaps eight times the amount he would have paid for a figure painting from an Italian artist.

Almost two years later a merchant ship, bound for Naples from Amsterdam with a cargo of raw silk, stopped briefly in Messina's harbour to unload a stout wooden box for Don Antonio. It contained a picture, one of Rembrandt's most original inventions, *Aristotle Contemplating a Bust of Homer* (left, detail right).

This famous picture is quite large and almost square, but originally it was slightly higher and wider. The three-quarter-length figure of Aristotle appears as a handsome, middle-aged, bearded man gazing at a marble bust of Homer on which he rests his hand. His expression conveys deep thought tinged with sadness. He wears a broad, flat hat, a black sleeveless tunic or apron over a white shirt of extraordinarily full cut and wonderfully silky texture. Looped over one shoulder and around his waist is a glittering gold chain, so encrusted with specks, blobs and dashes of thick paint that it stands up to five or six millimetres above the

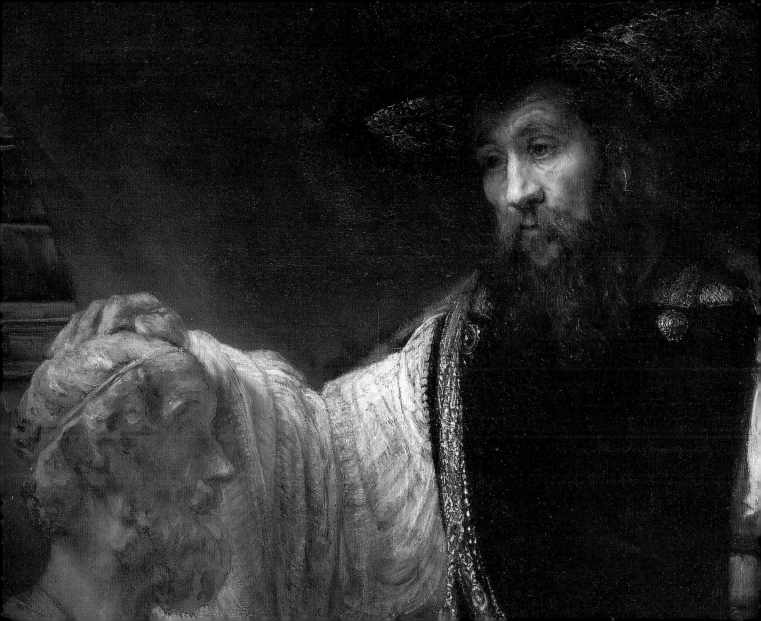

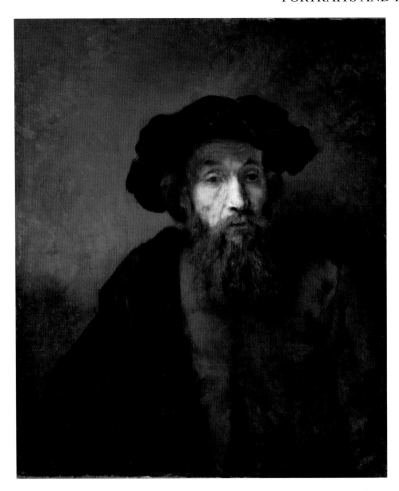

290

surface of the canvas. From the chain hangs a medallion with the head of a helmeted warrior identifiable as Alexander the Great. The bust of Homer stands on a table covered with a red cloth, with an enormous pile of books behind it.

This trio of heroes – the Philosopher, the Poet and the Prince – provide plenty of food for thought, and the picture has been much analyzed in the past for a deeper significance than is apparent, though it is not certain that there is any. The three are also, of course, personally connected. We know that Homer was greatly admired by Aristotle, who passed on his enthusiasm to his pupil, Alexander, to the extent, it is said, of preparing a special edition of the *Iliad* for him. Aristotle was also the favourite ancient philosopher of the Reformed Church. We know too that Rembrandt planned three paintings of these three individuals, which he intended to be hung together.

Rembrandt is renowned for his inventiveness, especially in finding ways to avoid the monotony of commissioned portraits, and this is a particularly striking idea. It has absolutely no predecessor in art, in itself a rare phenomenon. It also suggests a good knowledge of the classics. About the time that Rembrandt received Don Antonio's commission, he contributed the drawing of *Homer Reciting his Verses* to Jan Six's album, in which he flatteringly identified his friend with the Greek poet. It has been suggested that Jan Six was the Classical scholar who gave Rembrandt the idea for the

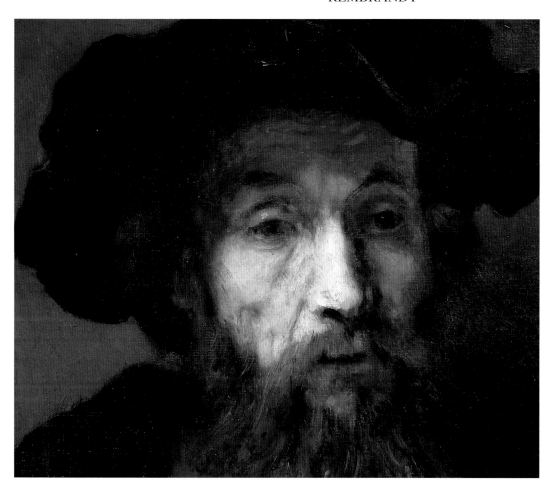

PREVIOUS PAGES
Aristotle Contemplating a Bust of
Homer, 1653
Oil on canvas, 56^1/$_2$ x 53^3/$_4$in
(143.5 x 136.5cm)
Metropolitan Museum of Art, New York

ABOVE
Ephraim Bueno (Bonus), 1647
Etching, 9^1/$_2$ x 7in (24.1 x 17.7cm)
Musées de la Ville de Paris

OPPOSITE and LEFT
A Bearded Man in a Cap, c.1655
Oil on canvas, 30^3/$_4$ x 26^1/$_4$in
(78 x 66.7cm)
National Gallery, London

This unknown sitter was clearly also the
model for Aristotle.

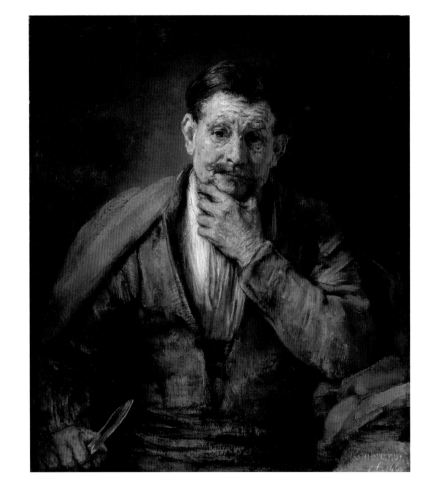

St. Bartholomew, 1661
Oil on canvas, 34^1/8 x 29^3/4in
(86.7 x 75.6 cm)
J. Paul Getty Museum, Malibu

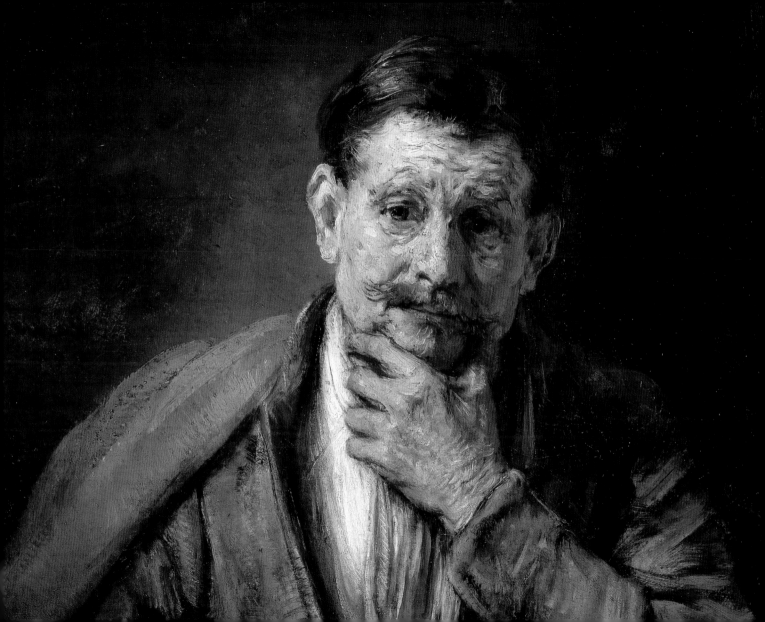

RIGHT
Homer Instructing His Pupils, 1663
Oil on canvas, 42^1/$_2$ x 32^3/$_8$in
(108 x 82.4cm)
Mauritshuis, The Hague

Homer was a favourite subject, whose bust, we know, Rembrandt owned. This is a fragment of what was originally a much larger painting.

OVERLEAF
A Man in Armour (Alexander the Great), 1655
Oil on canvas, 54^1/$_8$ x 41^1/$_8$in
(137.5 x 104.5cm)
Glasgow Art Gallery and Museum

Although now generally regarded as Alexander, the subject has been variously identified, with candidates including Titus in armour and Achilles.

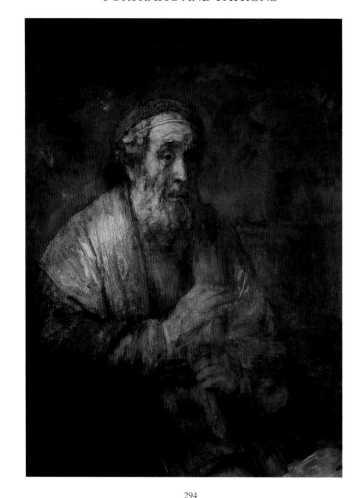

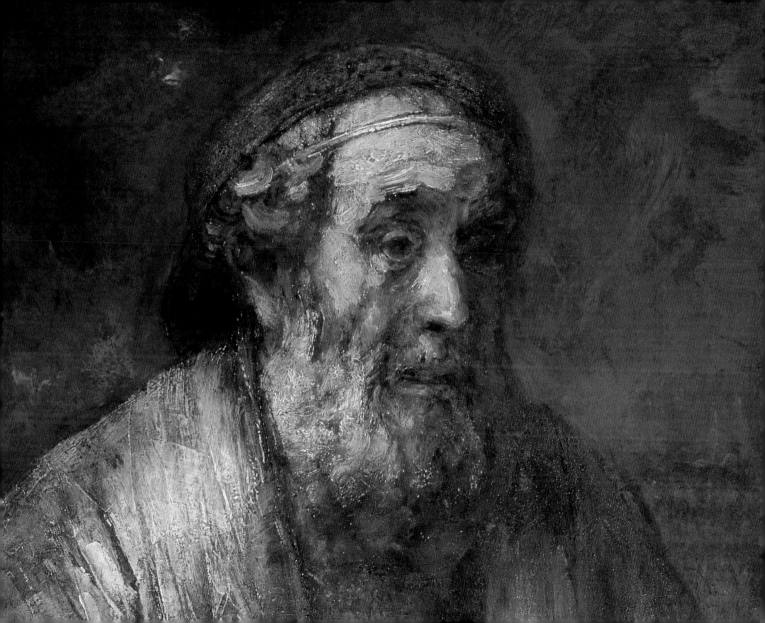

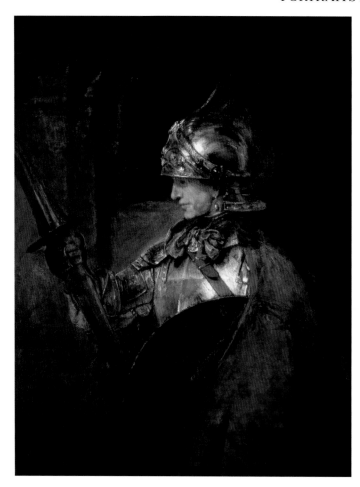

painting, and certainly the two men must have discussed the project.

The bust of Homer belonged to Rembrandt, one of his many expensive purchases in the Amsterdam salerooms, where he unwisely competed for desirable pieces with men vastly richer than himself. The model for Aristotle is not known, but he appears to have been the subject of at least one other painting by Rembrandt, the portrait *A Bearded Man in a Cap* (pages 290 and 291).

Don Antonio was gratified to receive the painting, if not ecstatic. He did not grasp the significance of the subject, though he guessed that the figure was a philosopher, either 'Aristotle or Albertus Magnus' he thought. However, some years later he asked Guercino of Bologna, then nearly 70 but a lot cheaper than Rembrandt (whom, incidentally, Guercino greatly admired), to provide a companion piece for the painting, in Rembrandt's style. Ruffo sent him what sounds like a very rough sketch of the picture, which Guercino thought must be of a phrenologist feeling for bumps. Guercino's painting has not survived, perhaps it never arrived, for Don Antonio later issued the same commission to another painter.

Eventually, Don Antonio was apprised of the meaning of Rembrandt's scheme and commissioned an Alexander to match the Aristotle – same height but less width. This time the result was not so satisfactory. The picture apparently

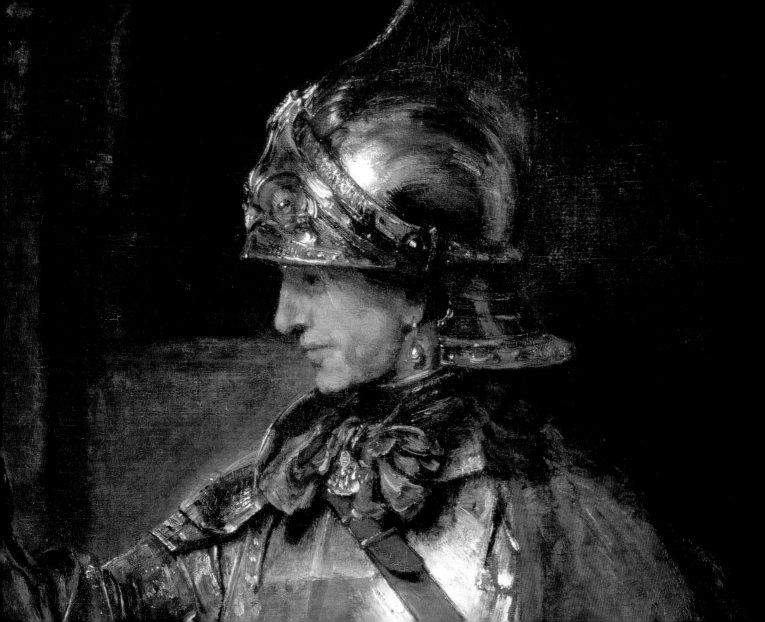

consisted of a head which had been extended into a half-length by tacking on extra pieces of canvas. It was accompanied by another painting, half-finished, of *Homer Instructing His Pupils*, or alternatively *Homer Dictating to a Scribe* (pages 294 and 295). Don Antonio wanted to send back both, the Alexander to be repaired or repainted or the fee refunded, the Homer to be finished, but at half the original fee. He received a brusque response. Clearly, Rembrandt wrote, few people in Messina had any understanding of art. There was nothing wrong with the Alexander that proper lighting would not cure, and he had added extra strips of canvas merely because he found it measured slightly less than the specification. He would paint another if required, but it would cost Don Atononio another 600 guilders, and he wanted the original price for the Homer.

Rembrandt refused to take any nonsense from his patrons. About this time a man named Diego Andrada (another of the mercantile Portuguese Jewish circle) complained that a portrait he had commissioned of a young woman (his daughter?), for which he had paid half the fee in advance, did not look like her. Unless Rembrandt was prepared to adjust this failing, he wanted his money back. Rembrandt refused to touch the canvas until he had received the full price, when he would submit the painting for arbitration to the Painters' Guild. If they supported Andrada's view of it, he would make changes. Otherwise he would sell it at auction.

Ruffo's admiration for Rembrandt was genuine enough (despite his complaints, he had also spoken of further commissions), and Rembrandt won the battle. Don Antonio kept the Alexander as it was, and paid the full price for the Homer. The latter, now in The Hague, has been considerably reduced (the pupils, or scribe, have disappeared) after being damaged by fire in the 18th century. As for the Alexander, there are two candidates, and no one is sure which, if either, belonged to Ruffo. Perhaps most favoured is the painting in the Gulbenkian Foundation in Lisbon, which is unsigned and undated, and has canvas additions that appear to be later. The identity of the subject is also open to argument. It is often listed as *Woman in Armour* and, if male, the subject is certainly very youthful. Rembrandt's son Titus might conceivably have been the model, but the figure has some attributes associated with the goddess Athena. The other, signed and dated 1655 (six years too early if it were Ruffo's) is *A Man in Armour* (pages 296 and 297), for which Titus was also the possible model (and if he was, the date must certainly be considerably later than 1655, when Titus was only 13 or 14).

Chapter Thirteen
Triumphs and Disaster

To the consternation of the Calvinists, who disapproved of the whole thing on moral grounds, theatre flourished in 17th-century Amsterdam in all its forms, from knockabout street burlesque to the learned reworkings of Classical drama by magnates of a literary bent, like Jan Six. Joost van den Vondel, who boasted of speaking no language but Dutch (despite his adaptations of Euripides and Seneca), was the most popular contemporary playwright after the success of his patriotic drama, *Gijsbrecht van Aemstel*, first performed in 1638 at the opening of the new city theatre and regularly staged thereafter.

Rembrandt, who well understood the theatricality of life itself and frequently demonstrated his fondness for dressing up or playing a role, was probably the first Western artist to leave us images of the theatre. No doubt he was acquainted with Vondel, though there is no evidence of contact between them, and he painted the portrait of another playwright, Jan Harmensz. Krul, in 1633 (Kassel, Gemäldegalerie). He made many sketches of scenes from Vondel's plays, and others whose subjects are thought to be scenes from plays, while several of his paintings in the 1650s, such as *Joseph Accused by Potiphar's Wife* (right), appear to be connected with the theatre. This may be the source for the most puzzling of Rembrandt's paintings and, in recent years, one of the most widely discussed, *The Polish Rider* (pages 302 and 303), although it is only one among many pet theories.

Joseph Accused by Potiphar's Wife, 1655
Oil on canvas, 44⁵/₈ x 35³/₈in (113.5 x 90cm)
Gemäldegalerie, Berlin

Jacob Blessing the Sons of Joseph,
1656
Oil on canvas, 69 x 82⁷/₈in
(175.5 x 210.5cm)
Gemäldegalerie, Kassel

The Polish Rider, c.1657
*Oil on canvas, 46 x 53^1/$_8$in
(116.8 x 134.9cm)
Frick Collection, New York*

*This, one of Rembrandt's most
impressive, fascinating and
controversial paintings, is discussed on
page 305 et seq.*

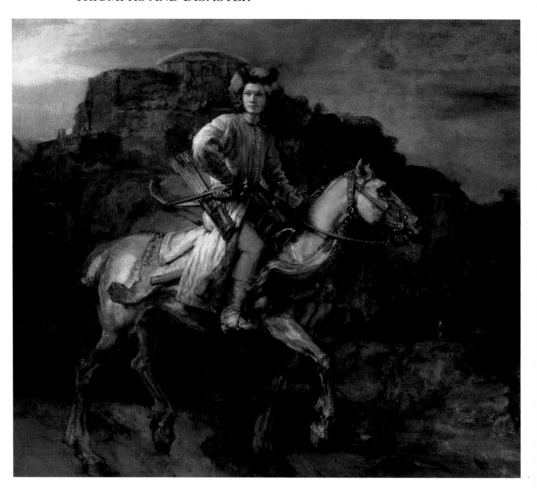

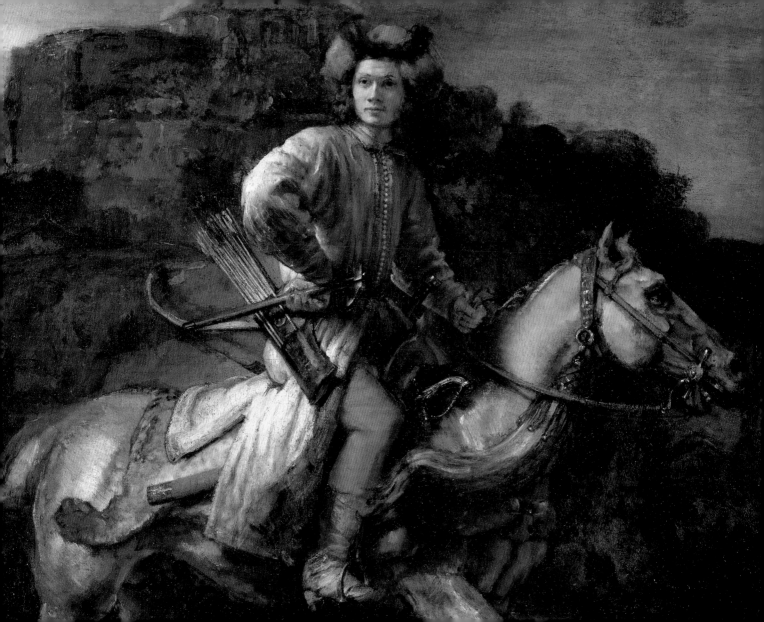

REMBRANDT

One of the chief reasons for Rembrandt's extraordinary popularity is undoubtedly his approachability. He is not obscure. The spectator, coming before a Rembrandt, feels an immediate sympathy, sometimes almost a sense of identification. There is no mystification, no arcane symbolism, with this artist. But *The Polish Rider* is an exception, because its attraction lies partly in its mystery; however, it is our ignorance more than the painter's intention that makes it so.

This painting has always had a special appeal. It is very beautiful but very strange, a fantasy, a romance, perhaps a *memento mori* – in short, an inscrutable mystery.

The rider is a young man, strikingly handsome, who wears clothes (red breeches, a long cloak) that suggest either the battleground or the hunting field, probably the former judging by his weaponry – two swords, a small mace, and bow and arrows (the latter more suggestive of hunting, bow and arrows being long obsolete in battle). He rides a grey, an animal so pale and gaunt that it recalls the drawing of a skeleton of a horse that Rembrandt made, probably a few months before, in the anatomy theatre when working on the projected *Anatomy Lesson of Dr. Deyman*. Nevertheless, its ears are pricked, its reddish eye is bright, its teeth parted, and it maintains a rapid trot with its hooves lightly touching the ground. The rider's head is turned to his right, towards us, though he is not looking at us but at something farther away,

OPPOSITE
The Parable of the Labourers in the Vineyard, 1637
Oil on panel, 12^1/5 x 16^1/2in
(31 x 42cm)
Hermitage, St Petersburg

LEFT
The Dream of St. Joseph, c.1650–55
Oil on canvas, 41^1/3 x 32^5/8in
(105 x 83cm)
Museum of Fine Arts, Budapest

TRIUMPHS AND DISASTER

OVERLEAF

Titus, c.1658

Oil on canvas, 26¹/₂ x 21³/₄in
(67.3 x 55.2cm)
Wallace Collection, London

and the jut of his elbow as it catches the light suggests the assertive self-confidence of youth. The hilly landscape behind, lit by a dullish gold evening light, rises to a peak surmounted by a domed structure behind the rider's head. It is altogether a powerfully evocative image, but what is it about, and who is the rider?

The titles of most of Rembrandt's paintings are, as we have seen, arbitrary. Many writers have questioned the description 'Polish' and offered alternatives, but the title is justifiable on historical grounds. The great collector Henry Clay Frick gave the picture this name in 1910, when he (or rather his agent, Roger Fry) bought it from 'a rather stupid country gentleman' living in a remote castle in Poland. However, its Polish associations are much older than that. Our earliest knowledge of it is a letter written in 1791 by a Lithuanian prince from an old Protestant family. He had himself visited Holland not long before and some of his ancestors had studied there. In the year that Rembrandt painted this picture, one of them was a student in his 20s at Leiden university.

The letter of 1791 was addressed to the last king of Poland: 'I am sending Your Majesty a Cossack, whom Reinbrand [sic] had set on his horse ...' In exchange, rather unexpectedly, King Stanislas had promised him a number of orange trees. Historians have confirmed that the rider's clothes and weapons, even his manner of riding (leaning

slightly forward, right arm curved backwards to grasp the mace), are characteristically Polish or Lithuanian (the two countries were united from the 16th century until the notorious Partitions at the end of the 18th century extinguished what had been the largest state in Europe). It seems possible that the painting was commissioned by a Lithuanian or Polish gentleman visiting Holland (to see his son at Leiden university?), which would explain the accuracy of details. He might have been put in touch with Rembrandt by Hendrick Uylenburgh, who had a Polish background.

Another common problem with Rembrandt's paintings, more tiresome than their titles, is establishing their authenticity. Connoisseurship is a potentially dangerous business, trickier than wine-tasting, and honest art historians have been known to admit that unusual qualities in a painting that seem to be strengths when the painter is a Great Master suddenly look like faults when he turns out to be some unheard-of copyist. This is not, in general, a subject that the ordinary enthusiast and exhibition-goer has the time, patience or academic background to pursue, but the case of *The Polish Rider* offers an interesting sample of the kind of arguments that arise. (A more detailed account can be found in Anthony Bailey, *Responses to Rembrandt*, 1994.)

The authenticity of nearly every painting ascribed to Rembrandt has been questioned by someone at some time. Even the simplest clues, such as the signature (or lack of it)

may be misleading. The signature on *The Polish Rider* consists only of 'Re...', the rest having been cut off when the canvas was trimmed; but until recently only one scholar has ever questioned its attribution to Rembrandt, and that was as long ago as 1906. Much about the painting was, and is always likely to remain, a mystery but, on grounds of style, both the date and the artist's identity seemed to be firmly established. That was the case until 1984, when Josua Bruyn, chairman of the prestigious Rembrandt Research Project, suggested that *The Polish Rider* was not by Rembrandt but by a hitherto almost unknown follower and former pupil named Willem Drost. The Rembrandt Research Project, founded by Bob Haak with Bruyn and others in 1968, is a team of top-notch Dutch Rembrandt experts assembled to compile a definitive (for the moment at least), multi-volume catalogue of the works of the greatest Dutch master. All its members apparently shared Bruyn's doubts concerning *The Polish Rider*, inflicting a fearful shock on professors, dealers and art historians throughout the world, not least, one imagines, the curators of the Frick Collection, whose director pronounced Bruyn's verdict 'unthinkable'.

No one is infallible and in spite of this weighty opinion, the views of the RRP, which is, quite rightly, always inclined to adopt a sceptical approach to its work, were not universally accepted. In certain circles, the Dutch scholars comprising the RRP were nicknamed 'the Amsterdam Mafia', and in 1997

Ernst van de Wetering, another leading member of the RRP, declared that he accepted *The Polish Rider* as essentially, if not entirely, the work of Rembrandt! His view seems to be currently the dominant one.

Well, these are perhaps technicalities that non-professionals should not get too concerned about, but they offer a hint of the difficulties of forming sure judgements on any artist, especially one so protean as Rembrandt, and in this case anyway, they may make us pause, if only to consider how disappointed we should be if it were proved that this magical picture is not the work of Rembrandt. Meanwhile, the arguments continue.

Surprisingly, the success of *The Anatomy Lesson of Dr. Tulp* in 1632, while it may have brought Rembrandt plenty of customers for portraits, did not result in many commissions from civic groups. *The Night Watch* was the only one between it and his second painting of a dissection, *The Anatomy Lesson of Dr. Joan Deyman* (1656; Amsterdam, Rikjsmuseum). The commission came soon after Jan Six married Tulp's daughter, and it seems to have been that event which led to the renewal of patronage from the medical community, already noted. And appropriately enough, it came from the same body, the Surgeons' Guild, that had commissioned the first Anatomy Lesson; in fact it was the first that the Guild had issued since 1632. As he was a burgomaster in 1656, Tulp himself must at least have given his support to the project.

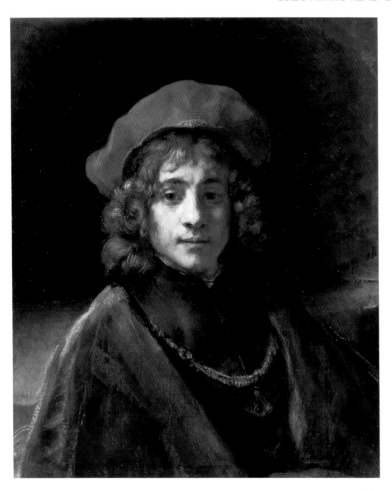

In its way, *The Anatomy Lesson of Dr. Joan Deyman* was no less ground-breaking than the earlier painting. It was originally much larger: the picture that now hangs in the Rijksmuseum measures 39^3/$_8$ x 52^3/$_4$in (100 x 134cm), but it is only a small part of the original. Sadly, the painting was almost completely consumed by a fire in 1723, and all that remains is this central fragment, consisting of the corpse being dissected, the surgeon's assistant (he was the son of the man closest to Dr. Tulp in the earlier painting) who stands to the left, and the hands and upper body (but not the head) of Dr. Deyman, which are engaged in delicately revealing the hemispheres of the brain.

There is, luckily, a preparatory sketch by Rembrandt (page 153 left)), shown with one of his favoured heavy frames that strongly resembles the proscenium arch of a theatre (the design of the frame may even have been the motive for the sketch). It offers clues to the composition, and the portion corresponding to the surviving section of the painting suggests that the two were closely related (and if the frame is the real subject of the drawing, it may have post-dated the painting). The inspiration for the composition was possibly an engraving of a painting of the dead Christ in Milan (Brera), by Mantegna, whom we know Rembrandt greatly admired.

The difference in atmosphere between this picture and its predecessor – for a time they were hung side by side – may

be linked with the difference in the painter's age. The later painting is no less of a painterly *tour de force*, but it is deeper, weightier, more solemn, even sombre, in its moral tone. It suggests not so much a theatre as a church, the anatomist standing, as it were, like a high priest behind the altar. In the drawing, there is an indication of some emblematic object behind and above him that vaguely suggests a cross. Several additional factors strengthen our sense of standing in the chancel of a church looking east. One is the low viewpoint. Another is the arrangement of spectators in two solemn groups on either side (the sketch suggests that the vigorously expressive gestures of Dr. Tulp's audience were absent). Finally, the assistant holds the removed section of the skull like a bowl or cup – or a ritual vessel. The corpse, which was that of a Fleming named Johan (or Joris) Fonteyn, convicted of robbery with violence, is presented at right angles to the picture plane, startlingly foreshortened so that hands and feet are practically on the same level. The body, undeniably Christ-like, has been opened to remove the internal organs, but the ribs remain intact, creating a dark, cavernous space at the viewer's eye level. Above it, the face is calm and unblemished, but the red mass of the brain is exposed as Dr. Deyman reverently removes the covering membrane.

What we have of *The Anatomy Lesson of Dr. Joan Deyman* is an impressively original example of Rembrandt's intellectual power as well as his pictorial abilities. If we had the whole painting, perhaps even without it, there is no doubt that this would be classed among the high proportion of Rembrandt's works of the mid-1650s that are generally accepted as masterpieces.

Such a group would include, besides Dr. Deyman's Anatomy Lesson, *The Slaughtered Ox*, *Woman Bathing in a Stream*, *Bathsheba*, *Portrait of Jan Six* and perhaps *Titus at His Desk* (page 323). It might include two Biblical ('history') paintings, possibly *Joseph Accused by Potiphar's Wife* (page 299) and, more certainly, *Jacob Blessing the Sons of Joseph* (pages 300 and 301).

As related in the Book of Genesis, Jacob, the son of Isaac and grandson of Abraham, was given the name Israel by the angel whom he defeated in a wrestling match (Genesis, Chapter 32). His 12 sons were the ancestors of the 12 tribes of Israel. Joseph was Jacob's favourite son, whose story is told in later chapters of the Book of Genesis. As a result of the hostility of his brothers, he was sold into slavery in Egypt, and bought by Potiphar, a professional soldier. While Potiphar was absent, his wife made advances to Joseph, which he resisted. In revenge she accused him of attempted rape and he was thrown into prison.

There are two versions of *Joseph Accused by Potiphar's Wife*, both signed and dated 1655, one in Berlin (Gemäldegalerie), the other in Washington (National

Gallery). (Joseph's evasion of the prurient wife of Potiphar was also the subject of an erotic – almost obscene – etching by Rembrandt of 1634, an extraordinary depiction of lust at its crudest.) We might suspect one of the two paintings to be a copy, and the signature on the Berlin version was questioned by Horst Gerson, but there is some reason to think that both are genuine. Gary Schwartz points out that the subject of the paintings does not correspond exactly with any point in the Bible story and is actually a scene from a successful contemporary play by Vondel, which was revived in 1655. Potiphar's wife, seated on the bed in slight disarray, is explaining to her concerned and consoling husband what has happened and gesturing to the guilty party, i.e. Joseph, who stands on the other side of the bed. In the Berlin picture he is emphatically denying his guilt with upraised hand; in the Washington picture he looks more sad than indignant. There is another, more striking difference: the model for Joseph in the two pictures is a different youth. On the basis of his theory that this is a scene from Vondel's play, Schwartz ingeniously suggests that a change in cast may be the explanation for the two pictures.

Jacob Blessing the Sons of Joseph (c.1656; Kassel, Gemäldegalerie) is a far more affecting painting – 'heart-breakingly beautiful' in the words of one modern critic. Jacob, ancient, near to death, bed-ridden and blind, is supported by the right arm of his favourite son, whose other hand, with a gesture of infinite tenderness that is echoed in his expression, guides the old man's arm so that his hand rests on the head of the elder grandson. The light, a divine one, falls on Joseph and on the face of his second wife, a sympathetic spectator. Rembrandt not only knew the Bible backwards, he was well versed in Hebrew tradition through his friendship with Menasseh ben Israel and others, and this painting contains many allusions that may have escaped some of his Christian contemporaries, not to mention the uninformed atheists of a later age. The benign figure of the onlooker, Jacob's Egyptian-born second wife whom Joseph described as 'that righteous woman', relates to a similar incident when the old and blind Isaac was conned by the very unbenign Rebecca into blessing her own 'smooth' son Jacob ahead of the elder and 'hairy' Esau, by covering Jacob with a furry shawl, like the one that Jacob is wearing here.

Several writers have commented on the prominence of blindness in Rembrandt's paintings, Homer and Tobit being other examples that featured many times in his art. It has been said of the early *Tobit Accuses Anna of Stealing the Kid*, the first painting that signalled Rembrandt's unusual talent, that its true subject is blindness. Not unnaturally, the prospect of blindness tends to be particularly dreadful for a painter, especially one such as Rembrandt, in whom, as Kenneth Clark remarked, 'the optic nerve must have been as quick and sensitive as in any human being since Leonardo da Vinci'.

David and Jonathan, 1642
Oil on panel, 28³/4 x 24¹/4in
(73 x 61.5cm)
Hermitage St. Petersburg

Looking at Rembrandt at work in his studio, it is easy to lose sight of the society in which he lived, the continuing warfare and civil turbulence, the unpredictable blows of fate, and the continuing hectic expansion of Amsterdam in spite of the prevalence of plague and 'Fevers, that lye most in the Head, and either kill suddenly or languish long ...' No one could remain immune to plague, or to the effects of national events, and Rembrandt was not the only individual who came to financial grief in the late 1650s (the poet Vondel was another) as a result of creditors calling in debts in response to a sharp economic recession. As for the causes of the recession, they lay beyond Amsterdam.

The Stadholder, Frederik Hendrik of Orange, had died in 1647, some months before the signing of the Treaty of Munster (one of the series of treaties known overall as the Peace of Westphalia that ended the Thirty Years War), bringing peace with Spain and belated official acknowledgement of the independence of the United Provinces. The treaty did not please all Dutchmen. In particular, it did not please Frederik Hendrik's son and successor, Willem (William) II of Orange, a young man full of martial spirit, in that respect more like his uncle Prince Maurice than his father. He planned to wrest the southern Netherlands from Spain with the aid of France.

The Estates of Holland, led by Amsterdam, not for the first time saw things differently from the Stadholder and the

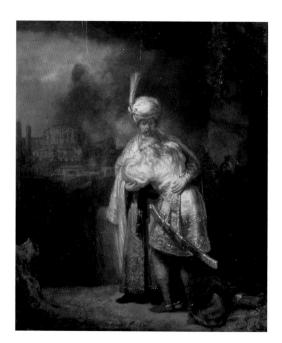

States General. The long wars against Spain had inevitably strengthened the national state, but Holland was now anxious to reassert the original independence of the provinces against

the pretensions of the Stadholder and the States General. The merchants looked askance at William II's foreign policy. In general, war was bad for business, and now that peace with Spain had finally been achieved, Holland wanted to cut defence expenditure, of which it paid a substantial proportion. The Amsterdamers also feared that if the southern Netherlands were captured, Antwerp might be restored as a rival to Amsterdam.

The quarrel escalated. Six members of the Holland estates were invited to The Hague, then thrown into gaol. Overnight, William marched on Amsterdam, but a fast-riding postman brought the city warning. The militia was called out, the gates closed, and William, who had banked on surprise, hesitated to attack. A compromise of sorts was reached, but the causes of conflict were not resolved, and civil war seemed imminent until the sudden death of William II a few months later, in October 1650, aged only 24. (A week after his death, his widow gave birth to William III, future stadholder and king of England.)

Holland, followed by four of the six other provinces, took the opportunity to abolish the office of stadholder, thus empowering the city oligarchies and enabling them to cut the defence budget. However, another foreign conflict loomed that was potentially even more damaging to Amsterdam than the campaigns planned by William II.

Relations with England had taken a turn for the worse

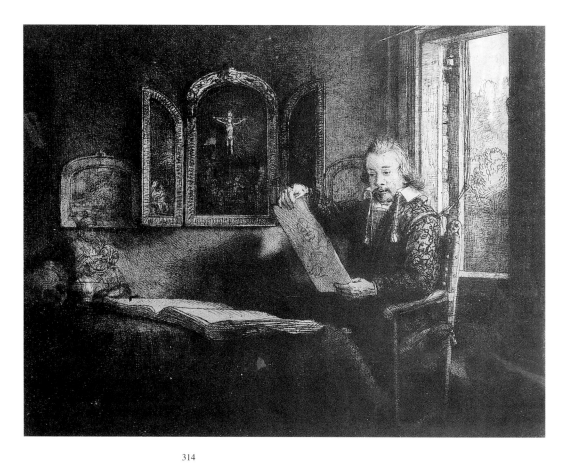

after the execution of King Charles I (1649), which shocked the Dutch. England and the United Provinces, both republics, both Protestant, should have been natural allies, but economic competition and commercial/colonial rivalry made them opponents. The English Navigation Acts of 1651 were a direct attack on Dutch shipping interests, and war broke out the following year. A few days later, Amsterdam's old Town Hall (already being replaced by a grander building) went up in flames, a bad omen (Rembrandt made a drawing of the remains). Despite the exploits of great admirals such as Tromp and Ruyter, the Dutch fleet had been weakened by the defence cuts, the English blockaded the coast, and the United Provinces were forced to yield. Oliver Cromwell was himself eager to halt the war with co-religionists, but that did not prevent the English insisting on hefty reparations in the Treaty of Westminster (1654).

By that time the blockade had already plunged Amsterdam into a financial depression. Early in 1653 Rembrandt received notice to pay off the outstanding debt on his house, which, 14 years before, he had agreed to pay off in six years. With interest, the sum owing amounted to well over 8,000 guilders. He raised loans, one of about 4,000 guilders from Cornelis Witsen, shortly to become a burgomaster, another, at five per cent interest, for about the same amount from Isaac van Heertsbeeck, which, plus the 1,000 guilders he had borrowed from Jan Six, just enabled

him to pay off the house. But his debts were merely redistributed, not diminished.

The whole business of Rembrandt's financial affairs in this period of crisis is very complicated. Although many relevant documents still exist, no one can be really sure what happened or, in particular, what Rembrandt was forced to do or what he did voluntarily.

Rembrandt made other efforts to stave off disaster. He attempted to transfer title in the house to his son Titus, and he began negotiations to buy another, cheaper house, for which nearly half the price was conveniently to be paid in pictures; but for an unknown reason the deal fell through. He also sold off some of his possessions at public auctions, though none of the proceeds seems to have gone to his creditors. Titus, now 14, made a will saying that if he died before his father, whatever remained of his mother's legacy should go to Rembrandt. It stated specifically that nothing was to go to his mother's family, whose concerns about Rembrandt's free-spending ways had cooled relations to freezing point.

In 1656 the crisis could be averted no longer. Faced with demands that he could not meet, Rembrandt was compelled to apply for what amounted to a declaration of insolvency, though it fell short of making him a fully declared bankrupt. He was, however, required to declare all his debts and assets and to convince the court that he had landed in this situation

OPPOSITE
Abraham Francen, c.1657
Etching, 6 x 8¹/4in (15.2 x 20.8cm)
British Museum, London

Portrait of a Young Man, 1658
Oil on canvas, 29¹/₂ x 23⁷/₈in
(75 x 60.5cm)
Louvre, Paris

Although this is attributed to
Rembrandt, it may in fact be the work
of a follower.

Young Boy in Fancy Dress, c.1660
Oil on canvas, 25^1/$_2$ x 22in
(64.8 x 55.9cm)
Norton Simon Collection, Pasadena

OVERLEAF
Titus in a Monk's Habit (as St. Francis), 1660
Oil on canvas, 31^1/$_4$ x 26^1/$_2$in
(79.5 x 67.5cm)
Rijksmuseum, Amsterdam

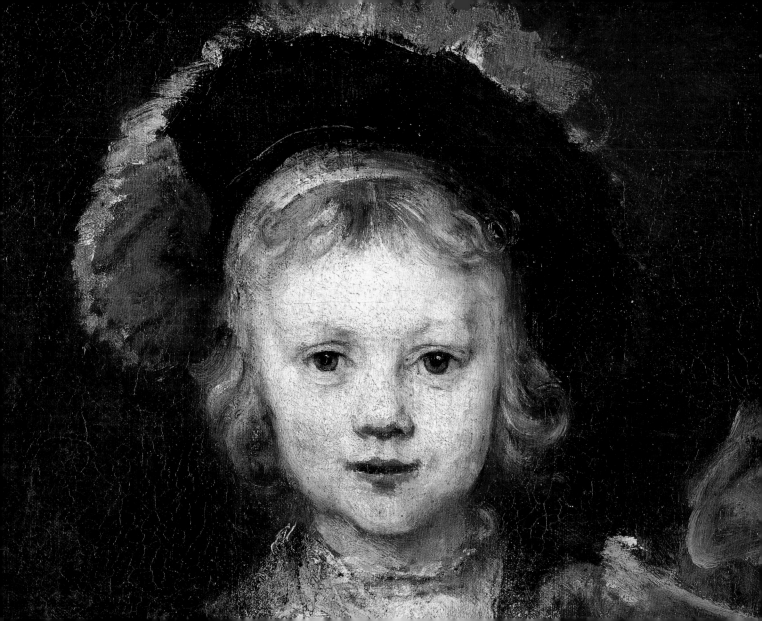

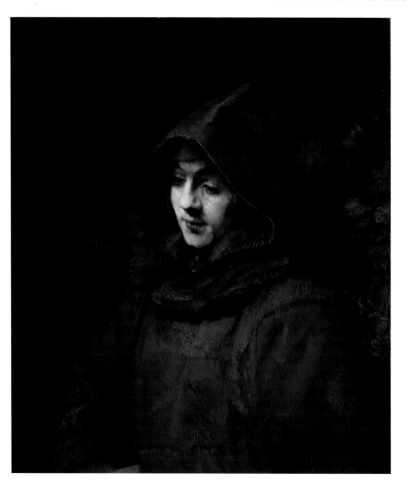

through no particular fault of his own. He cited business losses and 'losses at sea'. He could not deny his own extravagant spending, but he must have made a convincing case for being largely a victim of circumstances. One of the commissioners hearing the case was a son of Dr. Tulp, which may have helped. At any rate, he was believed, and for all we know he probably did, as he claimed, have commercial investments that collapsed in the recession, though there is no record of them. Certainly, a lot of money had disappeared without obvious cause.

The Court of Insolvency granted his petition, but since his creditors would have to be paid whatever could be raised from his possessions, he was required to help draw up an inventory of everything he owned – a grim task for poor Rembrandt but invaluable for posterity since the document, a lengthy one, has survived. It lists a huge variety of items, from books (not a great many, probably because he had sold some earlier), clothes and furniture to musical instruments, weapons of war, ceramics, glass, statuary, even a death mask of Frederik Hendrik. There were more than 70 paintings by Rembrandt himself, a startling total. Although he generally worked on several paintings at once, in order not to be idle while the paint was drying, this remarkable number strongly suggests that by this time Rembrandt was experiencing difficulties finishing a painting – at least, in finishing it to his own satisfaction (the inventory does in some cases

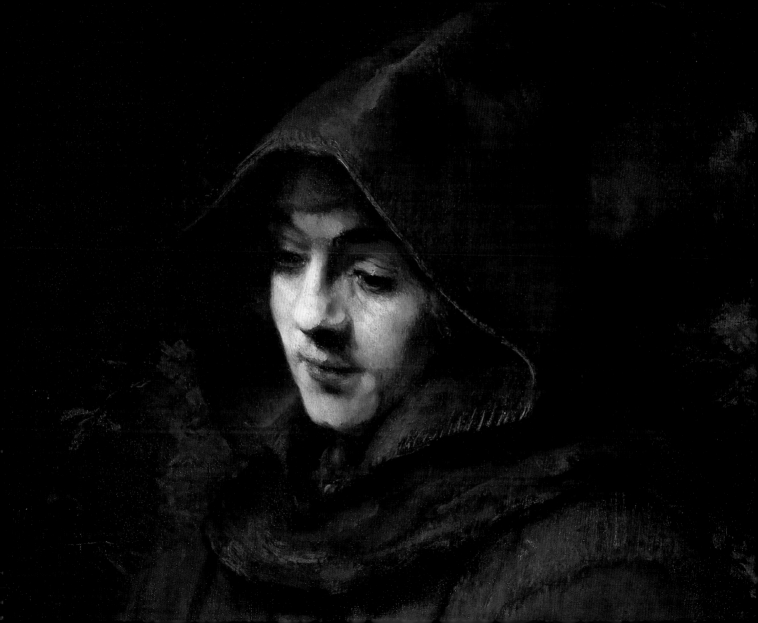

distinguish between finished and unfinished paintings, but it is ambiguous on many making the number difficult to judge). The inability to put down the brush and say, 'That's it!' is not uncommon among painters: Leonardo da Vinci was another notable sufferer from that affliction, which tends to get worse as time advances. Included also in the inventory was a huge number of Rembrandt's drawings, and a vast, mind-blowing collection of prints of other artists, a huge repository of ideas, themes and motifs that probably also served as a teaching aid and shows, if nothing more, the catholicity of Rembrandt's taste.

Legal affairs then as now took a long time to settle. Rembrandt seems still to have been living in the house in the Breestraat nearly two years later, and may have been there as late as 1660. Then there was a long battle to establish what belonged to Titus. It was in the creditors' interest to cut that sum down to a minimum, but the official acting as trustee, or guardian, for Titus (Rembrandt, being declared insolvent, was no longer allowed to perform that role and officially Titus was an orphan) established him as a preferential creditor. The creditors challenged Rembrandt's valuation of 1647, which he had made to satisfy Saskia's family, and Rembrandt called a number of witnesses to testify to its accuracy, among them Hendrick Uylenburgh, the artist Philips de Koninck, Jan van Loop and two members of the militia company who appeared in *The Night Watch*. In the

end his valuation was accepted, although Titus still ended up getting less from his mother's estate than had been anticipated because Cornelis Witsen, an unpleasant character whose loan to Rembrandt seems to have been motivated by obscure political manoeuvrings, had, as a burgomaster, the necessary influence to get his 4,000 guilders paid first. There was another hold-up over the sale of the house, which fetched 11,200 guilders, less than Rembrandt paid for it but a good price given the financial depression. On the other hand, Rembrandt's, to us priceless collection of prints and drawings was sold in 1658 for only 600 guilders. One reason for this paltry return seems to have been new regulations introduced by the artists' Guild of St. Luke.

Rembrandt had been a member of the guild since 1534. Thereafter, like other artists, he became theoretically subject to its rules, which turned out to be highly inconvenient. Rembrandt was not an organization man and cared little for institutions or, indeed, obeying rules. The guild would not have changed his inclinations for it dictated that someone who was selling up his collection had to sell it at once and in one lot. No doubt the guild had chiefly dealers in mind, but nearly all artists were also dealers to some extent. The guild also laid down that no one who had sold up could carry on trade in the city thereafter.

Rembrandt was in his early 50s, and although he had not aged particularly well, he was not an old man even by 17th-

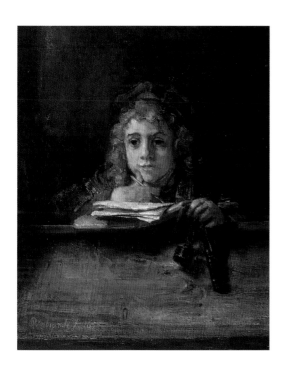

century standards (his fellow-bankrupt, Joos van den Vondel, lived into his 90s, as did Constantijn Huygens). We have seen that in 1659 he appears to have lost a lot of weight and looked ill. Could this have been the result of his misfortunes? That hardly seems likely, if only for the very different impression given by the Frick *Self-Portrait* of 1658, in which he appears as monarch of all he surveys, wholly impervious to the ruin that was engulfing him.

Rembrandt did not have to deal with his troubles on his own. Nearly every writer has commented on the loyal and sympathetic triangle formed by Rembrandt, Hendrickje and Titus, 'an indivisible trinity bound together by mutual love' (Christopher White). Yet this is a largely intuitive view, supported by very little hard evidence, except for the powerful testament of Rembrandt's portraits of his son and, as she was beginning to call herself, his wife.

When the dictates of the guild had placed Rembrandt in a situation where he could not legally sell a painting, Hendrickje and Titus came to the rescue. They formed a company, a little art dealership, in effect simply a legal front to enable Rembrandt to go on working. Ostensibly he became their adviser and employee, handing over his completed works to them. He was provided with free board and lodging, but received no salary – he still had unsatisfied creditors (including Heertsbeeck, who never did get his money back). He continued as a professional artist, still

Titus at His Desk, 1655
Oil on canvas, 30^1/$_3$ x 24^3/$_4$in
(77 x 63cm)
Museum Boymans-van Beuningen, Rotterdam

323

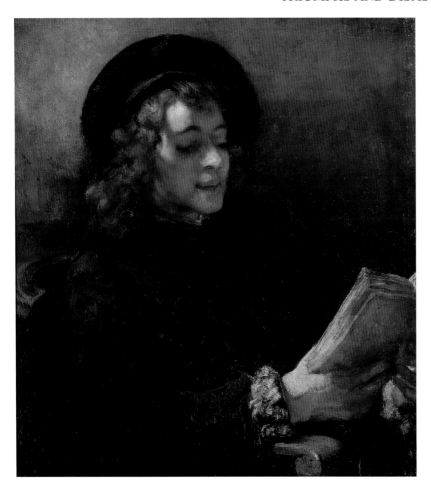

attracting pupils (they paid their fees to the company), such as Aert de Gelder, who came from Dordrecht and was still painting in something close to Rembrandt's manner well into the next century. Rembrandt was probably very happy with this arrangement. In the last decade of his life, he became increasingly withdrawn from society, retreating more and more into the world of his own imagination.

The family moved into a more modest house, rented for 225 guilders a year, in the Rozengracht on the other side of Amsterdam. It was an unfashionable district, inhabited mainly by small craftsmen, shopkeepers and the like. One advantage, possibly a contributory reason for choosing it, was that Abraham Francen, a great friend of Rembrandt's last years, was a neighbour. He was an apothecary, not a rich man, but a keen connoisseur who, according to an 18th-century writer, would go without food and drink to buy a desired print. Rembrandt made a portrait etching of him in about 1657, in 'landscape' format, showing him surrounded by *objets d'art* and closely studying a print by the light from a window behind him. Francen stood by Rembrandt throughout his financial troubles and seems to have acted, along with the painter Christian Dusart, as guardian of the only surviving member of Rembrandt's immediate family after the artist's death, Cornelia, his daughter by Hendrickje, who was born in 1654.

Some of the people with whom Rembrandt came into

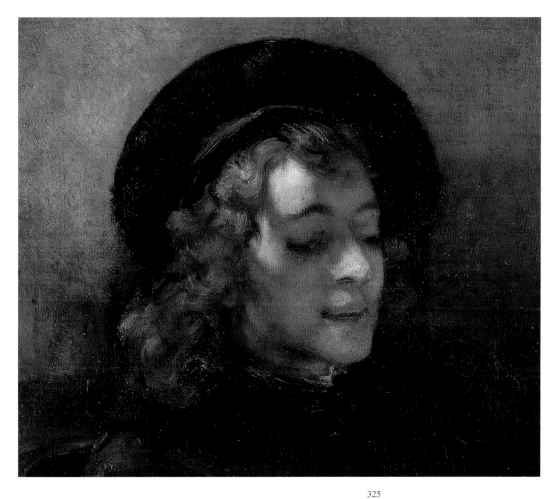

Titus Reading, c.1656
Oil on canvas, 27³/4 x 25¹/5in
(70.5 x 64cm)
Kuntsthistorisches Museum, Vienna

contact as a result of his troubles seem to have become friends or even patrons. In the same year as the etching of Abraham Francen (page 314) he did a slightly more conventional portrait etching – in fact executed largely in drypoint – of Thomas Jacobz. Haringh, who as warden of the Town Hall superintended the sales of Rembrandt's possessions. Of course they may have known each other earlier, since Rembrandt was a familiar figure at auctions though, in better times, as buyer rather than vendor.

The loyalty of his son, to whom he was clearly devoted, must have been a huge consolation in these years. In a way we know Titus very well and can follow his progress from boyhood to adulthood. That he was so often the subject of his father's work is not surprising, as Rembrandt painted anyone handy, but no one can mistake the pride and affection in these portraits. Besides a number of drawings, there are four or five surviving paintings of Titus, and more when he was probably model rather than subject. In fact, as so often is the case, the subject of the portraits is never identified by name, but there can be little doubt. He was a very good-looking young man, with abundant curly, reddish hair, much better-looking than his father although there is a definite resemblance: even the nose is a slimmer version of his father's famous conk. He seems to have been the model for several figures in Rembrandt's religious paintings, possibly even the beautiful angel in *Jacob Wrestling with the Angel*

(pages 344 and 345), and he is almost certainly Isaac in the etching of *The Sacrifice of Isaac* (pages 186 and 187).

The earliest, certain, painted portrait of him, also perhaps the most appealing, is *Titus at His Desk* (page 323), which shows him puzzling over his homework. The way his thumb presses into the youthfully resilient skin of his cheek, all done with colour, has impressed many admirers of the painting. Although it is dated 1655 in Rembrandt's hand, and the style suggests that the date must be about right, Titus appears to be several years younger than his 14 years. A slightly later portrait, *Titus Reading* (pages 324 and 325), shows him looking much more like his age, as does the portrait in the Louvre of about 1660. On the other hand, in the charming *Titus in a Monk's Habit* (pages 320 and 321), perhaps intended to represent St. Francis, Rembrandt again seems to be remembering his son, as parents tend to do, at an earlier age.

Titus seems to have been a gentle, affectionate, unremarkable youth, never a worry to his father and stepmother. No doubt Rembrandt hoped he would become an artist, and in time a useful assistant. But in spite of the benefits of a devoted teacher, Titus had not inherited his father's gifts, and what little survives that is supposedly by his hand is not very distinguished. But he continued to help his father and to run the company, on his father's instructions, after the death of Hendrickje. We hear a few

stories about him which don't altogether give the impression that father and son made a successful business combination. One minor disaster concerned a large and valuable mirror which, being transported to Rembrandt's house under Titus's direction, ended up smashed on the street. Later, when Titus was 24, he persuaded a bookseller in Leiden, who was looking for someone to engrave a frontispiece, that his father could do the job perfectly. But would his father do an engraving? The bookseller knew that Titus's father was an etcher, but had not heard that he was also an engraver, and this had to be an engraving because it allowed far more copies to be printed. Certainly his father could do an engraving, said Titus, and much better than the one the printer showed him, which had been rejected. Unfortunately, Rembrandt duly supplied ... an etching! Moreover it incorporated drypoint, which reproduces even fewer times than etching. No deal.

In 1665 Titus, who remained under the inconvenient authority of the court-appointed guardian, successfully applied to be declared of age (it seems strange that this took so long). He then received his share of the proceeds from the sale of the Breestraat house, which had been held in trust for him, though it amounted to a good deal less than his mother's original legacy. In February 1668 he married Magdalena van Loo, and moved from his father's to live in or near his mother-in-law's more spacious dwelling on the Singel. Magdalena was the daughter of the silversmith Jan van Loo, an old friend of Rembrandt's. He was one of the witnesses who had testified in support of Rembrandt's valuation of his property in the inventory of 1656 when it was queried by his creditors at the time of his insolvency. Moreover, Magdalena's mother was a Uylenburgh, so that what remained of Saskia's legacy was in this somewhat roundabout way eventually restored to the family, ending the possibility of further claims against Rembrandt from the Uylenburghs.

Chapter Fourteen
Rembrandt's
Religious Pictures

OPPOSITE
Christ, c.1650 (detail)
Oil on panel, 9⁷/₈ x 7⁷/₈in
(25 x 20cm)
Gemäldegalerie, Berlin

There are many similar portraits of
Christ, with the same Jewish model,
around this time. How many, and how
much of them were actually painted by
Rembrandt, is a matter for speculation.

Until the Reformation, the Church had been a major patron of the arts; in fact for most of the Middle Ages it had been practically the only patron. However, one of the objections of reformers to the practices of the Roman Church, in their insistence on returning to a purer, simpler Church founded on the Bible, was the worship of images, which, if not downright idolatrous, they saw as diverting people from the true worship of God. The cult of the Virgin Mary attracted particular criticism. These ideas were not new. Probably due partly to the influence of Islam, where such images were strictly forbidden, iconoclasm – the destruction of religious images – had caused a major constitutional crisis in the Byzantine empire that lasted, off and on, for much of the 8th and 9th centuries, and provoked protests from the pope in Rome.

The immediate effect of the Reformation on the arts was therefore largely negative, because most Protestants disapproved of religious images and rather than fill their churches with religious paintings and sculptures, were more inclined to strip them bare of what were already there, although outbreaks of iconoclasm appear to have been less widespread than is often assumed. Meanwhile, the Catholic Church staged a revival, marked by a reinvigorated papacy and the foundation of formidable religious orders such as the Jesuits; this placed a new demand on artists for expressive religious art that would stimulate people's faith and encourage worship by appealing directly to their emotions – in effect a form of propaganda. For that purpose the Baroque style was ideally suited, and it is no coincidence that, as is often said, it was primarily the style of Catholic countries, and strongest in those countries most closely tied to Rome, notably Italy. Of course, style in art is not invented by priests or patrons, it is invented by artists, and the Baroque, while stronger in southern, Catholic Europe, was not absent in the Protestant Rubens, for instance, was no less popular in the Dutch Republic than he was in his native, Catholic, Southern Netherlands. And Rubens, as we know, was a powerful presence in Rembrandt's art in his earlier years, always there in the background.

It might have been expected that with the disappearance of its chief customer, religious painting in Protestant countries would have languished. To some extent, and for a short time, it did. The Bible, with its infinity of well-known and oft-recorded stories, was more important to, and certainly far more studied by Protestants than Catholics, who until recently had not been able to read it at all unless they not only knew Latin but also took care to read it in secret. It is true that Protestantism was a religion of the Word, not the Image, and if Rembrandt had been an Italian rather than a Dutch artist he would not have had to paint such a high proportion of portraits to pay his way, although of course he did attract patrons from abroad. Anyway, even the Dutch

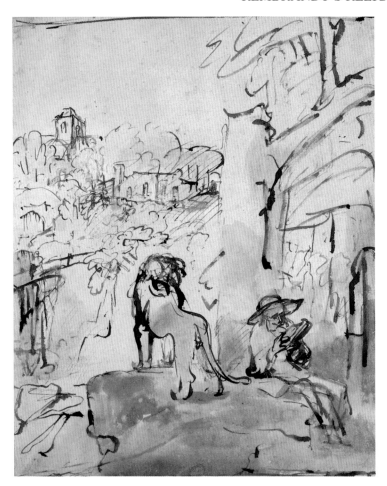

330

were not always unwilling to buy Biblical pictures, as well as portraits of themselves and their families, or *genre* pictures of their society – and as we have noticed earlier, for Rembrandt, Biblical and *genre* pictures frequently merged, a special but not exclusive characteristic of his drawings. The much-loved stories from the Old Testament and the Gospels formed a major part of so-called history painting, and it is significant that in spite of the rejection of the Apocrypha by the Synod of Dort, the fund of narrative subject matter that it contained remained as popular with artists, and therefore presumably their customers, as ever. Think only of the great number (if we include drawings) of Rembrandt's works on various aspects of the story of Tobias and his family, many of them representing exactly those incidents to which the Calvinist theologians of the Synod of Dort took exception as 'Jewish fables'. Of course, others, notably the Mennonites, took a more charitable view.

Though circumstances dictated that he painted more portraits, pictures based on the Bible formed the next largest proportion of Rembrandt's *oeuvre*. It has been estimated that the Bible provided the subjects of at least 160 paintings, 80 etchings and 600–700 drawings, the latter figure at least being probably too low.

It is undoubtedly true that Rembrandt would have been familiar with the Bible from an early age. Although the official Dutch version did not appear until the 1630s, the

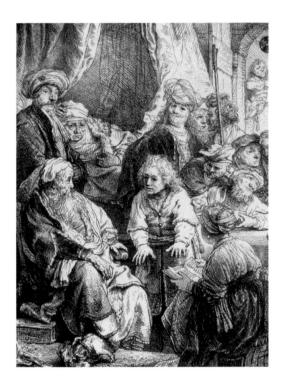

Bible was the one book that literate Protestant households always possessed. For Rembrandt and many others of his time, the Bible, Old Testament as well as New, was a living book. As a child, no doubt he had favourite stories that he liked to read or have read to him, just as later he had favourite subjects to paint. The Bible was not only read, it was eagerly discussed, especially among those like the Mennonites who put great emphasis on the individual's own interpretation. Although Rembrandt seems to have belonged formally to no Church, that did not imply a lack of religious commitment. He was probably closest in sympathy to the more moderate wing of the Mennonites, and we can be sure he discussed the Scriptures with someone like Cornelis Claesz. Anslo, the renowned Mennonite preacher, as well as other scholars and preachers whose portraits he painted. Possibly, although their acquaintance was short, among them was Johannes Cornelisz. Sylvius, Saskia's guardian, who was a Calvinist but no fanatic: he 'loved sincere simplicity and despised false appearance'. Certainly, Rembrandt's clients included representatives of all faiths, Remonstrants, Counter-Remonstrants, Catholics and Jews, the descendants of the ancient Hebrews of the Old Testament. Rembrandt must have talked with Menasseh ben Israel and other learned Jews such as the physician Ephraim Bueno (whose portrait he etched, descending a staircase, in 1647), and there is evidence that he was better informed about some aspects of the ancient

OPPOSITE
St. Jerome Reading in a Landscape
Pen and wash on paper, 10 x 8in
(25.2 x 20.4cm)
Kunsthalle, Hamburg

LEFT
Joseph Telling His Dreams
Pen and ink on paper, 4¹/4 x 2¹/4in
(10.9 x 8.2cm)
City Art Gallery, Leeds

The Flight into Egypt: Crossing a Rill,
1654
Etching, 3⁷/8 x 5⁵/8in (9.7 x 14.4cm)
Walter Hussey Bequest, Chichester

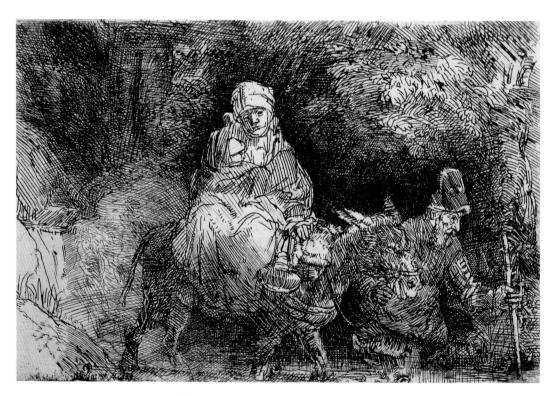

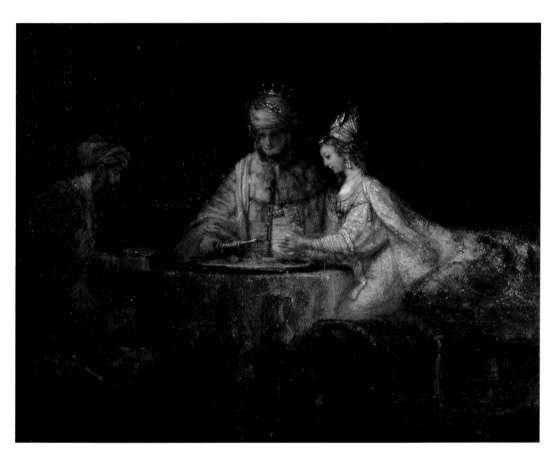

***Ahasuerus (Xerxes), Haman and
Esther, 1660***
*Oil on canvas, 28³/4 x 37in
(73 x 94cm)
Pushkin Museum, Moscow*

*This painting, which like that on pages
128 and 129 may have contemporary
literary allusions, was owned by one of
the city fathers, Jan Jacobsz. Hinlopen,
suggesting that Rembrandt was not
entirely bereft of powerful patrons at
this time.*

RIGHT
An Old Man in an Armchair, 1654
Oil on canvas, 43 x 33⅝in
(109 x 84.8cm)
Hermitage, St Petersburg

There is a probable companion piece,
An Old Woman in an Armchair, *in the*
same museum.

OPPOSITE
The Supper at Emmaus, c.1648–49
Pen and ink and brown wash,
7³/4 x 7¹/5in (19.8 x 18.3cm)
Fitzwilliam Museum, University of
Cambridge
(See also page 88)

Hebrews than he could have been if he had relied only on his reading of the Old Testament. It is a great virtue in Rembrandt that, while never doubting the sacred and inspirational character of Holy Writ, he was also sympathetically aware of its historical dimension, something hardly considered before the 17th century.

Judging by the frequency of his paintings and drawings of Jews, Rembrandt felt a special sympathy for them, distinct from that rather curious and contradictory affinity that existed, prejudices notwithstanding, between Protestantism and Jewry (and evident, for instance, in the Biblical names given to so many children of English Puritans), which was based in a common commitment to the Old Testament – and sometimes on shared Old Testament values. Rembrandt, with his broad human sympathies, saw the Jews as representing the ancient culture to which contemporary Christians belonged; nor was such a view particularly unusual. He drew and painted both the cultured, well-off Sephardic Jews who lived in the neighbourhood of the Breestraat and also the poor Ashkenazy Jews from eastern Europe, labouring people from the more impoverished districts. Many of his Jewish sitters were extremely handsome (though he also etched gnarled old men in raggedy clothes gossiping outside the synagogue). Another example of the absence of anti-Semitism in Rembrandt: he was the first European artist to portray Christ as a Jew. This was a revolutionary innovation,

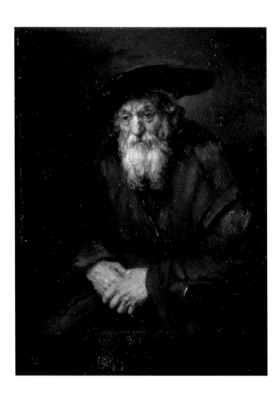

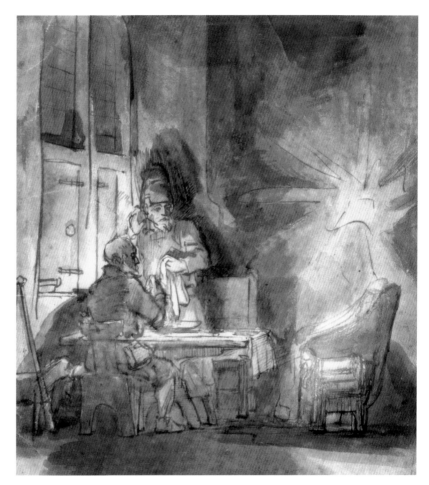

but it seemed perfectly natural to him, especially since in a way, we may feel, he saw Christ, as others have done since, as a great anti-hero (a term that might, without implying any great similarity, be applied to Rembrandt himself).

'History' painting, as we have seen, was regarded as the highest form of the art, and Rembrandt would hardly have questioned that doctrine. History painting generally consisted of two categories: pictures of Classical history and mythology, and pictures of religious subjects. The latter was much closer to Rembrandt's heart, and his preference is reflected in the much higher proportion of religious as against Classical subjects among his paintings and etchings. Another advantage of religious paintings was that the artist, in a Protestant environment, was relatively unrestricted in his choice of subjects, although there were exceptions, as in the case of commissions such as the Passion series for Prince Frederik Hendrik. There was generally less freedom of choice in Classical subjects, particularly when it came to great civic commissions. To be sure, there were not a great many of these going, but of what were available, Rembrandt obtained depressingly few.

We can assume that the subjects of Rembrandt's religious paintings were in the main the subjects that most appealed to him, and it is therefore interesting and instructive to see what he did, and did not, paint. Clearly he liked a strong narrative, which was not unusual, but he seems to have been drawn to

RIGHT
Abraham Receives the Three Angels
Oil on canvas
Aurora Trust

Apparently Rembrandt made a painting
of this subject, but it is known only
from this impressive sketch.

OPPOSITE LEFT
Susanna Brought to Judgement
Pen and ink, 9³/8 x 7³/4in
(23.8 x 19.6cm)
Ashmolean Museum, Oxford

OPPOSITE RIGHT
The Agony in the Garden
Etching
British Museum, London

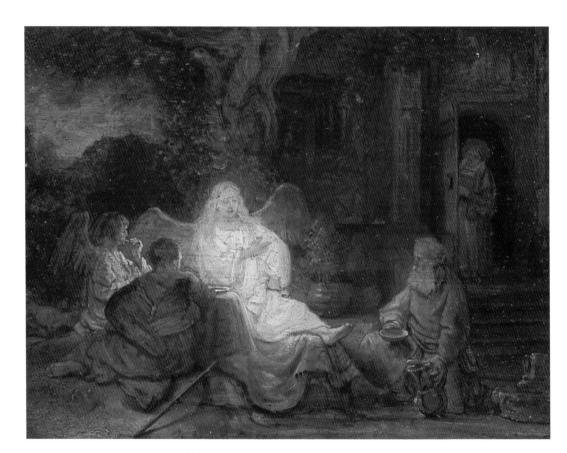

337

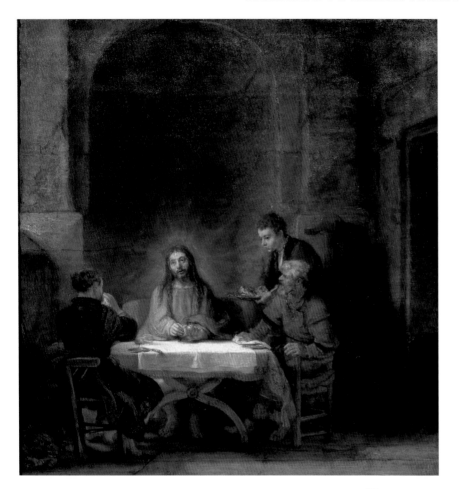

a special kind of story. Rembrandt was conscious of the immanence of the divine in everyday life, and it seems to have been Kenneth Clark who first observed that the kind of subjects that most strongly engaged him were those moments of revelation when the divine and the human were brought together, for instance.through a visitation by an angel (as in stories from the Book of Tobit), or by the manifestation of the divinity of Jesus Christ. An example is the Supper at Emmaus, admittedly a popular subject with artists generally, which concerns the incident after the Resurrection when Christ reappears to two disciples on the road to Emmaus and, according to St. Luke, joins them for supper at an inn. As we have seen, Rembrandt first painted this scene in 1628 (page 88), as an intensely theatrical experiment in light and shade. He did a much more restrained etching of the subject in 1654, and among the drawings is one in the Fitzwilliam Museum, Cambridge (page 335), almost as dramatic as the 1628 painting, in which Christ, after breaking the bread that reveals his identity, vanishes in a flash of light. (That this is an authentic Rembrandt is, however, disputed; Rembrandt's drawings in general are a minefield for connoisseurs.) There are two paintings of this event from the vintage year of 1648. The finest is the beautiful *The Risen Christ at Emmaus* (left and right), a calmer, more restrained version than the *coup de théâtre* of 1628, in which the gentle figure of Christ seems to derive from Leonardo's *Last Supper*. The other version, more

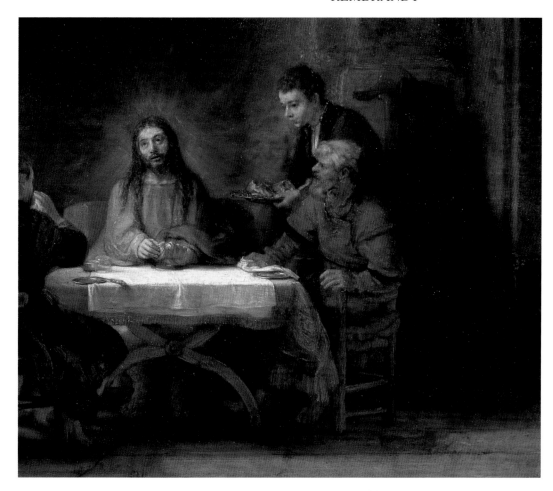

The Risen Christ at Emmaus, 1648
Oil on panel, 26³/4 x 25⁵/8in (68 x 65cm)
Louvre, Paris

OVERLEAF
The Risen Christ Appearing to Mary Magdalene (Noli me Tangere), 1638
Oil on panel, 24 x 19¹/2in (61 x 49.5cm)
The Royal Collection, Buckingham Palace, London

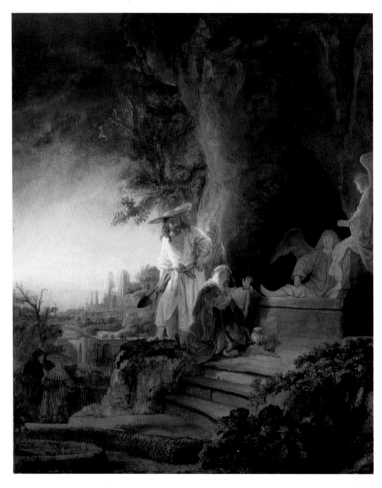

than possibly a copy, is in Stockholm (Statens Museum for Kunst), and seems to be a relatively conventional adaptation of the Louvre picture. It is more shadowy, the single light source being a concealed candle (a favourite Baroque device), instead of, as in the Louvre picture, a seeming emanation from Christ himself.

The Supper at Emmaus is immediately preceded in the Gospel by the account of the discovery of the empty tomb and the appearance of Christ to Mary Magdalene, another of those moments that touched Rembrandt with fervour. She at first supposes him to be a gardener, and indeed, in *The Risen Christ Appearing to Mary Magdalene* (left and right), Rembrandt, perhaps a shade too literally, has him carrying a spade. This painting may have been commissioned by a German court, and it was, to judge by the commendations of people like the poet Jeremias de Decker and the numerous copies that were made of it, a considerable contemporary success. Rembrandt painted the subject again, a much smaller picture in quite different, more intimate mode, in 1651 (Braunschweig, Herzog Anton Ulrich-Museum).

One of the most popular religious subjects of painters since the 15th century and one that might have been expected to hold a strong appeal for Rembrandt as a supreme example of the conjunction of the human and the divine is the Annunciation, when Mary is told by the Archangel Gabriel that she will conceive the Son of God by the Holy Spirit. In

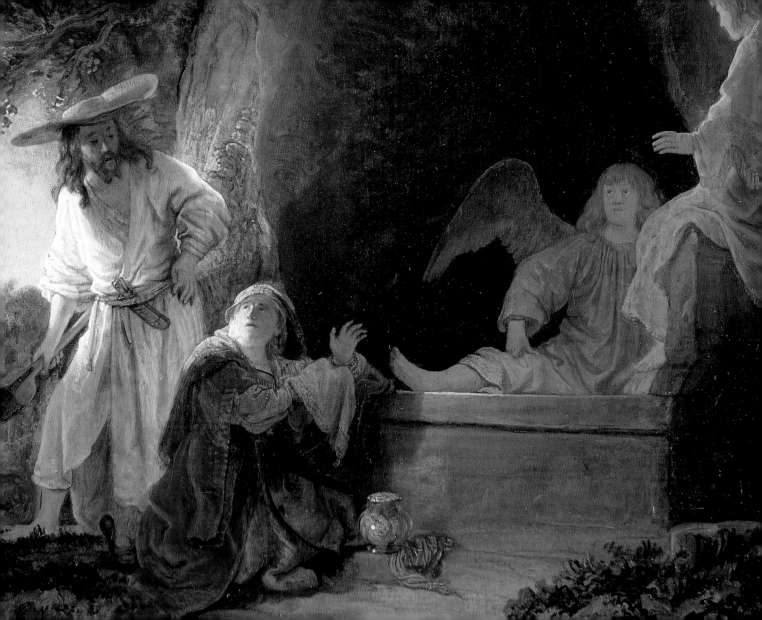

fact, the only work of Rembrandt on the subject is a drawing, in Besançon (left), which is done with swift, sure strokes of a reed pen, but if intended as a preparation for a painting, none ensued. In spirit it is quite unlike the typical *quattrocento* treatment of the subject, which tended to have something of the air of a formal interview. Rembrandt's drawing, as we might expect, is more human. The angel is not the usual gorgeous official messenger on a solemn diplomatic mission, but a caring, protective being, concerned for the shock that Mary is naturally feeling and sheltering her with his wings. Rembrandt almost always portrays the figures of Mary and the saints as human, rather than iconic, figures.

Yet Rembrandt, though not much attracted to the Annunciation as a subject – perhaps it was too 'Catholic' – made several drawings of other, less memorable, angelic visitations, to the family of Tobit, or to announce the birth of Samson to his father, Manoah (Book of Judges, Chapter 13). This is also the subject of an attractive painting, *Manoah's Offering* (Dresden, Staatliche Kunstsammlungen) which, however, was always problematic and though formerly attributed to Rembrandt has now, sadly, been withdrawn from the canon.

Among Old Testament figures, few had a more dramatic and eventful life than Joseph, but the incidents that Rembrandt painted were mainly about Joseph's dreams (from the Book of Genesis, Chapters 37–41), which earned him his

quite large it has unfortunately been cut down considerably on all four sides, which explains why Rembrandt's signature appears on a separate, stuck-on piece of canvas. The figures are full-size, and it is easy to imagine that in its original dimensions it was a much more imposing picture.

It has an obvious relationship with the painting of about the same time and today in the same gallery, *Moses with the Tablets of the Law* (page 347), also an extended half-length, with a similar background, the same very basic palette (but for Jacob's red tunic, both paintings are almost monochrome), roughly similar dimensions, and it too has been reduced in size. Even the subjects are similar, both concerning divine goodwill (the angel's blessing of Jacob, the gift of the Ten Commandments) towards the people. Ingenious suggestions have been made to explain exactly what the connection is. There can be no mistake over the titles, as the subjects could not conceivably be anything else, so most probably they were originally intended as a pair for some substantial public commission, possibly the new Town Hall (now the royal palace) on the Dam, which, though unfinished, was formally opened for business in 1655. (According to legend, Antwerp had started to decline when its new town hall opened, and superstitious Amsterdamers were therefore inclined to delay completion of their own, perhaps justifiably, for the long-term direction of Amsterdam's fortunes from 1655 was downward.) The

reputation as a prophet. Among them is the oil sketch (intended for an etching that was never realized), *Joseph Telling His Dreams* (above). The story of Joseph's father, Jacob, also offered a subject Rembrandt could not resist, in *Jacob Wrestling with the Angel*, overleaf, and mentioned above, which is a singularly unaggressive contest, more in the nature of an embrace (though they had of course been wrestling all night, and Simon Schama points out that the otherwise languid angel is ideally positioned to dislocate Jacob's hip, as the Bible says he did). The painting appears somewhat unsatisfying in composition because, although still

OPPOSITE
The Annunciation
Pen and ink
Musée des Beaux-Arts, Besançon

LEFT
Joseph Telling His Dreams, c.1640–43
Pen and brown ink with brown wash,
6⁷/₈ x 8⁷/₈in (17.5 x 22.5cm)
Private collection

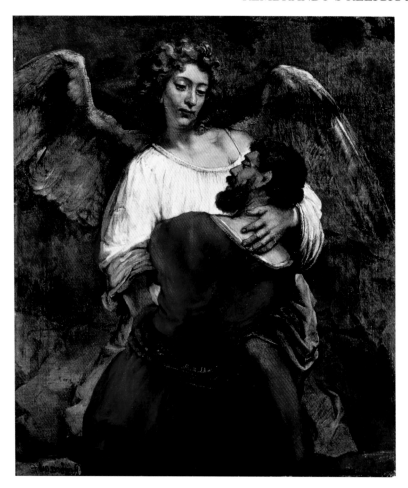

hypothesis that this pair of paintings was destined for the Town Hall is strengthened by the fact that, a few years later, a large painting of *Moses with the Tablets of the Law* was indeed placed there. The painter, however, was Rembrandt's former pupil Ferdinand Bol, no longer painting in his old master's manner but closer to Rubens, though lacking his exuberance, than to Rembrandt and, like the Classical Town Hall itself, not at all Dutch in style (see page 346).

Bol's picture was apparently not installed until at least 1662, and it was placed in the aldermen's chamber. At the time Rembrandt painted his version, three or four years earlier, one of the aldermen was Jacob Hinlopen, Rembrandt's supporter and patron, and it has been suggested that, in spite of the time gap, Hinlopen ordered the painting from Rembrandt for his own house, as a reminder of the figure in the aldermen's hall, not an uncommon custom (we have seen that Banning Cocq ordered a copy of *The Nightwatch*). However, this does not tell us anything about *Jacob Wrestling* and so advances us nowhere in the quest for the significance of the relationship of the two paintings.

Among New Testament subjects, Rembrandt was drawn to those examples of manifestations of the divine in everyday life offered by the miracles of Christ and his apostles. The Restoring of the Daughter of Jairus, related in the first three Gospels ('the maid is not dead but sleepeth'), a story that requires no suspension of disbelief, was a favourite subject,

344

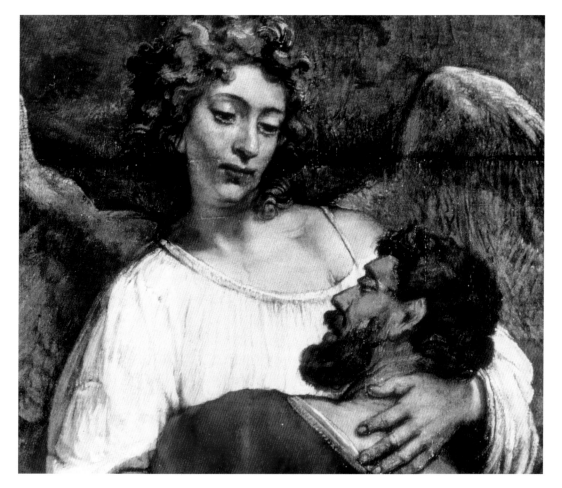

Jacob Wrestling with the Angel, c.1658
Oil on canvas, 54 x 45⁵/₈in
(137 x 116cm)
Staatliche Museen, Berlin

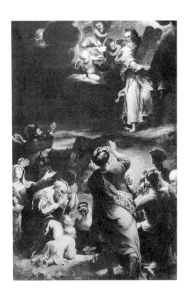

Ferdinand Bol
Moses with the Tablets of the Law, 1662
Oil on canvas
Koninklijk Paleis, Amsterdam

as was the resurrection of Lazarus. The early painting, *The Raising of Lazarus* (page 97 left), was a rather demonstrative and theatrical piece, done in competition with Jan Lievens, and the same could be said for a large etching of the subject done about the same time. When Rembrandt returned to it in another etching about ten years later, the need to flaunt his abilities had passed, and the result is calmer and more spiritual. At least two paintings of this subject were listed in the inventory of 1656 and, in the absence of other survivors, it may well be that they were the paintings by Lievens and himself done a quarter of a century earlier.

No one would deny that Rembrandt's art touches the highest peaks in at least a handful of his etchings of his religious subjects. One of the most famous is the large and moving print, *Christ Healing the Sick* (page 348), dating from the 1640s. It is popularly known as 'The Hundred-Guilder Print', because that was the sum – unheard-of for a print – that Rembrandt himself was prepared to pay for it. It shows a number of incidents chiefly from St. Mark's Gospel ('... they brought unto Him all that were diseased and them that were possessed with devils, and all the city was gathered together at the door. And He healed many that were sick of divers diseases...', Chapter 4). It was worked and reworked many times over a long period, hence the difficulty in dating it. It began as a large set-piece, done when Rembrandt was still finding drama in the tight grouping of small figures, with a

huge crowd of people arranged around the central one of Christ, a similar composition to the painting of *St. John the Baptist Preaching* (page 284). Over the years it was gradually refined, with individual figures highlighted, and many changes were made to the *chiaroscuro*, forming a ceaseless flow of movement in a pattern around Christ. Among the individuals carefully and sympathetically depicted appear those who are sick or crippled, some who are perfectly healthy, some rich, some poor, some agreeable, others critical, some devout, others skeptical. It is a picture informed throughout by the artist's knowledge of the Bible, and it probably reflects Mennonite influence on Rembrandt, which was at its height in the 1640s. As always, the divine and the mundane are closely associated and all people are candidates for salvation – no Calvinist predestination here. There are some allusions that few people today would spot unaided, such as the camel at the right (which would pass through the eye of a needle more easily than a rich man would enter heaven) or the mysterious little scallop shell lying on the ground in front of Christ, the significance of which remains obscure. The figure of Christ, with a gentle, all-encompassing gesture of acceptance, conveys both humanity and divinity, and the whole picture is filled with the quality that we associate more with Rembrandt than almost any other great artist, a deep feeling of compassion for ordinary people and the trials and travails they must suffer and endure in this vale of tears.

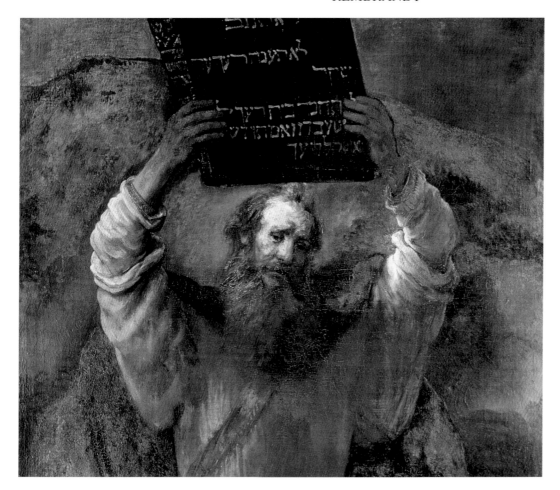

***Moses with the Tablets of the Law,
1659***

*Oil on canvas, 66$^{1}/_{3}$ x 53$^{3}/_{4}$in
(168.5 x 136.5cm)
Gemäldegalerie, Berlin*

RIGHT
***Christ Healing the Sick (The
Hundred-Guilder Print), c.1642–49***
Etching on Japanese paper
11 x 15¹/₄in (27.8 x 38.8cm)
British Museum, London

OPPOSITE
***Christ and the Woman of Samaria,
1655***
Oil on panel, 25 x 19¹/₄in
(63.5 x 48.9cm)
Metropolitan Museum of Art, New York

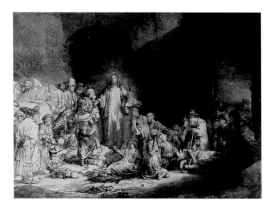

That same quality appears in many of Rembrandt's
religious images, in his etchings and drawings (apparently
the basis for a picture that was never painted) of the parable
of the Good Samaritan (page 125), who takes pity on the
victim of a violent robbery ignored by other travellers, and in
another favourite subject hingeing on Jewish-Samaritan
relations, *Christ and the Woman of Samaria*. They meet at a
well, where Jesus asks the woman to draw him some water
but she argues with him until, eventually, she is convinced
that he is the Messiah and asks him for water from the spring
of eternal life. Rembrandt made no less than three paintings
besides an etching and drawings of this subject between 1655

and 1659. All three paintings are relatively small and
two are on panels; they are now divided between the New
York Metropolitan (right), the Berlin Gemäldegalerie, and
the Hermitage in St. Petersburg. A certain Venetian
atmosphere in all three paintings may be connected with
Rembrandt's ownership (in 1656) of a painting of the
subject by Giorgione. It was a popular subject generally
with artists because the well was such a gift to composition.
All the same, it is strange that Rembrandt should have
produced three finished paintings of the subject in a short
space of time.

Rembrandt felt a little less sympathetic towards the
Woman of Samaria, who argued with Jesus, than he did
towards other penitents in the incidents and parables to
which he returned again and again. One of these was the
Return of the Prodigal Son. A young man demands his share
of his father's estate, spends it all on extravagant living, and
goes home remorseful, to be received with love, forgiveness
and roast veal! This was the subject of one of his last
paintings (pages 350 and 351), left in his studio and finished
by another hand, very likely Aert de Gelder. It has
nevertheless attracted extravagant praise from the most
discriminating of scholars, and Simon Schama draws a
comparison with another picture left unfinished, *Simeon with
the Christ Child in the Temple* (pages 285 and 286): an old
man cradling, in the former picture the sinner; in the latter

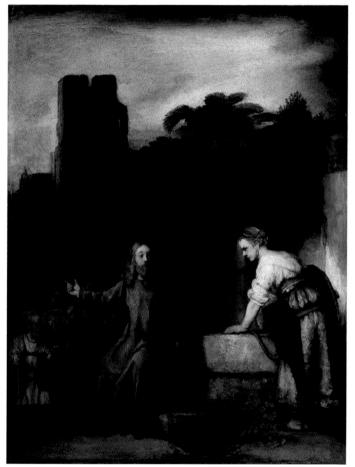

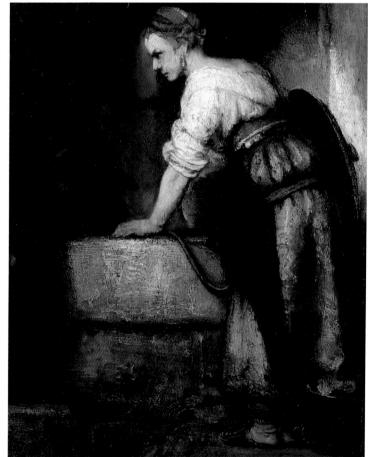

**The Return of the Prodigal Son,
c.1666–68**
*Oil on canvas, 103¹/₈ x 81¹/₈in
(262 x 206cm)
Hermitage, St. Petersburg*

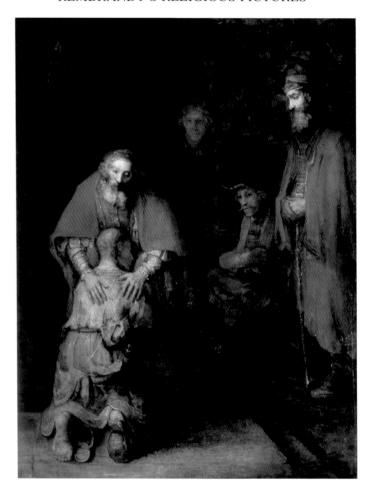

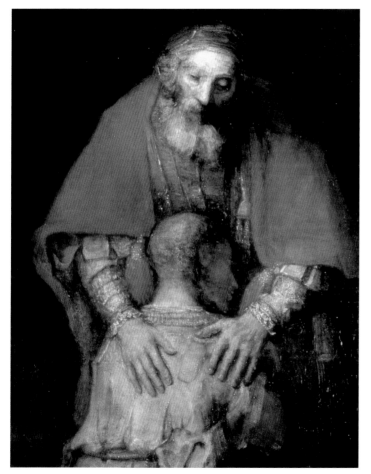 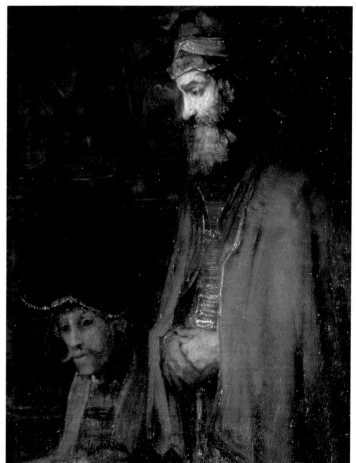

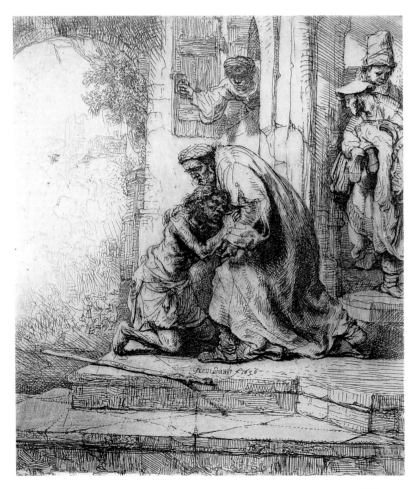

the saviour. The story comes from St. Luke, the patron saint of painters (Chapter 2). Simeon, having seen the infant Messiah, utters the famous invocation known after the opening words of the Latin version as the *Nunc Dimittis*, 'Lord, now lettest thou thy servant depart in peace...', traditionally used at Vespers or Evening Prayer. Was this perhaps Rembrandt's last picture?

Another story of a penitent sinner that attracted Rembrandt was the compelling tale from St. John's Gospel (Chapter 8), of the Woman Taken in Adultery. The Pharisees, trying to trap Jesus, point out that the law of Moses decrees she be stoned, what does Jesus think? He ignores them, stooping to write in the dust, but when they persist he stands up and answers, 'He that is without sin amongst you, let him first cast a stone at her', then goes on writing in the dust. The woman's accusers slink away, one by one. In Stockholm's Nationalmuseum there is a wonderful drawing of Christ writing in the dust (the Gospel does not say what he wrote, and this is one of those strange, apparently irrelevant details that has made some people think that parts of St. John's Gospel must have been written by an eyewitness). But Rembrandt's best-known work on the subject is the painting of 1644 in the National Gallery, London (pages 356 and 357). Rembrandt, following the Gospel's account, sets the scene in the Temple, a dim cavernous space with vast golden arches, columns and throne glowing in the gloom and the

figures grouped small slightly above eye level. The atmosphere is calm: even the scribe addressing Christ seems more inquiring than provocative; the woman kneels on the steps, dressed all in penitential white (with brilliant blue slippers) which, along with the tall, still figure of Christ, catches most of the light apparently coming from somewhere far above. There is a distinct resemblance to other Temple paintings, especially the earlier version of the Simeon story, done before Rembrandt left Leiden. There is not much sign here (except in details) of the intimate domesticity that lent added impetus (for instance) to his paintings of the Holy Family.

Christ and the Woman Taken in Adultery, which is on a wooden panel, was an artistic landmark for the best part of two centuries. Both its composition and various individual motifs were copied by many others, and according to the 1656 inventory, Rembrandt himself owned a copy of it. In the following year the original was listed in the estate of a dealer, Johannes de Renialme, who seems to have had considerable influence on both Rembrandt's style and subject matter in the 1640s. It was valued at over 1500 guilders, higher than any other of Rembrandt's history paintings and not far short of the price he was paid for *The Night Watch*. That is a reflection of the popular preference for Rembrandt's early, 'jewelled' style (this picture might easily have been painted earlier than 1644). It then passed into the

possession of Jacob Hinlopen, and on his death, when it was acquired by the Six family, it was valued at 2,000 guilders. Later it passed to John Julius Angerstein whose entire collection of 38 pictures was purchased for £57,000 as the nucleus of England's National Gallery collection on its foundation in 1824.

Christ's Passion was the subject of Rembrandt's first major commission, for Frederik Hendrik, arranged initially by Constantijn Huygens though the Stadholder's secretary was to be disappointed in his hope, no doubt shared by the artist, that Rembrandt would prove to be a Protestant Rubens. In the end, the commission proved to be a burden to Rembrandt. Why?

Part of the trouble was the very nature of the task, which left Rembrandt to resolve conflicting demands. He was engaged on what was essentially a Catholic project for which Rubens was the model, but the Catholic assumptions on which such a work was based contradicted Protestant belief. At the core lay the doctrine of transubstantiation, the issue on which all attempts at religious compromise during the Reformation had foundered. According to Catholic doctrine, the bread in the holy communion ceremony is transformed physically into the body of Christ. This ritual bound the worshipper and his God together in an extraordinarily intimate way, virtually abandoning the boundary between the divine and the worldly. A sincere Catholic, looking at a

OPPOSITE
The Return of the Prodigal Son, 1636
Etching
Pierpont Morgan Library, New York

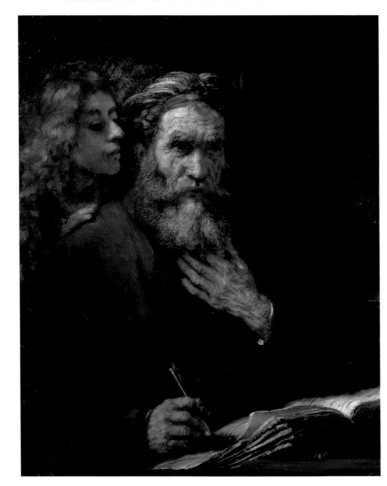

The Evangelist Matthew Inspired by the Angel, 1661
Oil on canvas, 37³/4 x 31⁷/8in
(96 x 81cm)
Louvre, Paris

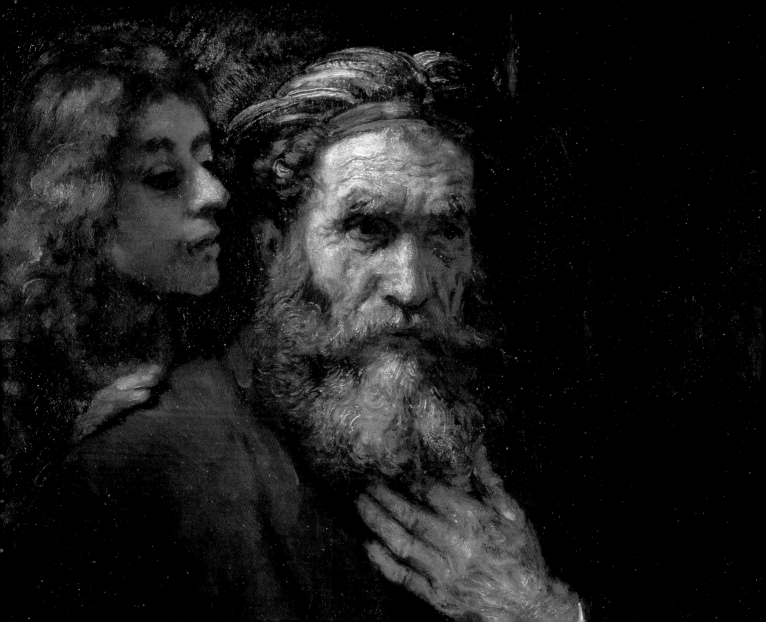

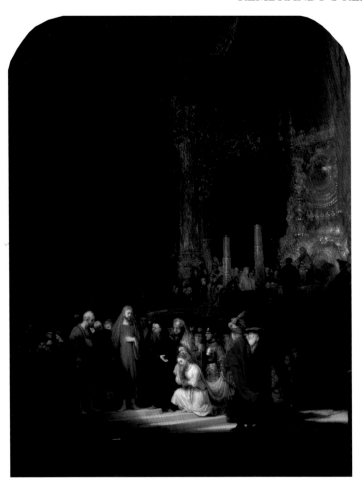

picture of the Crucifixion, took part in the experience in an almost physical manner, and this feeling of identification was encouraged by the Baroque painters of the Counter-Reformation. But all the leading Reformers had rejected the belief in a physical union, and interpreted the communion as a purely symbolic act. They taught that salvation depended not on any action taken by individuals, but 'on faith alone'. Sinners should accept their own unworthiness and put their faith in God's mercy to redeem them. They could do nothing themselves to assist the process, and the boundary between God and human beings was not to be crossed. It was the Christian's duty to wait, watch and pray, not to participate. The kind of painting that aimed to engage the viewer's emotions as actively and intensely as possible was essentially alien to Protestant belief (hence the association of the Baroque style primarily with the Roman Catholic Church).

This raised further difficult and complex problems for Rembrandt. There was no doubt of his ability to paint dramatic, difficult to ignore, audience-involving action – just look at *Belshazzar's Feast* or *The Blinding of Samson*. Moreover in the 1630s he was still largely in thrall to painters like Caravaggio, Titian and of course Rubens. The difficulties he faced in producing a Protestant Passion were never entirely resolved, and perhaps they could not be.

On a different level Rembrandt, more than any painter before him, brought the divine and the human into closer

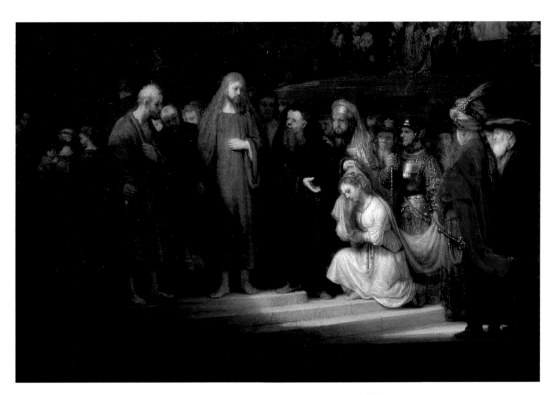

Christ and the Woman Taken in Adultery, 1644
Oil on panel, 32³/4 x 25³/4in
(83.3 x 65.4cm)
National Gallery, London

The Lamentation over the Dead Christ,
c.1635
Oil on paper and canvas, 12¹/₂ x 10¹/₂in
(31.9 x 26.7cm)
National Gallery, London

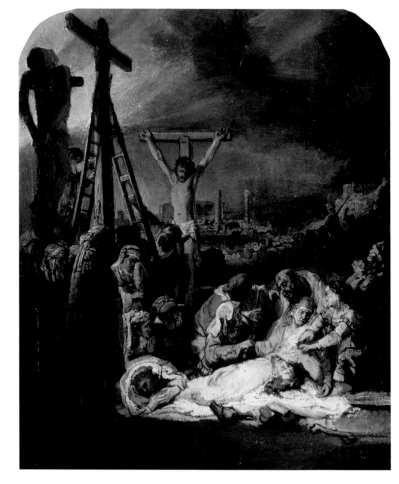

358

intimacy by emphasizing the details of ordinary existence, which make his figures easy to relate to. This struggle to reconcile great sacred events with mundane human incident is evident in the Passion series, especially in *The Ascension* (page 105 right), in which the need to combine the worldly and the celestial produces a picture, 'full of unresolved dilemmas', a Baroque set-piece in which, 'more than any others he ever executed, Rembrandt went as far as he dared toward Catholic apostasy, delivering an abbreviated version of an inspirational altarpiece which would have suited any Roman church' (Schama). That impression would be even stronger if Rembrandt had carried out his original intention (as revealed by modern X-ray examination) to include an image of God the Father receiving his Son into Heaven with the Holy Ghost attendant in the customary guise of a dove.

The same difficulty may well account for the curious physical make-up of the wonderful little *Lamentation over the Dead Christ* (left and right), an oil sketch on paper and several bits of canvas, these oddments being evidence of reworking and revision that may have gone on over a period of years. Extra bits of canvas at top and bottom were then probably added, in the opinion of the National Gallery, by a pupil in preparation for an etching which was never done.

The childhood of Jesus, in which there is hardly a single incident that Rembrandt did not paint or, more often, etch and draw, was probably, after the events of the Passion, the

359

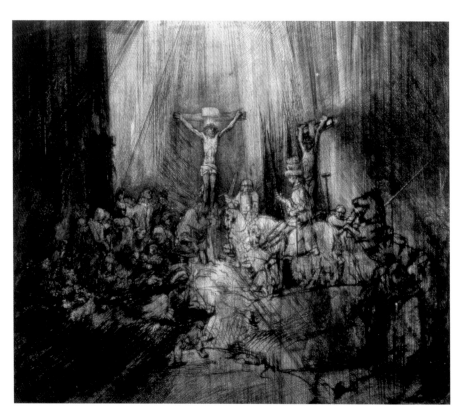

subject that appealed to him most strongly. Many painters before him had shared this predilection, but none portrayed the Holy Family with Rembrandt's simple humanity. The world is not short of Nativities, but none has quite the immediacy of Rembrandt's *Adoration of the Shepherds* of 1646, in which the faith and goodness of ordinary people is beautifully and convincingly depicted. He painted two versions of the picture, one now in Munich (page 365), the other in London (pages 362 and 363). The former was commissioned (after an interval of 13 years since the Passion series) by Frederik Hendrik. The London version is smaller and was done somewhat later, but it is more than a copy, with an added hint of timeless mystery, and it is superior in composition.

During the same period when he was working, if sporadically, on the Passion series, Rembrandt painted *The Holy Family*, now in the Alte Pinakothek, Munich (pages 368 and 369), also the subject of countless drawings, etchings and paintings, including the better-known *The Holy Family with Angels* in the Hermitage (page 368 left). Ironically, the Munich painting of an intimate, domestic scene is considerably larger than the great events of the Passion series, which vary slightly in size. Possibly because Rembrandt was no longer restricted by the inclinations of Huygens, who preferred his smaller paintings with small figures, he was able to paint life-size figures.

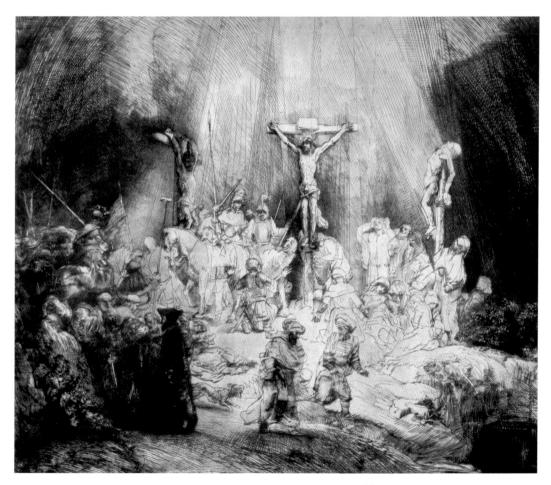

OPPOSITE
The Three Crosses, 1653
Etching
Hermitage, St. Petersburg

The different states of an etching often show marked changes, as in this case. See also left and page 376.

LEFT
The Three Crosses, c.1660
Etching
Fitzwilliam Museum, Cambridge

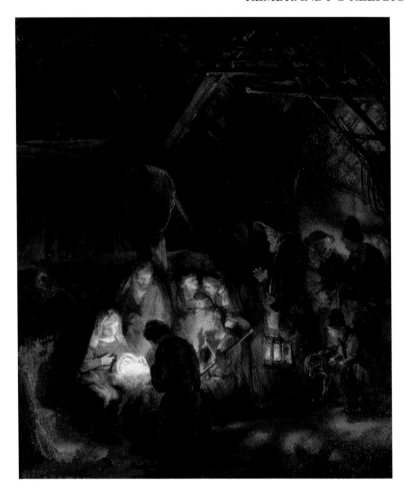

This is a very ordinary family, one might almost say an ordinary Dutch family, and, to judge by the clothes and the cradle, not an impoverished one, though of course not wealthy either. The setting is the carpenter's shop, with tools hanging on the walls and a length of rough wood, a detail invariably explained as symbolic, alluding to the future fate of the Holy Child. The infant, having just completed his feed (Mary's breast is still exposed), sleeps happily on a fur blanket on his mother's lap. She plays with his toes, as all mothers seem to do, while Joseph gently turns back the edge of the fur to gaze fondly at his foster-child. In Rembrandt's pictures, unlike those of the Renaissance masters, Joseph always gets, if not equal billing, at least a starring role. In Protestant eyes, the cult of the Virgin was another Catholic deviation from the truth of the Gospels.

In the Hermitage painting, one of the finest of Rembrandt's religious paintings, Joseph is shown at work in the background, and this beautiful picture would be indistinguishable from a genre piece were it not for the little angels hovering over the cradle. This was a rewarding subject for Rembrandt in the prolific mid-1640s. A third picture of the carpenter's shop at this time (the models for Mary and Joseph appear to be the same in the latter two and Joseph, though not Mary, might just be the same as in the Munich picture though if so he has not aged), is often known for obvious reasons as *The Holy Family with Painted Frame*

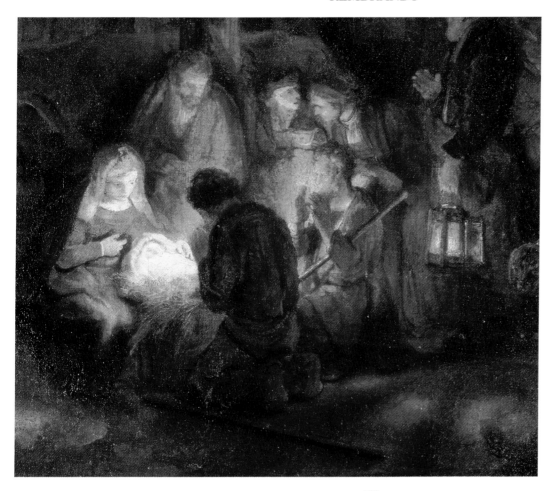

The Adoration of the Shepherds, 1646
Oil on canvas, 25³/₄ x 21⁵/₈in
(65.5 x 55cm)
National Gallery, London

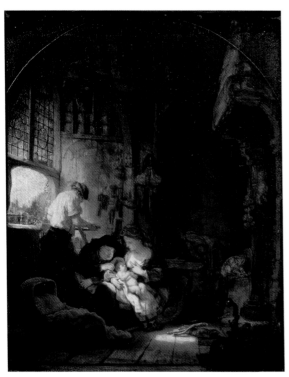

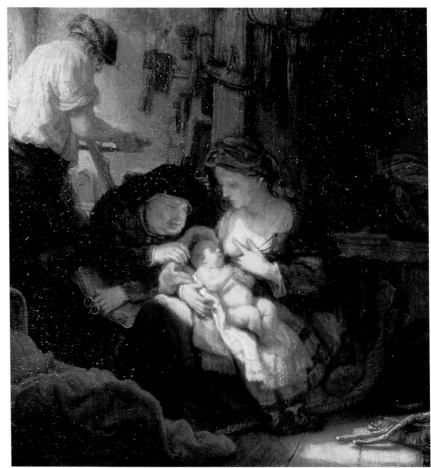

and Curtain (1646; Kassel, Gemäldegalerie), being depicted as a scene in a theatre, with Joseph again working away in the background, the Infant Jesus in his mother's arms at left, and a plump tabby eyeing a dish warming by the fire at centre stage. Another Holy Family of about this date was acquired by the Rijksmuseum in Amsterdam in the 1960s, but the weight of opinion is against Rembrandt's authorship.

Opinions vary, but if *The Ascension* was the least successful of the Passion pictures of the 1630s, the one that has aroused most enthusiasm is probably *The Entombment*, another subject to which Rembrandt often returned. Perhaps this event, marking the permanent removal from the world of the Son of God in his human form, had a special poignancy for Rembrandt. The Munich painting is in poor condition, which may be the result of Rembrandt having finished it in a hurry as well as the ham-fisted 18th-century 'restoration'. It was delivered along with *The Resurrection* in 1639 when Rembrandt, having just moved into his house in the Breestraat, needed cash quickly. There is a variant of the painting in the University of Glasgow (Hunterian Art Gallery) probably of the same year, loosely painted on a small panel and possibly done to submit to The Hague for advance approval. Among other versions is a very lightly etched print of about 1657 in which one of the leading pallbearers seems to have been modelled on Titus (although the body is definitely not that of Rembrandt!).

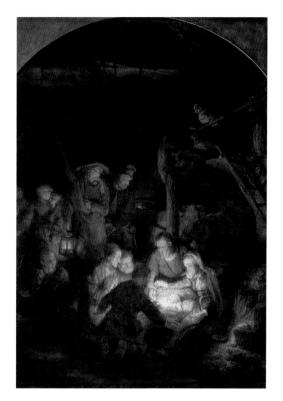

OPPOSITE
The Carpenter's Shop, 1640
Oil on panel, 16^{1}/8 x 13^{3}/8in
(41 x 34cm)
Louvre, Paris

LEFT
The Adoration of the Shepherds, 1646
Oil on canvas, 38^{1}/5 x 28in
(97 x 71.3cm)
Alte Pinakothek, Munich

Simeon and Jesus in the Temple
Pen and ink
Musée des Beaux-Arts, Besançon

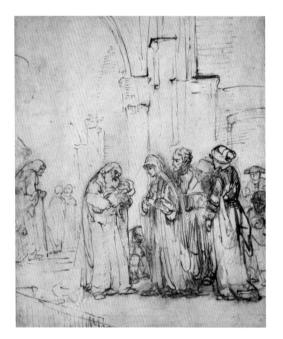

The *Entombment* of 1657, which was one of his last
etchings (he seems to have given up the medium almost
entirely a few years later) was among a series of fine

drawings and etchings of Biblical subjects in the 1650s. They
included another version of the *Supper at Emmaus*, several
pen and wash drawings of scenes from the Passion, many
Old Testament incidents, especially concerning King David,
who must have been, like Samson earlier, a figure of
particular importance for Rembrandt. They often convey just
the spirit of the episode, done with extraordinary economy,
and again themes of love, compassion, and penitence are
most prominent.

But these generalizations are not very valuable. It is
always difficult to make broad statements about Rembrandt,
and in his later period especially so. Such was the fecundity
of his invention, that he could (and did) depict a superficially
similar subject in different ways with different emphasis,
even to carry a different message. One characteristic we may
notice, however, is that in the religious pictures of his later
years, his art was most personal. In fact, it would be
interesting to know what prompted all those religious
drawings. It seems unlikely that they were done for sale, and
there is no evidence that they were (though that is not
surprising). Perhaps as gifts for friends and patrons? Or
perhaps, and this really seems the most likely explanation, he
did them for himself.

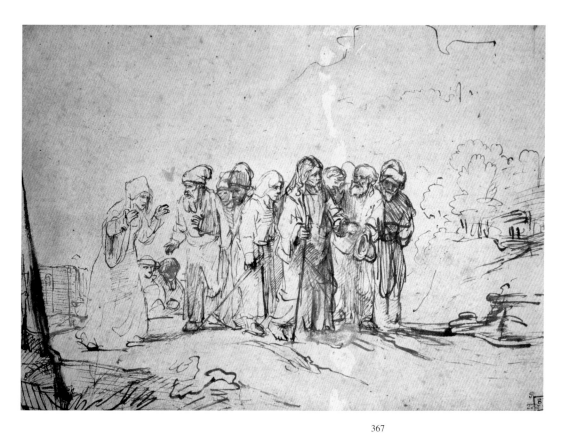

Christ and the Canaanite Woman
Pen and ink
Christie's Images, London

RIGHT
The Holy Family with Angels, 1645
Oil on canvas, 46 x 35⁷/₈in
(117 x 91cm)
Hermitage, St. Petersburg

OPPOSITE
The Holy Family, c.1634
Oil on canvas, 72¹/₄ x 48³/₈in
(183.5 x 123cm)
Alte Pinakothek, Munich

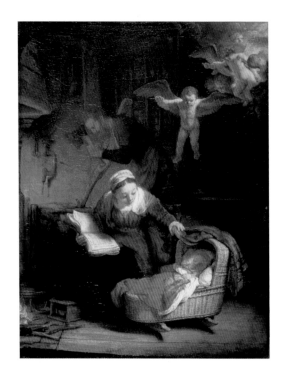

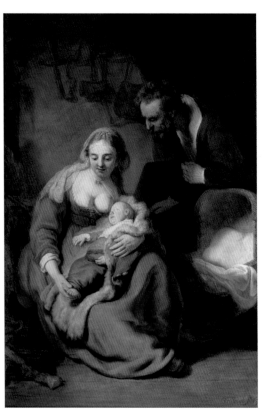

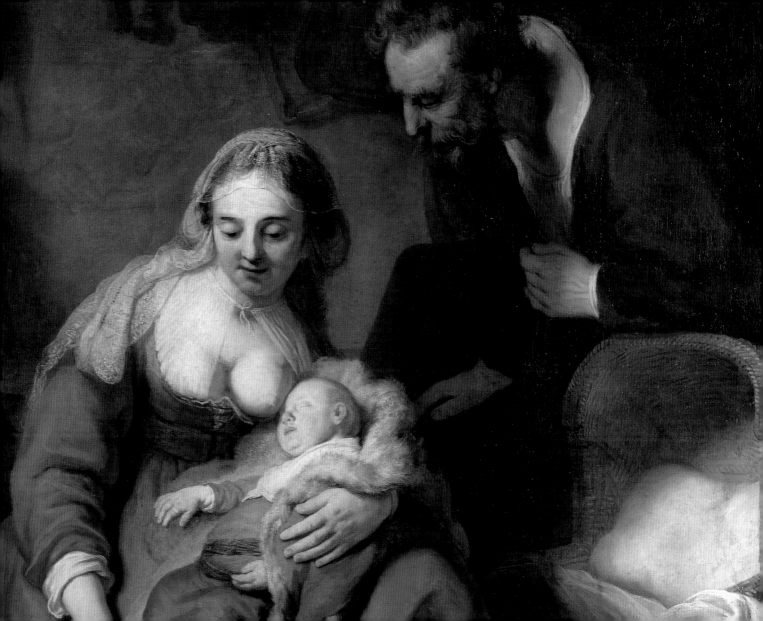

Chapter Fifteen
The Last Decade

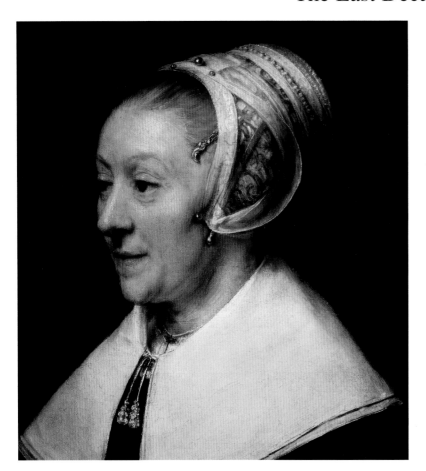

370

M̲ost people record their greatest achievements in youth or middle life, seldom in old age. Yet many great artists have entered a rich and markedly different phase in their creative life during their final years. It is often characterized by a turning away from the world and a more personal style rooted in their own creative imagination, and notwithstanding the growing conservatism associated with growing old, it is frequently radical and experimental. This was true of Rembrandt, who in his last decade painted some of his greatest pictures. But whereas, in most artists, this late flowering tends to involve greater obscurity – Beethoven's late string quartets are not to everyone's taste – that is not true of Rembrandt's late paintings. He has been seen, in a telling image, as an explorer who, having struggled through all kinds of difficulty, combated plagues, tempests and ravening beasts, has finally, battered and weary, come within sight of an unknown country, where things are unfamiliar, and the relationship between reality and representation is subtly changed. Part of this new awareness was Rembrandt's long-gestating feeling, which we have already noticed, for the actuality of paint, for paint as subject as well as medium, another development often characteristic of artists in their later years.

That had some effect, though it cannot have been the sole cause, on the narrowing of his interests. During these last ten years he practically abandoned landscape and genre scenes

altogether, and though he continued to draw, often in a rather hectic style, he did fewer and fewer etchings.

Inevitably, an air of melancholy invades Rembrandt's last years, or to be more accurate, it invades our sense of them. It is much less certain that Rembrandt himself was similarly affected. But what a grim comparison could be made between his situation and that of his old exemplar Rubens at the same stage of life: hugely rich, the owner of several estates, acclaimed throughout Europe, honoured by four royal dynasties. These achievements had utterly evaded the Amsterdam artist. Here he was, living in a rented house in a poor quarter of town, a bankrupt, a yesterday's man, unhonoured even by his own city. But it is unlikely that Rembrandt indulged in such thoughts, or, if he did, that he was much depressed by them, for he was blessed with confidence in his own ability, he knew his worth, he made no compromise.

Poverty, however, has few compensations, and he remained very poor although, characteristically, he talked of buying a Holbein for 1,000 guilders! According to Houbraken, he dined on bread and pickled herring, but there are worse diets and surely Rembrandt was no gourmet. He sold Saskia's grave, which meant that the purchaser was entitled to remove her bones and dispose of them elsewhere to make room for his own deceased, and there is a story about him breaking into his 15-year-old daughter's small

OPPOSITE
Portrait of Catrina Hoogshaet at the Age of Fifty, 1657
Oil on canvas, 48⁵/8 x 37³/8in (123.5 x 95cm)
Private collection

LEFT
Portrait of Jeremias de Decker, 1666
Oil on panel, 28 x 22in (71 x 56cm)
Hermitage, St. Petersburg

OVERLEAF
Self-Portrait, 1669
Oil on canvas, 25 x 22³/4in (63.5 x 57.8cm)
Mauritshuis, The Hague

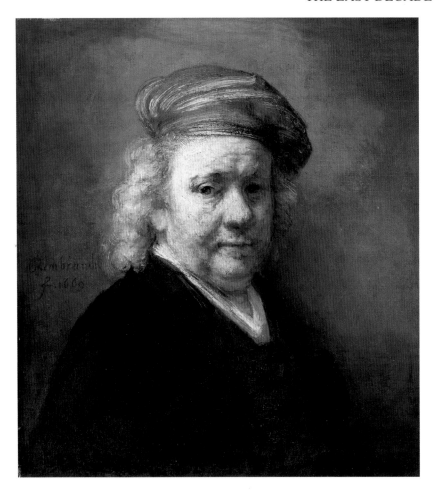

inheritance from her mother. That may have been malicious gossip, although, after the death of Titus, his widow Magdalena complained that Rembrandt was milking his baby granddaughter's inheritance in order to pay his rent. In the same way, years before, Saskia's relatives had feared that Rembrandt was exploiting Titus's inheritance from his mother. He also borrowed money from Harmen Becker, who had acquired the credit note for 1,000 guilders lent by Jan Six in 1653. Becker was an admirer and willing to accept pictures as collateral, but not so great that he forbore to pursue Rembrandt for payment. When he died in 1578, Becker owned 16 pictures by Rembrandt, and although later loans had been repaid, the original Jan Six loan was still outstanding. Nevertheless, Harmen Becker is said to have been the only one of Rembrandt's many creditors who died rich!

Throughout his life, Rembrandt had fallen out with a lot of people – relations, friends, patrons and business associates. In most cases we do not know why, and in no case do we know the whole story, but there can be little doubt that Rembrandt was partly to blame. Clearly, he had a short fuse. There is plenty of evidence of his cavalier attitude towards his patrons and, whatever the truth of the affair, he emerges with no honour from the quarrel with Geertge Dircx. On the other hand, he earned their devotion and was devoted to his most intimate relatives, and he had several friends and

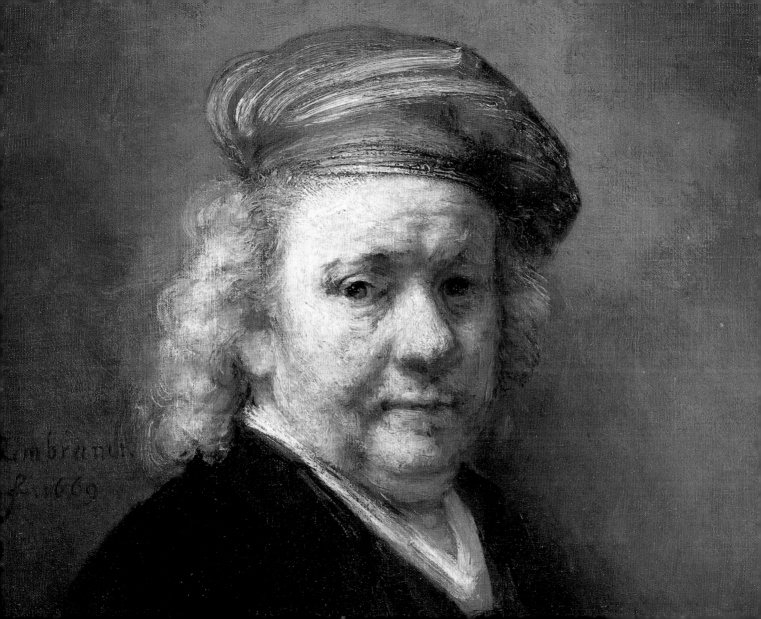

 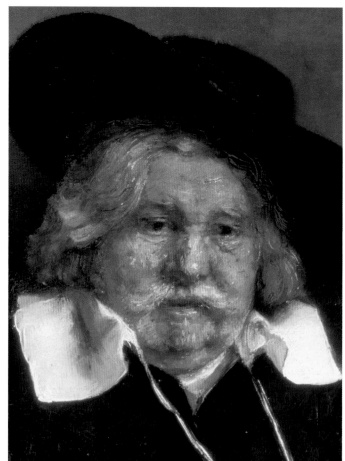

patrons of long standing. As a person, Rembrandt may be open to greater criticism than he is as an artist, but it is impossible to accept the judgment of one of his most accomplished modern biographers that 'Rembrandt had a nasty disposition and an untrustworthy character'.

His situation might have been much worse. Rembrandt was not friendless, he was not ignored or forgotten, and he still attracted patrons. Some of them were unusual characters. Among Rembrandt's late etchings is a striking portrait of about 1658 of Lieven Willemsz. Coppenol. He was an eccentric, considered mad by some of his contemporaries, a former teacher who had developed an obsession with calligraphy (Rembrandt shows him pen in hand). About this time he commissioned a number of artists to make etchings or engravings of him, and then sent prints to various poets with a request that they write verses in his praise. Rembrandt in fact did two etchings of him about this time, and several poets wrote in praise of his etchings as well as the virtues of his patron.

Coppenol was related by marriage to Catrina Hoogshaert whose portrait (page 370), now in a private collection, Rembrandt painted in 1657, one of the many superb pictures among his late portraits. It was probably accompanied by a portrait of her husband, now lost. Another example was the universally admired *Portrait of Jeremias de Decker* (page 371). There seem to have been two portraits of him in fact,

but again, only one has survived. Decker was a poet, a somewhat melancholic and lonely character but an old friend of Rembrandt and a probable spiritual influence on some of his religious etchings, such as *The Three Crosses*. They had known each other at least since 1638, the date of Rembrandt's *The Risen Christ Appearing to Mary Magdalene*, a painting that, as we saw in the previous chapter, Decker had praised in a poem in which he recalls watching Rembrandt painting it. He also wrote a poem of thanks for the portrait of himself (probably the earlier one, now lost), in which he described Rembrandt as the Apelles of the day (Apelles was regarded as the greatest painter of ancient Greece) and tells us that Rembrandt refused a fee for the picture. As Rembrandt was on his beam ends, this fact throws a different light on his alleged meanness. The elegaic 1666 portrait mirrors Decker's character so far as we know it, the shadow cast over his brow by the brim of his hat contributing to his expression of solemn contemplation of things unseen. There is no mistaking Rembrandt's affection for his subject, the approach of whose death, which occurred later in the same year, the artist seems to sense.

Rembrandt was also still admired by some of his younger peers. Gérard de Lairesse was a talented young painter from Liège, who had the misfortune to be extremely ugly, due partly to nature and partly to the ravages of syphilis: Houbraken described his appearance as 'sickening'.

OPPOSITE
Portrait of an Old Man, 1666
Oil on canvas, 31 x 26in
(78.7 x 66cm)
Mauritshaus, The Hague

The Three Crosses, c.1653
Etching, drypoint and burin,
$15^{1}/_{8}$ *x* $17^{3}/_{4}$ *(38.5 x 45cm)*
British Museum, London

Rembrandt's *Portrait of Gérard de Lairesse* (right) appears to make the best of a bad job, without being totally dishonest. Lairesse was only 25 at the time of this painting, and had not yet become the forceful defender of Classicism, and therefore the fierce opponent of Rembrandt's style, that he soon became. In his book on painting published over 40 years later, when he was about the most successful painter in the country, he lays into Rembrandt with the usual arguments of the Classicist ('vulgar and prosaic subjects ... an effect of rottenness'), but he was still prepared to admit that he had mixed feelings: 'I do not wish to deny that I used to have a particular weakness for his style ...' Perhaps he would be pleased to know that most of us suffer the same weakness!

Lairesse came from a well-to-do mercantile family, which had dealings with the Trips, and he may have come into contact with Rembrandt through this connection. The formidable Trips, who came originlly from Dordrecht and were keen patrons of Rembrandt's former pupil from that town, Ferdinand Bol, were also among Rembrandt's patrons. The suberb three-quarter-length painting of Jacob Trip is shown on page 142. This too was one of a pair, for Rembrandt also painted Jacob Trip's wife, *Marguerite de Geer* (pages 378 and 379). Although painted the same year, her husband had since died aged 86 (Rembrandt probably finished his portrait after his death), and that is why she faces the viewer instead of being turned towards the left. It may

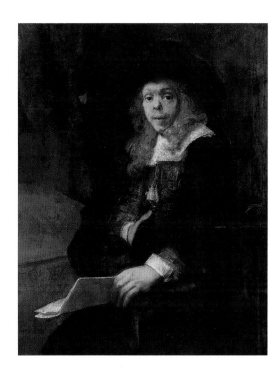

Portrait of Gérard de Lairesse, 1665
Oil on canvas, 44^1/$_4$ x 34^1/$_2$in
(112.4 x 87.6cm)
Metropolitan Museum of Art, New York

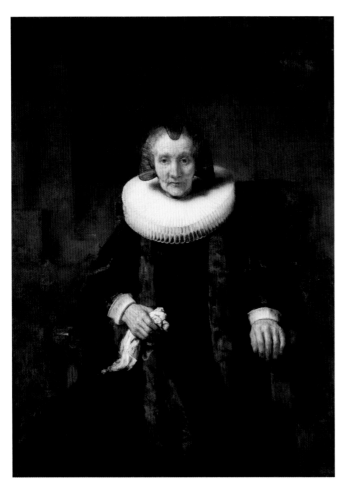

also explain why the subsidiary parts of the painting have a smoother finish. Although she was eight years younger than her husband and lived 11 years after him, Marguerite de Geer's pinched face is that of a very old woman. Her hairstyle and mill-stone ruff belong to a style that had long gone out of fashion. She is painted with all Rembrandt's sympathy and understanding of old age, and with meticulous care: the mottled effect of her skin is achieved by adding tiny, individual spots of colour after the paint has dried. This painstaking method suggests that either she was a remarkably patient sitter or, as some have suggested, the portrait was not done from life, which is hard to believe. It was John Singer Sargent, the greatest portrait painter of a later age, who said that he usually knew how things had been done, but that the head of Mrs. Trip defeated him.

Also in the National Gallery is a second, smaller, head-and-shoulders portrait of her, signed and dated the same year, which is similar but slightly less formal, carrying the suggestion of a smile and memories of the beautiful young woman she once undoubtedly had been. Some have suggested that it is a copy, chiefly because that seems the most logical explanation for it, but most believe it is also by Rembrandt.

Other old patrons remained loyal to Rembrandt. However exasperated Don Antonio Ruffo may have felt as a result of the artist's cavalier attitude in the matter of the patched-up

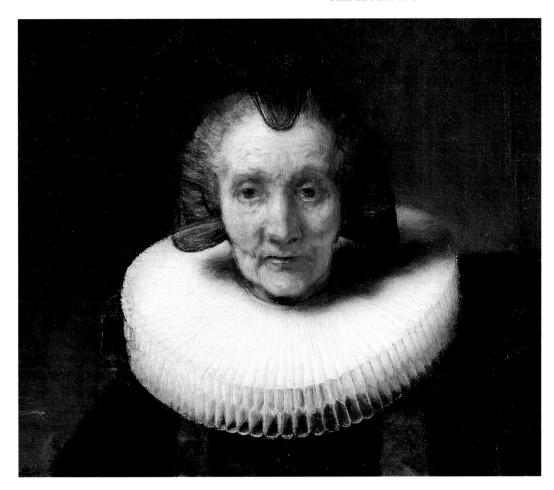

***Marguerite (Margaretha) de Geer,
1661***
*Oil on canvas, $51^{3}/_{8}$ x $38^{3}/_{8}$in
(130.5 x 97.5cm)
National Gallery, London*

Lucretia, 1666
Oil on canvas, 41³/8 x 36¹/3in
(105.1 x 92.3cm)
Minneapolis Institute of Arts

OVERLEAF
Lucretia, 1664
Oil on canvas, 47¹/4 x 39³/4in
(120 x 101cm)
National Gallery of Art, Washington,
D.C.

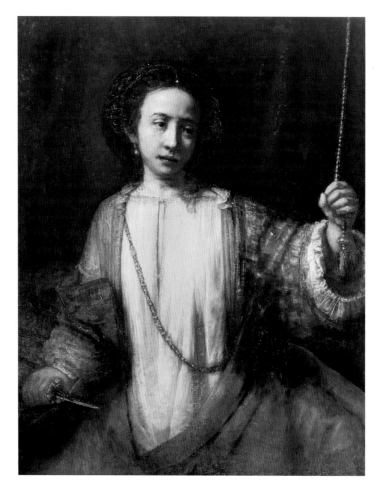

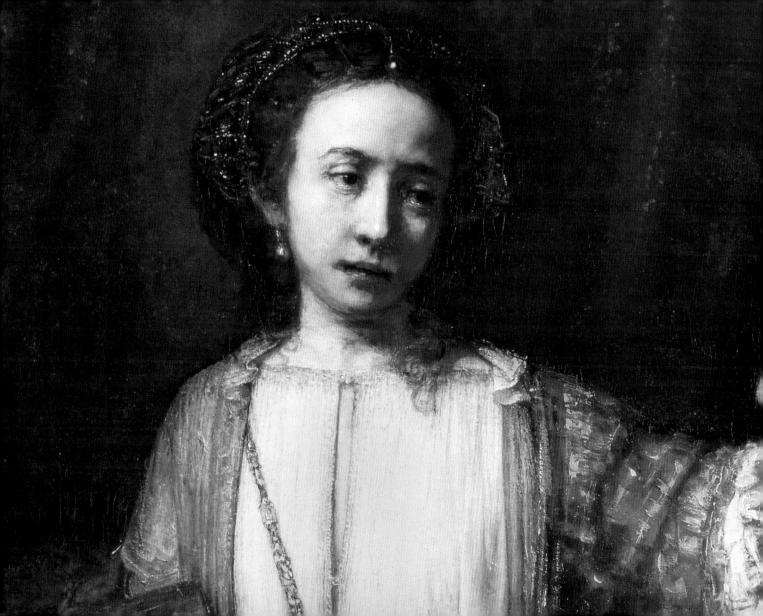

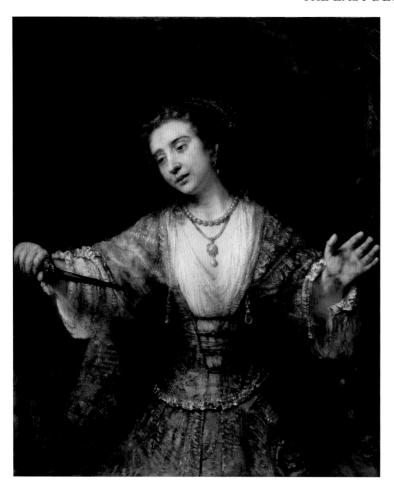

Alexander painting, he did not cease to admire his work, and not long before Rembrandt died he ordered nearly 200 of his etchings. In Amsterdam, another, more eminent Italian, Cosimo de' Medici, later grand duke of Tuscany, paid a visit to Rembrandt's studio in 1667. One of his companions kept a diary, though unfortunately it tells us little of what transpired and the young Medici prince did not linger long. Rembrandt apparently had nothing on hand to offer, which is strange in view of the large number of paintings left in his studio at the time of his death two years later, but Cosimo is thought to have acquired, presumably elsewhere in the city, the *Self-Portrait* of about 1660, now in the Uffizi in Florence, although most experts today suspect that the painting is a copy.

In spite of a vague Italian connection, the idea that Cosimo may have had something to do with Leonardo's two versions of *Lucretia* seems to be baseless. These two late masterpieces are signed and dated 1664 (Washington, National Gallery) and 1666 (Minneapolis, Institute of Arts). Lucretia was the early Roman heroine who, having been raped by the son of the tyrant Tarquin, publicly committed suicide to purge the disgrace brought upon her family, and so stimulated the revolt that overthrew the Etruscan monarchy and resulted in the foundation of the Roman republic. The story, the subject of a long poem by Shakespeare, had long been hugely popular among artists, with Govert Flinck's

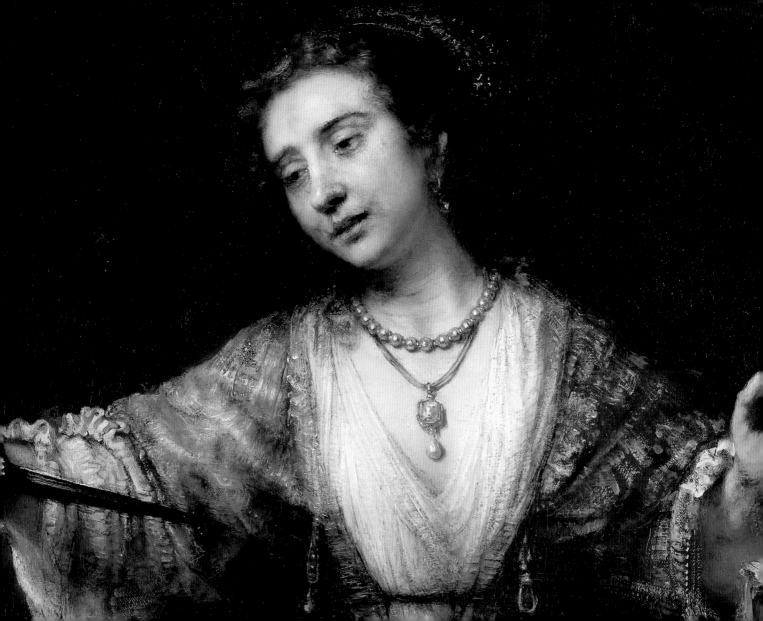

RIGHT
The Conspiracy of the Batavians
under Claudius Civilis, 1661
Pen and brown ink, brown and white
wash, 7³/4 x 7¹/8in (19.6 x 18cm)
Staatlische Graphische Sammlung,
Munich

OPPOSITE
The Conspiracy of the Batavians
under Claudius Civilis, c.1661
Oil on canvas,77¹/8 x 121⁵/8in
(196 x 309cm)
Nationalmuseum, Stockholm

A wounded masterpiece, and the last
great demonstration of the inviolable
integrity of Rembrandt's genius.

painting inspiring another poem, by Jan Vos. Needless to say,
Rembrandt's treatment of the subject, despite the vast
number of precedents, is thoroughly original. Artists tended
to paint the rape somewhat more often than the suicide, but
in both cases Lucretia usually appeared semi-nude. In both of

Rembrandt's's paintings she is fully dressed, although in the
Minneapolis version, in which she has just withdrawn the
dagger, her dishevelled dress is pulled away to reveal a fine
white shift through which the blood is seeping from the
unseen wound ('There is nothing', Simon Schama remarked,
'like this bloodstain in all the countless martyrdoms of
Baroque painting, in all of the spurting severed heads and
severed breasts ...'). Her left hand grasps the rope that draws
the bed curtains as she feels herself about to fall. In the
earlier picture, now in Washington, she is about to plunge the
dagger into her heart. In both, the richly layered impasto of
her clothing emphasizes the fragility of the skin that is
exposed at her throat. The suicide of Lucretia took place in
front of her family and household, and most other painters
included other figures in the scene, but Rembrandt
characteristically excluded them to concentrate all attention
on the tragedy of the young woman's death. The model, who
a few years earlier would no doubt have been Hendrickje, is
the same in both pictures, but her identity is unknown. She
cannot have been either of the two females remaining in the
artist's household, as his daughter Cornelia was only nine or
ten years old when the first picture was painted and his
housekeeper, Rebecca Willems, was elderly.

This story was also seen as a political allegory, with the
Prince of Orange in the role of tyrant and the fair city of
Amsterdam as the wronged maiden. Whether or to what

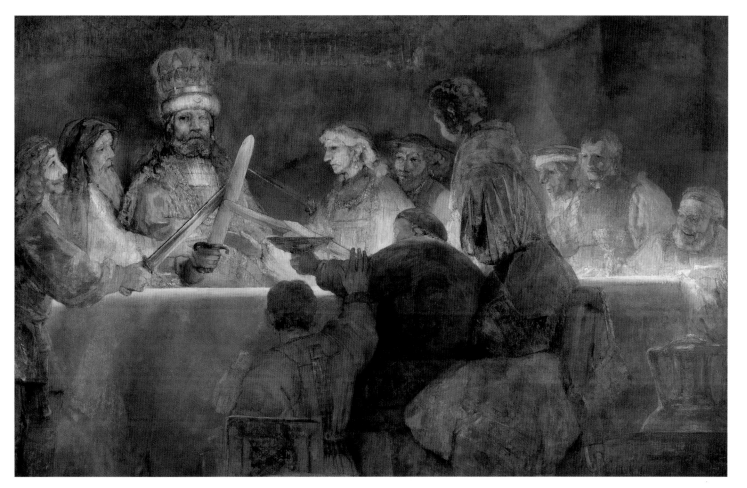

extent Rembrandt was in sympathy with this view, it seems a strange subject for him to have chosen to paint in his last years. Yet he painted it twice. Who commissioned either painting (or both) we do not know, but Rembrandt may have painted the subject before, as an inventory of the possessions of a bankrupt Amsterdam merchant in 1656 lists 'a large painting of Lucretia by R. van Rijn'.

We have seen how the commission for decorating the main chamber in the new Town Hall, where eight paintings were required to fill the large, arched spaces around the gallery, went to Govert Flinck. After some discussion a theme for the series was agreed: the revolt of the Batavians against the Romans in the 1st century BC under the chief known to the Romans (including Tacitus who recorded these events), as Julius (or Claudius) Civilis. The Batavians, or Batavi, who occupied the Rhine delta and the region to the north – roughly Holland – at the time of the Roman conquest in AD 12, were regarded by the Dutch as their ancestors. Their northern neighbours, the Friesians, had twice rebelled unsuccessfully against the Roman occupation before the Batavian revolt of AD 69 and, although the rebels had some military success, in the long run the Romans retained control. The episode was a particularly appropriate one because of the obvious parallel with the revolt of the Netherlands against the rule of Spain, which had been formally concluded only seven years before the inauguration of the new Town

Hall in an all-day ceremony in 1655. (A medal was struck showing Mercury, god of trade, flying over the new building with a motto *Omnibus idem* – 'the same for all'. The same what, though?).

When Flinck unexpectedly died, he had completed sketches but not started painting. The city council was keen to get things moving and initially commissioned three painters to produce one picture each. The small committee appointed to decide which artists should be chosen included at least one Rembrandt sympathizer, and he was the first to be named. The others were Jacob Jordaens, former assistant to Rubens in Antwerp, and none other than Rembrandt's old friend and rival, Jan Lievens, who had been resident in Amsterdam since 1644 or earlier, though we have no record of any social contact with Rembrandt.

Rembrandt's subject was to be the midnight banquet hosted by Claudius Civilis which was the cover for an oath-taking ceremony to confirm the alliance that he had succeeded in constructing among local tribes, both Germanic and Belgic (Celtic), partly to avenge the killing of his brother at the order of the Emperor Nero. Today, only a fragment of *The Conspiracy of Claudius Civilis* (page 385) remains, since it was drastically cut down to its present dimensions. Its original measurements were about $16^{1}/_{2}$ft (5m) in each direction, which made it the largest picture Rembrandt ever painted, exceeding *The Night Watch* by some margin. A small

sketch (page 384), done on the back of an invitation to a funeral, has survived that gives us an idea of the whole composition. Assuming that this was a preparatory sketch (the Rembrandt scholar Svetlana Alpers suggests that it was done later, while Rembrandt was supposedly contemplating alterations to the finished painting) it shows how Rembrandt would exploit the architectural space. It confirms also that the feast was taking place out of doors, as Tacitus reports, or at least a place open to the moonlit sky, under a great vault that matches the arched space the painting was to occupy. The conspirators – a mixed bunch including a couple of clownish grotesques – are grouped around a long table that stands on a low flight of steps beyond the large, vacant foreground, designed to lead the viewer seamlessly from the gallery into the picture.

What remains may be only a fragment (consisting of the table and figures), but it is nevertheless a sensational painting. If Rembrandt is compared with Shakespeare (he often is), then this is his King Lear. The artist has achieved his usual empathy with his subject: the extravagant and roughly handled paint reflects a primitive tribal society and the savage rites of war. At the same time, his technique is infinitely subtle, especially in the crucial mix of colour and light: *chiaroscuro* plays little part in this picture. The light source is hidden, hard to locate exactly, and the light, quite glaring at its brightest, is certainly too bright to come from

any natural source. There is a lot of red in the picture, as if it is bathed in fire. Finally, dominating the table in his exotic headdress and robes, is the massive figure of Claudius Civilis himself, dwarfing his fellow-conspirators and resembling Rembrandt's vision of some Old Testament figure. Tacitus says that Claudius was blind in one eye, and in Rembrandt's portrayal his one-eyed glare makes him all the more formidable.

Flinck, as his own sketch shows, would have treated the subject very differently. His Claudius Civilis is shown in profile, so that his optical disability is concealed, and his conspirators affirm their alliance by shaking hands, like nice civilized Romans. Rembrandt, more authentic in historical detail (having read Tacitus) as well as in poetic spirit, shows them touching sword blades while someone raises a vessel of wine (or blood?). Kenneth Clark saw this painting as final confirmation of his view of Rembrandt as essentially a rebel. 'He was as much in rebellion against the Classical legacy of Rome as were [Claudius] Civilis and his friends.'

But surely the artist might have guessed that this painting would raise some powerful hackles.

The painting was set in place in 1662, and was described in a guidebook to Amsterdam published the same year. Within a few months, it was removed. There was talk that it was not the right size, which sounds susiciously like political spin. Then it was given out that Rembrandt had taken it back

OVERLEAF
Portrait of Frederik Rihel on Horseback, c. 1633
Oil on canvas, 116 x 94⁷⁄₈in
(294.5 x 241cm)
National Gallery, London

One of Rembrandt's largest paintings, though not one of his most attractive (and possibly including work by other hands), this is yet more evidence that stories of Rembrandt's rejection in old age are exaggerated. Rihel was a rich merchant, who came from Strasbourg (hence the name sometimes given to this picture, The Strasbourg Rider*).*

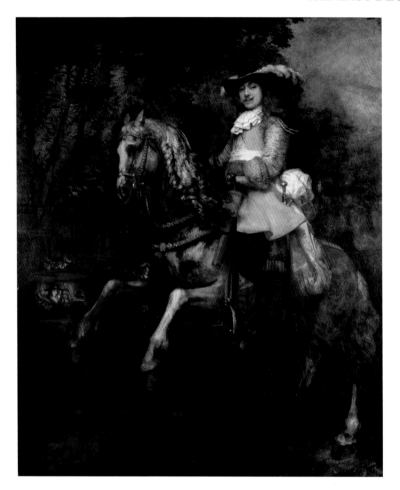

for unspecified 'alterations'. A few months after that it was replaced by a different painting, the work of an undistinguished former pupil of Rembrandt named Jurriaen Ovens who, no doubt on instructions, based his painting on Flinck's design, and finished the job in just four days for a modest fee of 48 guilders. Other than these details, we know little about the circumstances of the withdrawal of this masterpiece. We might assume that there was a great fuss, like that which was supposed to have greeted *The Night Watch*, and since Rembrandt never received his 1,000-guilders fee, we can be sure that he at least had something to say. Perhaps the burghers were more diplomatic, but it is not difficult to understand the consternation of the city council when they saw the heroic patriot-leader of their imagination – the prototype for William the Silent – portrayed as a sinister barbarian brigand, and in a style that, far from the mildly classical elegance envisaged in Flinck's design, appeared equally barbaric, a thousand miles removed from the sort of pompous Baroque set-piece that they had anticipated.

Rembrandt had challenged the establishment before and got away with it. But not this time.

A painting of that size and shape was something of a white elephant, and even the rolled-up canvas must have been an inconvenience in Rembrandt's comparatively small house. It is generally assumed that, in the hope of finding a

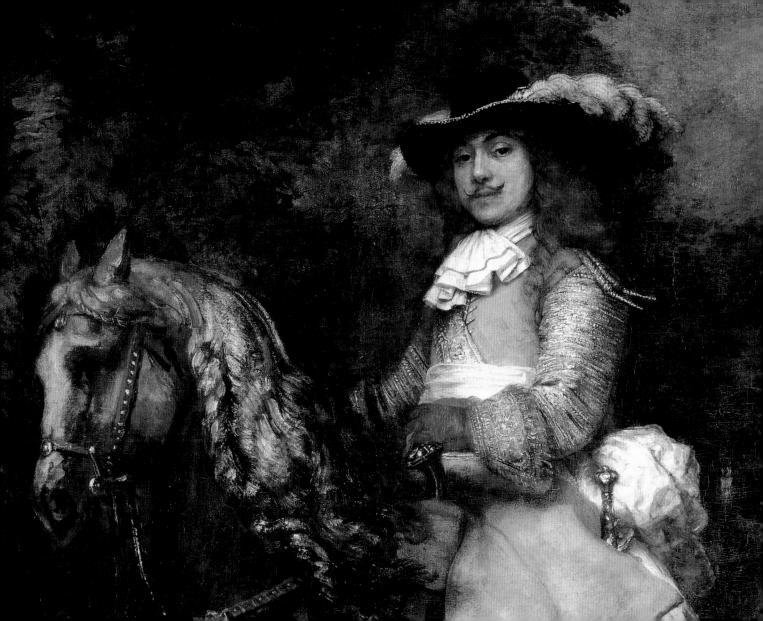

RIGHT and OVERLEAF
The Syndics [of the Cloth-Makers'
Guild], 1661–62
Oil on canvas, 75³/8 x 109⁷/8in
(191.5 x 279cm)
Rijksmuseum, Amsterdam

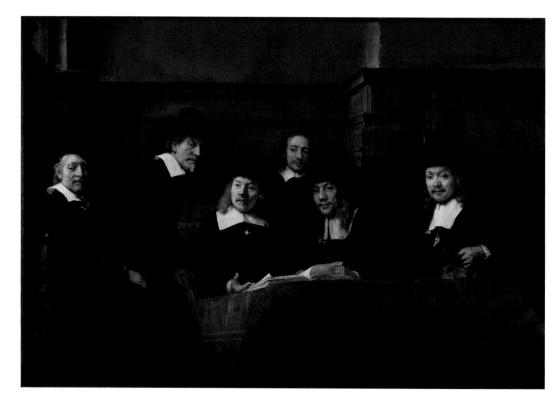

buyer, Rembrandt himself, after first clearing away the furniture, laid it out on the floor and cut it down to a more manageable size.

Perhaps the experience gave Rembrandt a taste for large canvases, for soon afterwards he painted his equestrian portrait of the German Lutheran merchant Frederik Rihel (pages 388 and 389), which occupies one wall of the Rembrandt room in the National Gallery. Rembrandt's signature is no longer visible to the naked eye but is revealed under infra-red light. The picture is usually ascribed to Rembrandt and an unidentified pupil, but it is not easy to believe that Rembrandt had very much to do with this rather mediocre painting.

Rembrandt's last civic group portrait must have overlapped with his great painting for the Town Hall, though two paintings more different could scarcely be imagined. Barbarous vigour on the one hand, calm sophistication on the other. It is known as *The Syndics* [*of the Cloth-Makers' Guild*], left, though the title is slightly inaccurate. The subjects are the members of the guild's sampling committee, the *staalmeesters*, the five elected officers responsible for what would now be called quality control, who held office for one year. The book they are consulting contains the standards against which samples are tested before receiving the guild's seal of approval. They were persons of some status and distinction, as indeed is evident by looking at

them. These are clearly reliable men of discerning judgement and integrity, the cream of Amsterdam society, guardians of the community no less than the watch-tower in the wooden wall panel behind them on the right. Their air of authority is emphasized by the low viewpoint, although that may have been dictated by the intended location of the painting high on the wall of the Guild's Staalhof, or Sampling Hall. The building stood, incidentally, on the other side of the canal from the Kloveniersdoelen, where *The Night Watch* hung, and not far from the Surgeons' Hall containing Rembrandt's Anatomies. .

Though it lacks the drama of *Dr. Tulp's Anatomy Lesson* and the glamour of *The Night Watch*, this painting is regarded by many discerning critics as Rembrandt's finest group portrait. We know, from scientific examination of the painting as well as a number of drawings, that Rembrandt took a great deal of trouble over the composition, and no doubt his shade would be gratified by the universal admiration with which his final design is now regarded: it looks so simple and so obvious but is actually the result of deep thought and experiment. Take, for instance, the position of the servant (the hatless figure at the back), which Rembrandt changed or adjusted many times. Apparently an insignificant addition, he is actually the key to the whole composition, and the relationship of all six figures to each other is so finely calculated that the precise angle of a hat

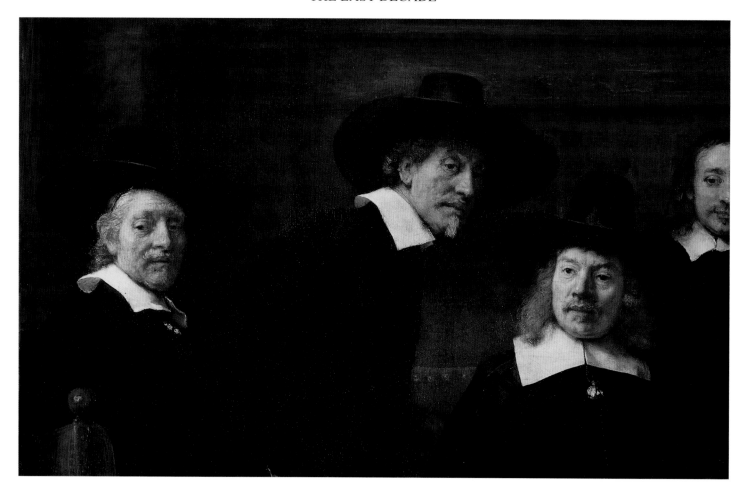

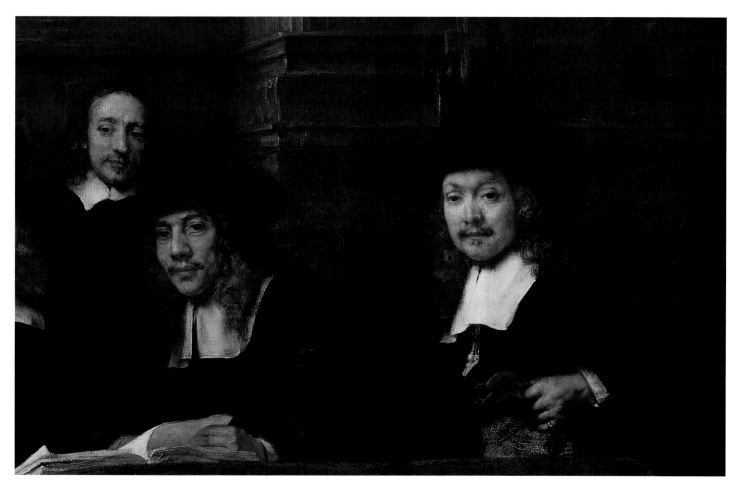

brim is crucial to the sublimely harmonious effect, to which Rembrandt's characteristic colours, red (in the gorgeous Turkish rug that covers the table), brown and black, contribute.

The problems that a group portrait presented to the artist have been described already, and yet again Rembrandt found an original and daring way of avoiding monotony, by as it were freezing a moment in time, with one man in the act of rising (in an earlier version, revealed by X-ray, he was standing upright). He looks as if he might be about to address an audience, and we find ourselves in the position of that audience, since all five officials either look the viewer directly in the eyes or slightly to one side as if fixed on someone in the next seat. In reality, of course, no speeches were made and there was no audience. Yet in one sense surely, the *staalmeesters* were addressing an audience – their successors, those later generations who would sit in that hall and see the discerning eyes of the 1661–62 committee upon them. Rembrandt's presentation of civic virtue is so convincing that we are liable to forget just what a cut-throat activity business in 17th-century Amsterdam really was!

 Nor would the group have met together in this fashion, as they performed their official duty individually, taking it in turns. But it was a tradition for the *staalmeesters* to have their combined portrait done at the end of their year of office, and this painting joined five other group portraits hanging in the same room, the oldest done 100 years before (the office itself had existed for 250 years). All of them show all five men seated, with the steward alone on his feet. The identity of Rembrandt's sitters, including the steward, is known, and so is their religious affiliation. One was a Calvinist, two were Catholics, one a Remonstrant and the last (the man half-standing) a Mennonite. They provide convincing evidence of the precedence of business over religious faith in Amsterdam. It is doubtful that such a body could have been found in any other European city in the 17th century.

Any artist who is as productive and as long-lived as Rembrandt is bound to demonstrate changes in style in the course of his career. Rembrandt is probably more consistent over four decades than most comparable artists, but there are obvious and striking contrasts between his early style, from the time Constantijn Huygens first noted his talent, and the style of his later years. Like other painters – Titian for example – his style became more 'impressionistic' with increasing age. Words such as 'loose', 'rough' or 'broad' are commonly used, though none of those adjectives is quite adequate. But certainly, Rembrandt in the later period grew more interested in paint as an end in itself, working more freely with the palette knife, perhaps even with his fingers, to produce the effect that is called impasto – paint applied so thickly that it stand up in lumps on the canvas and becomes something almost akin to sculpture.

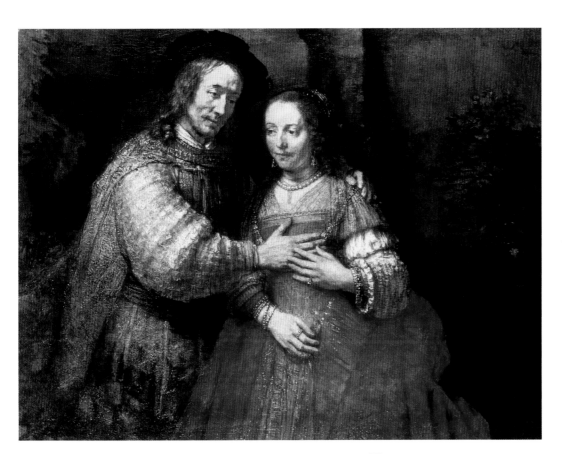

The Jewish Bride, c.1662
Oil on canvas, 47^{7}/$_{8}$ x 65^{1}/$_{2}$in
(121.5 x 166.5cm)
Rijksmuseum, Amsterdam

The title is now firmly established by custom, but there seems to be no convincing reason for it. There is nothing definitively Jewish about this couple, except for the general assumption that they represent figures from the Old Testament.

THE LAST DECADE

Differences in style of painting are not, in Rembrandt, to be explained exclusively in chronological terms. We may be able to say more or less when he abandoned the principles of Baroque – inasmuch as he ever obeyed them; but if we distinguish between what someone has called his 'tight' and 'loose' styles, or what Kenneth Clark called his 'prose' and 'poetic' styles, we find examples of both in the same period. *The Syndics*, an important civic commission for a conservative organization, in which the paint is so self-effacing one barely notices the trace of a brushmark, is an example of the former; *The Jewish Bride* (page 395), which, although its origin is a mystery, is a much more personal – and poetic – painting, is an example of the latter.

We sometimes tend to think of great artists in a romantic way as lone operators, whose work is determined only by their own genius. In reality, of course, many other factors play a part. Throughout his career Rembrandt showed a robust disregard for the views of others and held in very low esteem the opinion of critics. In a drawing of 1644 (New York, Metropolitan Museum) in which a group of people are listening respectfully to a connoisseur expounding on the qualities of a painting, we notice that the two protrusions from the expert's hat are donkey's ears while the artist himself, the only figure not paying attention to the pronouncements of the connoisseur, is coolly defecating. Rembrandt was wont to advise visitors to his studio not to get too close to the picture as 'the smell of paint will put you off'. But Rembrandt, no more than any other artist, could not ignore the opinion of other people, for he depended on them for a living. He might well have challenged the expectations of his patrons and, as the Town Hall commission demonstrated, not always successfully, but in his portrait painting, much of it no more than bread-and-butter work, he clearly set out in a thoroughly professional, craftsmanlike manner to produce a picture that would satisfy the client.

Whether or not it was intellectually conceived, in his great paintings of the 1660s Rembrandt seems to show an awareness of how a rough surface engages the eye more fruitfully than a smooth one, in daubed and dabbled paintwork that has an unfinished look to it. Like the architect who deliberately exposes rather than conceals the technology of a building, Rembrandt draws the viewer more intimately into the picture by showing, or showing off, his technique. This is hardly unusual in modern art, but it was startling, and to the majority objectionable, in the 17th century. But what critics interpreted as carelessness, clumsiness or sheer bloody-minded ignorance was, of course, none of those things. Rembrandt remained a deliberate, painstaking artist: his dense layers of paint become more and more substantial and more various, as if conceived in three dimensions, and they often incorporated other materials, such as charcoal or grit, introduced for their textural properties. Modern

scientific research has established that *The Jewish Bride* contains bits of egg among the intense impasto, which was applied partly with a palette knife and apparently also by other means that still have the analyists bewildered. The density of the paint matches the depth of the emotions communicated.

This is one of Rembrandt's most beautiful and remarkable paintings; Van Gogh said he would give ten years of his life to sit and look at it uninterrupted for ten hours. It is unique, for there had been nothing else like it in Western art, and it is also mysterious, partly because Rembrandt's annoying habit of never signifying his subjects has in this case, as in some others, left us wondering who this newly married couple are and what the picture represents.

It is a simple picture; the bridegroom, having perhaps just placed the gold necklace around his bride's neck, leaves his hand resting on her breast in a gesture full of love and tenderness rather than lustful desire (as such a gesture would have appeared in the work of almost any contemporary). She reciprocates by gently placing her hand over his. The whole picture is suffused with a softly glowing light. The couple are generally identified as Old Testament figures, and the most likely candidates, among many alternatives, are Isaac and Rebecca (whose romantic story is told in the Book of Genesis, Chapter 24). A claim has been put forward for a contemporary Jewish poet, Miguel de Barrios, and his wife.

However, some people who can claim to speak with authority on the subject have stated for a variety of reasons that Rembrandt's couple are definitely not Jewish, which makes Titus and Magdalena possible candidates, though not very likely ones. Gary Schwartz has suggested that this is another picture of theatrical origin, citing parallels with a contemporary Dutch play on the subject of the ancient King Cyrus (a notably fertile source of legend) who was said to have fallen in love with a shepherdess.

In the end, perhaps it is better that we do not know, for this work is not really about an individual couple at all. As 'one of the greatest expressions of spiritual and physical love in the history of painting', it testifies to Rembrandt's unparalleled ability to make a universal and immortal statement out of a particular incident.

Chapter Sixteen
A Quiet Funeral

Plague was a great killer in Europe during the 1660s. It is said to have carried off Hendrickje, though she had clearly been ill for a long time before she died, and in 1668 it killed Titus. The death of his son must have been a savage blow to his father, perhaps the worst of all, and now Rembrandt really was alone, for it seems that Titus, although he had moved out, was still looking after his father's affairs until his final and, one hopes, short (the symptoms of plague are gruesome), final illness. Titus, like Hendrickje, was buried in a rented grave in the Westerkerk.

Of the three latest self-portraits, including the Cologne picture of the artist as a cackling old man, all are generally now dated to 1669, the last year of Rembrandt's life, but it is generally assumed that the picture in The Hague (Mauritshuis) is the last. There is no incontrovertible evidence that it was later than the fine portrait in London (National Gallery), but the latter was formerly thought to have been done several years earlier and the Mauritshuis portrait certainly looks as if it ought to have been later, since it shows a man who, one feels, has almost reached the end of his tether. Rembrandt remained uncompromisingly honest until the last, and the face has somehow become soft and blubbery. The jaw has gone slack, the features are flabby, the eyes puffy, the chin pouchy, the hair wispy. He has not given up completely, for although there is a look of resignation in the eyes, there is no sign of submission, nor, for that matter,

is there any evidence of resentment against the cruel blows that life had dealt him. Moreover, the artist's hand has not lost its skill. The picture is boldly painted, with strong, thick strokes of the brush.

At the beginning of October 1669 a man called Pieter van Brederode called on Rembrandt. He was a shopkeeper by trade, but also a keen amateur antiquarian and genealogist. He had heard of Rembrandt's collection of curiosities, some of which had survived the sales of 1657–58, and was especially interested in a helmet said to have belonged to a famous knight of the age of chivalry. It seems to have been a spur-of-the-moment visit, and perhaps it is rather surprising that he was admitted. He admired the armour, the flayed limbs that may have been worked on by Vesalius, and other odds and ends, making notes of what he saw. Perhaps he admired the pictures too – there were a great many of them – and perhaps he conversed with the painter, though he does not say so and more likely Rembrandt was not well enough to receive him. Whether he saw him or not, this was probably his last visitor.

Rembrandt died quite suddenly a few days later, on 5 October 1669. A small bag of gold was found in Cornelia's cupboard, and after Magdalena had taken half of it on behalf of her daughter, there was enough left to pay for the funeral. Among the rich families of Amsterdam, funerals, however depressingly frequent, were celebrated with some style. The

fashionable thing was a torch-lit procession at night,
followed by a large party at home, with a banquet, music,
and plenty to drink. It was attended by relatives, friends and
even the tradesmen who supplied the family. Cash was
distributed to poor hangers-on.

There was none of that for the man that posterity would
regard as Amsterdam's greatest citizen. A minimum number
of pall-bearers, a small group of mourners, a hurried disposal
of the remains in another rented grave in the Westerkerk.
Perhaps Rembrandt's bones are still there. No one knows.

CHRONOLOGY

1574 Leiden withstands a long Spanish siege

1578 Amsterdam joins the revolt after Calvinists gain control of the city

1579 The Union of Utrecht unites the seven northern provinces

1602 The Dutch East India Company founded

1606 Birth of Rembrandt Harmensz. van Rijn

1609 A Twelve-Year Truce agreed with the Spanish

1610 Arminian Remonstrance presented to Estates of Holland

1613 Rubens paints *The Descent from the Cross* for Antwerp Cathedral

c1614 Rembrandt attends Latin school in Leiden

1617 Prince Maurice backs Gomarists (Counter-Remonstrants)

1618 Oldenbarneveldt arrested (executed 1619)

1619 The Synod of Dort (Dordrecht) condemns Arminianism

1620 Rembrandt enrolled at University of Leiden

1621 War against the Spanish resumes

1624 Rembrandt studies with Pieter Lastman in Amsterdam

1625 Death of Prince Maurice, succeeded by Frederik Hendrik

Rembrandt shares a studio with Jan Lievens in Leiden

1626 Rembrandt paints *Tobit Accuses Anna of Stealing the Kid*

1628 Gerrit Dou becomes Rembrandt's pupil

1629 Constantijn Huygens visits Rembrandt and Lievens in Leiden

1630 Death of Rembrandt's father

1631 Rembrandt settles in Amsterdam, living with Hendrickje Uylenburgh

1632 Rembrandt paints *The Anatomy Lecture of Dr. Nicolaes Tulp*

1634 Marriage of Rembrandt and Saskia

1635 Rembrandt rents a house on the Nieue Doelenstraat

1636 He paints *Danäe* (reworked in the 1640s)

1637 Rembrant is living in 'the Sugar Factory' on the Binnen-Amstel

1639 Rembrandt moves into the Rembrandthuis (Rembrandt House)

1640 Death of Rembrandt's mother

1641 Birth of Titus

1642 Death of Saskia
Rembrandt paints *The Night Watch*

c1646 Hendrickje employed as a servant

1647 Death of Frederik Hendrik, succeed by William (Willem) II

1648 Spain recognizes Dutch independence in Treaty of Munster

1649 Geertge Dircx sues Rembrandt for breach of promise

1650 Prince William II marches on Amsterdam

1652 Outbreak of the First Anglo-Dutch War (to 1654)

1653 Rembrandt paints *Aristotle Contemplating a Bust of Homer*

1654 Birth of Hendrickje's daughter, Cornelia
Rembrandt paints a *Portrait of Jan Six*
He is forced to pay the outstanding debt on his house

1656 Rembrandt applies for official declaration of insolvency

1657 First sale of Rembrandt's property

c1658 Rembrandt moves to a smaller, rented house on the Rozengracht

1660 Hendrickje and Titus form a company employing Rembrandt

1661-62 Rembrandt paints *The Conspiracy of the Batavians under Claudius Civilis*, *The Syndics [of the Clothmakers' Guild]* and *The Jewish Bride*

1663 Death of Hendrickje

1668 Marriage (February) and death (September) of Titus

1665 Outbreak of the Second Anglo-Dutch War (to 1667)

1669 Death of Rembrandt (5 October)

CHRONOLOGICAL LIST OF WORKS/ACKNOWLEDGEMENTS

REMBRANDT

Self-Portrait in Oriental Costume, 1631
Musée de la Ville de Paris, Musée du Petit-
Palais/Giraudon/The Bridgeman Art Library,
London
Pages 8 and 9

Young Man at His Desk, 1631
Hermitage, St. Petersburg
Page 149

The Abduction of Proserpina, c.1632
Gemäldegalerie, Berlin
Page 117

Amalia van Solms (Princess of Orange), 1632
Musée Jacquemart-André, Paris
Page 113

The Anatomy Lesson of Dr. Nicolaes Tulp, 1632
Mauritshuis, The Hague/The Bridgeman Art Library,
London
Pages 154 and 155

An Artist in a Studio, c.1632
J. Paul Getty Museum, Malibu
Page 16 right

Jacques (Jacob) de Gheyn III, 1632
By permission of the Trustees of Dulwich Picture
Gallery, London
Pages 160 and 161

Philosopher in Meditation, 1632
Louvre, Paris/The Bridgeman Art Library, London
Page 59

Portrait of Marten Looten, 1632
County Museum of Art, Los Angeles
Page 148

Portrait of Maurits Huygens, 1632
Kunsthalle, Hamburg/The Bridgeman Art Library,
London
Page 60

The Raising of Lazarus, c.1632
Rijksprentenkabinet, Rijksmuseum, Amsterdam
Page 180

The Rape of Europa, 1632
J. Paul Getty Museum, Malibu
Pages 120 and 121

**Jean Pellicorne and His Son Casper,
c. 1632–34**
Wallace Collection, London/The Bridgeman Art
Library, London
Pages 14 and 15

**Susanna van Collen, Wife of Jean Pellicorne, and
Her daughter Eva, c.1632–34**
Wallace Collection, London/The Bridgeman Art
Library, London
Page 137

A Boy in Fanciful Costume, 1633
Wallace Collection, London/The Bridgeman Art
Library, London
Page 58

The Descent from the Cross, c.1633
Blauel-Gnamm Artothek/Alte Pinakothek, Munich
Pages 104 left, 106 and 107

REMBRANDT

Portrait of a Young Man with a Lace Collar, 1634
Hermitage, St Petersburg/The Bridgeman Art
Library, London
Page 61

St. John the Baptist Preaching. c.1634
Gemäldegalerie, Berlin
Page 284

Saskia as Flora, 1634
Hermitage, St. Petersburg/The Bridgeman Art Library,
London
Pages 164 and 165

**Saskia with a Veil (Saskia Uylenburgh, the Wife of
the Artist), 1634**
Widener Collection, Image © 2003 Board of Trustees,
National Gallery of Art, Washington, D.C.
Pages 132 and 133

Susanna Bathing, 1634
Mauritshuis, The Hague/The Bridgeman Art Library,
London
Pages 192 and 193

**Saskia van Uylenburgh in Arcadian Costume
(Saskia as Flora), c.1634–35**
© National Gallery, London
Pages 168 and 169

Saskia in a Red Hat, c.1634–42
Gemäldegalerie, Kassel
Page 179

The Abduction of Ganymede, 1635
Gemäldegalerie, Dresden/The Bridgeman Art Library,
London
Pages 196 and 197

Johannes Wtenbogaert, 1635
Rijksmuseum, Amsterdam
Page 119

The Lamentation over the Dead Christ, c.1635
© The National Gallery, London
Pages 358 and 359

The Sacrifice of Isaac, 1635
Hermitage, St. Petersburg/The Bridgeman Art Library,
London
Pages 186 and 187

Samson Threatening His Father-in-Law, c.1635
Gemäldegalerie, Berlin
Page 215 right

**Self-Portrait with Saskia (Scene of the Prodigal Son
in the Tavern), c.1635**
Gemäldegalerie, Dresden/The Bridgeman Art Library,
London
Pages 162 right and 163

Self-Portrait in Fancy Dress, 1635-36
Mauritshuis, The Hague/The Bridgeman Art Library,
London
Page 135

The Ascension of Christ, 1636
Joachim Blauel Artothek/Alte Pinakothek, Munich
Page 105 right

The Blinding of Samson, 1636
Städelsches Kunstinstitut, Frankfurt
Page 203

REMBRANDT

CHRONOLOGICAL LIST OF WORKS/ACKNOWLEDGEMENTS

REMBRANDT

Medea, or The Marriage of Jason and Creusa 1648
The Pierpont Morgan Library/Art Resource, New York
Page 283

Self-Portrait by a Window, 1648
Rijksprentenkabinet, Rijksmuseum, Amsterdam
Page 254

The Risen Christ at Emmaus, 1648
Louvre, Paris/The Bridgeman Art Library, London
Pages 338 and 339

The Supper at Emmaus, c.1648–49
Fitzwilliam Museum, University of Cambridge/The Bridgeman Art Library, London
Page 335

Christ, c.1650
Gemäldegalerie, Berlin/The Bridgeman Art Library, London
Page 329

Portrait of an Elderly Woman, c.1650
Pushkin Museum, Moscow/The Bridgeman Art Library, London
Pages 36 and 37

Portrait of a Man in Military Costume, c.1650
Fitzwilliam Museum, Cambridge/The Bridgeman Art Library, London
Pages 20 right and 21

The Dream of St. Joseph, c.1650–55
Museum of Fine Arts, Budapest/Interfoto/The Bridgeman Art Library, London
Page 305

The Goldweigher's Field, 1651
Rijksprentenkabinet, Rijksmuseum, Amsterdam
Page 242 left

Portrait of an Old Man in Period Costume, 1651
Chatsworth House, Derbyshire/Peter Willi/The Bridgeman Art Library, London
Page 20 left

An Old Man in an Armchair, 1652
National Gallery, London/The Bridgeman Art Library, London
Pages 30 and 31

Self-Portrait, 1652
Kunsthistorisches Museum, Vienna
Page 264

Aristotle Contemplating a Bust of Homer, 1653
Metropolitan Museum of Art, Purchase, special contributions and funds given or bequeathed by friends of the Museum, 1961. (61.198) Photograph ©1993 The Metropolitan Museum of Art, New York
Pages 288 and 289

The Three Crosses, c.1653
British Museum, London/The Bridgeman Art Library, London
Page 376

The Three Crosses, 1653
Hermitage, St. Petersburg/The Bridgeman Art Library, London
Page 360

Bathsheba, 1654
Louvre, Paris/The Bridgeman Art Library, London
Pages 252 and 253

REMBRANDT

CHRONOLOGICAL LIST OF WORKS/ACKNOWLEDGEMENTS

REMBRANDT

The Woman with the Arrow, 1661
Fitzwilliam Museum, Cambridge/The Bridgeman Art
Library, London
Page 39 left

**Self-Portrait with Two Circles,
c.1661–62**
English Heritage, Kenwood House, London. The
Iveagh Bequest /The Bridgeman Art Library, London
Page 273 right

The Syndics (of the Cloth-Makers' Guild), 1661–62
Rijksmuseum, Amsterdam
Pages 390, 392 and 393

The Jewish Bride, c.1662
Rijksmuseum, Amsterdam/The Bridgeman Art Library,
London
Page 395

Homer Instructing His Pupils, 1663
Mauritshuis, The Hague/The Bridgeman Art Library,
London
Pages 294 and 295

Lucretia, 1664
Andrew W. Mellon Collection, Image © 2003 Board of
Trustees, The National Gallery of Art, Washington,
D.C.
Pages 382 and 383

Portrait of Gérard de Lairesse, 1665
Metropolitan Museum of Art, New York
Page 377

Lucretia, 1666
Minneapolis Institute of Arts/The Bridgeman Art
Library, London
Pages 380 and 381

Portrait of an Old Man, 1666 (plus detail)
Mauritshaus, The Hague/The Bridgeman Art Library,
London
Page 374

Portrait of Jeremias de Decker, 1666
Hermitage, St. Petersburg
Page 371

**The Return of the Prodigal Son,
c.1666–68**
Hermitage, St. Petersburg/The Bridgeman Art
Library, London
Pages 350 and 351

Self-Portrait, 1669
Mauritshuis, The Hague
Pages 372 and 373

Self-Portrait at the Age of 63, 1669
National Gallery, London/The Bridgeman Art Library,
London
Pages 276 and 277

Self-Portrait Laughing (Zeuxis), c.1669
Wallraf-Richartz Museum, Cologne/The Bridgeman
Art Library, London
Page 275 right

Simeon with the Christ Child in the Temple, c.1669
Nationalmuseum, Stockholm/The Bridgeman Art
Library, London
Pages 285 and 286

CHRONOLOGICAL LIST OF WORKS/ACKNOWLEDGEMENTS

REMBRANDT

Works by other artists

Gerard van Honthorst
Frederik Hendrik, 1631
Huis ten Borsch, The Hague
Page 56

Caravaggio
Death of the Virgin, 1605-06
Louvre, Paris
Page 64

Pieter Lastman
Coriolanus and the Roman Women, 1625
Trinity College, Dublin
Page 67 left

Gerard Dou
An Old Painter Writing behind His Easel, c.1631–32
Private collection
Page 91

Jan Lievens
Portrait of Constantijn Huygens, c.1628
Rijksmuseum, Amsterdam
Page 93

Jan Lievens
The Raising of Lazarus, 1631
By courtesy of the Royal Pavilion, Libraries and Museums, Brighton and Hove, U.K.
Page 97 right

Peter Paul Rubens
Self-Portrait, c.1622–23
Royal Collection, Windsor Castle, U.K.
Page 100

Thomas de Keyser
Constantijn Huygens and His Secretary, 1627
National Gallery, London
Page 114

Joris Hoefnagel
Map of Amsterdam from Civitates Orbis Terrarum, c. 1572, by Georg Braun and Frans Hogenburg
The Stapleton Collection/The Bridgeman Art Library, London
Page 115

Anthony van Dyke
Portrait of Frederik Hendrik, c.1631–32
Baltimore Museum of Art
Page 145

Thomas de Keyser
The Anatomy Lesson of Dr. Sebastian Egbertsz. de Vrij, 1619
Historisch Museum, Amsterdam
Page 153 right

Peter Paul Rubens with Frans Snyders
Prometheus Bound, 1618
Philadelphia Museum of Art
Page 216

Leonardo da Vinci
The Last Supper, 1495–98
Santa Maria delle Grazie, Milan
Page 218

Raphael
Portrait of Baldassare Castiglione, before 1516
Louvre, Paris/The Bridgeman Art Library, London
Page 221 right

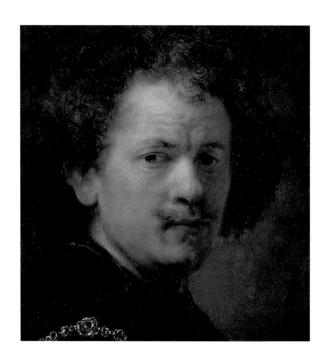

INDEX

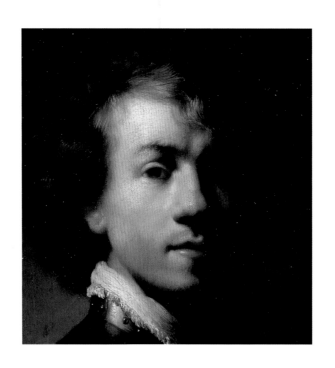

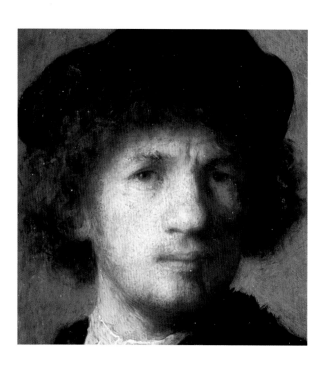

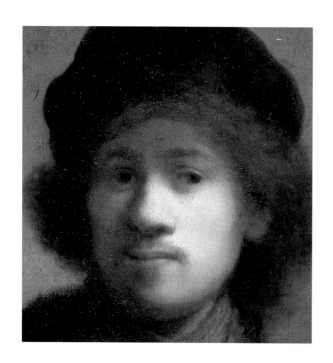

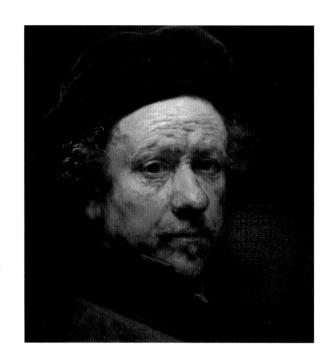

426

INDEX

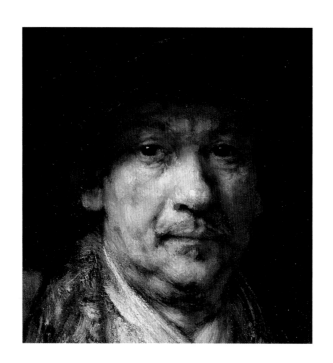

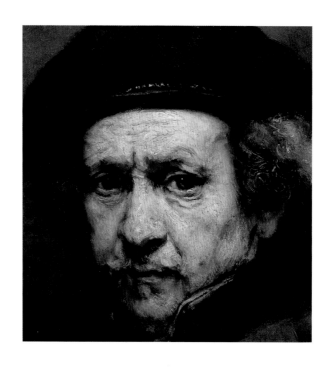

INDEX

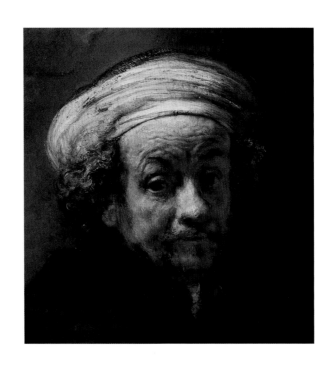

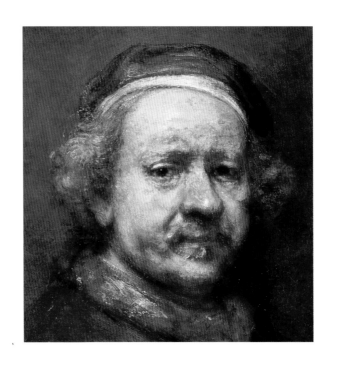

INDEX

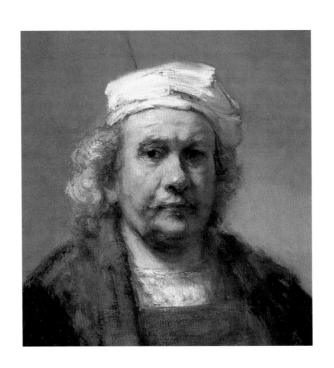

INDEX